comic & fantasy artist's pho

Colossal Collection
of Action Poses

Buddy Scalera

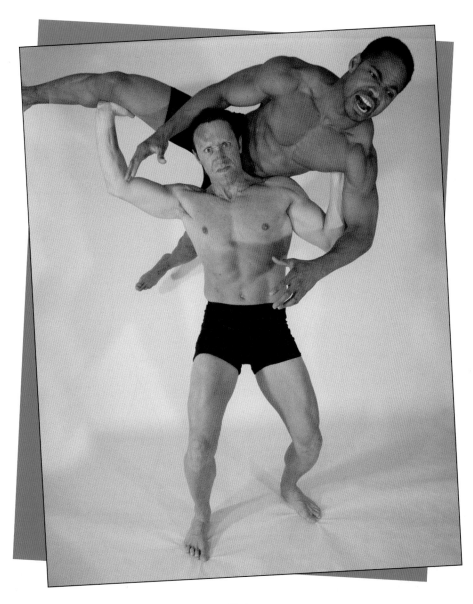

IMPACT
Cincinnati, Ohio
www.impact-books.com

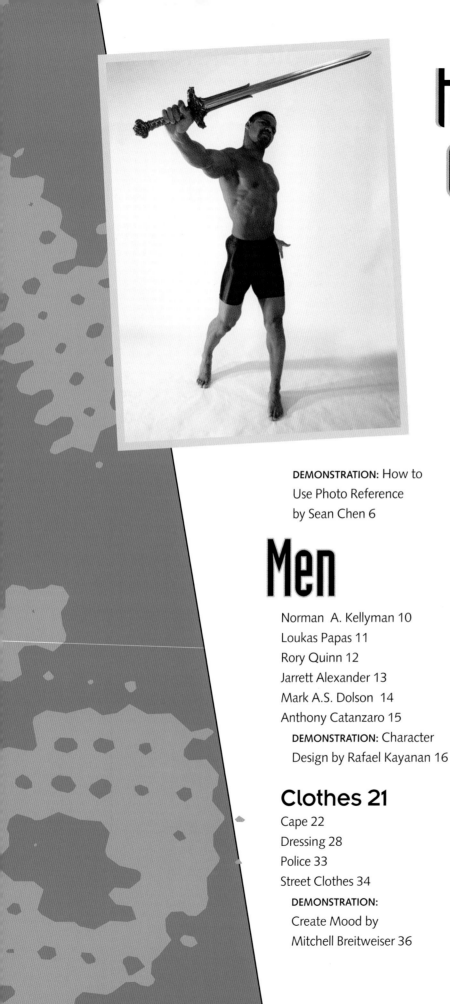

table of contents

Expressions 39

Angry 40

Confused 41

Happy 42

Sad 44

Scared 46

Wounded 50

DEMONSTRATION: Make Your Art
Tell a Story by Mike Lilly 56

Action 60

Choking 62

Crawling 64

Flying 65

Jumping 70

Kicking 74

Kneeling 76

Lifting 77

Punching 82

Pushing 88

DEMONSTRATION: The Body in
Motion by Matt Haley 89

DEMONSTRATION: How to
Use Photo Reference
by Sean Chen 6

Men

Norman A. Kellyman 10

Loukas Papas 11

Rory Quinn 12

Jarrett Alexander 13

Mark A.S. Dolson 14

Anthony Catanzaro 15

DEMONSTRATION: Character
Design by Rafael Kayanan 16

Clothes 21

Cape 22

Dressing 28

Police 33

Street Clothes 34

DEMONSTRATION:
Create Mood by
Mitchell Breitweiser 36

Action, cont.
Running 94
Sitting 98
Standing 102
Walking 106

Weapons 108
Blasts 110
Bow 112
 DEMONSTRATION: Watercolor
 Painting From Photo
 Reference by Mark Smylie 117
Guns 120
Knife 128
Nunchucks 130
Staff 130
Swords 132
 DEMONSTRATION: Team of
 Heroes, Collage-Style by Jamal
 Igle 142

Women

Haydee Urena 146
Vanessa Carroll 147
Chanel Wiggins 148
Pamela Paige 149
Zoe Labella 150
Ridada Elias 151
Veronica Bond 152

Clothes 153
Boots 154
Cape 155
Street Clothes 159
Dressing 164
 DEMONSTRATION: Think 3-D
 by Terry Moore 166
Dressing, cont. 170
Gloves 172
Hair 173

Lying Down 226
Make-up 227
Punching 230
 DEMONSTRATION: Teen
 Action Hero by Josh
 Howard 234
Running 236
Sitting 240
Standing 244
 DEMONSTRATION: Drawing
 Energy From a Photo Refer-
 ence by Thom Zahler 247
Swinging 251
Twisting 252
Walking 253

Weapons 254

Blasts 255
Bow 257
Guns 258
 DEMONSTRATION: Draw a
 Character on a Background
 by Paul Chadwick 262
Guns , cont. 264
Knife 266
Nunchucks 267
Sticks 268
Swords 270
 DEMONSTRATION: Evolution
 of a Cover by JG Jones
 with cover designer Terri
 Woesner 274
Swords, cont. 278

Expressions 176

Angry 177
Happy 179
Sad 180
Skeptical 182
 DEMONSTRATION: Draw a
 Beautiful Woman by Greg
 Land 183
Scared 186
Surprised 192
Wounded 194
 DEMONSTRATION: Work from
 Studies by William Tucci 200

Action 204

Crouching 205
Climbing 207
Flying 208
Jumping 212
 DEMONSTRATION: Tracing
 (Yes, Tracing) by
 Michael Oeming 216
Kicking 220
Lifting 222

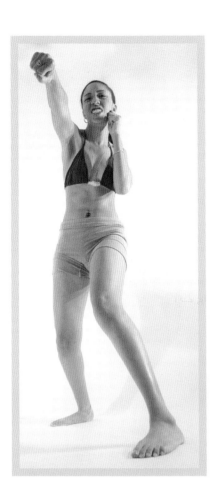

More Stuff 282

DEMONSTRATION: Creating Pitch Art by David Hahn 284

Battle 287

Drinking 292

Loading a Gun 294

DEMONSTRATION: Use Photo Reference to Create a Cartoonish Figure by Fernando Ruiz 296

Phone 300

Romance 302

Slapping 306

Smoking 307

Special Lighting 310

About the Artists 314

About the Author 318

Acknowledgments 318

Dedications

To Janet
You're still my favorite.

To Danielle & Nicole
Stick together and help your sister.
Everything else will fall into place.

To Dad & Mom
Thanks for years and years of support
and encouragement.

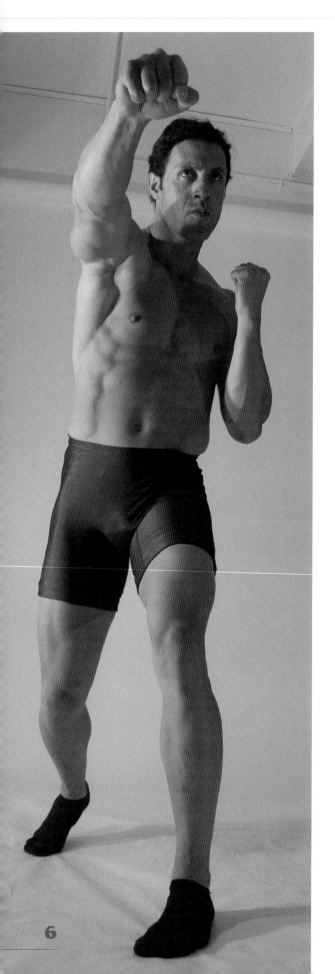

BY SEAN CHEN

You'd think that looking at photo reference would be a simple and straightforward process. But it just isn't. Photographs and comic book pages are two-dimensional representations of three-dimensional objects.

An experienced artist can trick the viewer into seeing 3-D people, places or things by leveraging art techniques such as foreshortening, shading and perspective. A good photograph can help you add weight, depth and realism to your illustrations. But first, you need to know how to look beyond the flat image of the photo to see form and motion.

Find Your Photo

Look for a photo that gives you the pose you need to tell your story. There are only so many ways that the body can move and twist, but there are infinite ways to draw it. As an artist, you can move your mental "camera" in any possible angle to create a new, fresh and exciting illustration. Choose a photograph that closely approximates the picture you want to draw. It may not match perfectly, but as an artist you can borrow gestures and expressions from other photographs or something that you envision in your head.

This photograph shows a tall, physically powerful man throwing a punch. The low angle of the shot makes him seem even taller and more imposing.

From an emotional standpoint, a reference photo with two light sources adds drama, depth and feeling to the figure.

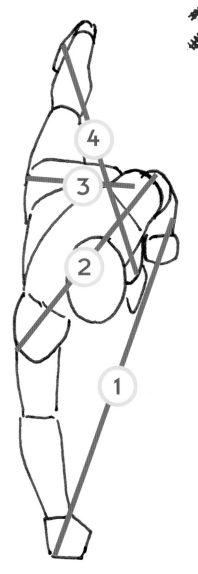

2 Understand Three-Dimensional Space

The model in this photo exists in the real world, in 3-D space. But the photograph shows only a 2-D representation of this person. Our minds allow us to use visual cues to perceive depth and distance in a flat image.

Try to move the mental camera I mentioned in step 1 to a vantage point directly above the figure, and draw what the model is doing in the 3-D space. This will allow you to see how the body is moving in the real world. You can see that this model's body is moving forward while one of the legs remains firmly behind. Most of his body weight is on the left leg. All the other body parts fan out from this point. When the figure is standing at rest, it is completely balanced. When the body begins to move, there is a new dynamic as the figure stretches and expands in the 3-D plane. The figure in this position is out of balance. One side is compressed and bears most of the weight. The other side is delivering energy by pushing weight into a punch. Notice how the punch leads the body with forward momentum. It looks almost like a spiral staircase, which gives you a sense of how this shape exists in the real world. These are important details that will make your final drawing breathe with depth, weight and motion.

1 The fist is the part of the body that has travelled farthest from its original position.

2 The head and shoulders lead the torso. Because of the outstretched arm, the shoulders are angled from their original position. Notice how the angle differs from that of the hips.

3 The hips remain straight and close to their starting position. In the starting position, the hips bear the body's weight, but here the weight has shifted to the model's left upper thigh and left knee.

4 The model's right foot remains in its original position. It anchors the figure and gives him something to push and launch against. If this model were standing on ice, he would not have the power and thrust shown in this pose.

Ultimately this is a body out of balance. This pose suggests a figure in motion and delivering energy, which is something that comic artists must be able to draw.

throw off the balance

The natural, at-rest state of the body is standing up straight (near right). That's when the body is most balanced. Running and punching (far right) put the body out of balance. In comics, the action will often make the body look like it's about to tip over. Use this to your advantage to heighten the sense of motion.

These figures are approximately the same height, weight and body type, but notice the subtle visual cues that tell the reader that the body on the far right is in motion. Notice also how the pose on the near right is very relaxed, compared to the picture on the far right. Both are effective poses that convey different messages to the reader.

3 Break Down the Body Into Sections

Every part of the body has weight and volume. Start your drawing by sketching the figure with simple lines. When you draw the hips and shoulders, imagine the 3-D space. Notice how the body torques and spirals, just as we discussed in step 2. Look for other anatomy clues, such as the way the back leg and the hip pivot together. The hip and the leg can bend and move, but the anatomy and mechanics will stay relatively consistent in all figures. That is, there are only so many ways the leg can move within the bone structure of the hip.

Imagine each body part to be a cylinder stacked on top of another cylinder, then draw the cylinders.

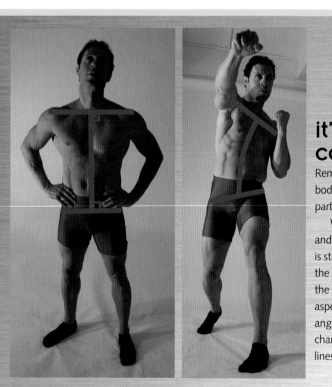

it's all connected

Remember that the parts of the body are interconnected. When one part moves, it affects other parts.

When the body is stable and straight (far left), the spine is straight and perpendicular to the shoulders and hips. When the spine bends (near left), other aspects change too: The spine's angle to the shoulders and hips changes, and the shoulder and hip lines go from parallel to angled.

Primary light source

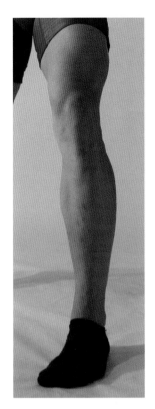

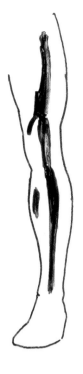

Secondary, weaker light source

Add Shading

Two light sources reveal the contours and volume of the figure in this photo. The bones add structure, but the musculature creates complex shadows. You can figure out about 70 percent of the shadows from just knowing the direction of the light. But to get the core tonality right, you must analyze the peaks and valleys created by the muscles. Remember, also, that bones are not perfectly straight. Use a ruler to reveal the natural curve of the bone, and use this knowledge to create a more realistic shadow.

look for the subtleties

Notice that the shin bone is not perfectly straight; there is a slight natural curve to it. This causes the shading to curve as well. Paying attention to details such as this will take your art to a new level of realism.

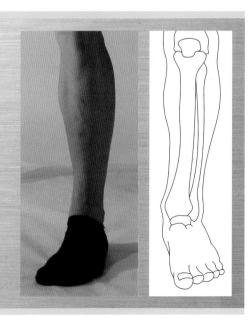

Norman A. Kellyman

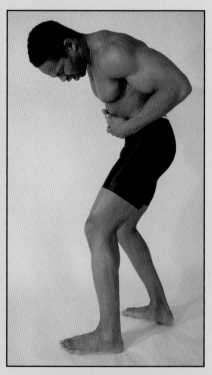

Age: 32

Height: 5' 11" (1.8m)

Weight: 178 lbs. (81kg)

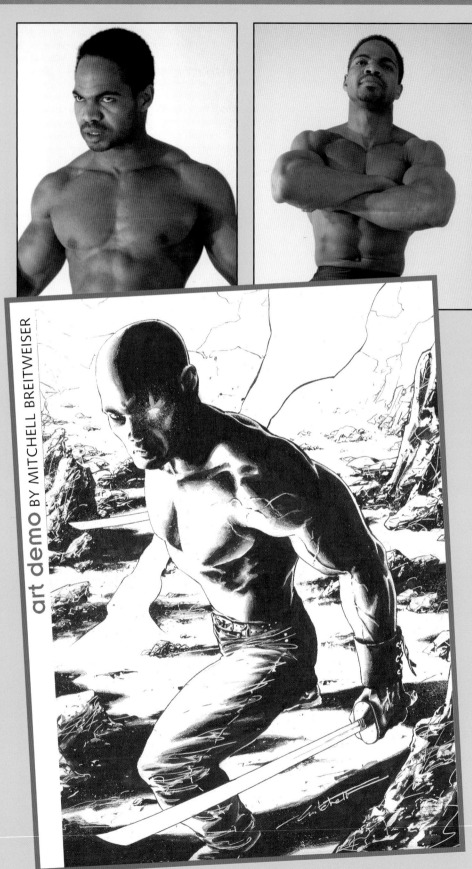

art demo BY MITCHELL BREITWEISER

Loukas Papas

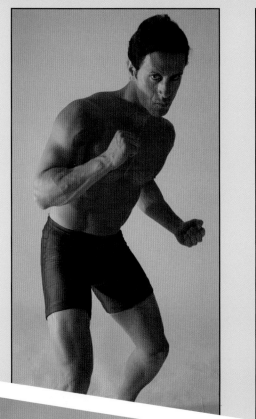
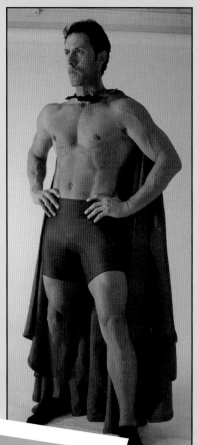

Age: 39

Height: 6' 1" (1.9m)

Weight: 185 lbs. (84kg)

art demo BY MATT HALEY

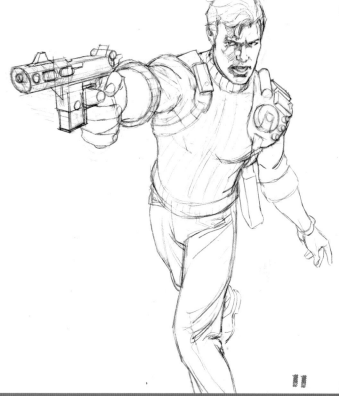

11

Rory Quinn

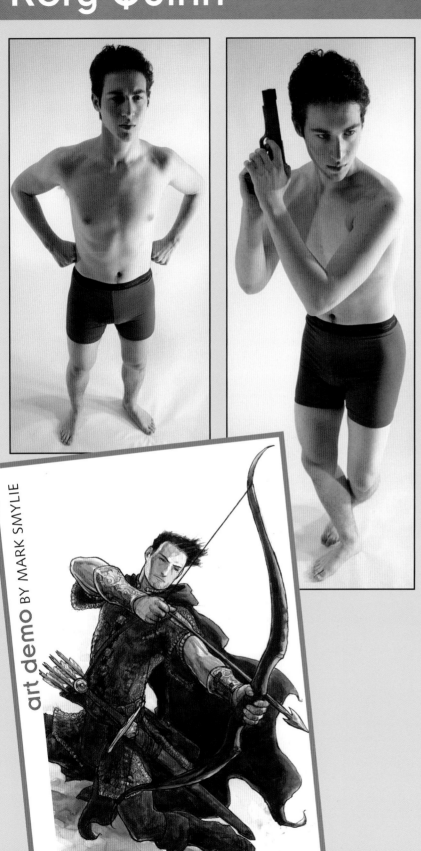

art demo BY MARK SMYLIE

Age: 18

Height: 5' 10" (1.8m)

Weight: 150 lbs. (68kg)

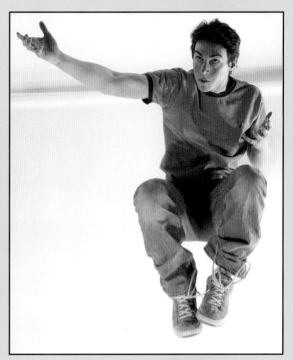

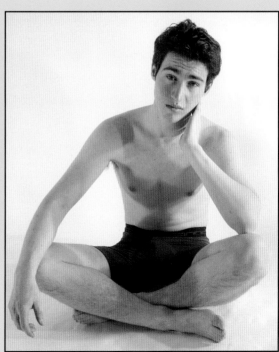

Jarrett Alexander

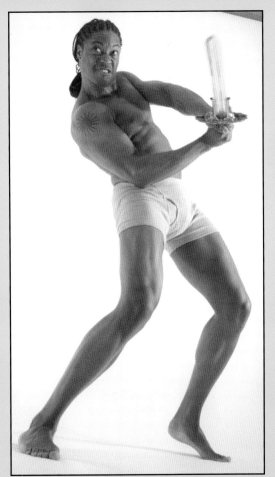

Age: 25

Height: 5' 10" (1.8m)

Weight: 170 lbs. (77kg)

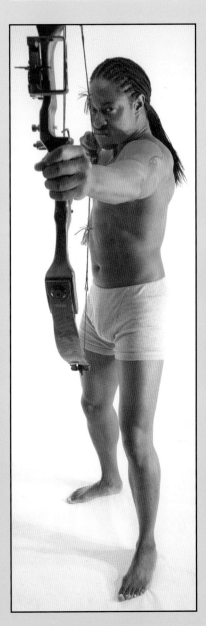

art demo BY DAVID HAHN

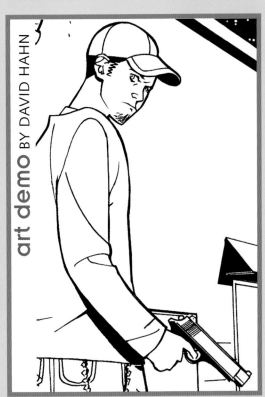

For more action poses, visit
impact-books.com/
colossal-collection

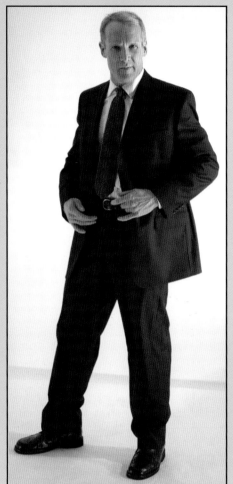

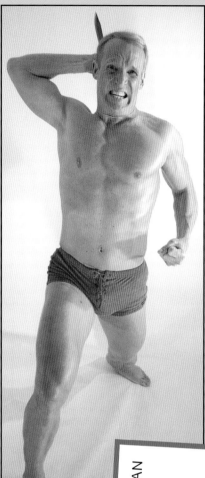

Age: 44

Height: 6' 1" (1.9m)

Weight: 190 lbs. (86kg)

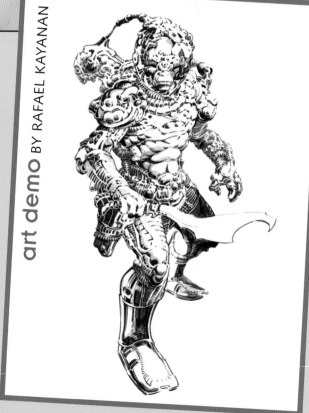

art demo BY RAFAEL KAYANAN

Anthony Catanzaro

Age: 37

Height: 5' 11" (1.8m)

Weight: 190 lbs. (86kg)

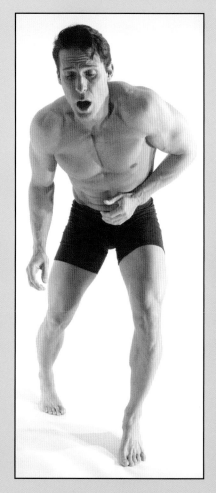

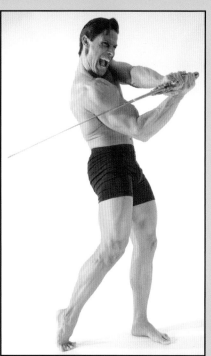

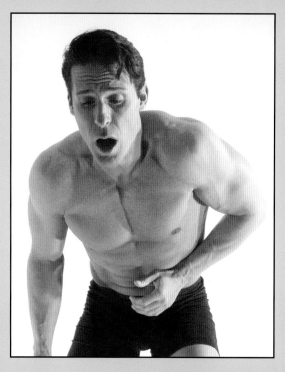

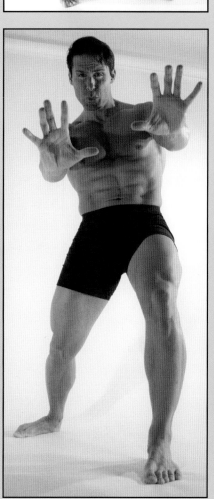

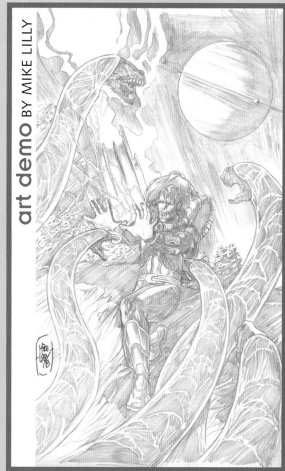

art demo BY MIKE LILLY

Demonstration

Character Design

BY RAFAEL KAYANAN

I'm going to show you how I start a character design on paper and finish it on the computer. The photos in this book are a great basis for a drawing like this because they give you an appropriately exciting pose for your character. The model becomes the armature on which to build the details of your fictional creature.

The finished piece in this demo could be a concept drawing, that is, a drawing to show a film producer or a comic book editor how a proposed character might look.

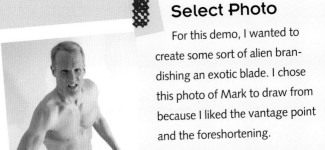

Select Photo

For this demo, I wanted to create some sort of alien brandishing an exotic blade. I chose this photo of Mark to draw from because I liked the vantage point and the foreshortening.

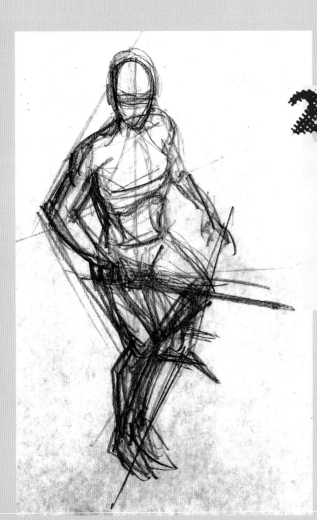

Sketch Figure in Pencil

First I rough out the figure on sketch paper using a Parker Duofold mechanical pencil with an HB lead. The proportions of the figure are approximate; at this stage I'm more focused on capturing the gesture. To help me capture the angles, I add straight lines on the outside of the figure to connect the points of tension, such as elbows, knees and the tips of the hands and feet.

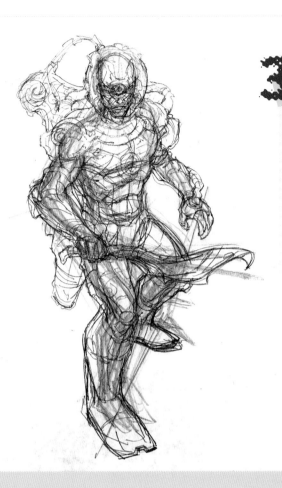

3 Refine the Pencil Sketch

With the mechanical pencil I begin to scribble in forms to suggest weaponry and alien machinery or a biosuit. I avoid using templates; I prefer to keep my lines lively. By now I have practically abandoned any form of likeness to the original model.

As I refine the sketch, I rotate the hands a bit to add depth and to make it so we'll see more of the blade.

As I add detail, I'm careful to leave the negative spaces. That keeps the silhouette of the character clear and understandable.

4 Create Midtones With Markers, Then Scan

I place a sheet of Borden & Riley 100S Smooth Cotton Comp marker paper over the pencil rough from step 2. I begin drawing directly on the marker paper using a light gray Pitt brush pen, which is waterproof and contains an excellent tip for the kind of fluid linework I'm laying down. The marker paper is somewhat transparent and retains the marker ink very well.

I outline the shapes I want to keep, then add some darks to spot the figure and suggest more depth. I make sure the blade will have a dark area behind it to help it pop out. I'll be adding heavy shadows in the next stage; I leave those areas alone for now.

Next, I scan the marker sheet with a piece of blank white paper behind it so that the scanner picks up all the tones correctly. After looking at the image some more, I was not happy with an eyepiece that I put in front of the left eye, so I deleted it in Photoshop.

You can start to tell here that I'm not following the shadows in the original photo. Instead I'm imagining that the light is not as intensely directional as in the photo. I reduced certain shadows to make the lit areas wider and brighter.

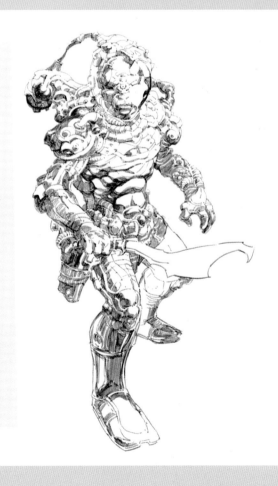

 ## Add Shadows With Markers, Then Scan

Now I want to add the deep shadow areas. I return to the marker sheet that I scanned in the previous step and use a darker Pitt marker on it to add more crevices and creases. I add lines to the left eye to fill in the void where I erased the unwanted eyepiece from the digital file in the previous step. I scan the marker sheet again, then use Photoshop to adjust the levels to my liking. I keep this scan a lighter tone to allow leeway for future experiments in tonal value.

6 Combine Scans

I copy the scan from step 5 and paste it into a new layer in the scan from step 4. I set the new layer to Multiply mode and change its opacity to somewhere between 50 and 60 percent. When you change a layer to Multiply mode, it allows the gray tones (in this case) to be added on top of the lighter surfaces in the layer beneath it without affecting the darker tones on that lower layer. Thanks to the Multiply layer, I got deeper midtones without having to do a second layer of gray marker over the midtone areas on my marker sheet.

 ## Erase the Dark Areas From the Multiply Layer

From here on out, all the work will be in Photoshop. I take the Eraser tool, using custom shapes that I created, and start to erase on the Multiply layer to allow the lighter grays beneath it to come through.

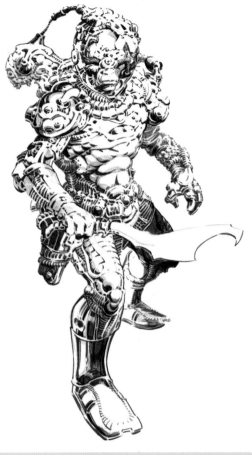

Add Texture and Tone

I use Photoshop's Noise filter and Levels adjustments to generate a texture. I copy and paste the texture into a new layer, set the layer mode to Multiply, scale it to cover the entire figure, and adjust the opacity.

I like having lots of texture options. To save time, I cover sheets of paper with different kinds of pencil shading, scan the sheets and save the scans for future use.

For more action poses, visit impact-books.com/ colossal-collection

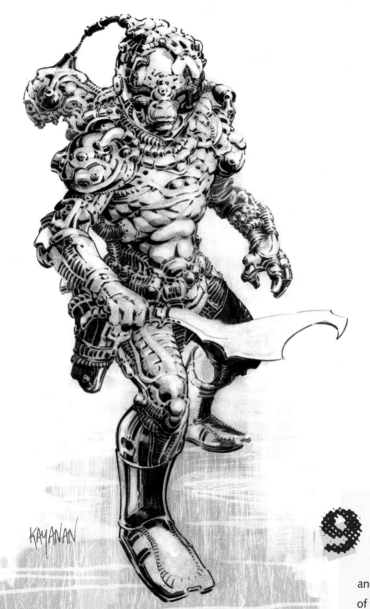

KAYANAN

For more action poses, visit
impact-books.com/
colossal-collection

9 Complete the Concept Drawing

I create a custom brush shape in Photoshop and use it with the Eraser tool to erase much of the texture and reveal the final image. This quickly gives the drawing a gritty texture. For this concept drawing I did not want an immaculate surface, but more of an environment and suit that had some wear and tear.

To suggest a setting for the character, I pasted in another tone image (one I had created with black Prismacolor marker) and then skewed it so that it receded into the distance. With the Eraser tool and larger brush shapes, I removed a good chunk of grays over the figure and then added vertical streaks on the floor.

cape

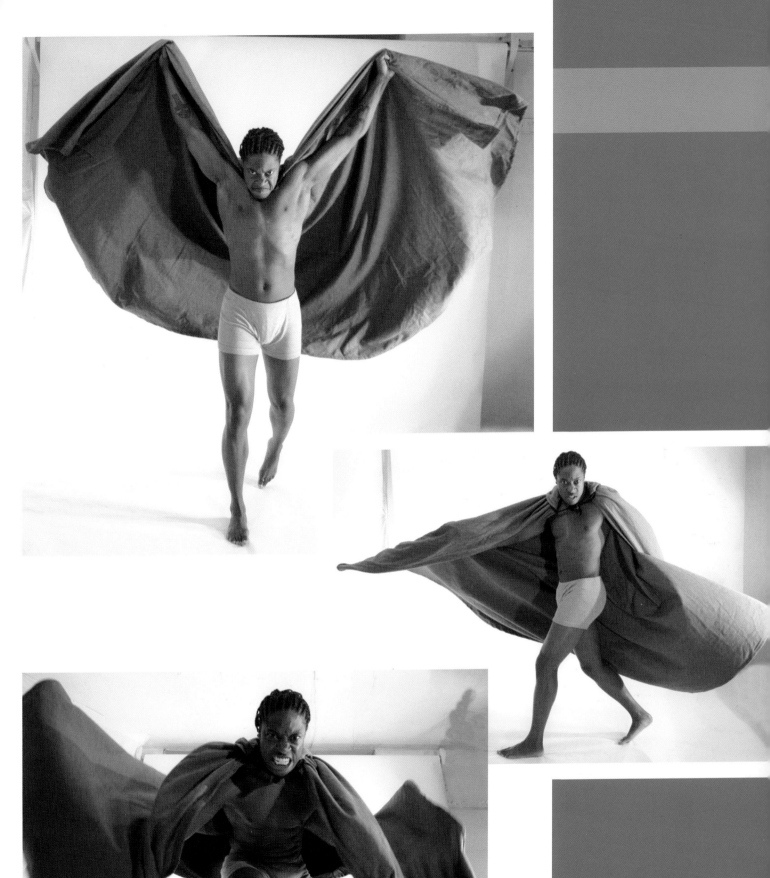

For more action poses, visit
impact-books.com/
colossal-collection

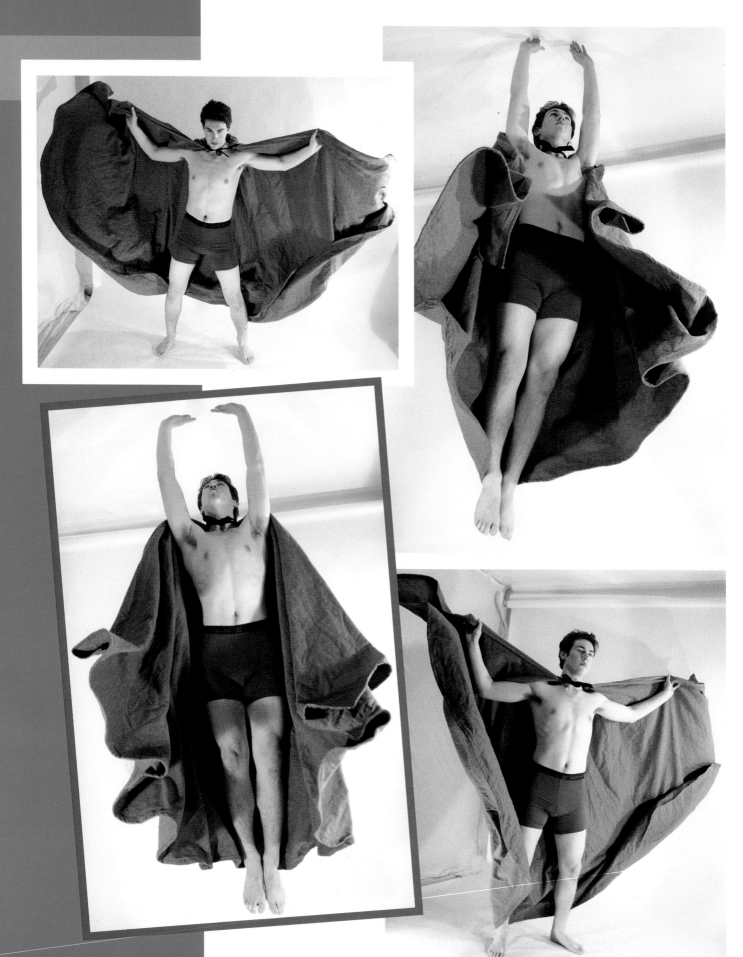

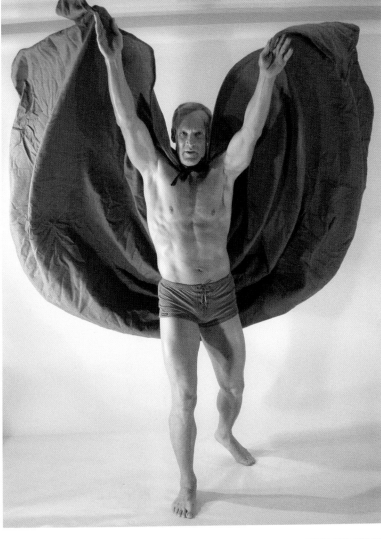

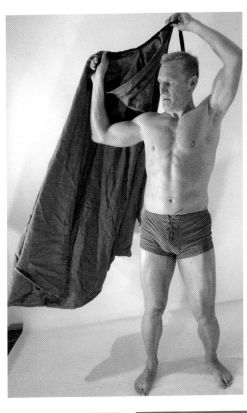

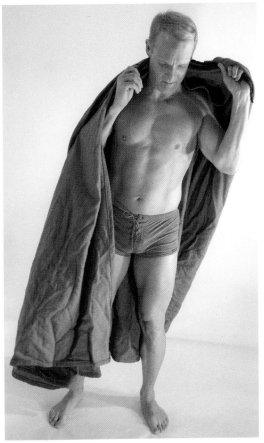

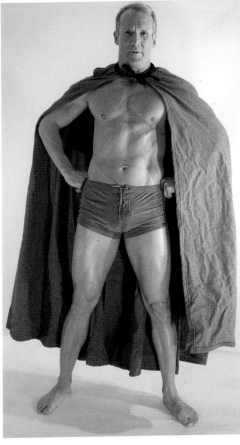

For more action poses, visit
impact-books.com/
colossal-collection

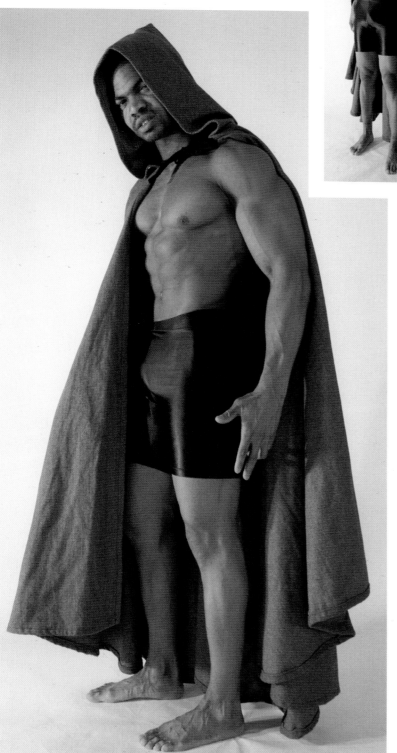

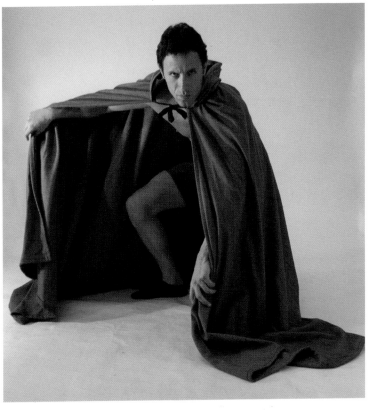

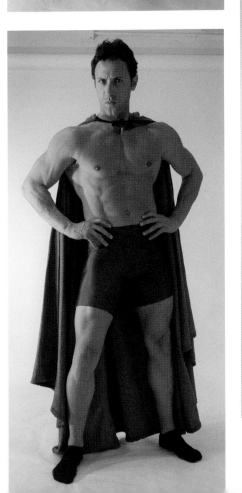

dressing

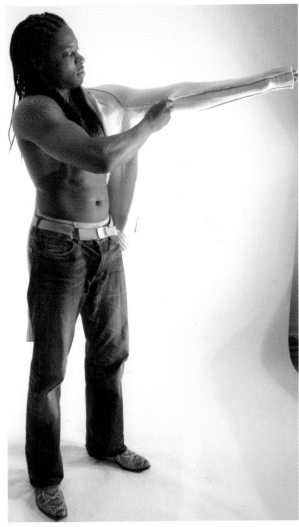

For more action poses, visit
impact-books.com/
colossal-collection

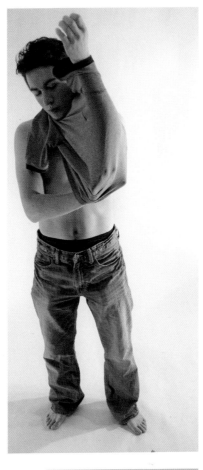

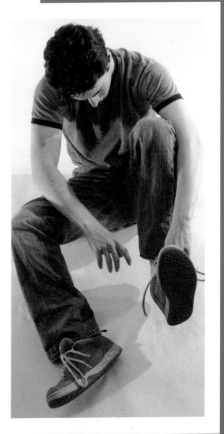

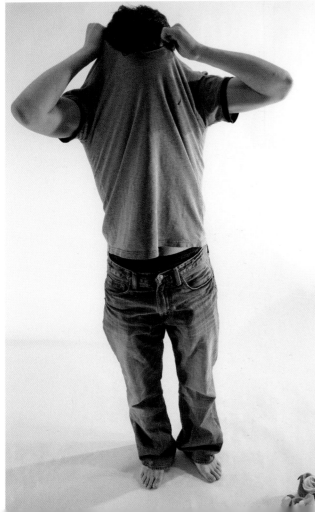

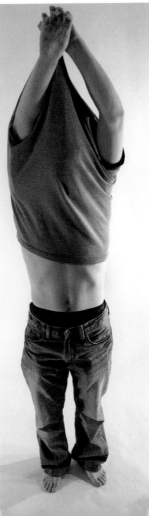

For more action poses, visit
impact-books.com/
colossal-collection

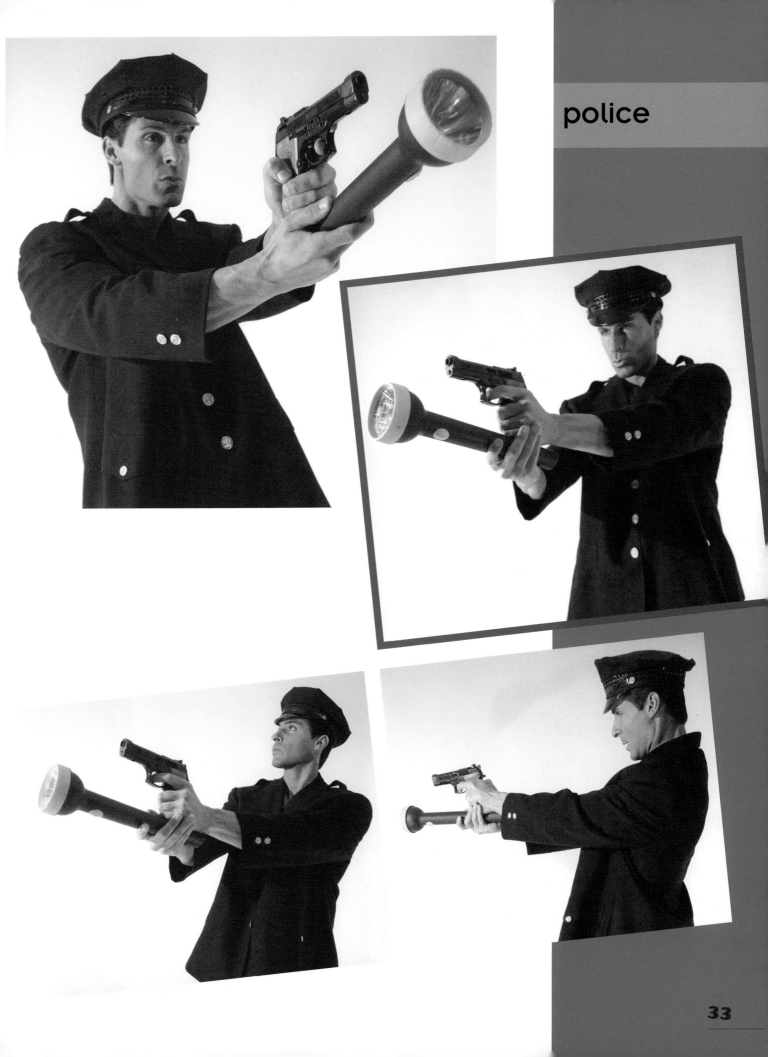

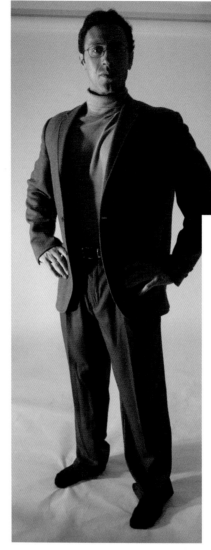

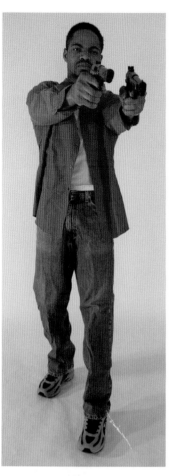

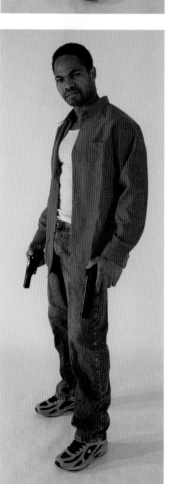

For more action poses, visit
impact-books.com/
colossal-collection

Create Mood

BY MITCHELL BREITWEISER

There are two ways to approach reference material. You can produce a rough sketch, then search out reference that fits what you have already drawn. Use this approach when you have a clear vision of where you want to take the artwork. Or, if you are experiencing a bit of artist's block, seek out reference first for inspiration. Look around for a photo that jumps out at you or captures the general mood you are hoping to achieve for the finished art.

I consider myself more skilled at inking than penciling. Unlike most comic book artists, I never fully flesh out my pencils. I make most of my decisions during inking. I believe this makes my artwork more expressive and spontaneous.

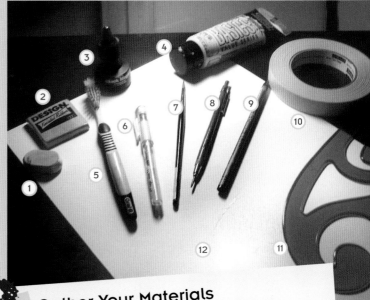

Pick Your Photo
This photo has good moodiness and lighting, and the pose would lend itself to a very striking cover.

Gather Your Materials
Here are the materials I used for this demo:

1. Plastic eraser—for completely removing pencil marks
2. Kneaded rubber eraser—for picking up excess graphite off the page or for cleaning up smudges
3. Higgins Black Magic ink
4. White acrylic paint—for spatter effects and fixing mistakes
5. Toothbrush—for spattering paint and ink for textural or atmospheric effects
6. White gel pen—for working white linework back into ink; a stylistic tool not essential for every artist
7. Winsor & Newton Series 7, no. 4 kolinsky sable brush
8. 7mm mechanical drafting pencil with HB lead
9. Woodless HB pencil—for broader strokes; also for softening inked edges
10. Drafting tape—for masking off areas during inking
11. French curves and rulers
12. Two-ply illustration board

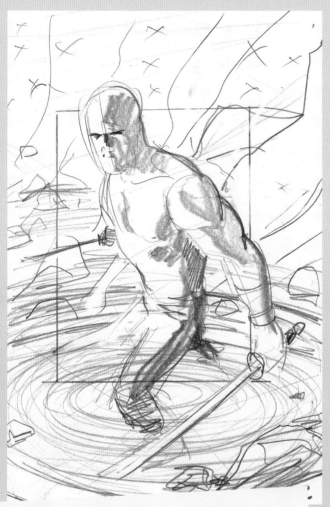

Sketch the Scene

First do a preliminary sketch on any paper you have handy. Copy paper is fine. To keep the sketch loose, try using a wood- less pencil, which creates a broader and somewhat clumsier stroke. Use the photo reference during this stage for lighting and general structure of the figure. Avoid fleshing anything out here, because you will make adjustments in later stages.

Design is paramount in this step, so here are some design tips to keep in mind:

1. Establish the light source now—it affects the artwork in every step.
2. Notice that the swords are not parallel. Keep them slightly off kilter in order to lead the viewer from the nearer sword into the figure and back to the other sword.
3. Use the steam or smoke lines in the background to "agi- tate" the figure. Making the steam flow in the direction opposite that of the figure creates visual tension.
4. Make sure to leave some breathing room. You don't want the art to feel cluttered or claustrophobic.

Pencil It

Now start your pencils on two-ply illustration board. Penciling is my least favorite step; I never fully flesh out my pencils. Try keeping yours loose, as I've done here.

Use the photo reference to help you get the muscular and vascular construction right, as well as the facial features. You can also deviate from the reference a bit. Notice how the arms on the art spread out a bit more than in the photo. If you make the head a bit smaller, the figure will look proportionally larger and more imposing. Also notice how the figure leans in quite a bit to make the pose look more aggressive.

TIP

Draw your layouts at a standard comic book size to visualize how the art will look on the shelves and to the reader.

For more action poses, visit impact-books.com/ colossal-collection

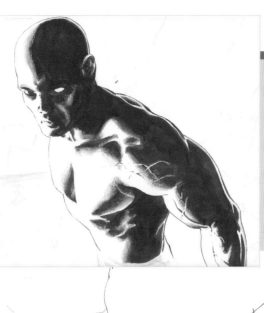

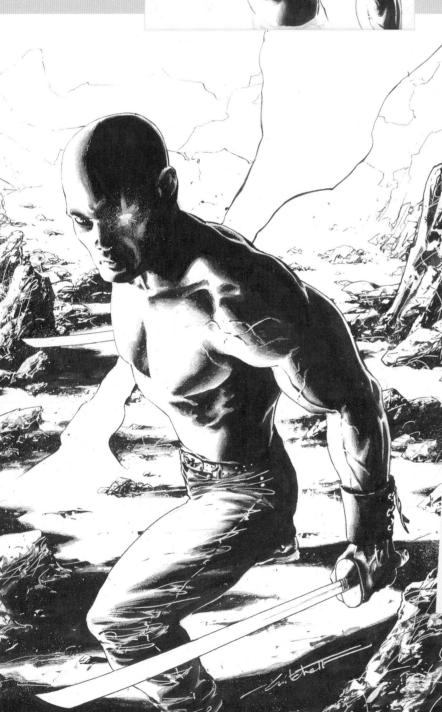

Ink It

Ah, the big payoff. So far, we have avoided detailed linework as much as possible. Now, with your inks, focus on dramatic lighting and textural and atmospheric effects. Many of today's artists are using less linework and hatching.

Try inking with a brush rather than pens for its expressive and spontaneous qualities. A brushstroke will give you more life than a pen. Although a difficult tool to master, a quality brush will allow you to achieve a wide variance in line weight as well as a variety of textures. Experiment with the dry-brush technique: Partially blot the ink off the brush, then drag it across the paper to create a rough textural effect.

Use an HB pencil around the edges of the ink to soften some of the hard edges, especially on figures, where you want a softer, fleshier feel.

It's good to look back at the photo reference while inking. Keep it handy when working out the details of the face, as well as to double-check the muscular and vascular structure.

Finish by working some expressive lines from your white gel pen back into the rocks and clothing. Also splatter some white acrylic onto the background for an extra touch of texture.

Give it a once-over, deem it finished, sign it and call it a night.

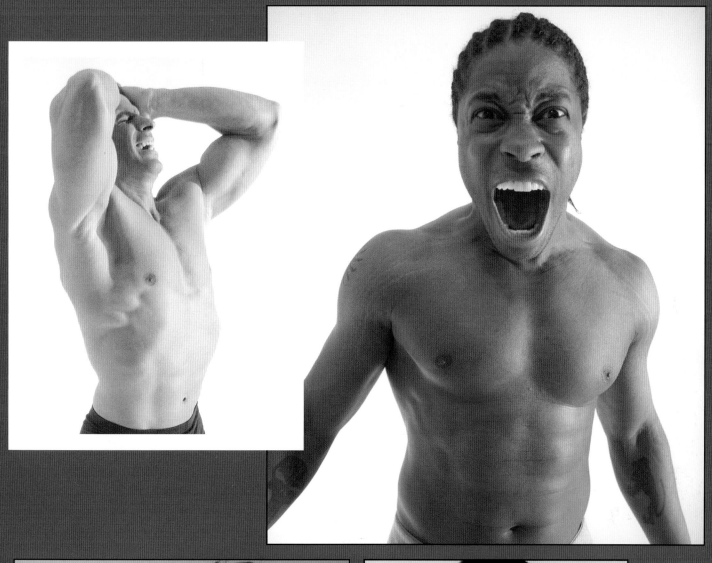

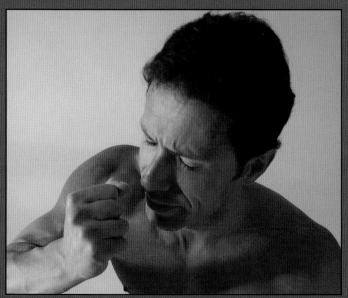

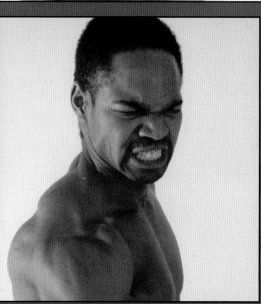

angry

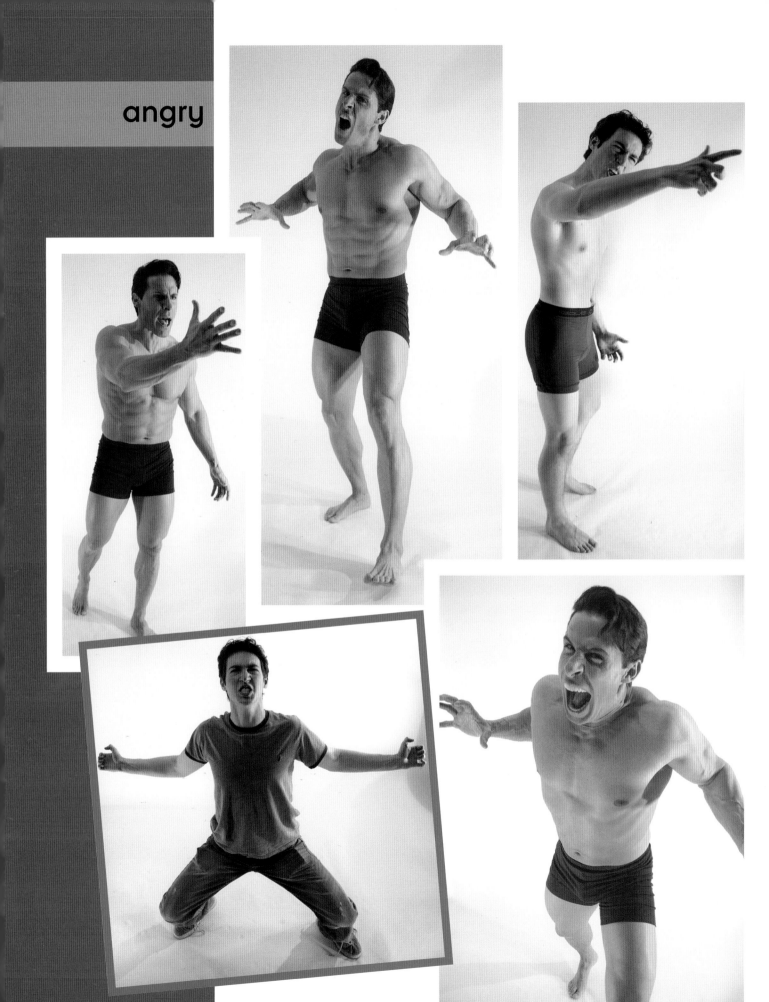

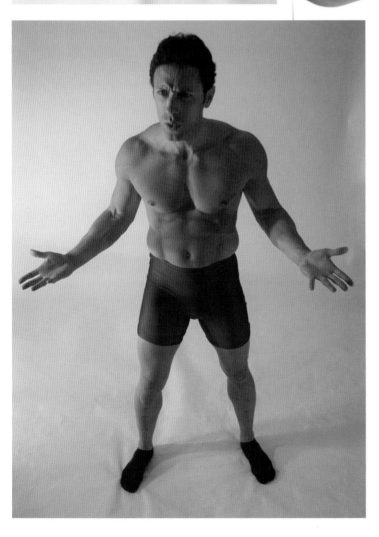

For more action poses, visit
impact-books.com/
colossal-collection

41

happy

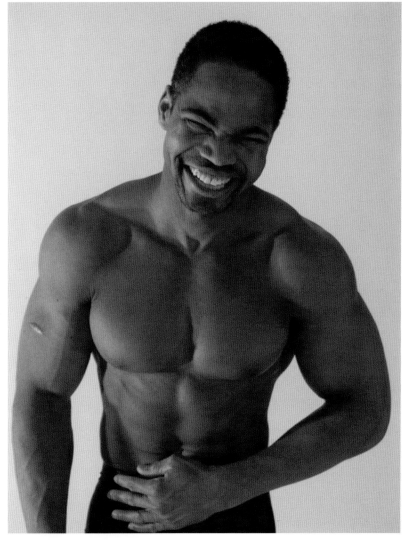

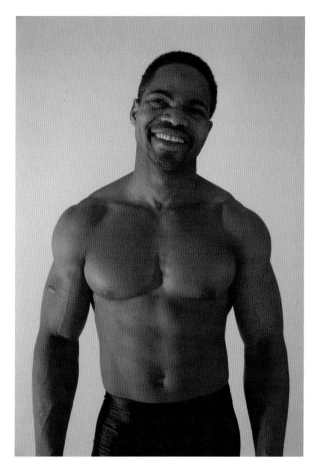

For more action poses, visit
impact-books.com/
colossal-collection

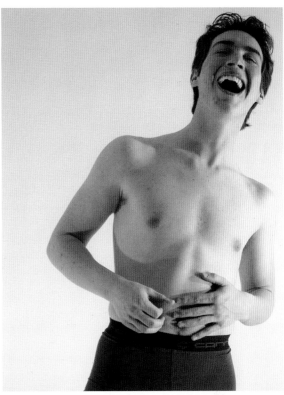

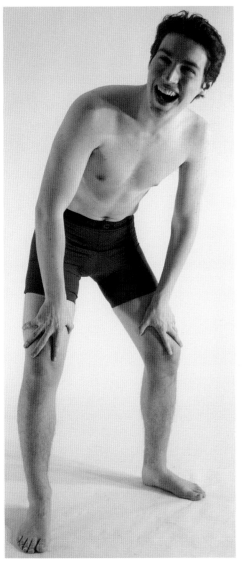

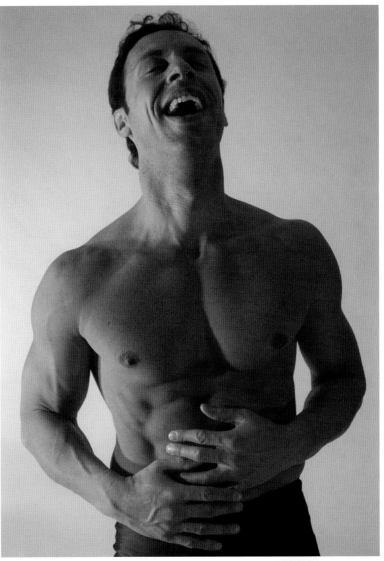

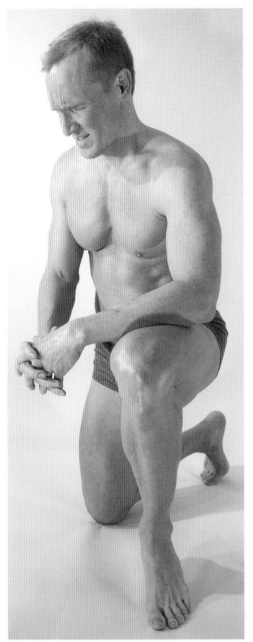
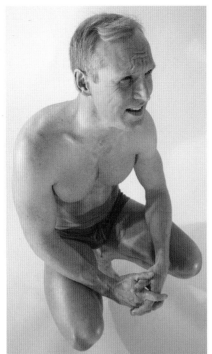
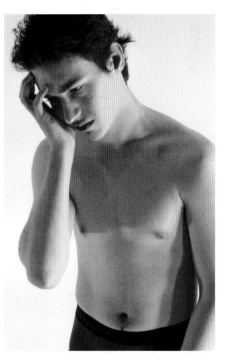
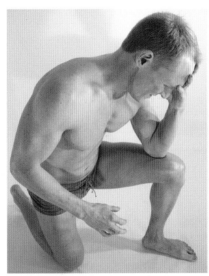
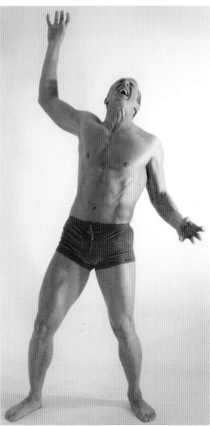
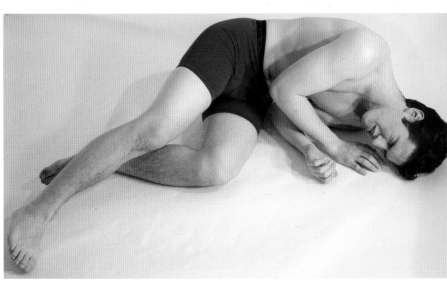

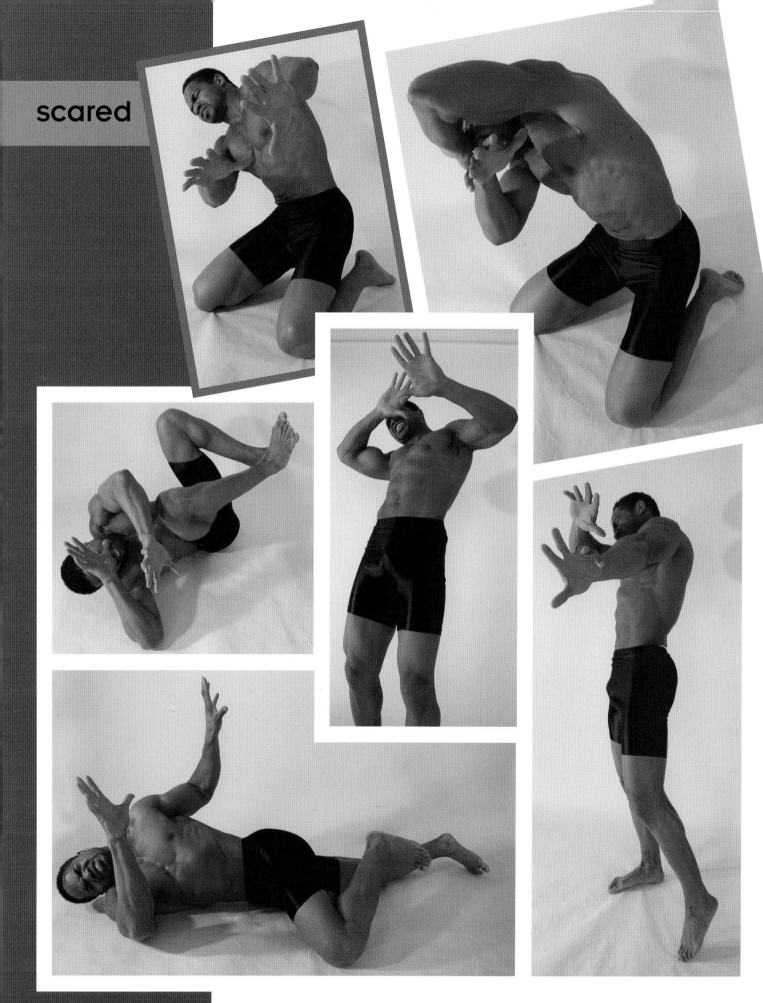

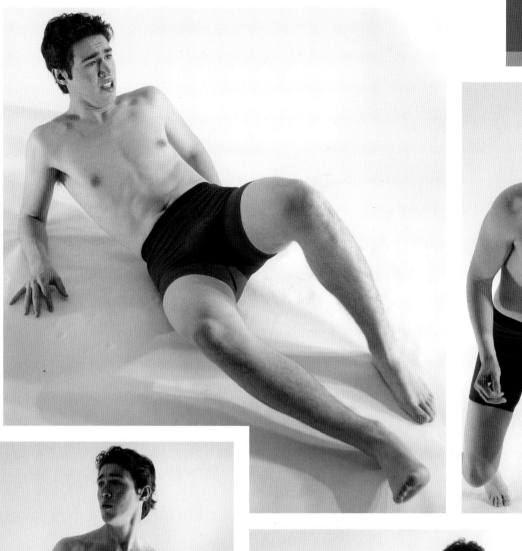

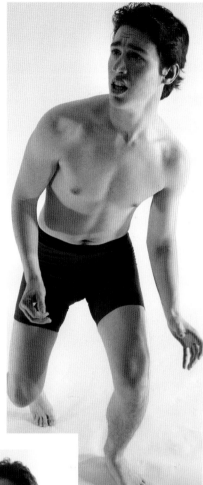

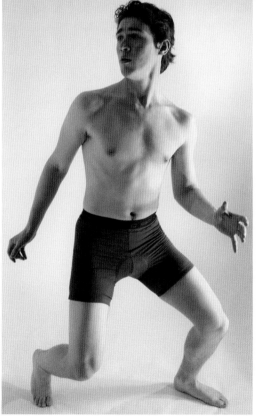

For more action poses, visit
impact-books.com/
colossal-collection

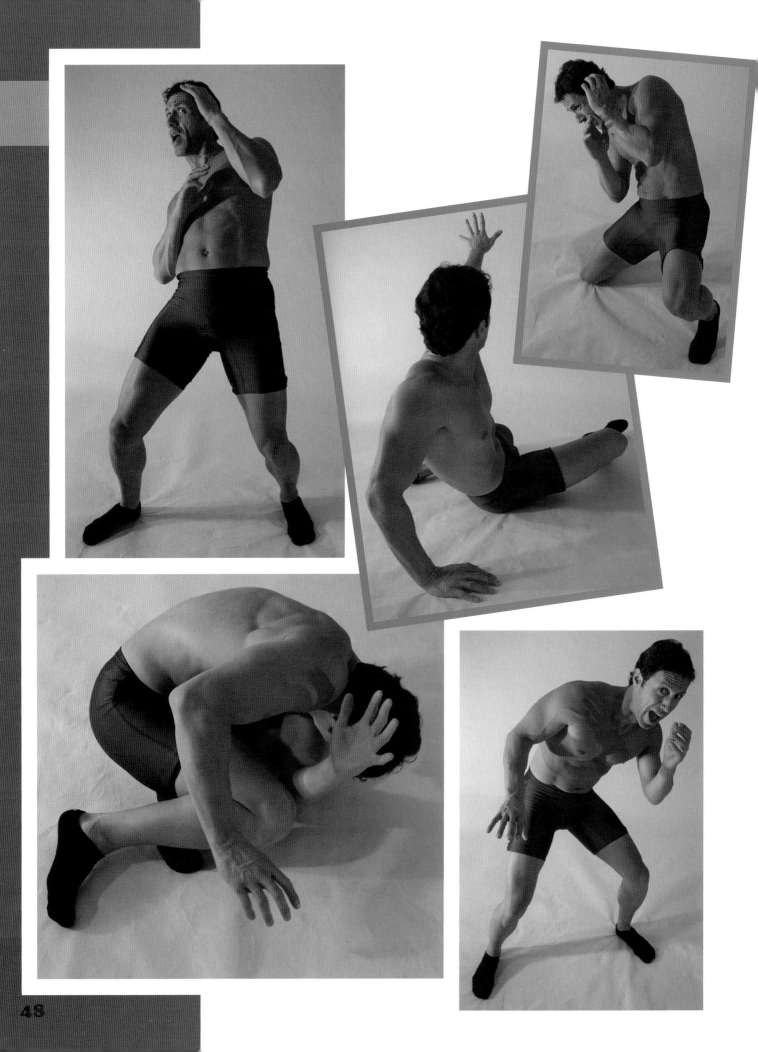

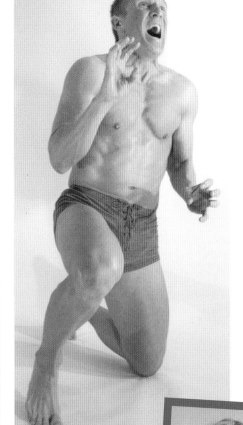

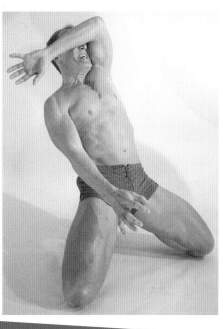

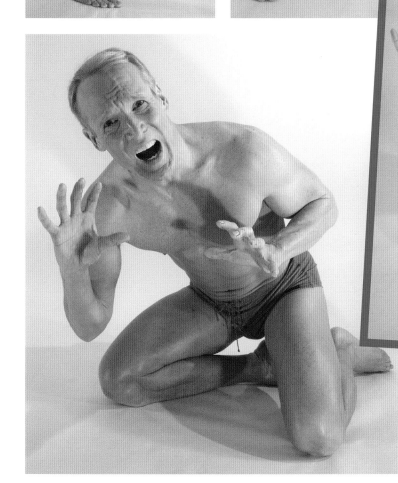

For more action poses, visit impact-books.com/ colossal-collection

49

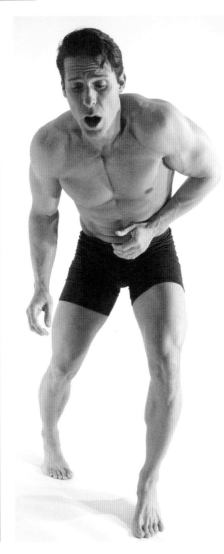
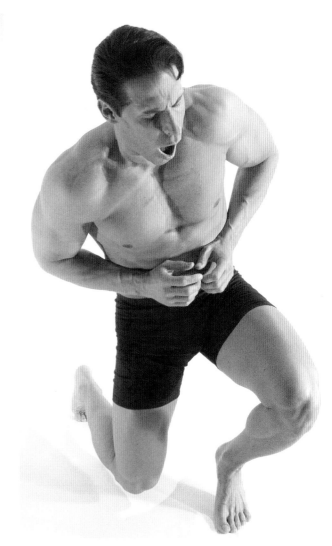
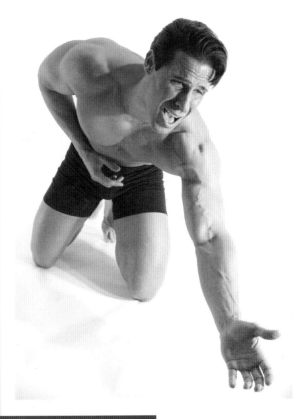
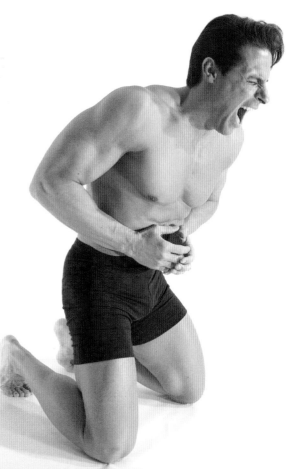

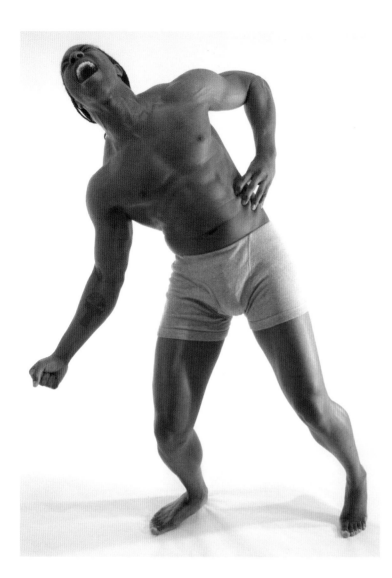

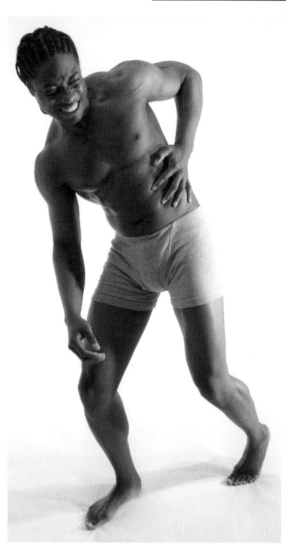

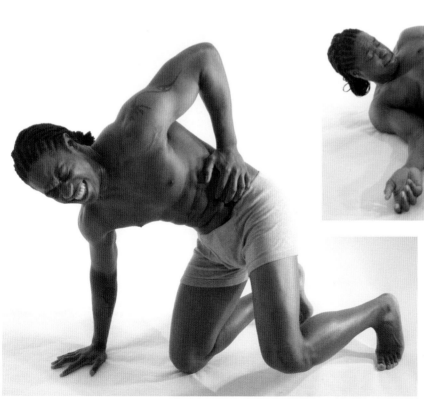

For more action poses, visit
impact-books.com/
colossal-collection

wounded

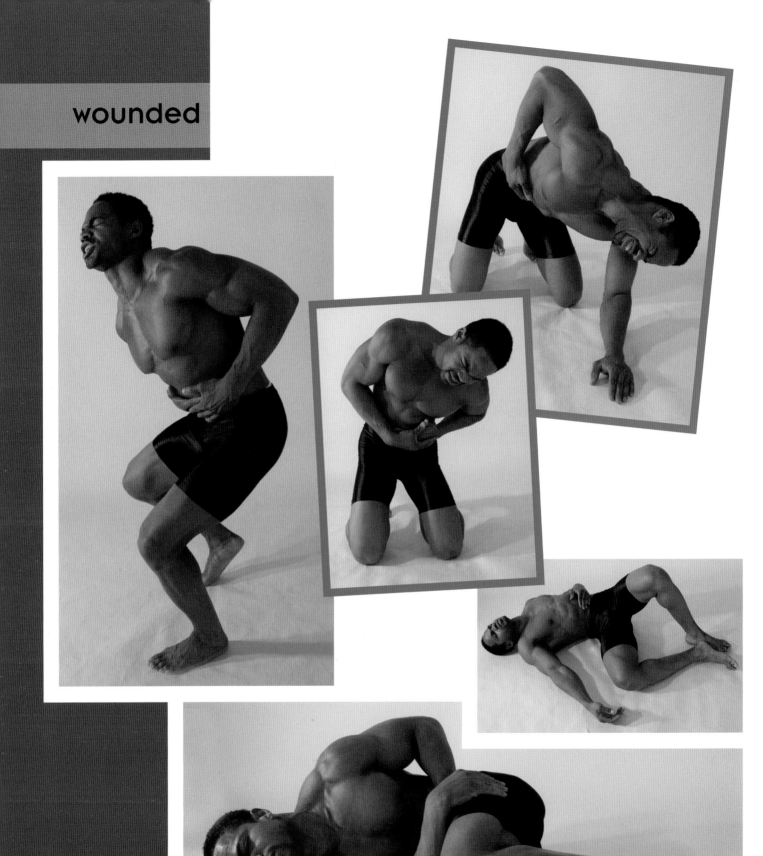

For more action poses, visit
impact-books.com/
colossal-collection

wounded

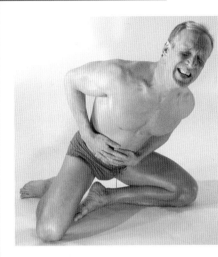

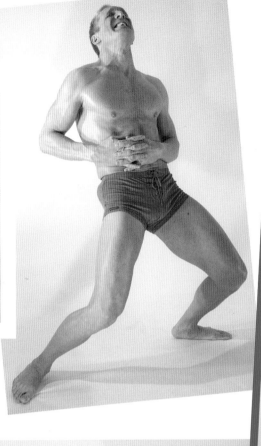

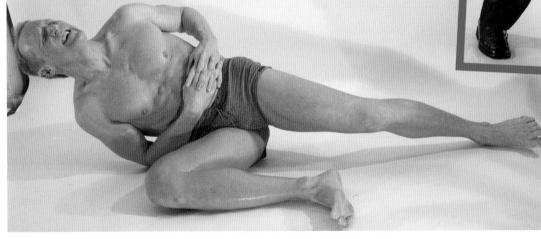

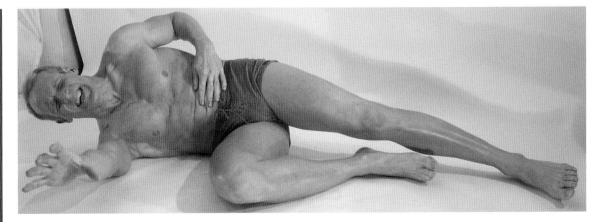

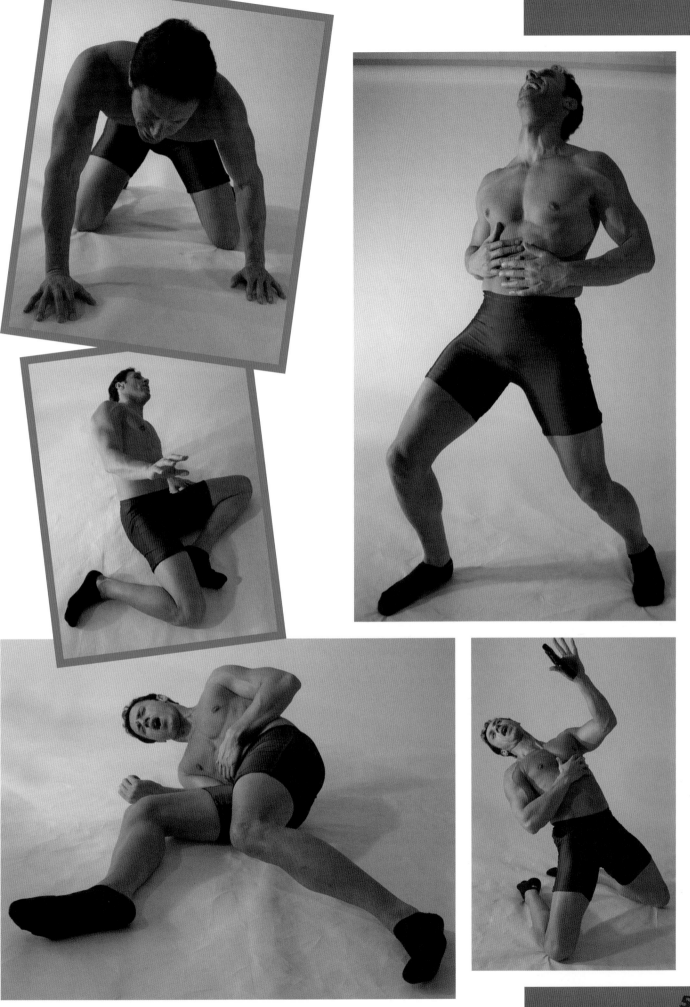

Demonstration

Make Your Art Tell a Story

BY MIKE LILLY

I like to make a drawing do more than just show a pose or a moment of action. I want to give the reader an idea of what happened to get the character to that moment, and what might happen next.

Select a Photo

Lately I've been watching my *Twilight Zone* DVDs a lot. Some of my favorite episodes are the ones with a stranded, lone survivor. Often it's an astronaut from a crashed spaceship, alone and fearing the unknown. So when Buddy asked me to do this art demo, I knew I wanted to do a spaceman, pulp-type piece.

I had a dozen or so photos of Anthony to choose from for the demo. Right away, I liked the pushing and lifting poses. I thought, hmm…strong guy…draw him lifting a vehicle? A boulder? I decided those ideas were too clichéd. Then I realized that the hands in these pushing and lifting photos could just as easily be interpreted in other ways: wielding swords or ray guns, or throwing blasts of energy.

Photo reference is a key tool in illustration. About 99 percent of artists use some form of reference to get the shots they want. Use it, but also change it and mold it to suit your needs.

2 Choose your Idea

In my sketchbook, I did a few quick, simple idea sketches with an HB pencil. I tried reimagining some of the poses with Anthony wielding a sword. But the out-stretched hands in the photos are so expressive; I didn't want to change them. So instead of a weapon, I decided our hero would have an electrical charge emanating from his hands.

Sometimes I sketch with a marker instead of a pencil, as I did here when I was planning where to put the shadows on the tentacles.

3 Sketch the Composition

I settled on the photo of Anthony kneeling. I imagined our space-man centered in the composition, slightly tilted, with a monster in the foreground and a crashed ship in the background. His lone defense against the monster would be the energy blasts coming from his hands.

At first I expected I would draw a single monster, but then I thought a snakelike monster with multiple tentacle-like elements would better convey the sci-fi feel I was going for. Another benefit of the snake idea is that I was able to bend and point the tentacles toward our hero to direct the viewer's attention to him.

This scenario lets the reader imagine a backstory. Why isn't the man using a weapon? Perhaps he had one but it was damaged in the crash, or maybe he used up its power fighting other creatures. So now, maybe he has used his skill and ingenuity to redirect power from his space suit to create a crude but effective defense.

Demonstration

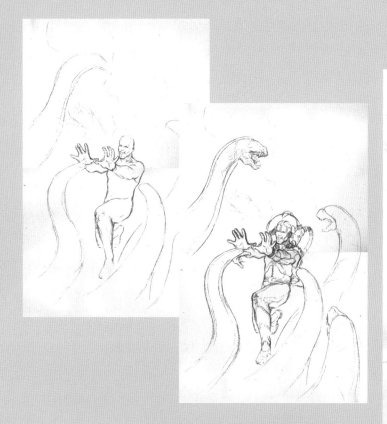

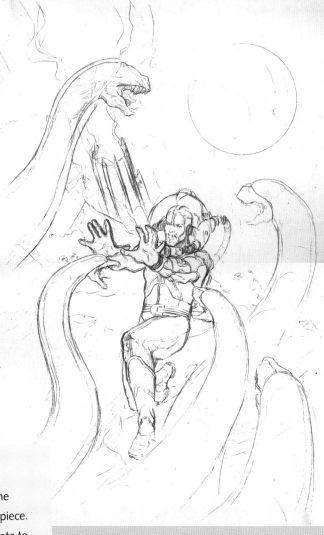

Saturn is a science-fiction icon.
It's a cliché, yes, but one that
always seems to work.

4 Create a Detail Sketch

I started another sketch to work out some of the details. Some artists work out every detail in sketches before starting the final piece. When I sketch, if I see something I don't like, I make a mental note to go in another direction when I get to the final piece. For me, sketches are how I get my "bad" drawings out of the way. Then my better ideas often emerge during the final.

Regarding the photo reference, I kept the entire pose except for the facial expression. I wanted an angry, pain-filled face to go with the action. I also could have kept the stoic face to suggest extreme confidence in the hero. Just by changing a facial expression, you can give a piece an entirely different mood.

To top it off, I added the planet Saturn dominating the starry sky.

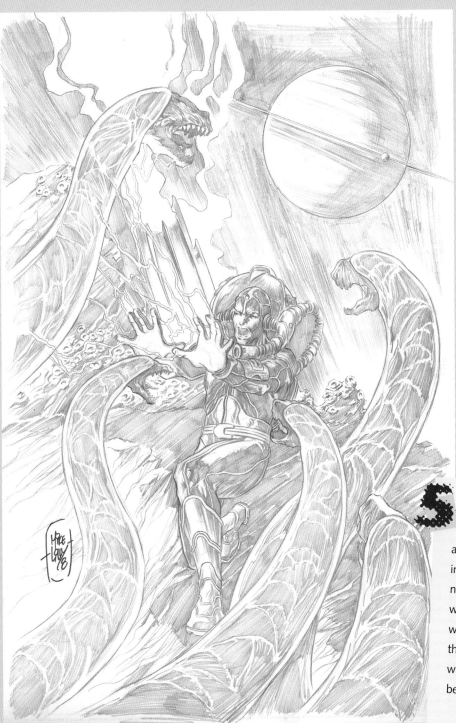

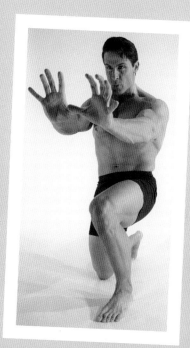

For more action poses, visit
impact-books.com/
colossal-collection

Final Scene

To begin the final piece, I do an underdrawing on art board using a light blue Col-Erase colored pencil in a very loose, organic style. That pencil is not truly nonphoto blue, but as long as you use it lightly, it won't show when photocopied. Once I get going with the Col-Erase pencil, I use it to indicate some of the details and shadows. Then I finish off the piece with my HB pencil. The HB gives me a nice balance between line and softness.

If I want to change something, I usually use a kneaded eraser. It lets me soften areas or clean up spots without removing the blue underdrawing. If I need to erase both the HB pencil and the blue underdrawing from an area, I use a Staedtler Mars plastic eraser.

Action

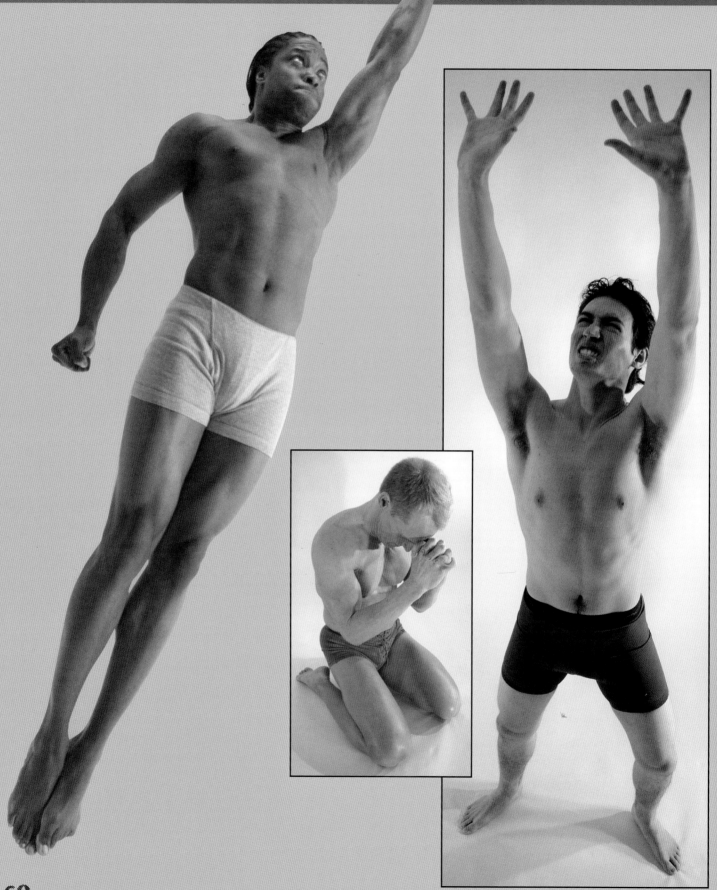

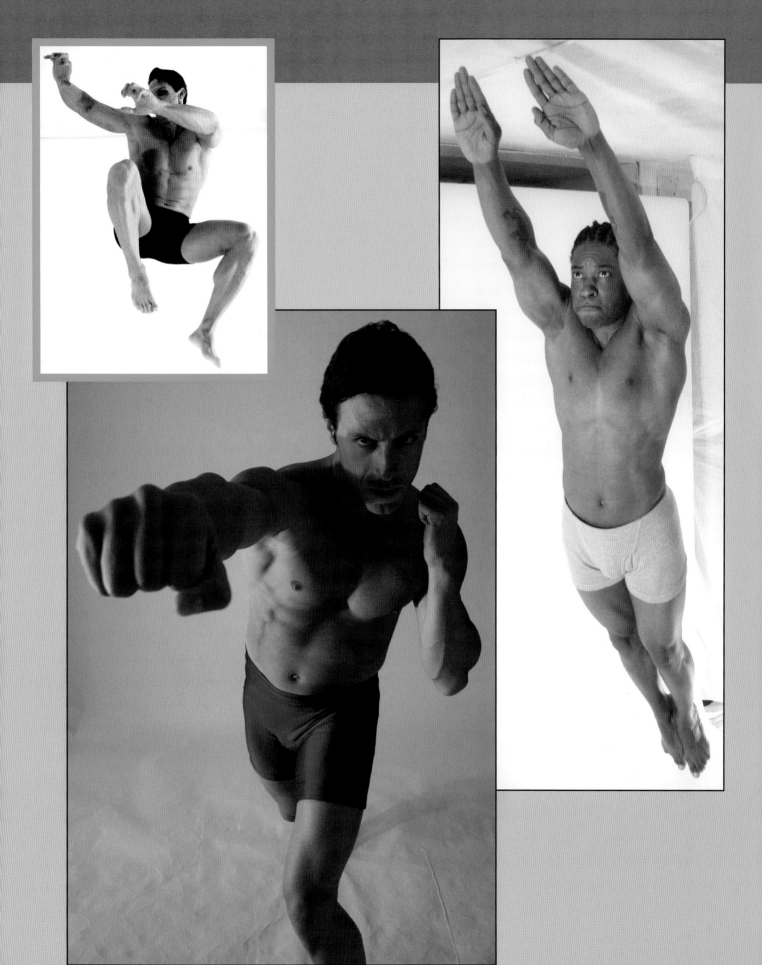

choking

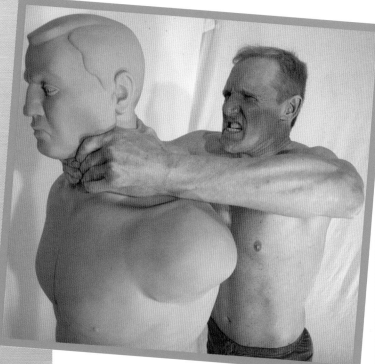

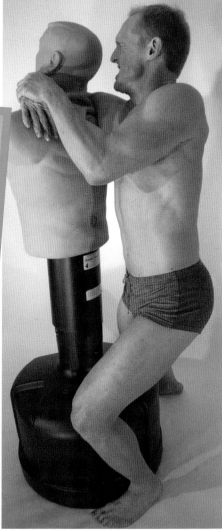

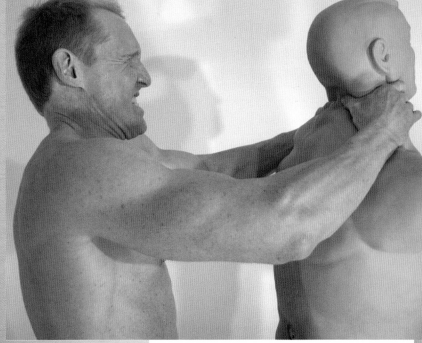

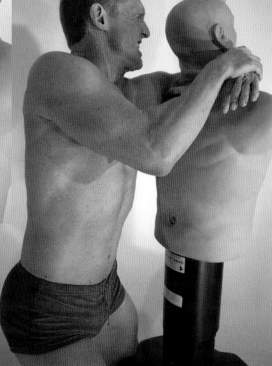

For more action poses, visit
impact-books.com/
colossal-collection

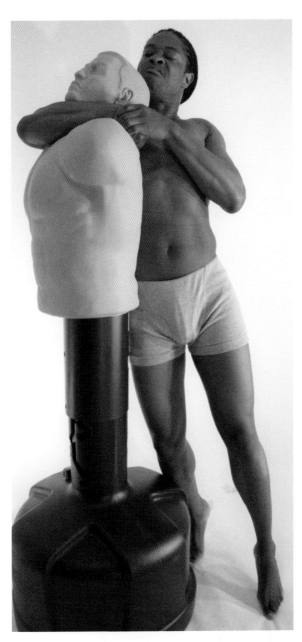
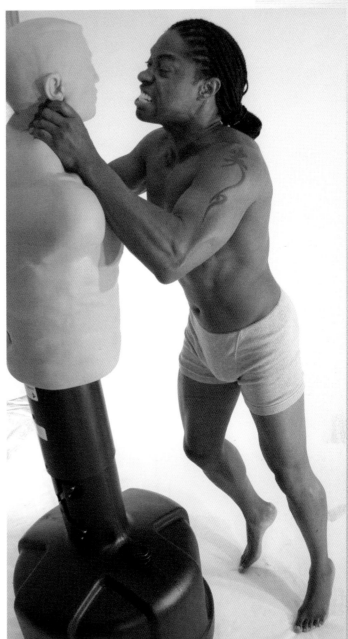
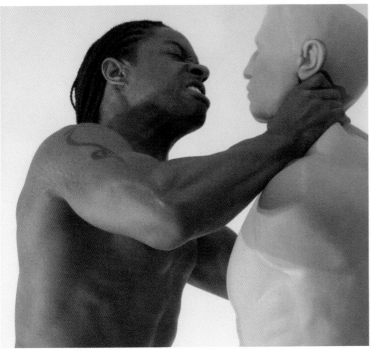
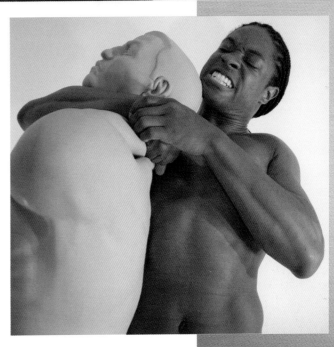

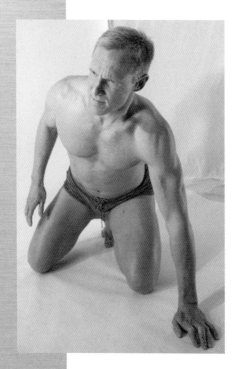

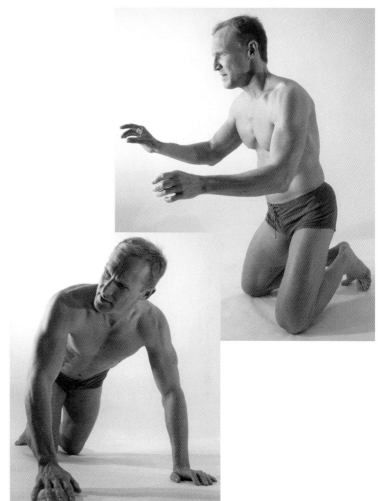

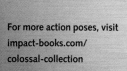

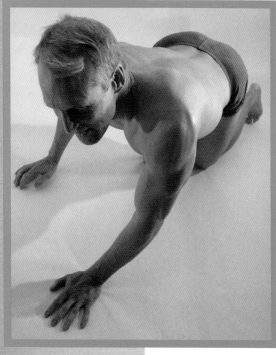

For more action poses, visit
impact-books.com/
colossal-collection

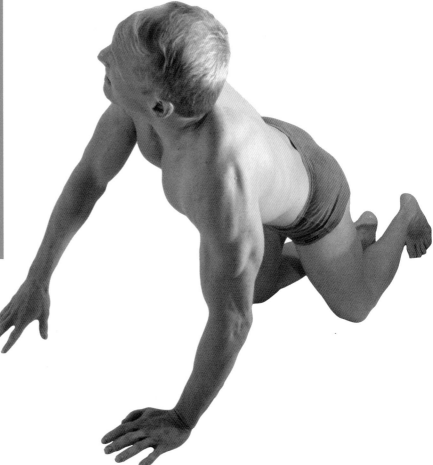

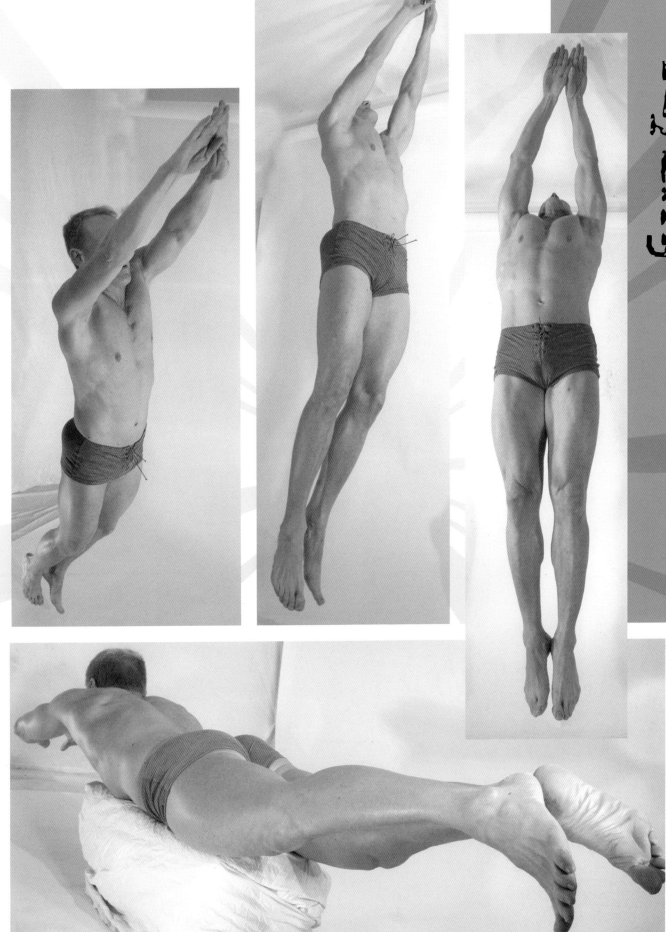

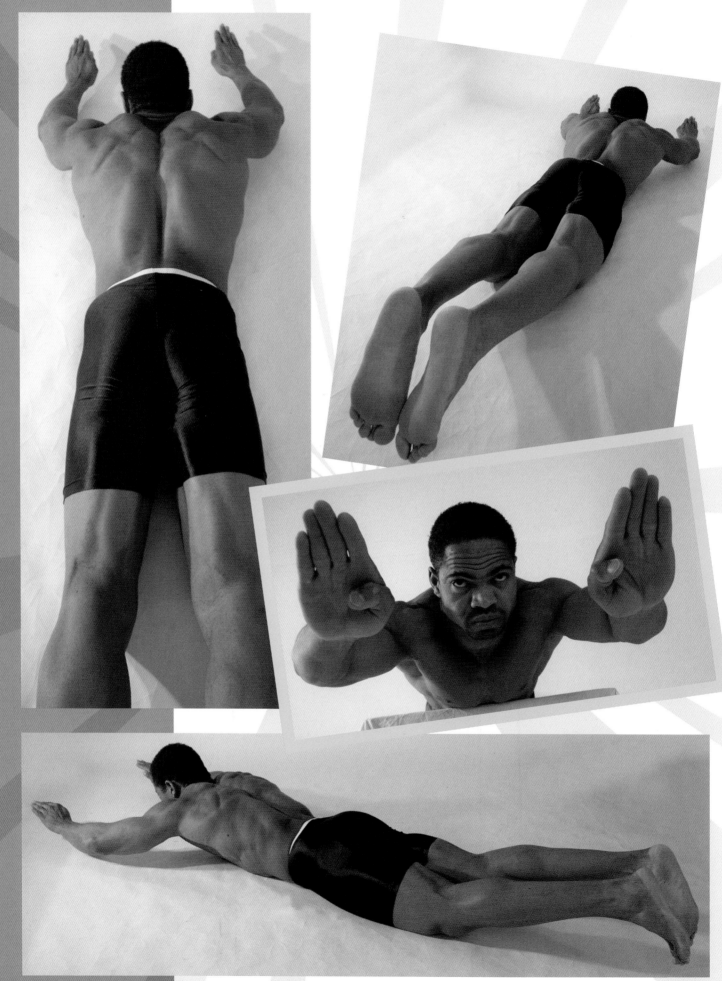

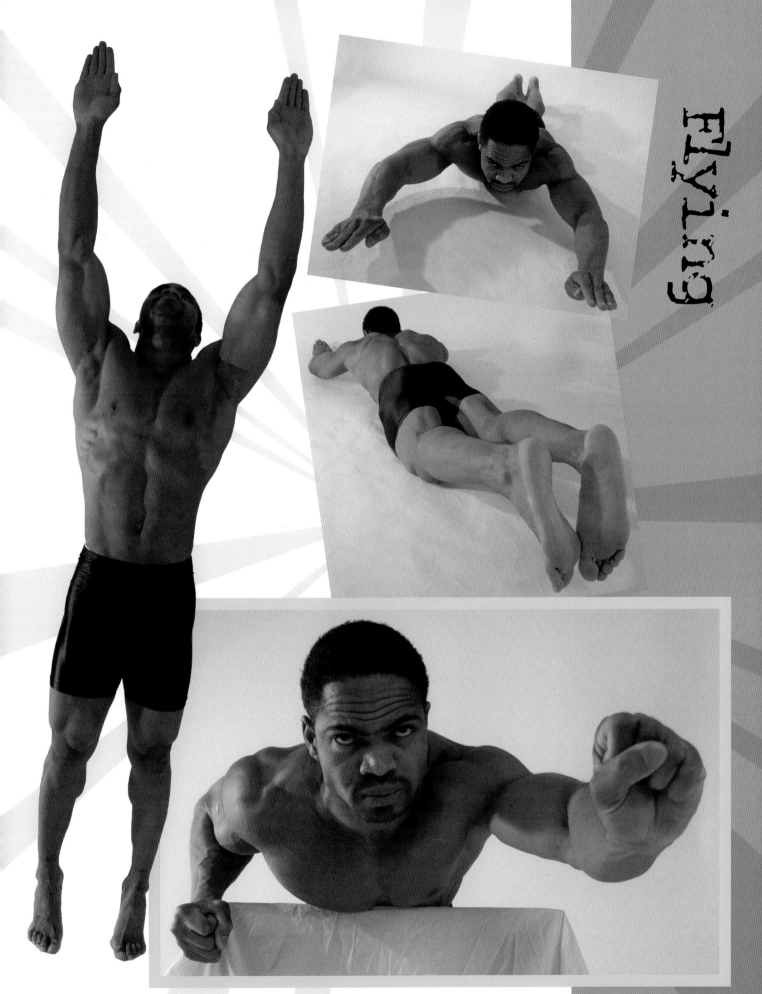

Flying

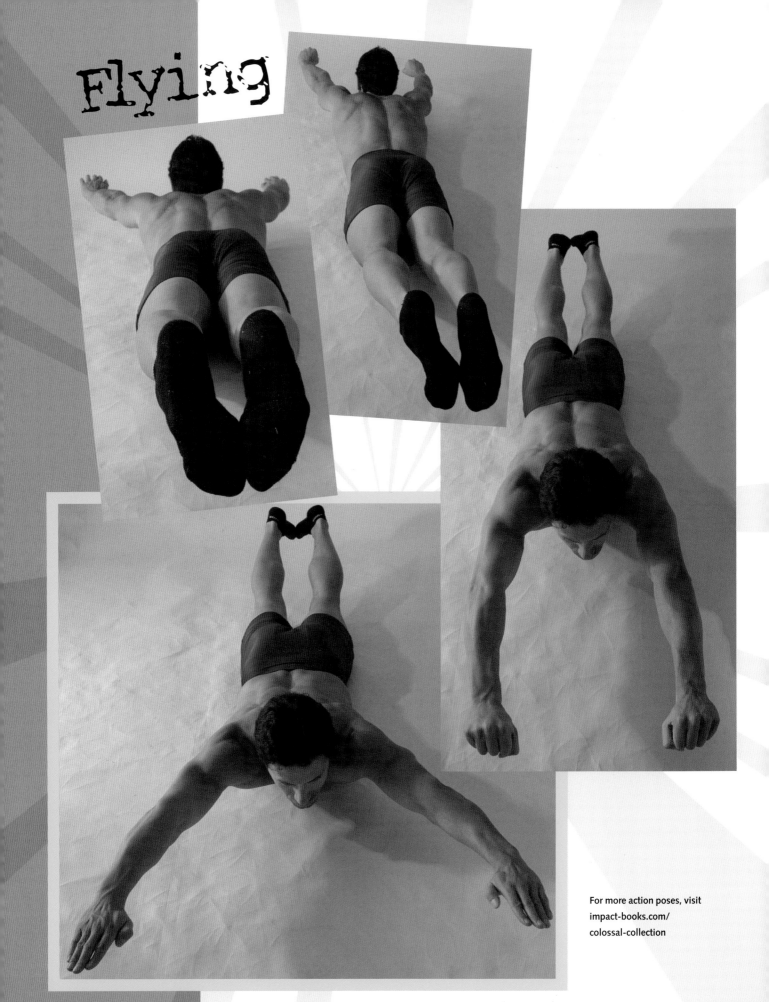

For more action poses, visit
impact-books.com/
colossal-collection

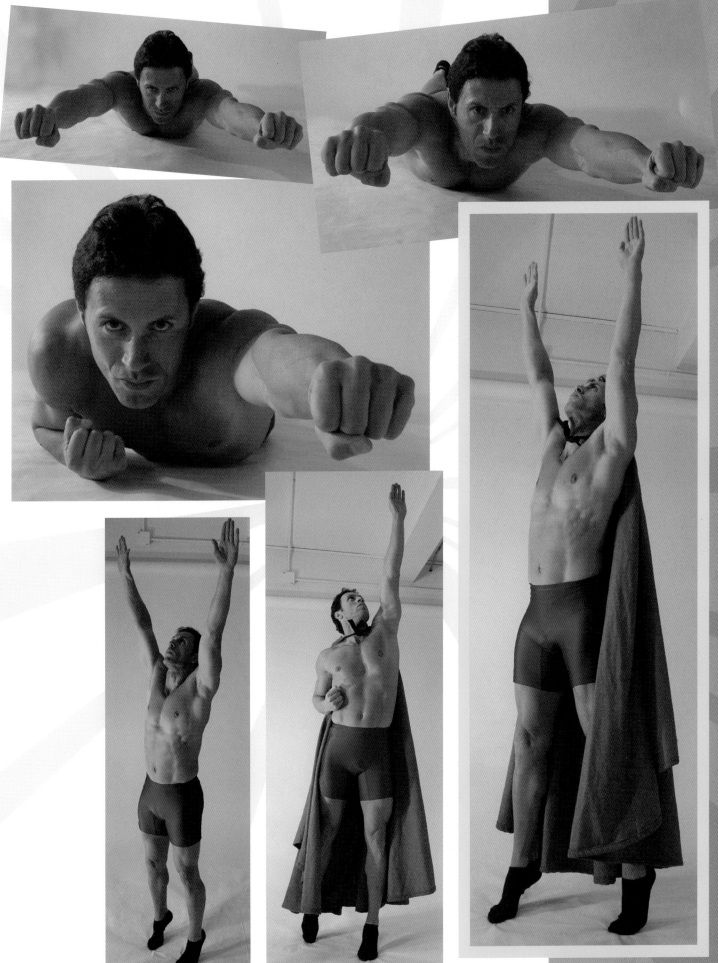

Jumping

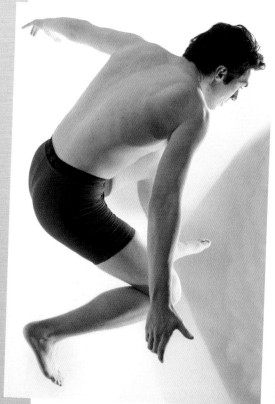
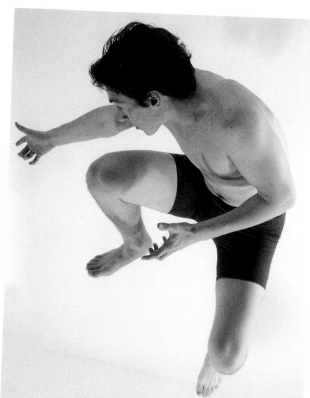
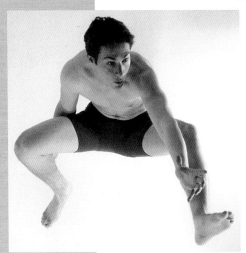
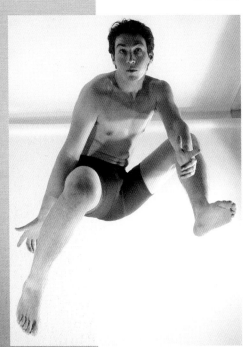
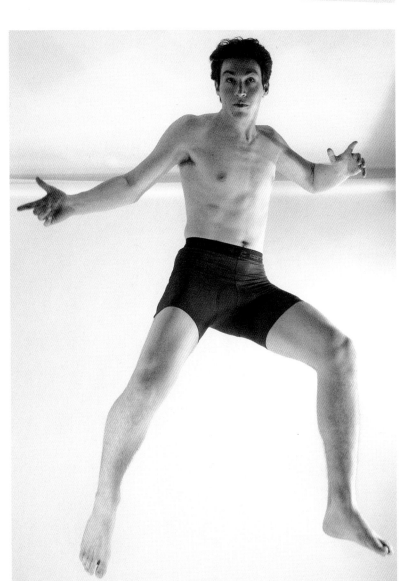

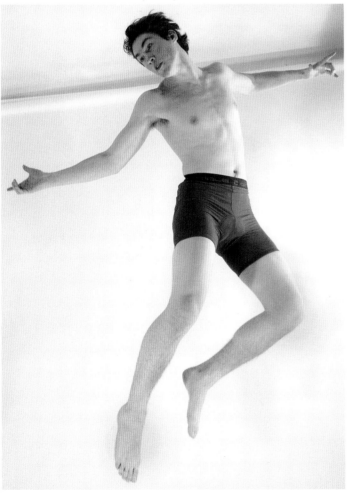

For more action poses, visit
impact-books.com/
colossal-collection

Jumping

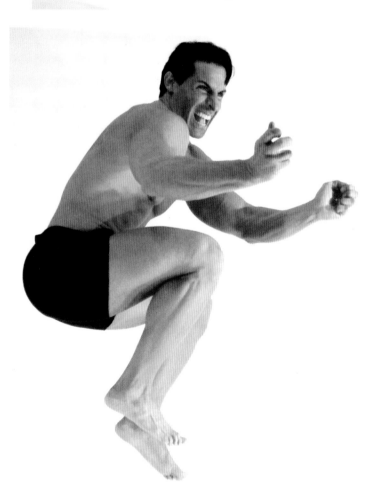

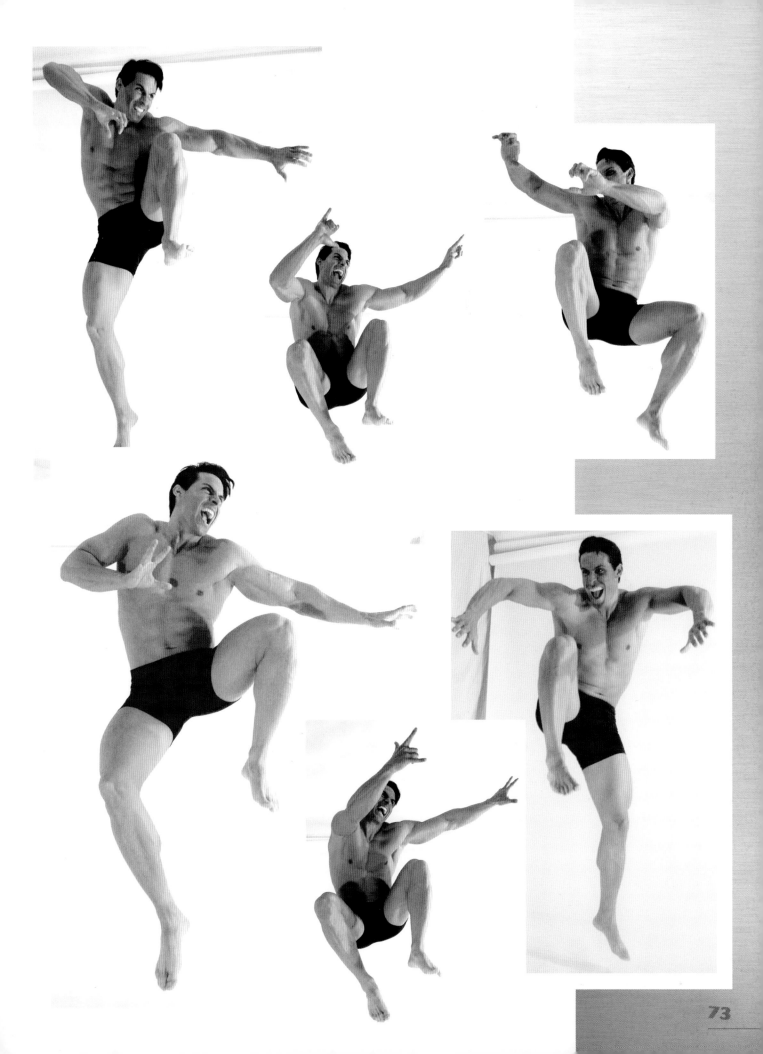

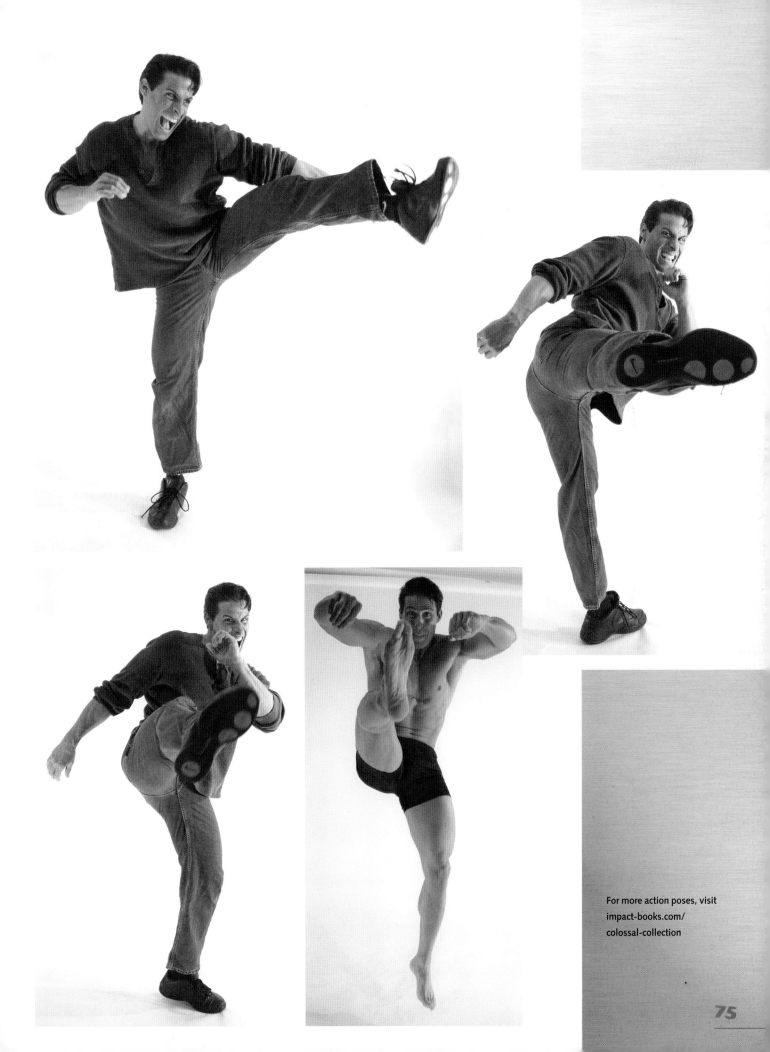

For more action poses, visit
impact-books.com/
colossal-collection

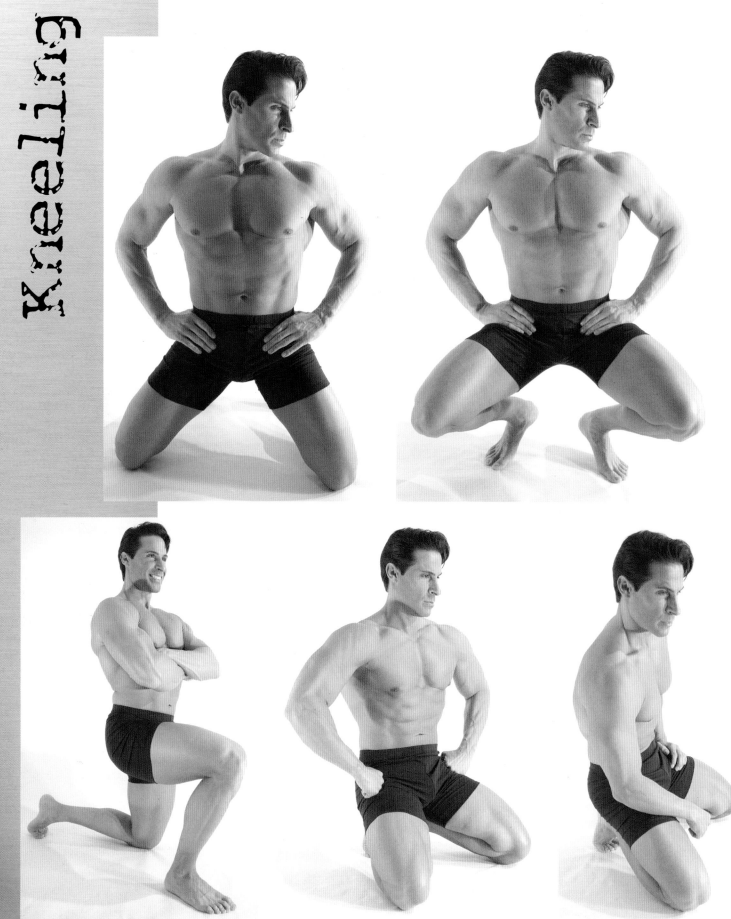

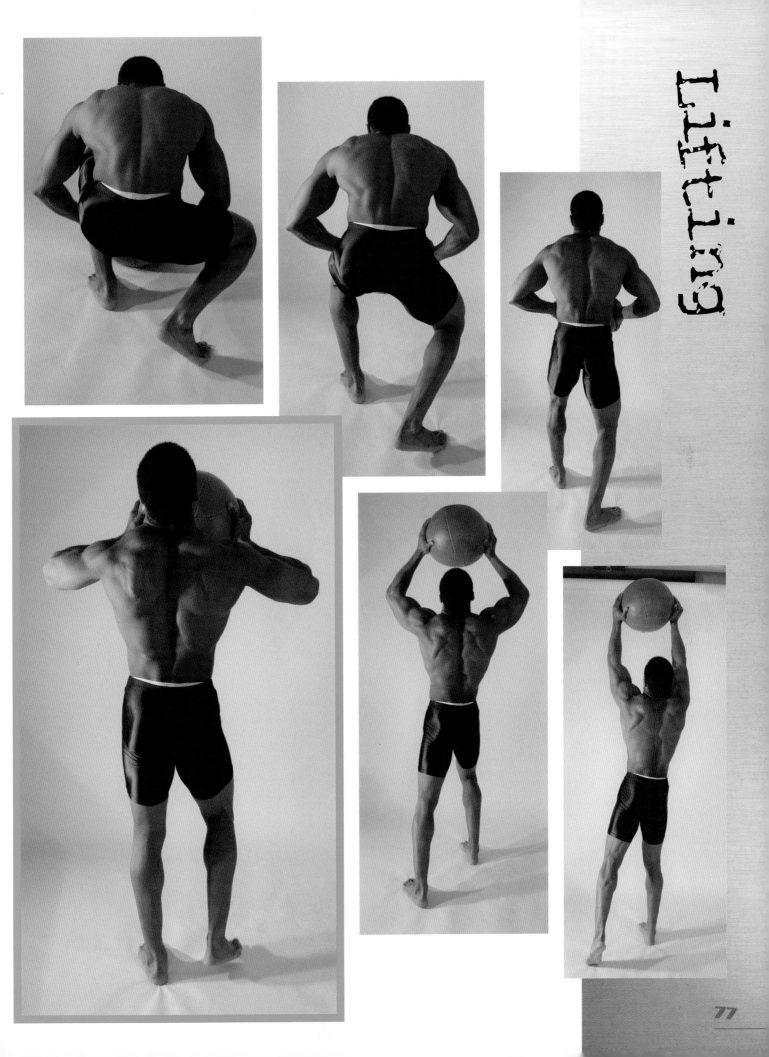

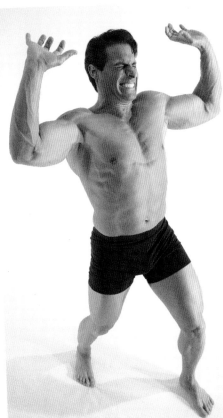
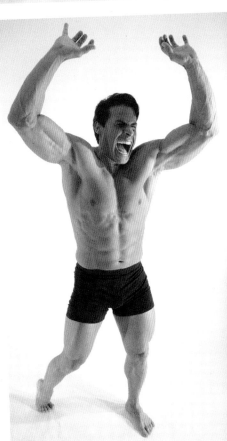

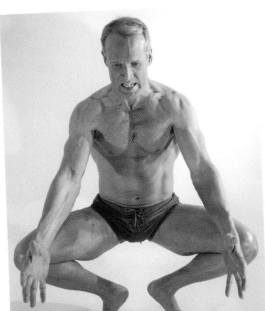
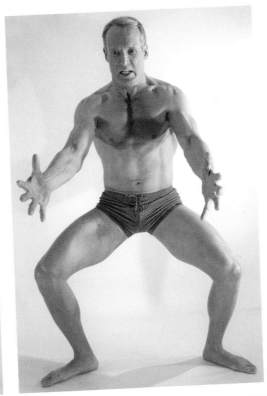

For more action poses, visit
impact-books.com/
colossal-collection

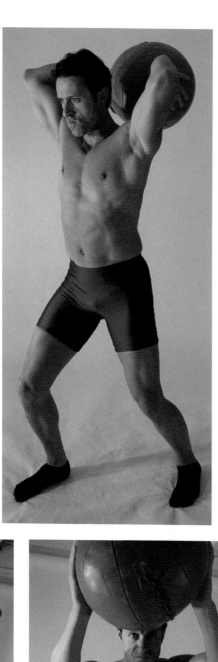
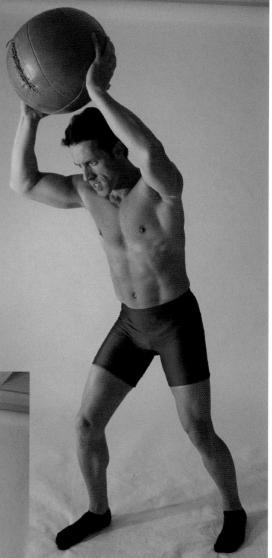
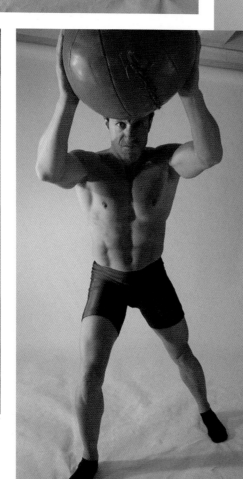

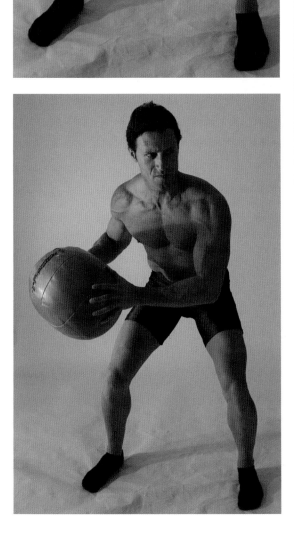

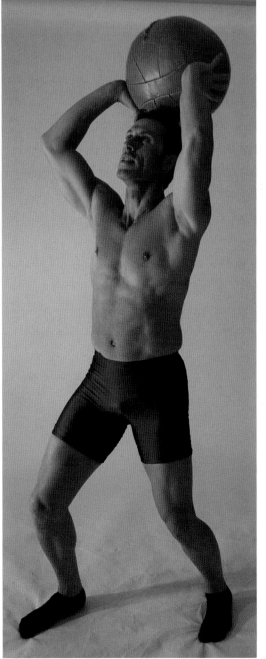

For more action poses, visit
impact-books.com/
colossal-collection

Punching

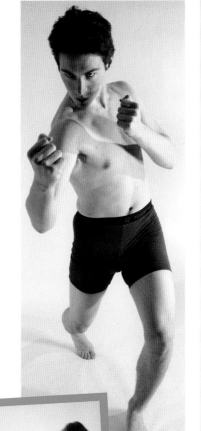

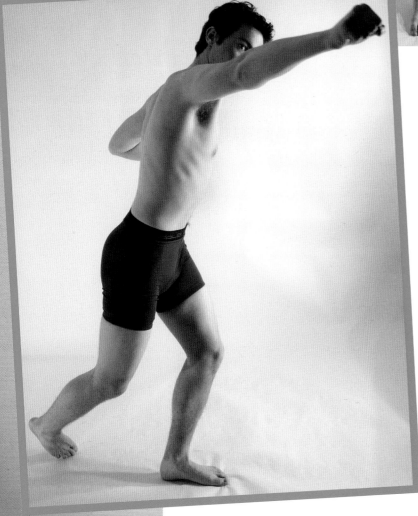

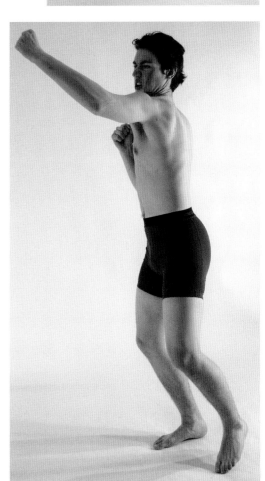

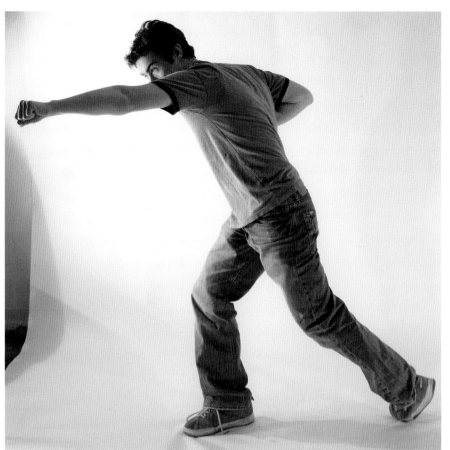

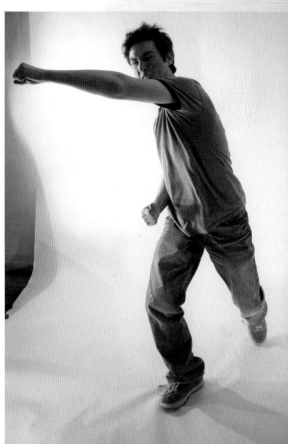

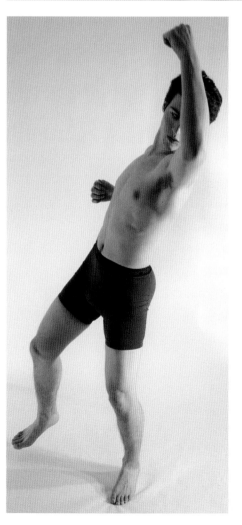

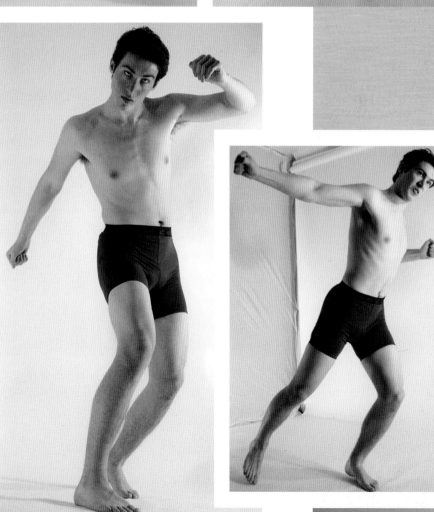

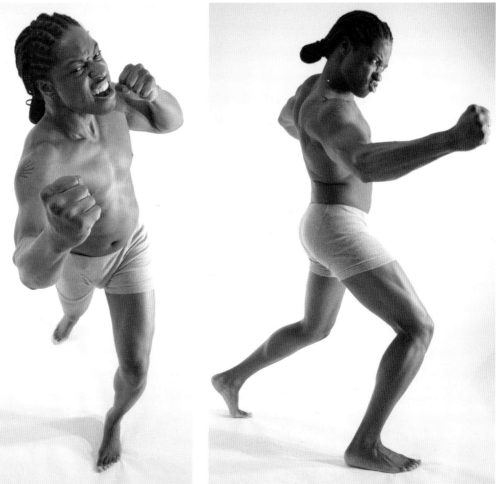

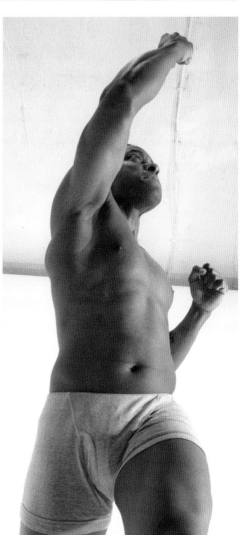

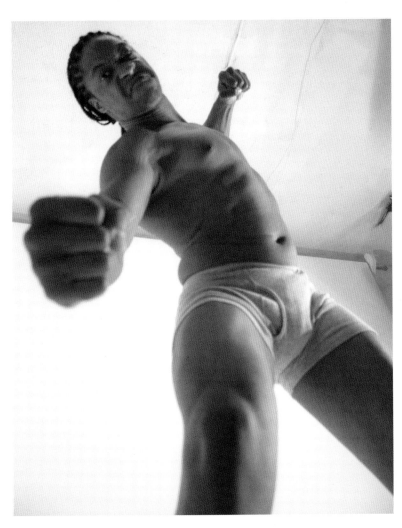

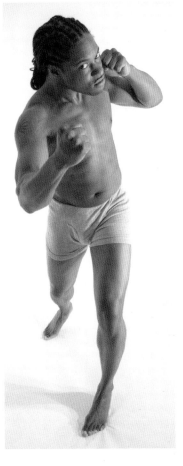
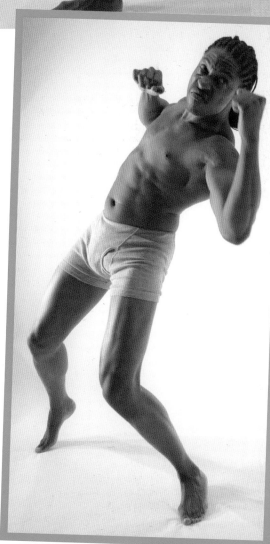

85

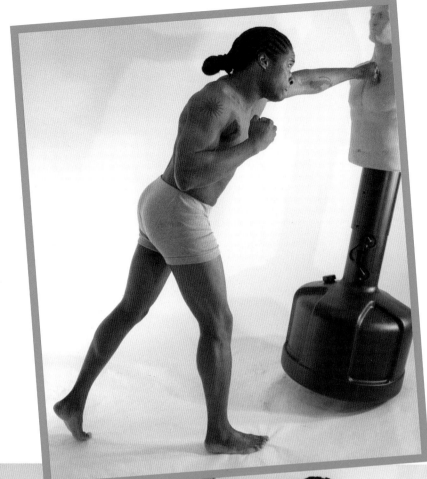

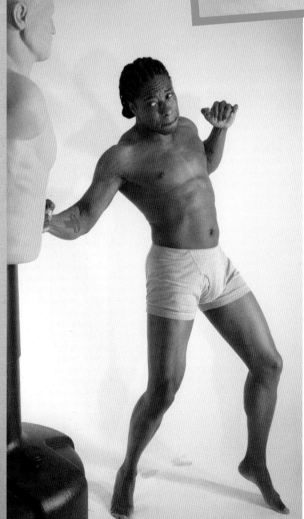

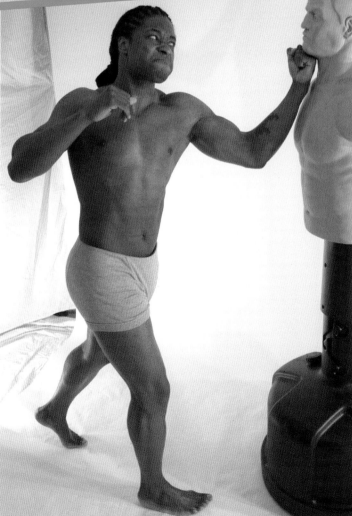

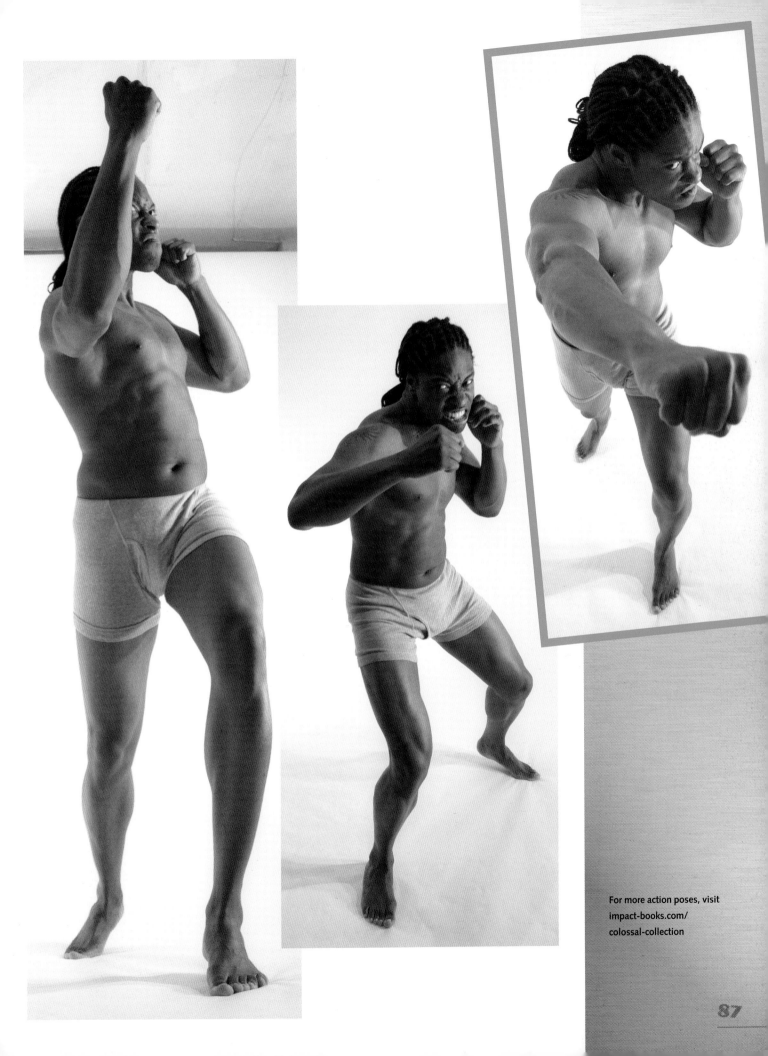

For more action poses, visit
impact-books.com/
colossal-collection

Pushing

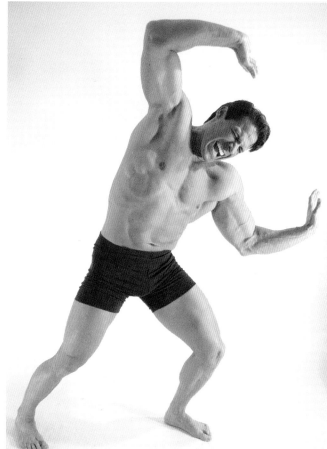

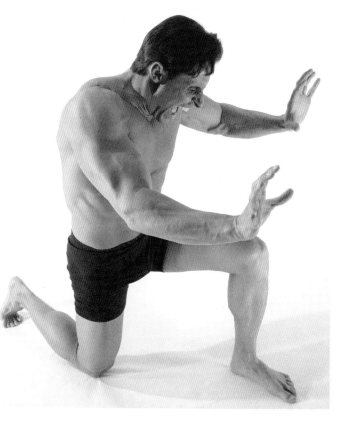

The Body in Motion

BY MATT HALEY

One of the challenges of drawing comics is that you are often called upon to imply motion on flat paper. When you rely too heavily on photo reference, your art can appear motionless—like a photo. Learn how to interpret photo reference so you can create something original and dynamic.

A lot of artists draw the easy pose to get the page done. Sometimes it's difficult to draw what best serves the story, but that's what you have to do.

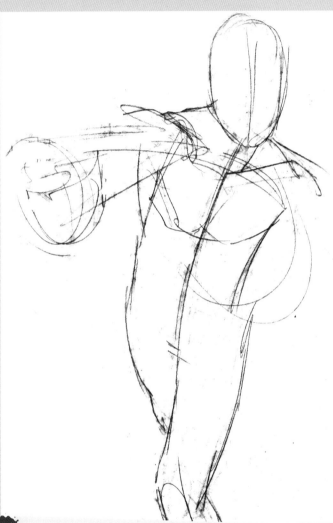

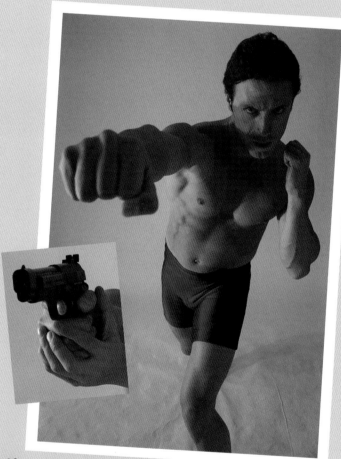

Pick Your Photos

Look for a photo that has a dynamic pose. This picture has some forced perspective; the limbs look like they are coming right through the photo. Remember, the photo does not have to be an exact shot of what you plan to draw. You're not going to be tracing; you're going to be drawing with the photo as a reference for structure and certain details.

The gun reference comes from a different photo.

Sketch Broadly

Make a quick sketch using broad strokes. If you hold the pencil as if you were writing, you'll get very little movement at the tip of the pencil. This is good for detail work, but at this early stage, you want to hold the pencil like a stick. Slash a line from the head through the spine. This will suggest the direction in which the figure's body is moving. Don't worry about the details; right now, you want something free and fluid. You could do this step with a nonphoto blue pencil, since it won't smear and it won't reproduce on the final art.

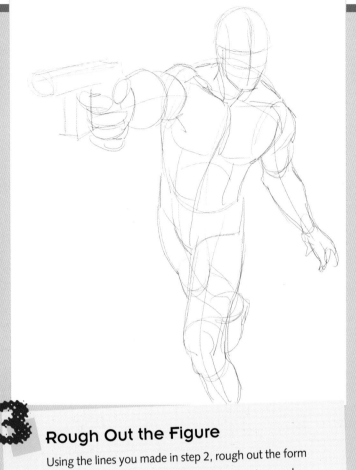

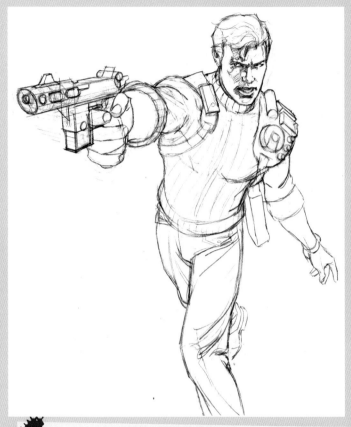

3 Rough Out the Figure

Using the lines you made in step 2, rough out the form of the figure using cylinders, cones and spheres. As you do this, it's very important to draw through (see TECHNIQUE below). Even though you don't see the model's back leg in this picture, draw it anyway. If you draw only one leg, your figure may appear off balance, and it will be difficult to fix later. Your rough should also include basic foreshortening of the receding lines. Notice how the model's right forearm looks stubby and compressed. Foreshortening suggests depth and distance to the reader, who knows approximately how long the arm should be based on the length of the other arm. The art is already starting to evolve away from the photo.

4 Draw the Figure, Then Dress It

Refining the contours of the figure and adding clothing is a two-step process. First draw the anatomy without any real clothing other than the snug-fitting clothing the model in the photo is wearing. That way you're able to see the anatomy clearly and draw it accurately. Now, just as you do in real life, put the clothes on. This two-step process will help you to understand how the clothes should fold and drape.

If you start with a silhouette and then just throw clothes on the figure, it will appear as if the clothes are part of the anatomy, which just isn't the case. We exist as humans, and then we add clothes. Learning how to properly draw the folds and draping of clothing requires a lot of practice, so don't worry if you don't nail it the first time.

drawing through

TECHNIQUE

Drawing through means adding lines to represent all sides of a form, even the sides that aren't visible. Drawing through adds weight and depth and helps you capture perspective and form more accurately.

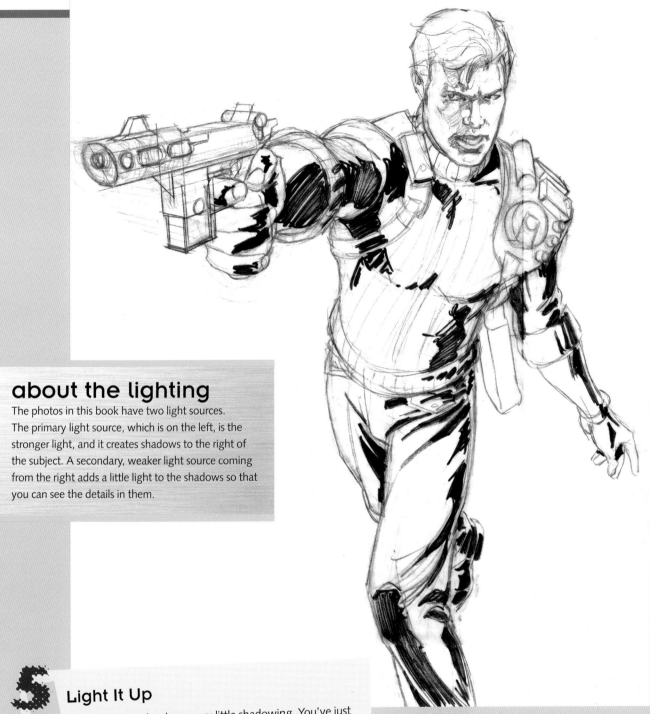

about the lighting

The photos in this book have two light sources. The primary light source, which is on the left, is the stronger light, and it creates shadows to the right of the subject. A secondary, weaker light source coming from the right adds a little light to the shadows so that you can see the details in them.

Light It Up

Until now, there has been very little shadowing. You've just been working to get the figure and the pose correct. Now it's time to give your drawing some life and depth with shadows.

The dominant light in this image is coming from the left. To properly utilize this light, treat it as if it were water shooting from a garden hose. If water were coming from the left, it wouldn't hit the right side of the model's face. The same goes for light. Shine a desk light on an artist's mannequin to better understand how the light is hitting the figure in the photo.

For more action poses, visit impact-books.com/ colossal-collection

6 Add Detail and Background

This art became the real cover for a comic book, so it needed a complete background. Here's some extra information on how this was done.

This character is going to appear slightly behind the main character, but you should draw through the entire figure on a separate page.

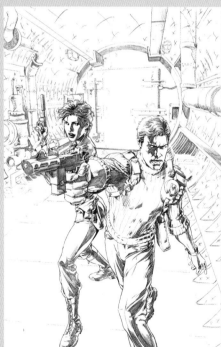

Use a light table to insert the female character behind the male one. Rough out your background so that you have a sense of proportion and perspective.

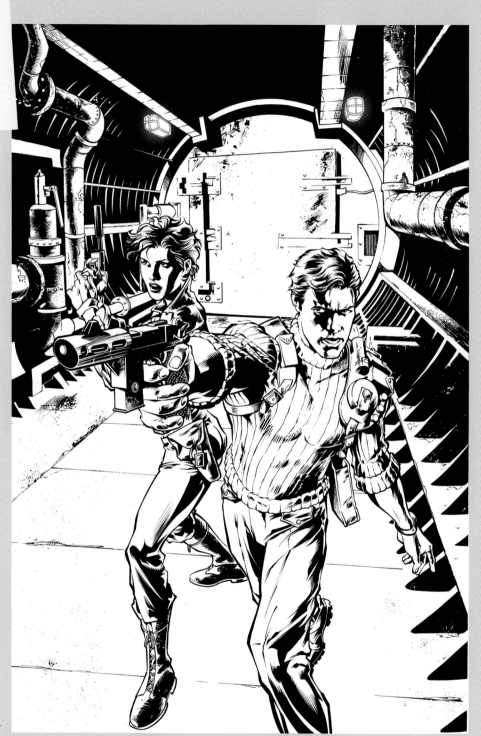

Inking makes the whole illustration come alive with contrast. Ink the blacks, referring to the photograph again to confirm the direction of the light.

Once the art is inked, it is difficult to change it back.

TIP

When combining two or more reference photos, try to find photos with similar light sources.

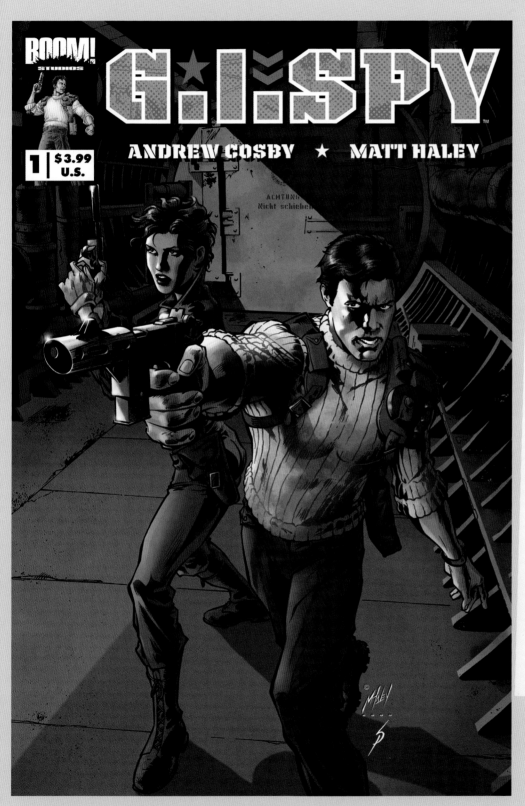

For more action poses, visit
impact-books.com/
colossal-collection

The Finished Cover

Now that the color and logo have been placed, notice how this image controls your eye. You want something eye-catching in the top left corner to draw the eye into a Z pattern). This is where many publishers place a logo. Notice how the eye travels from the logo to the woman's face, up her hair to the title, and down the right side of the circle. The circle guides the eye to Jack's face, out his arm to the gun, down the woman's body, to her right foot, right into Jack's body, up the vertical lines of his sweater and back to his face . . . right where we want it. The fully colored art with logos draws the reader into the image.

A photo is a jumping-off point that you can use for inspiration and reference. But at a certain point you need to put it away so that you have room to change your image as you draw.

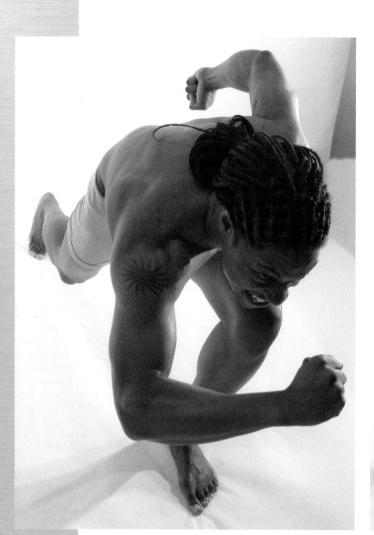
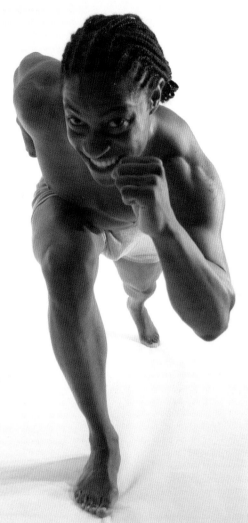
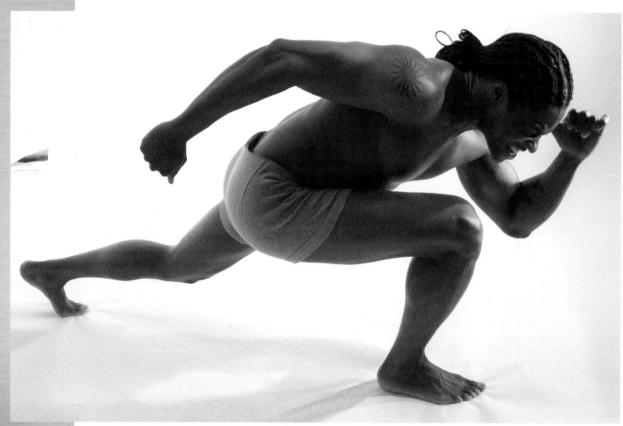

Running

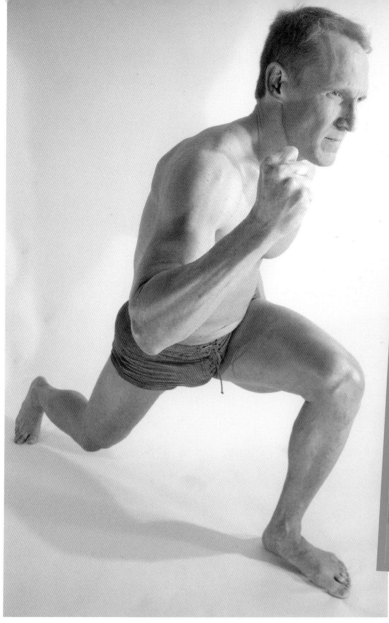
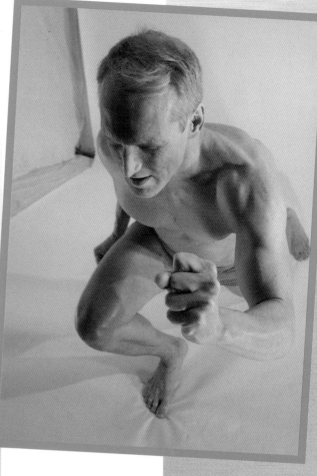
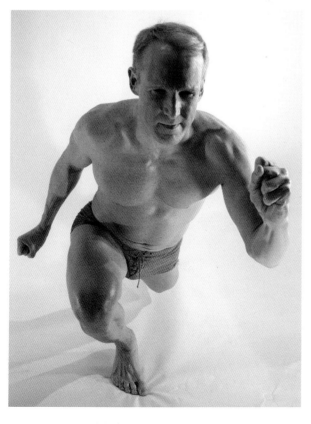
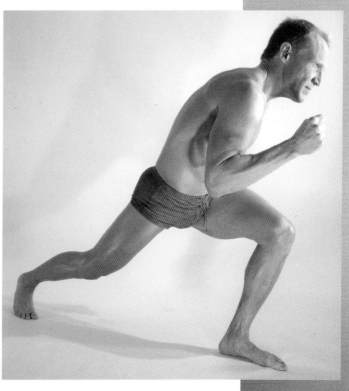

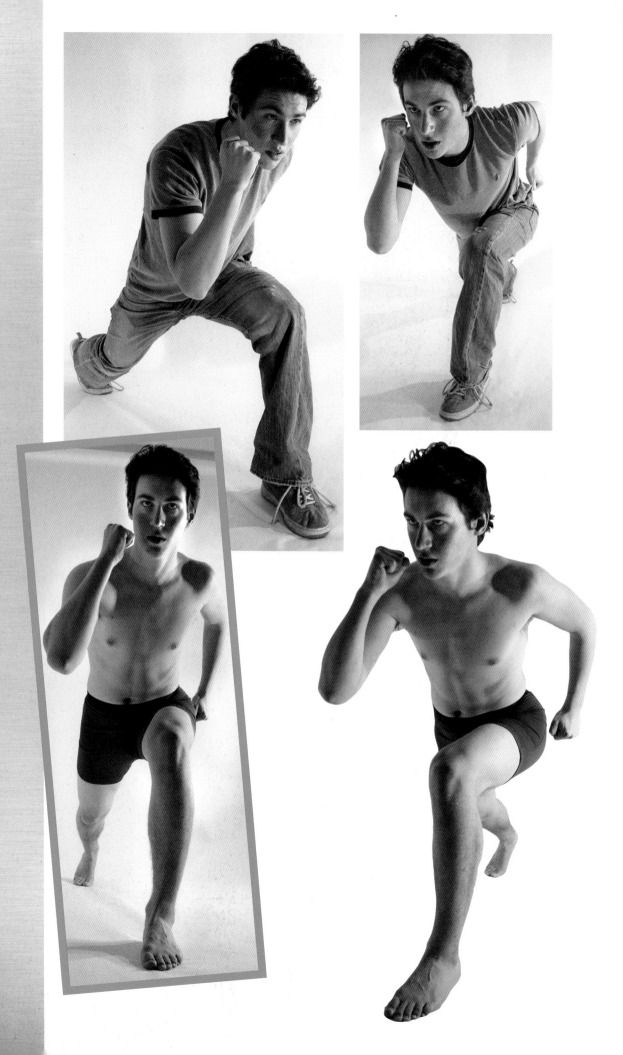

For more action poses, visit
impact-books.com/
colossal-collection

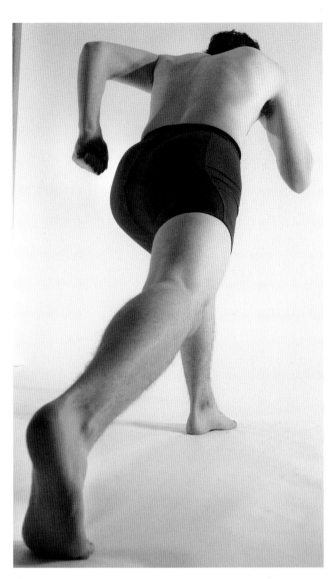

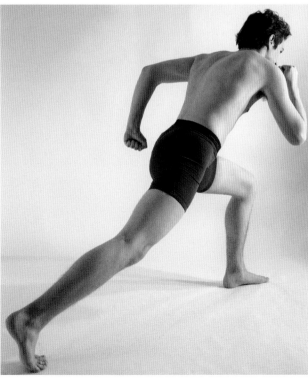

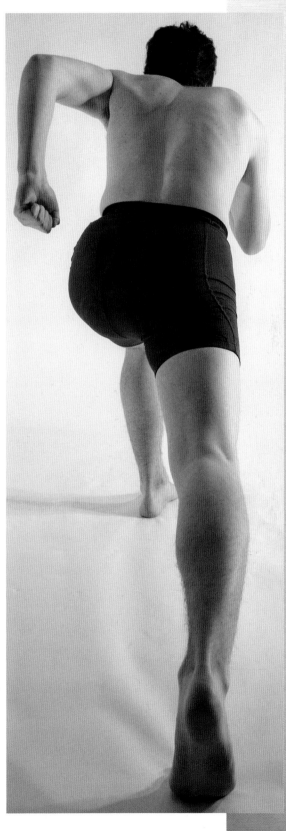

sitting

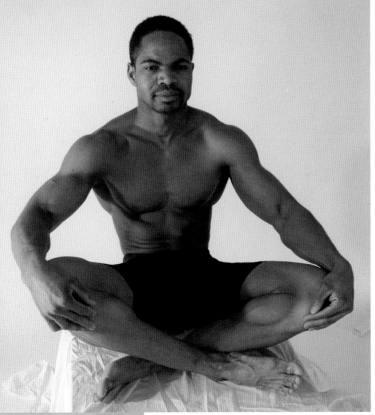

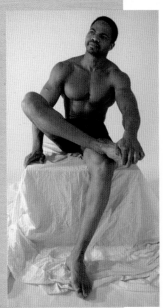

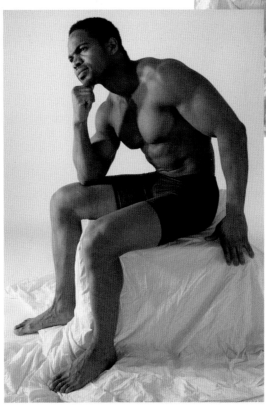

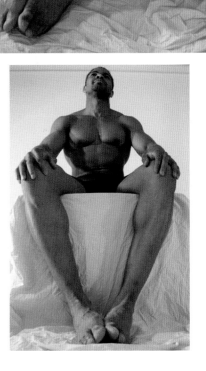

For more action poses, visit
impact-books.com/
colossal-collection

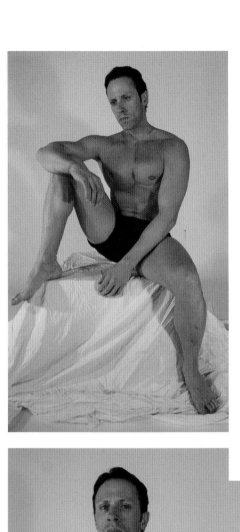
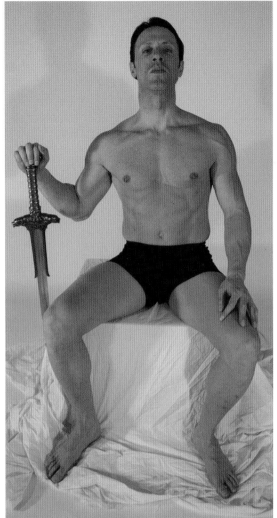

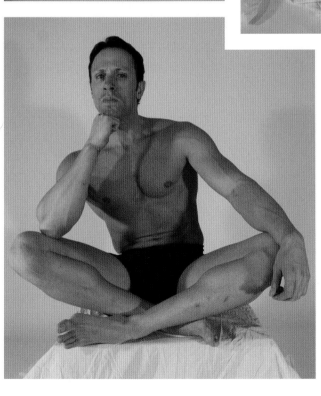
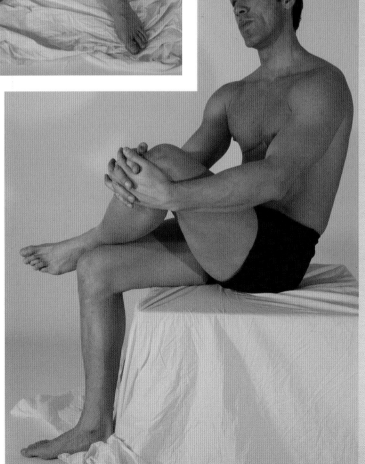

sitting

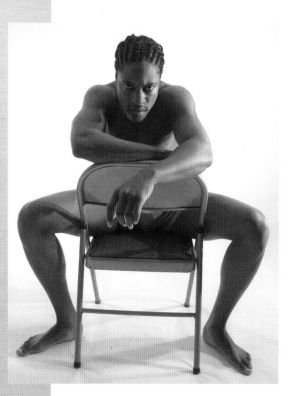

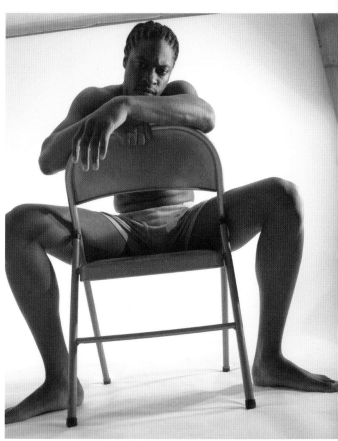

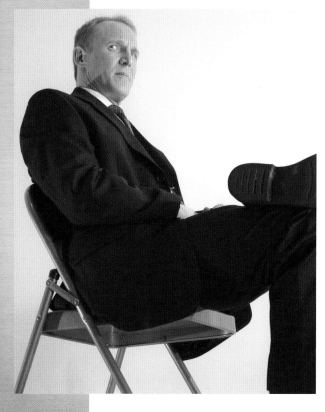

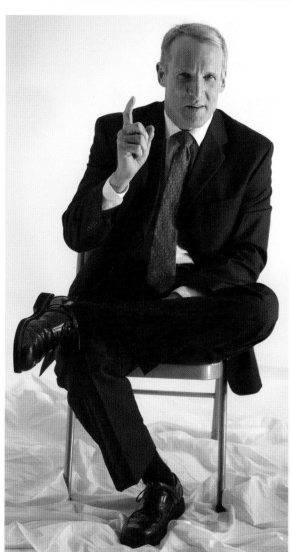

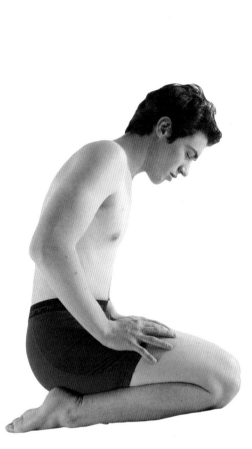
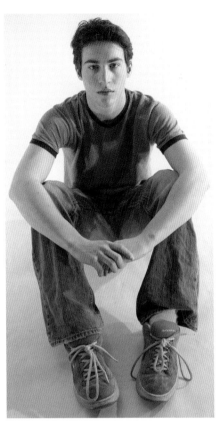
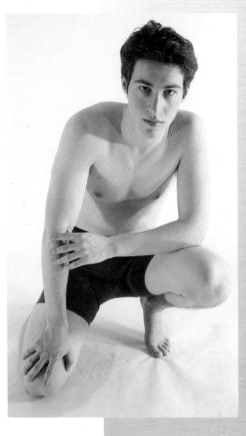
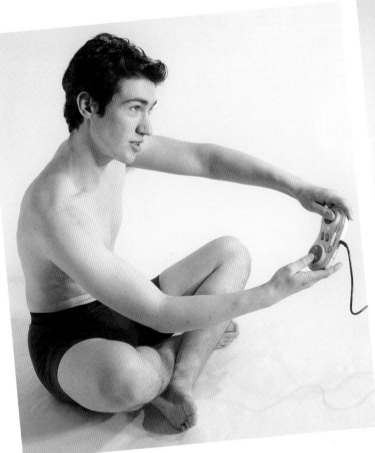
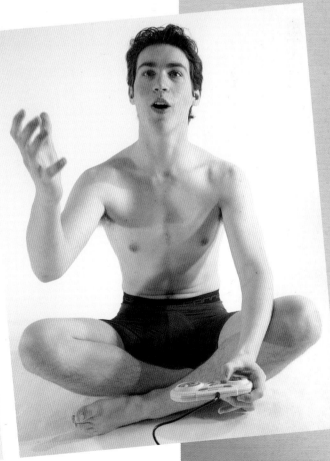

Standing

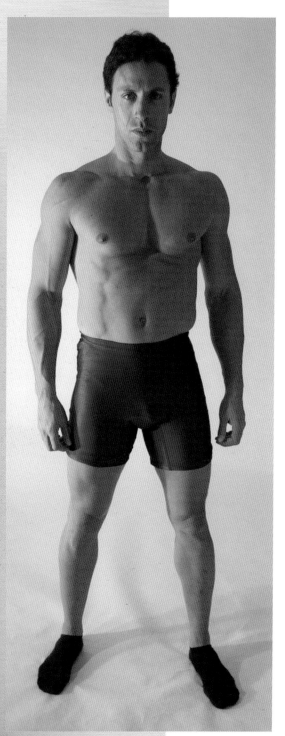

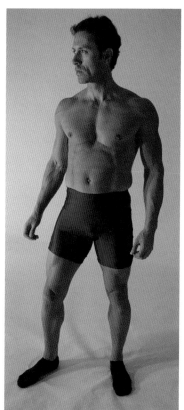

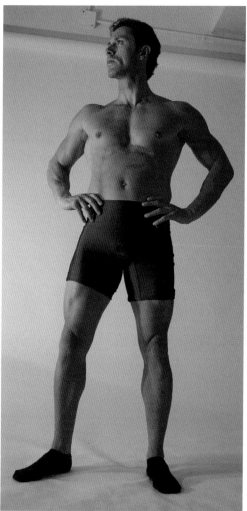

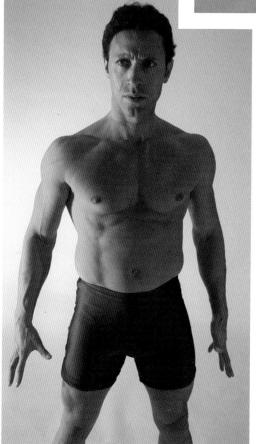

For more action poses, visit
impact-books.com/
colossal-collection

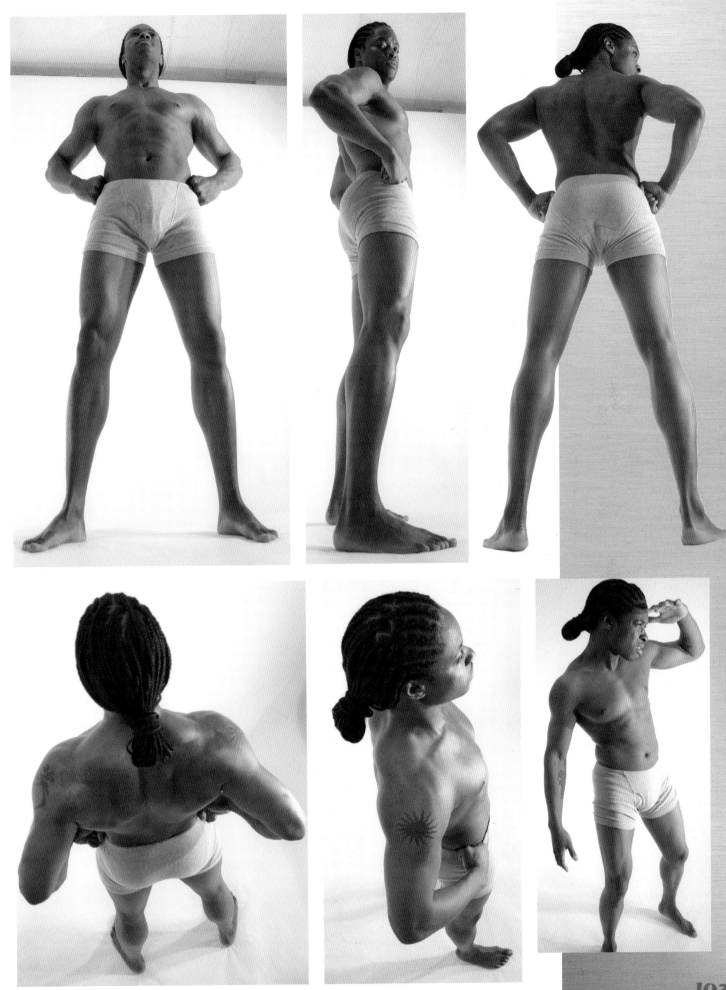

Standing

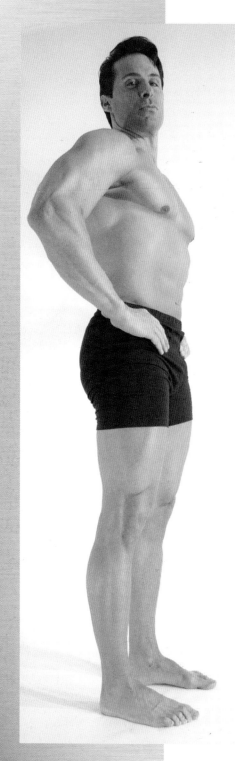

For more action poses, visit
impact-books.com/
colossal-collection

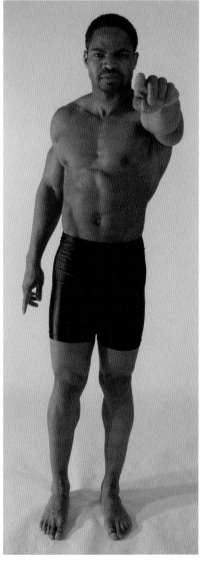
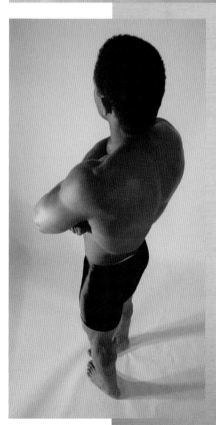

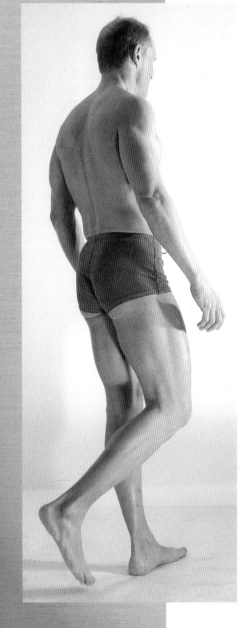

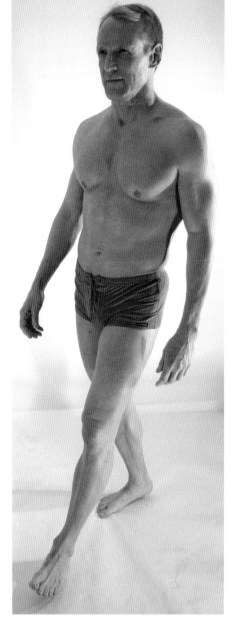

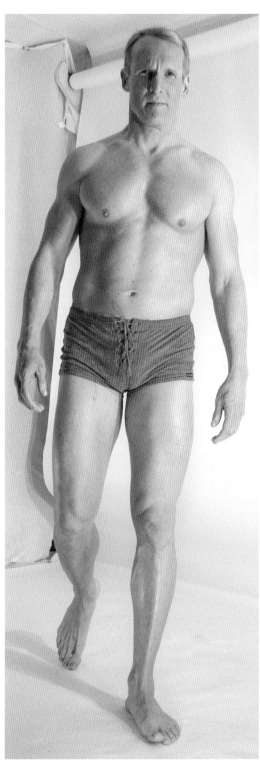

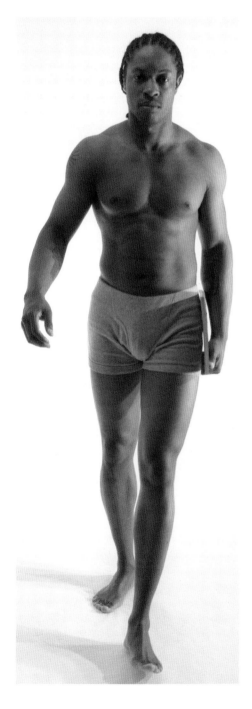

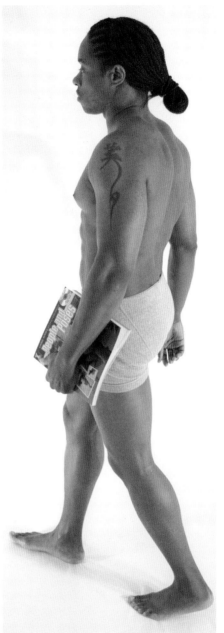

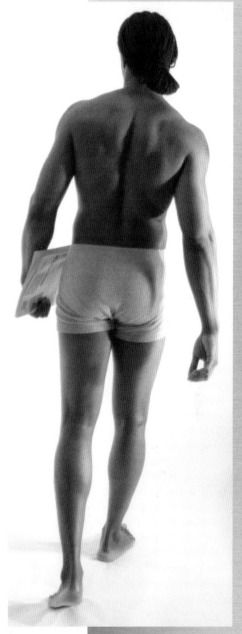

For more action poses, visit
impact-books.com/
colossal-collection

Weapons

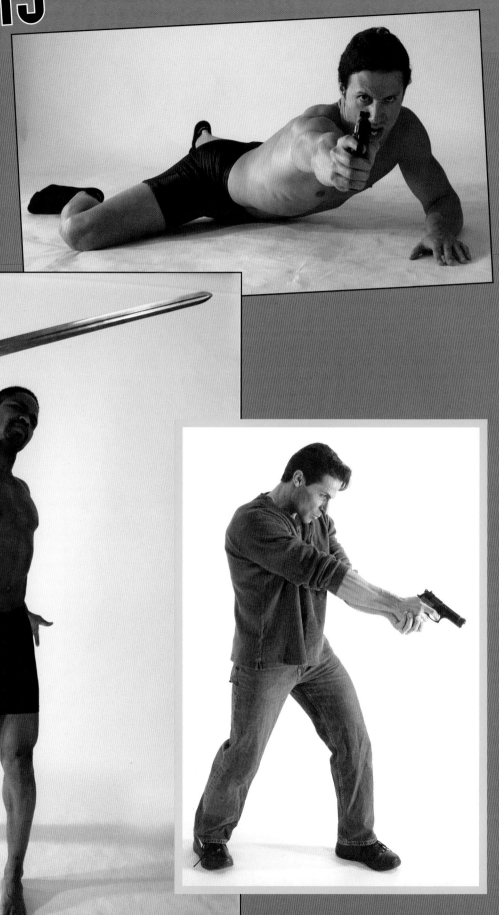

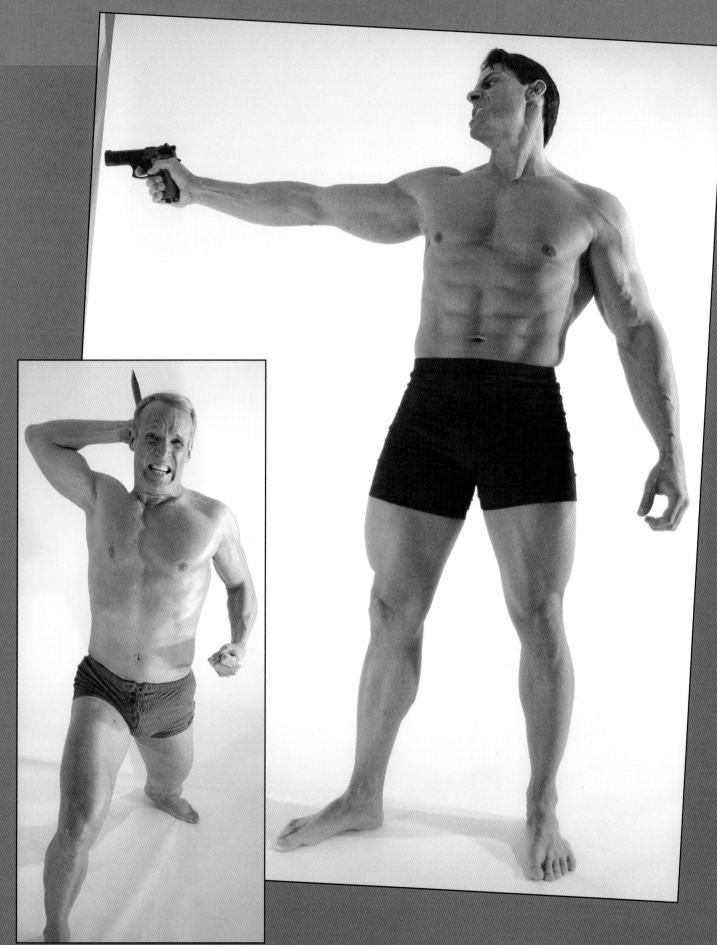

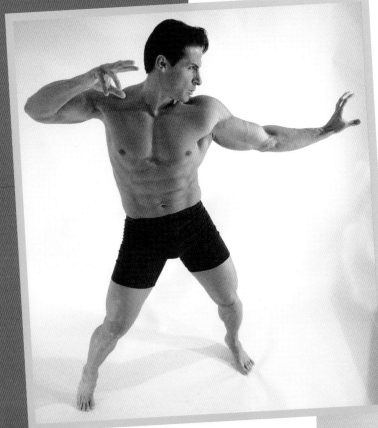

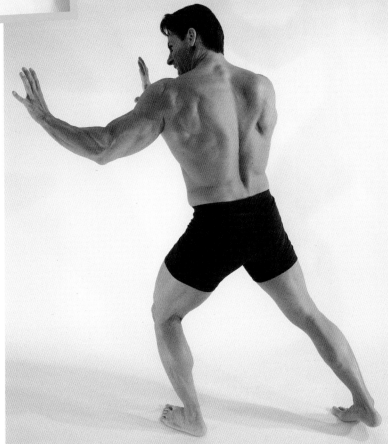

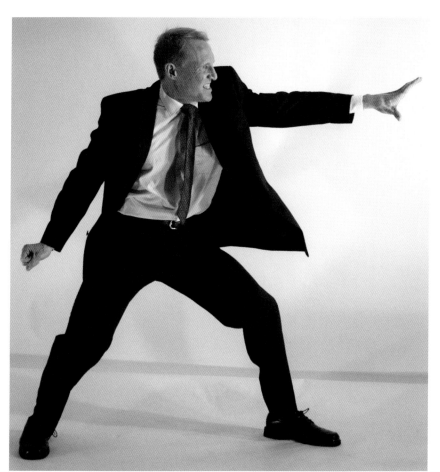

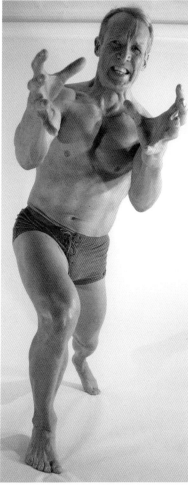

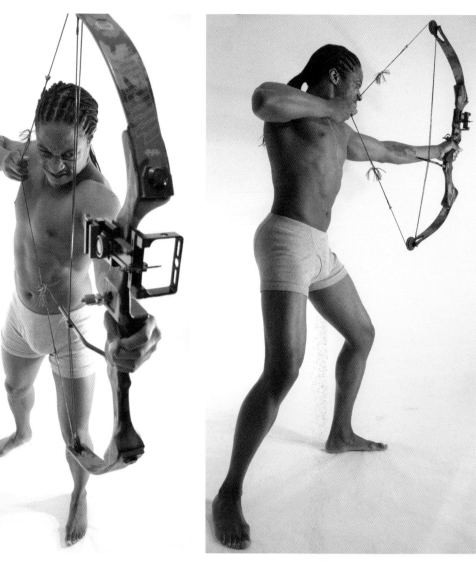

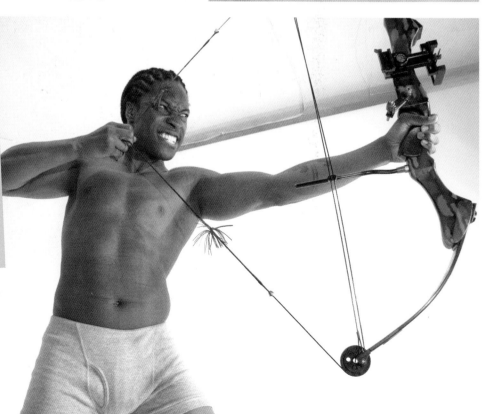

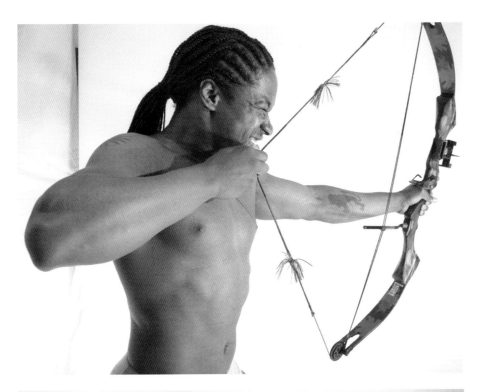

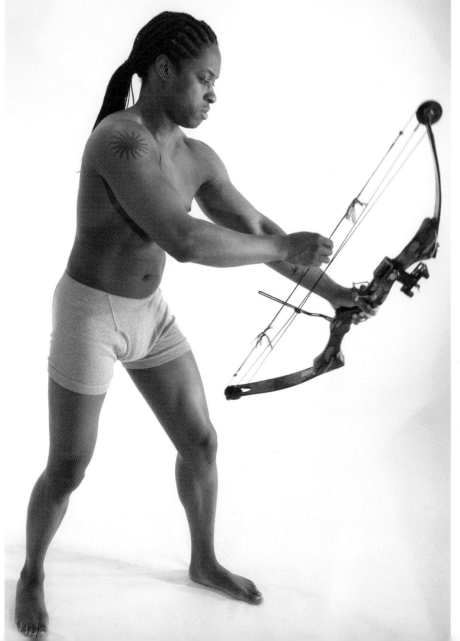

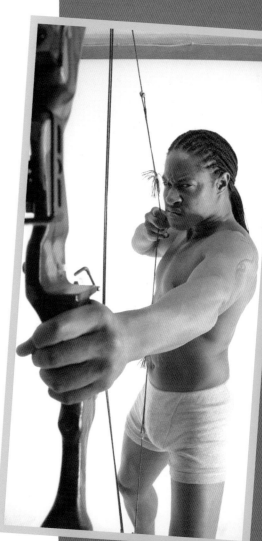

For more action poses, visit
impact-books.com/
colossal-collection

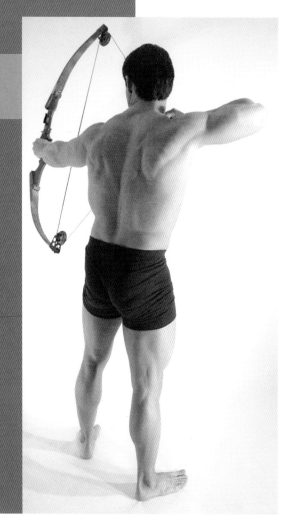

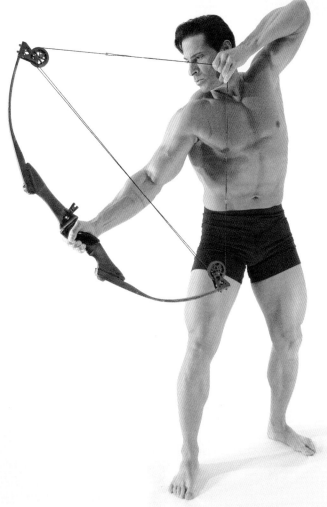

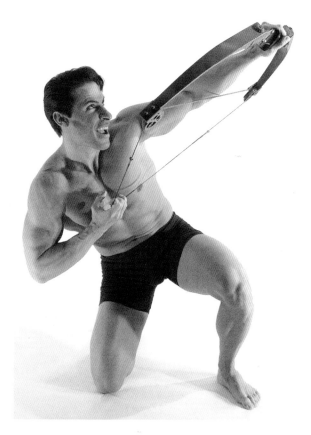

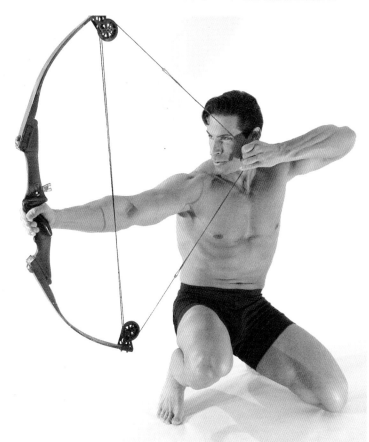

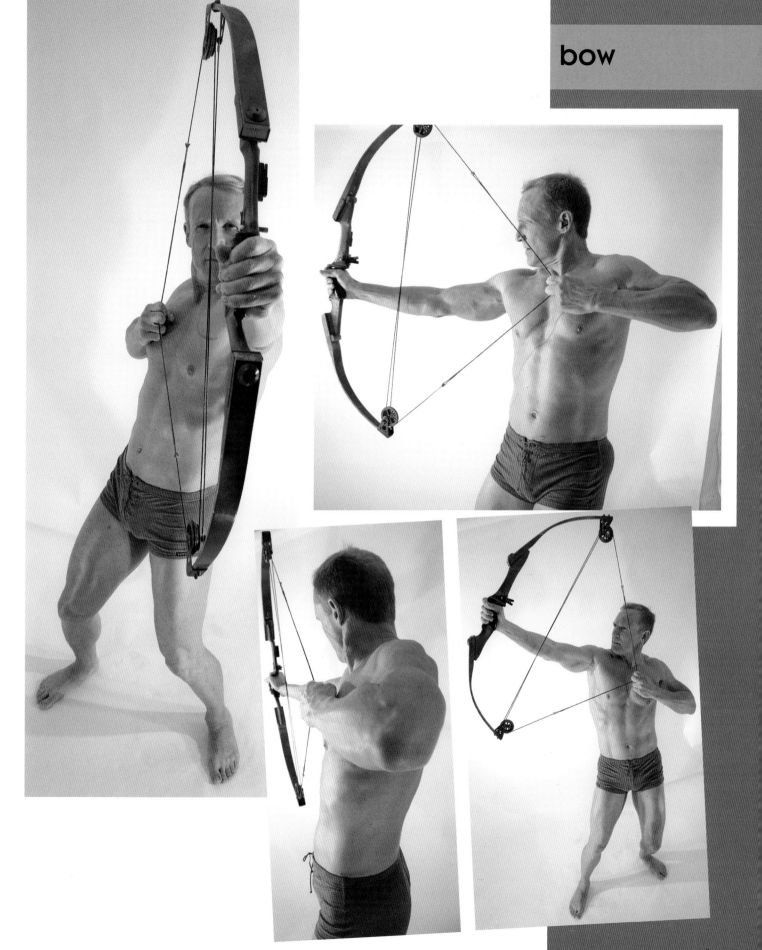

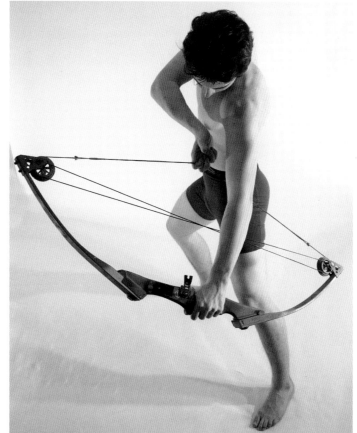

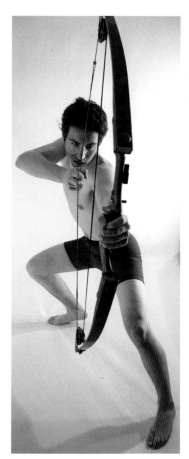

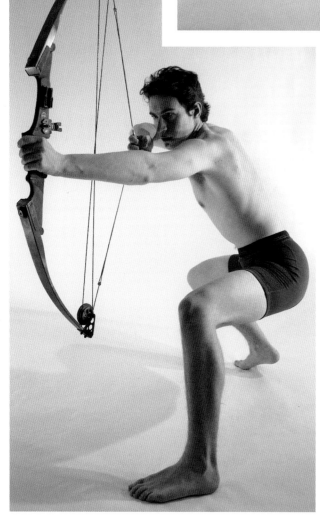

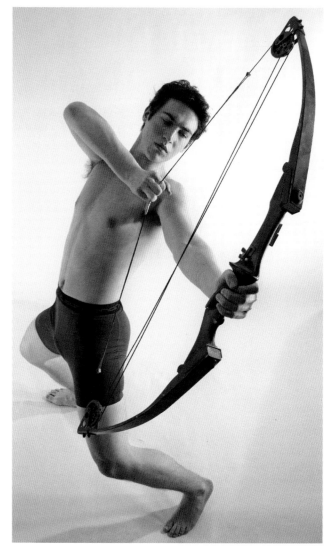

Watercolor Painting From Photo Reference

BY MARK SMYLIE

A lot of my artwork is in the genre of fantasy. I paint with watercolor because I like its subdued tones. In this demo, you'll see how I draw, paint, ink and then add a little texture with colored pencils.

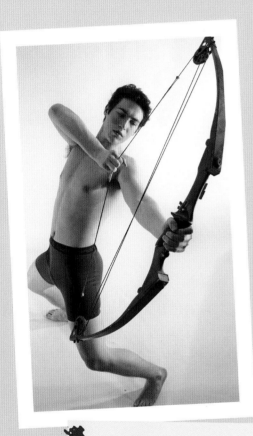

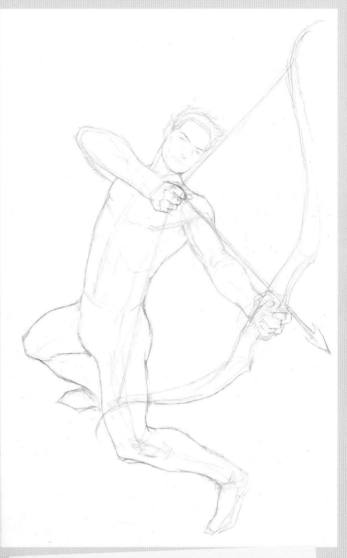

1 Select a Photo

For this demo, Buddy asked me to take a look at a set of photos he had done featuring a male figure holding a bow. I chose this pose, which I thought had a very nice dramatic quality because of the foreshortening and the model's backward lean.

2 Build a Rough Sketch

First I blocked out the pose roughly, trying to capture the overall gesture and proportions. When drawing from photos, I don't use a light box; I just set the photo next to my drawing paper so I can refer to it.

I made a few adjustments as I drew. I dropped in the arrow, and I adjusted the finger positions on the archer's right hand a little bit and toyed with the idea of giving the figure pointy ears (going elf with it, as it were).

Demonstration

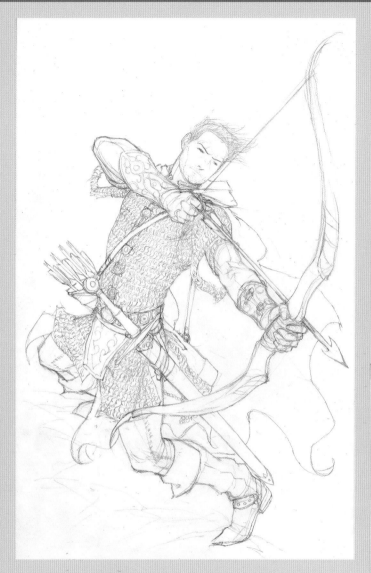

 Finish the Pencils

Next I added the accoutrements. Given the pose and the bow, I could have gone for a Green Arrow look, but I work primarily in the fantasy genre, so I went with a ranger type: chain-mail shirt, arm bracers, sword belt, etc., plus a flowing cloak to hopefully emphasize the sense of motion in the original photo.

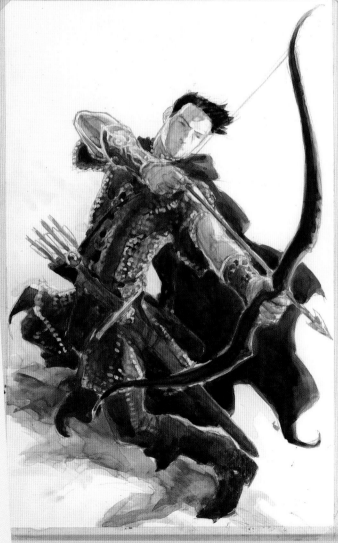

 Add Color

To prepare for painting, I taped the paper down so it wouldn't buckle. I applied masking fluid to some of the light areas on the character's metal gear to keep them paper-white for a reflective look in the final painting. Then I added watercolor. I kept the bow greenish blue as a nod to the original photo, though normally I would probably go for a wood tone for a bow.

Some watercolor artists prefer to ink first and then use a workable fixative before painting, but I prefer to paint first and ink second. If you ink first, you need to apply a workable fixative to prevent bleeding, and fixative makes the paper less able to absorb the watercolor.

 Ink and Finalize

I inked the image with a Rapido-graph technical pen to sharpen the linework. Then I retouched the watercolor a bit. Finally, I added some colored pencil here and there to shape the colors more exactly or to lend a bit of texture.

When I use photo reference, I do not simply copy the photo. The final artwork is inspired by the photo and hopefully draws from it for a sense of energy and accuracy.

For more action poses, visit impact-books.com/ colossal-collection

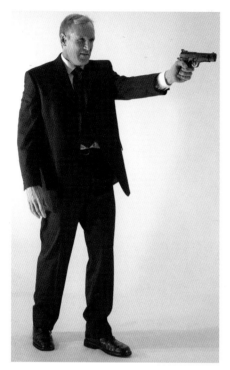

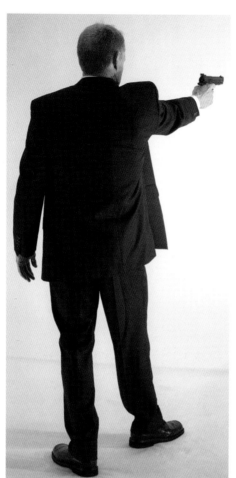

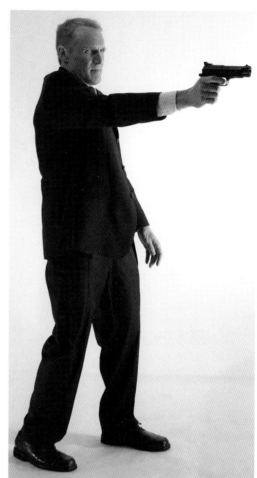

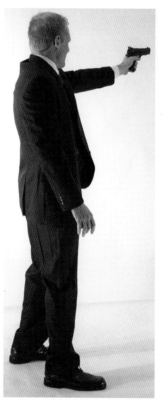

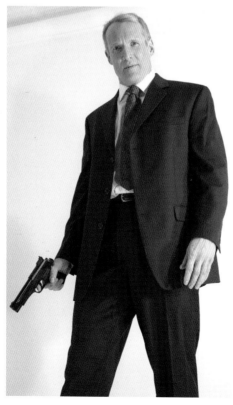

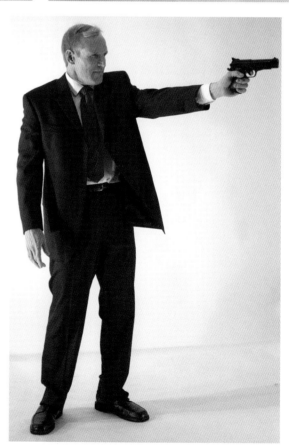

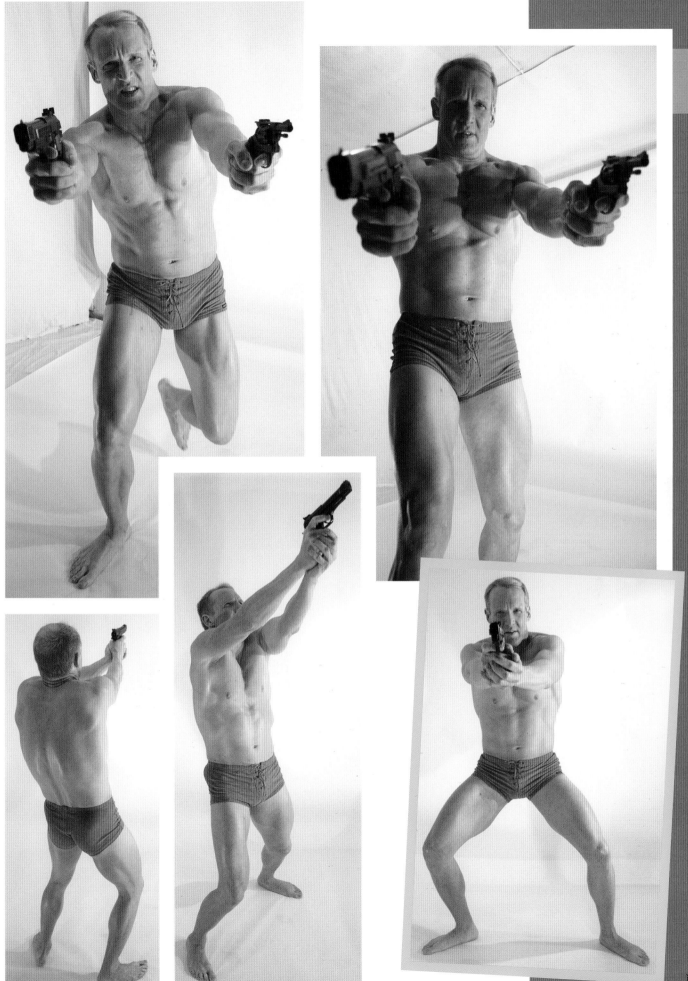

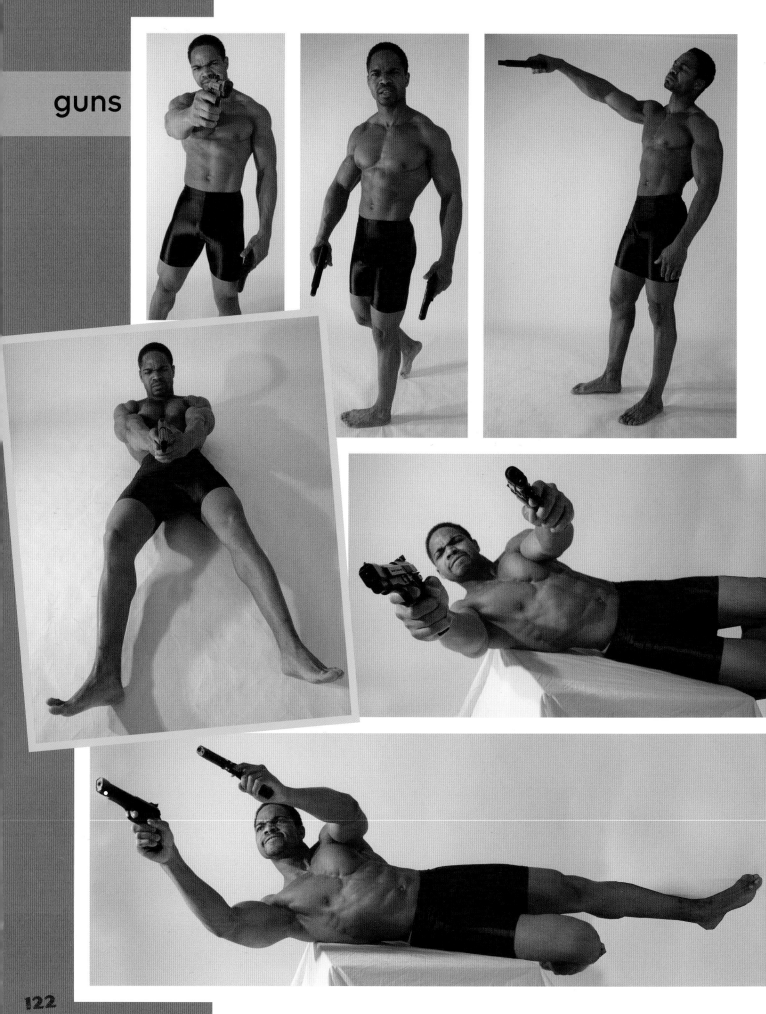

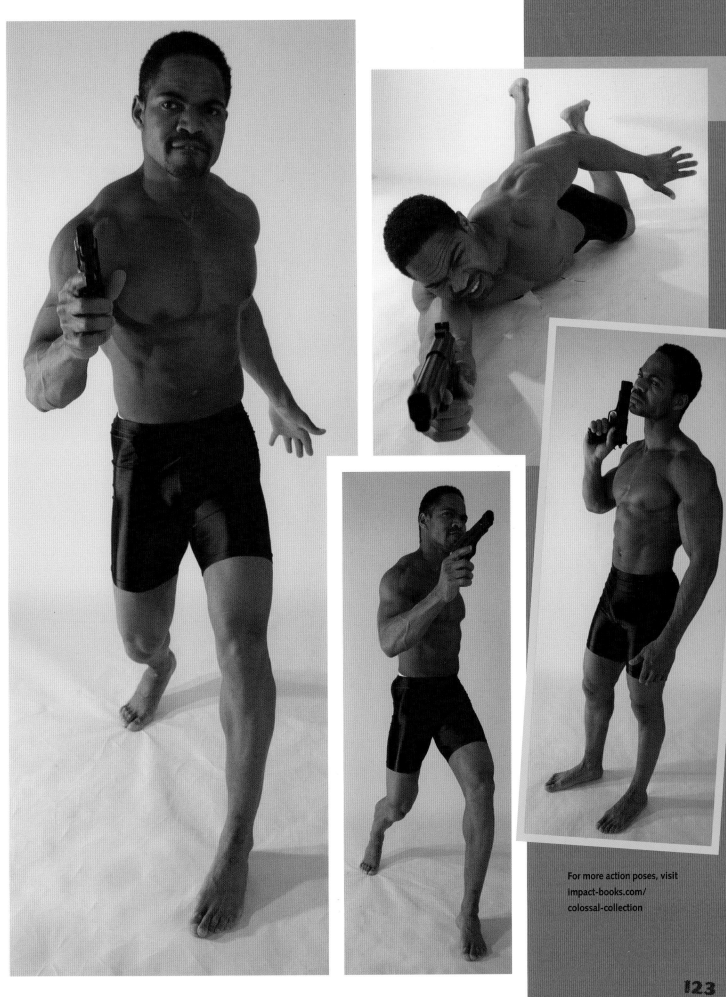

For more action poses, visit
impact-books.com/
colossal-collection

123

guns

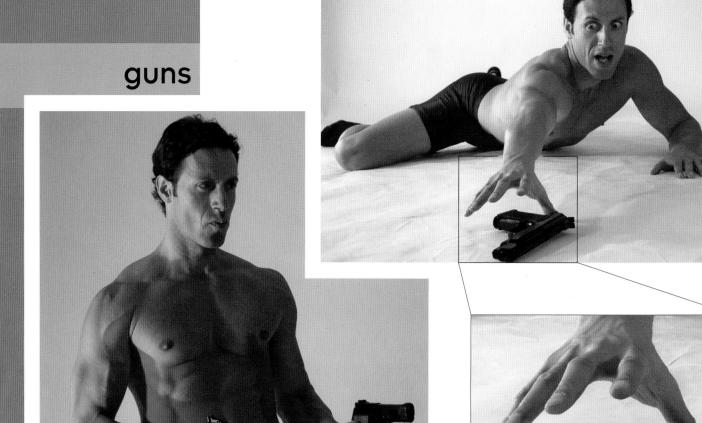

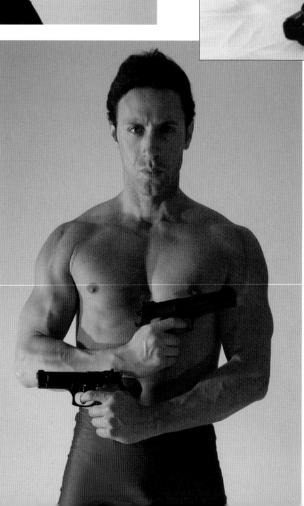

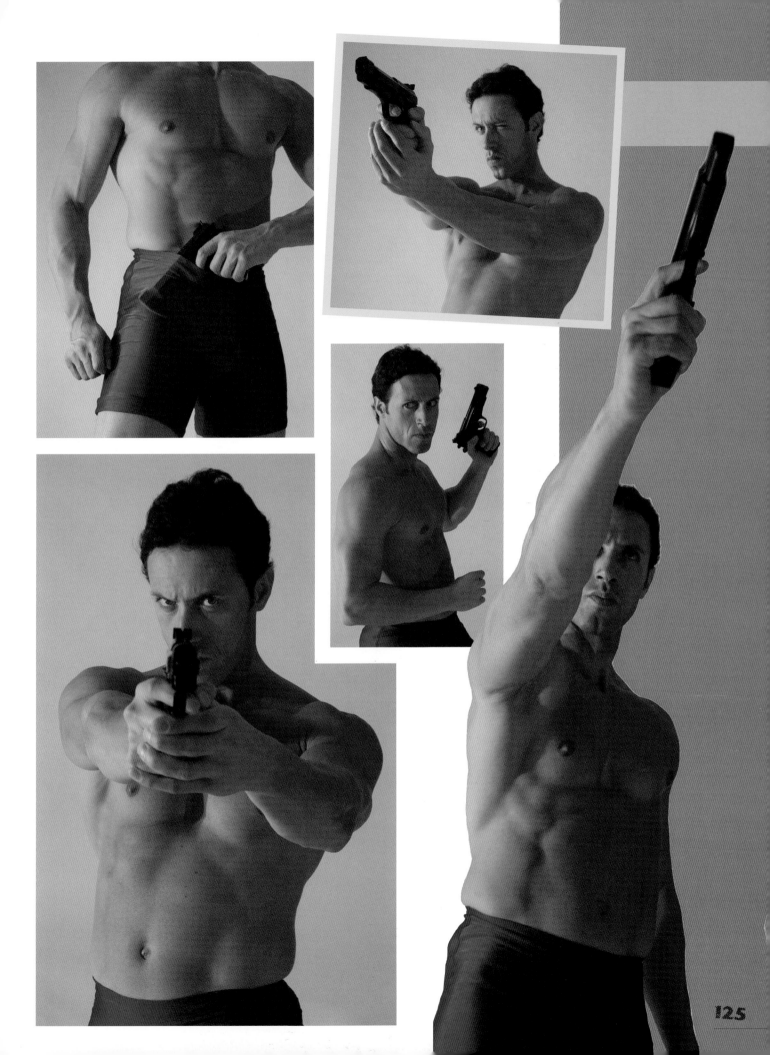

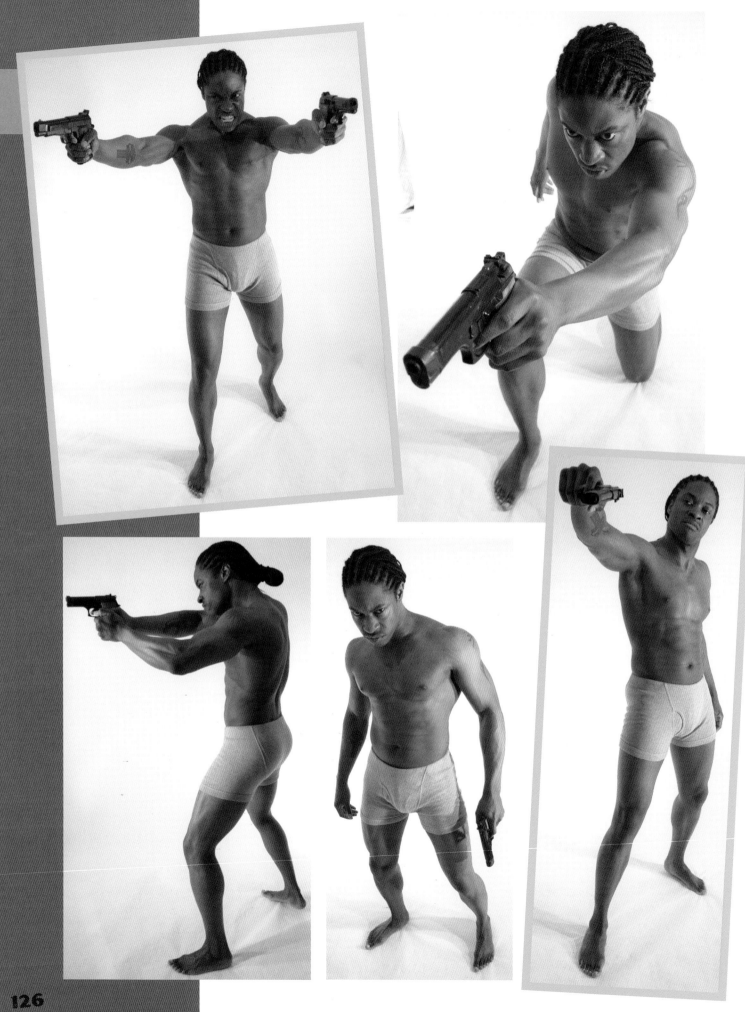

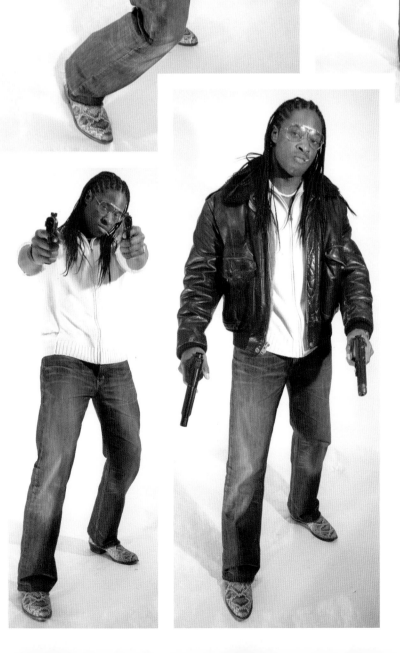

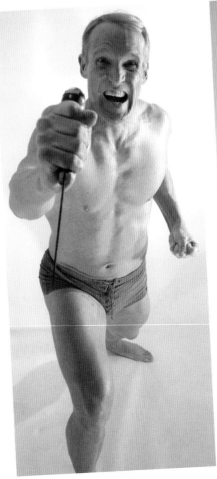

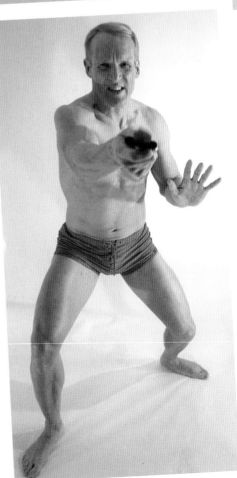

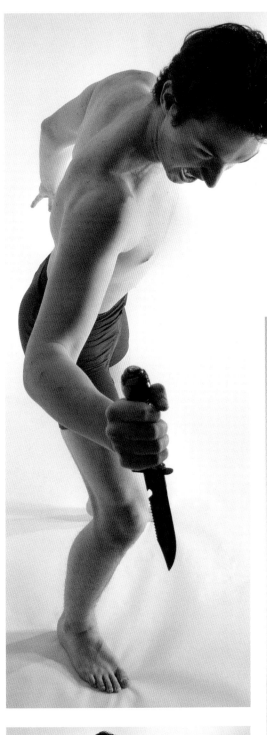

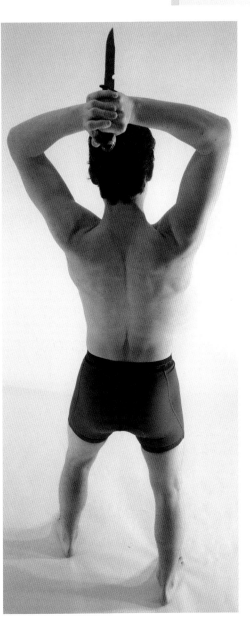

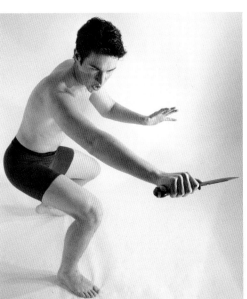

For more action poses, visit
impact-books.com/
colossal-collection

nunchucks

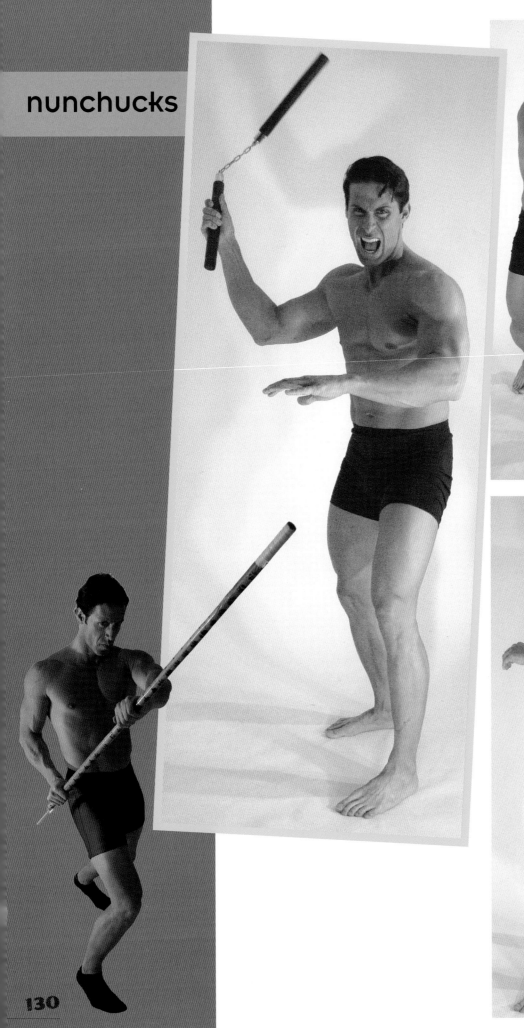
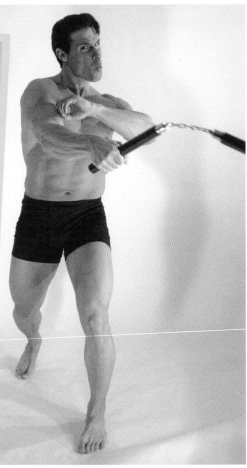
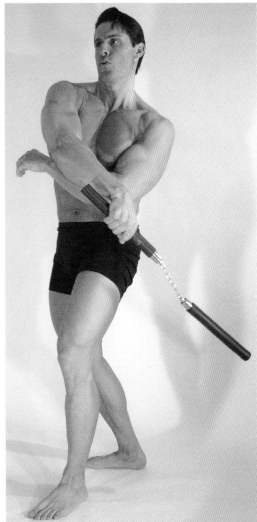

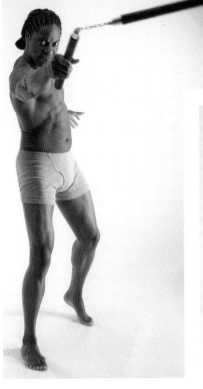

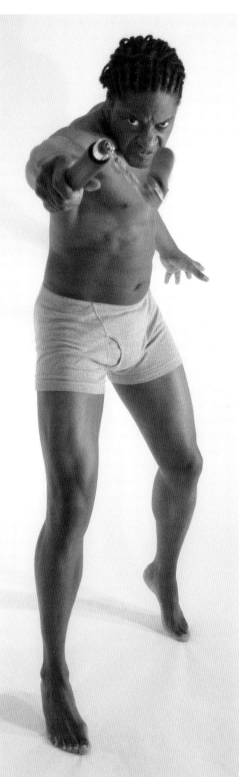

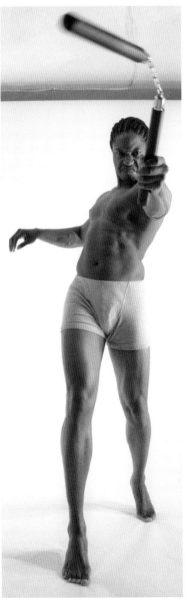

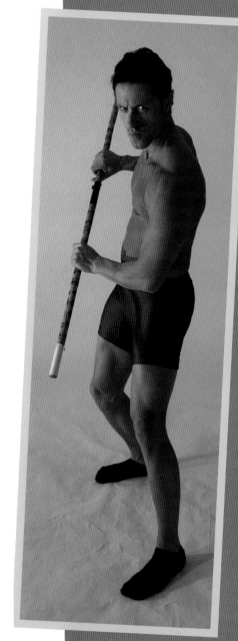

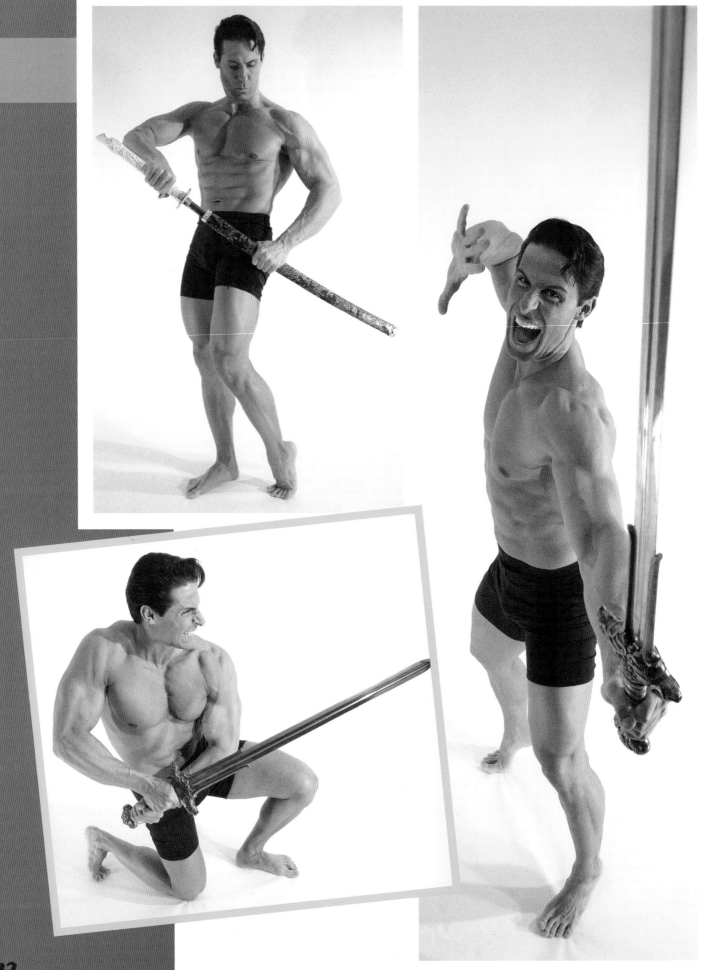

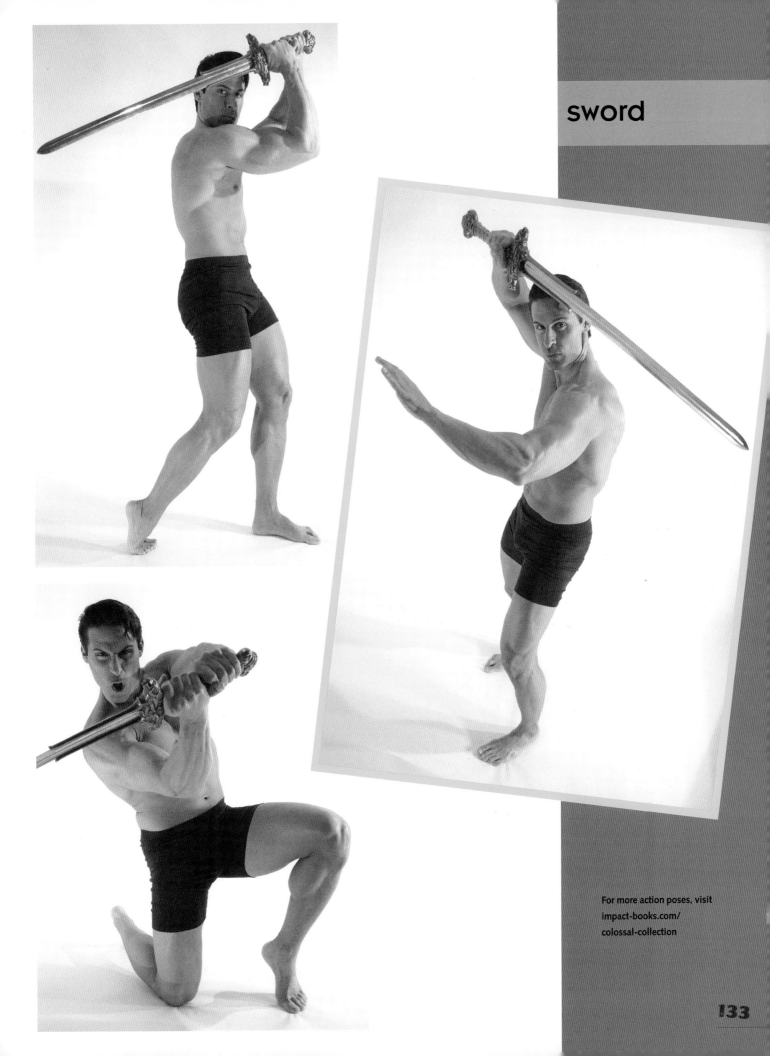

sword

For more action poses, visit
impact-books.com/
colossal-collection

133

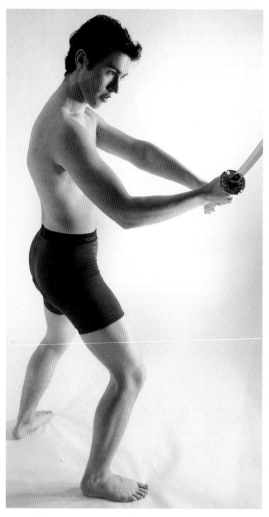

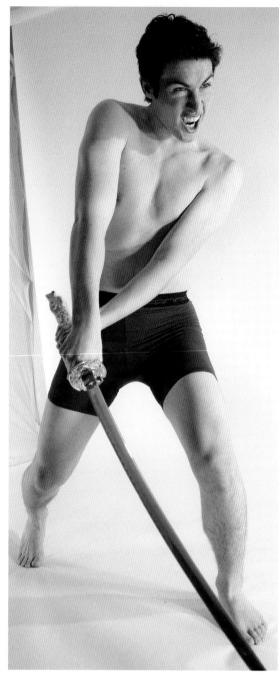

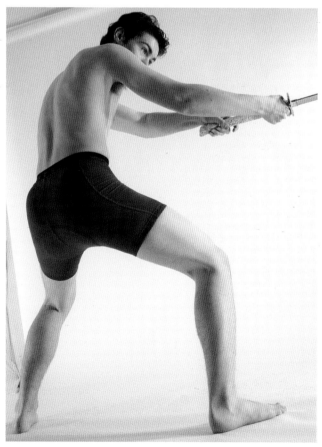

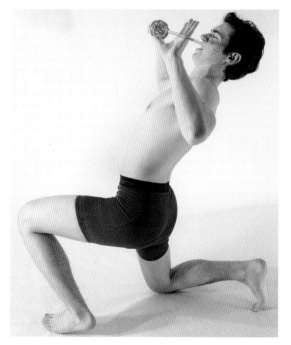

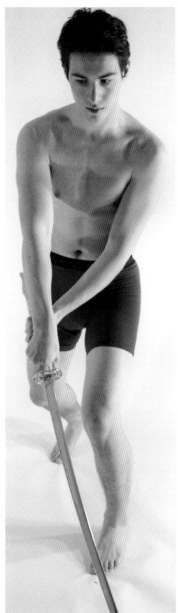

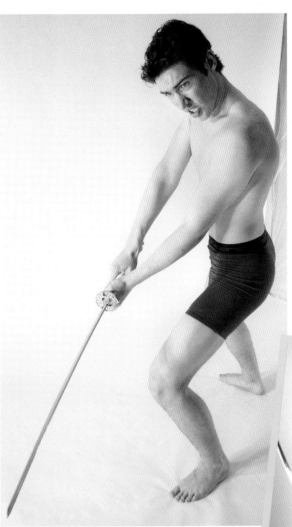

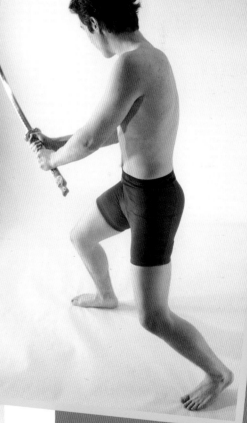

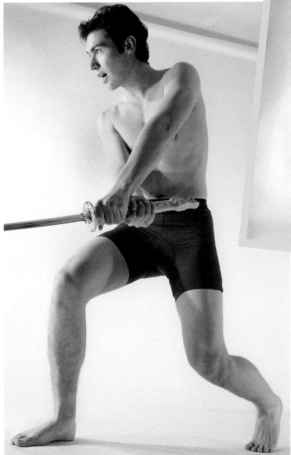

For more action poses, visit
impact-books.com/
colossal-collection

135

sword

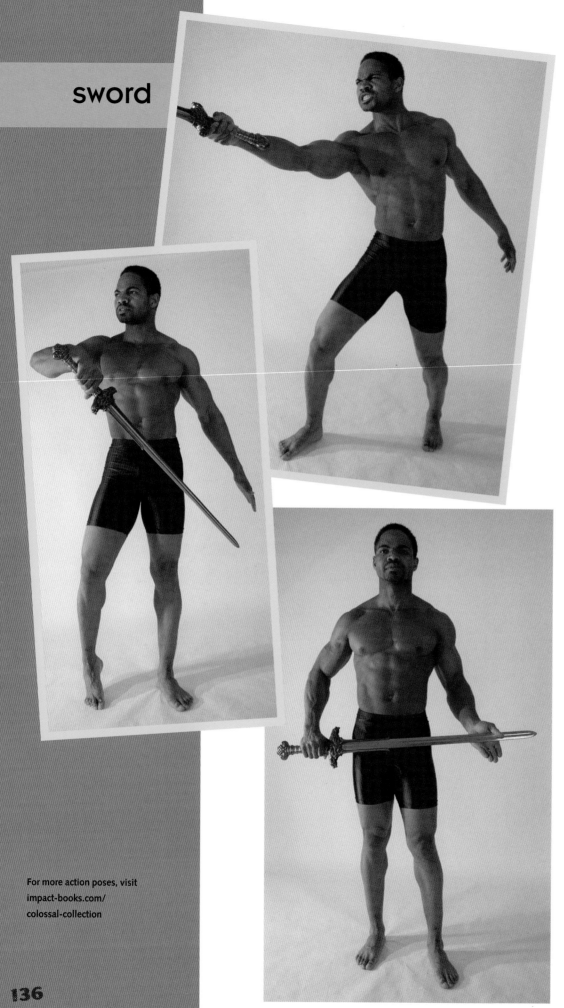
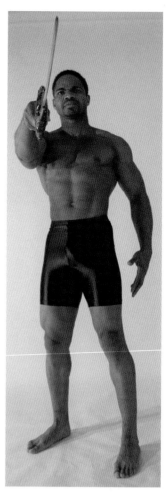
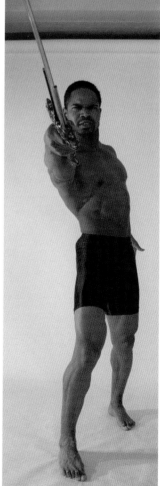

For more action poses, visit
impact-books.com/
colossal-collection

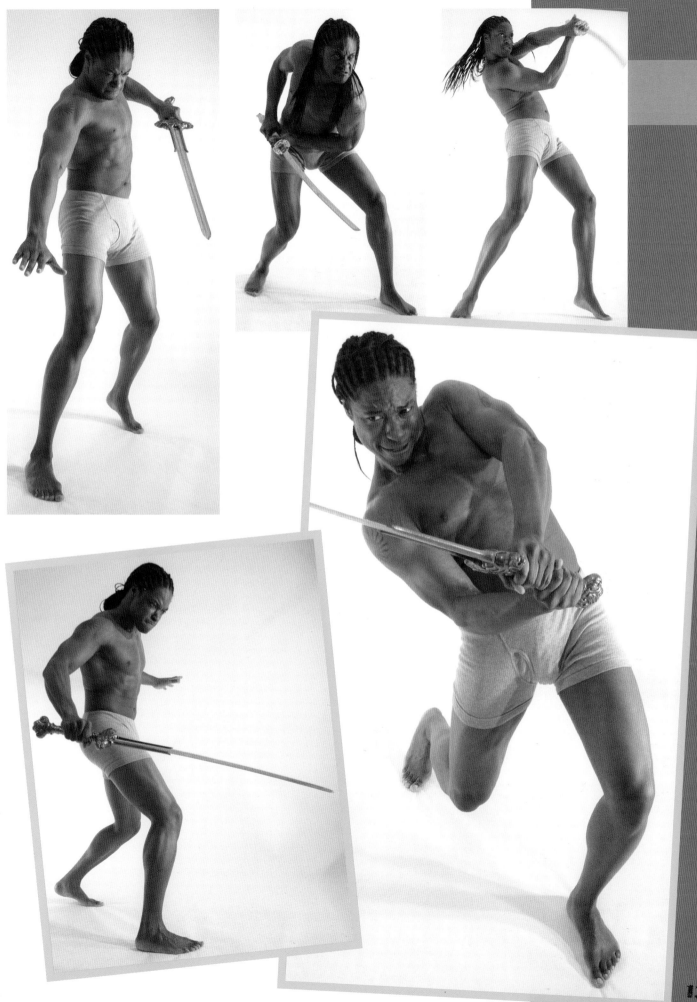

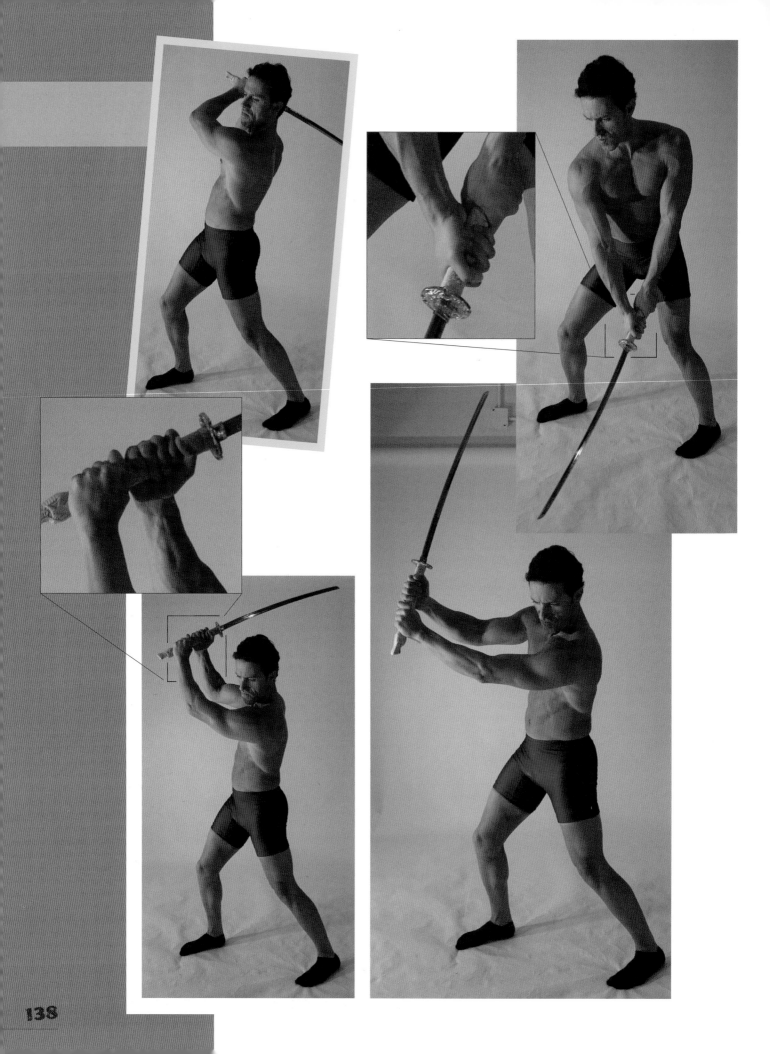

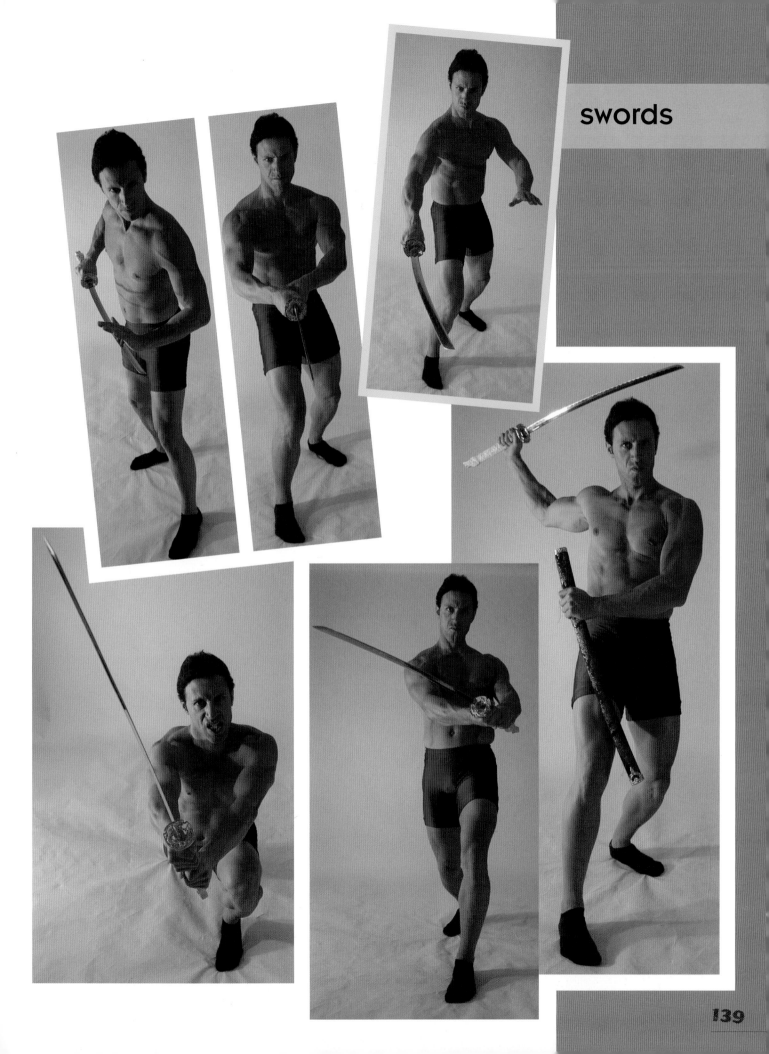

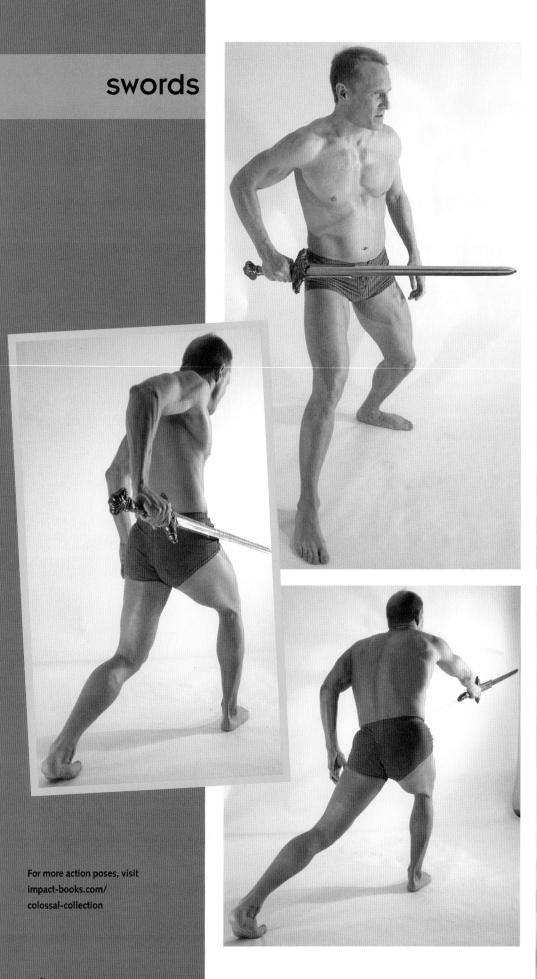
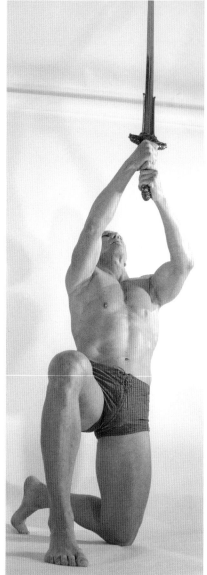
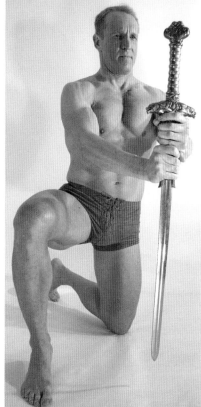

For more action poses, visit
impact-books.com/
colossal-collection

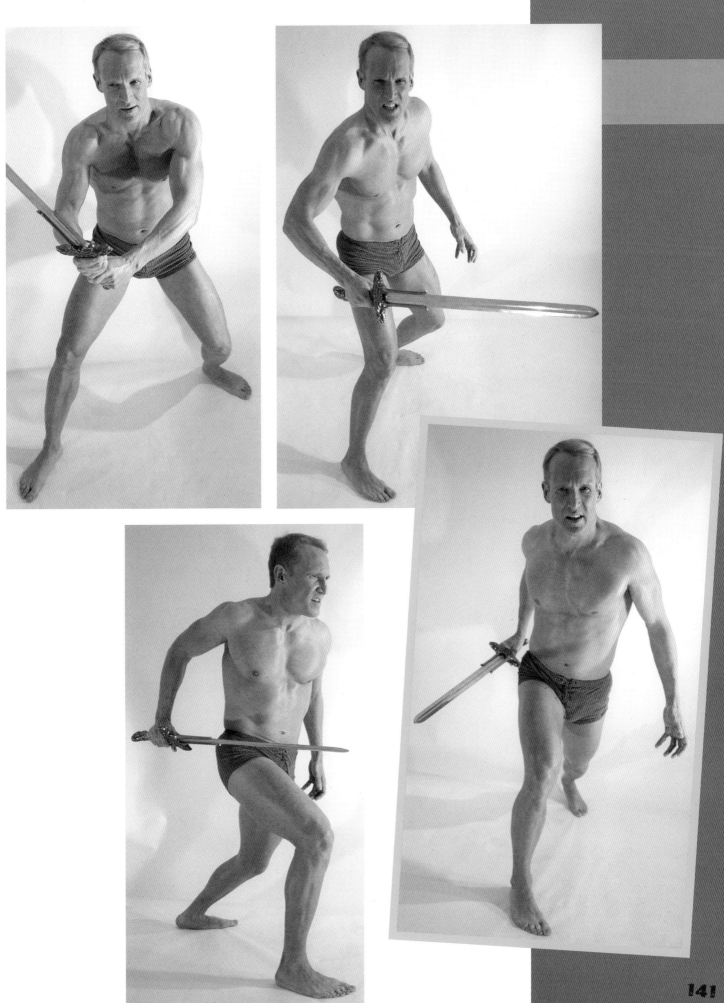

Team of Heroes, Collage-Style

BY JAMAL IGLE

I'm a big fan of collage-style art that features a team of characters—such as Drew Struzan's movie posters for Indiana Jones, *Star Wars*, Harry Potter and many others. I'm going to show you how to design a collage-style team portrait that could be used for a first-issue cover.

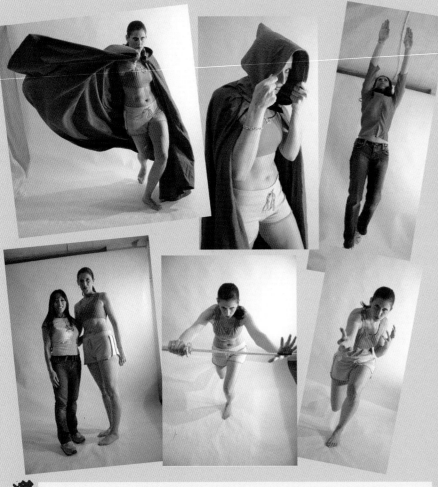

2 Sketch Your Concept

Create a rough sketch of the overall idea. The purpose of this sketch is to plan the placement of all the elements of the collage. At the same time, you are beginning to design your characters' costumes and powers. The idea is to skirt familiar archetypes without using existing characters. The team I'm creating here, Strikeforce Sappho, includes a star-spangled warrior princess, a samurai droid, a fiery hothead, a high-flying character, a techno-girl, and also a scaly creature whose role is mysterious (is she friend or foe?).

Choose a Variety of Photos

Pick at least half a dozen poses to draw from. The members of a comic book team need to be memorable and distinct from each other, so each photo you choose should show different body language and a different mood. Try to find photos with similar lighting as well, to help unify the images in the collage. As you make your selections, think about what heroic type or personality each photo suggests to you.

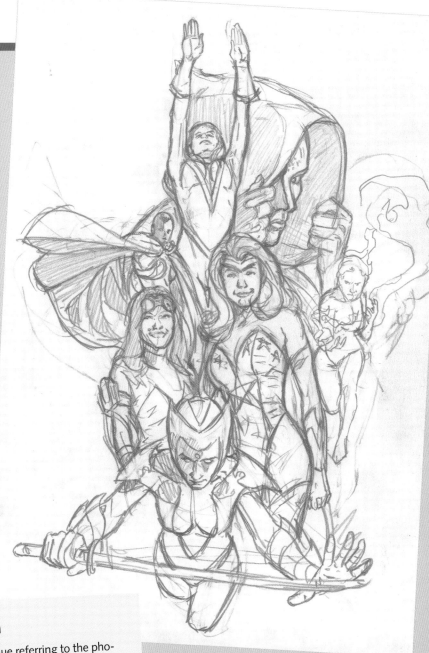

3 Do a More Detailed Sketch

Sketch again on ordinary copier paper. Continue referring to the photos, but tweak the poses a bit; you don't want to copy them exactly. Your goal should be to capture the lighting and the attitude of the pose. Rough in the details that individualize each character. Create symmetry and balance.

As you place the lights and darks, play with the negative spaces around the characters. The characters in the middle ground and foreground have very few shadows in them. I've put the dark, hooded figure in the background so that its dark tones can peek through the spaces between the other characters. This contrast helps the other characters pop out of the image.

When you feel this sketch is done, put down your pencil and just look things over. Is the lighting the way you want it? Is there anything about the design that needs tweaking to make it more balanced or more exciting? Make any needed changes.

I believe in symmetry in art. As human beings we are drawn to symmetry; it should be a priority for any artist.

Demonstration

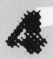

Rough In With Nonphoto Blue

Enlarge the sketch from step 3 on a photocopier from 8½" × 11" (22cm × 28cm) to 11" × 17" (28cm × 43cm), a 140 percent enlargement. Tape the photocopy face down on the back of a sheet of 11" × 17" (28cm × 43cm) blueline board or any two-ply bristol board. Turn the board face up, lay it on a light table, and transfer the sketch onto the board with a nonphoto blue pencil. This kind of pencil won't reproduce when scanned or photocopied, so it is an ideal base for your final drawing. You can make minor tweaks to the drawing as you go.

When you're done transferring your sketch, use a gum eraser to remove all nonessential lines. Nonphoto blue pencils, being wax-based, don't take graphite pencil very well, so you want the finished blueline drawing to be very light and unobtrusive.

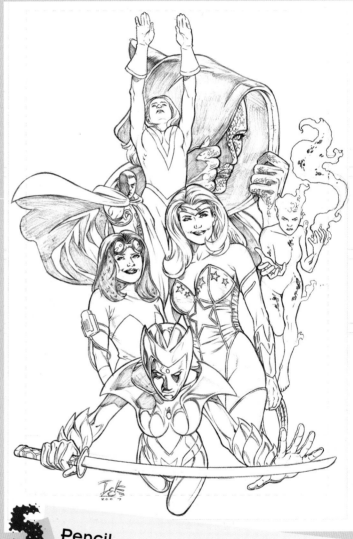

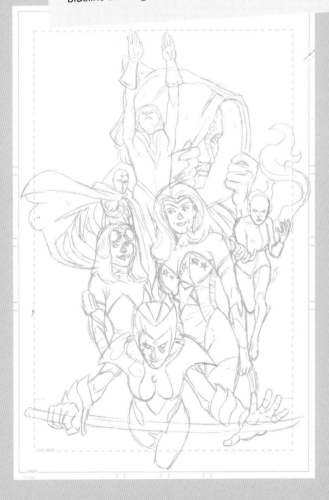

Pencil

Draw on top of the blueline drawing with an HB pencil. As you're pencilling, you may find yourself redrawing a bit. This stage can be a long process because as you're penciling, you're sometimes redrawing, making the final determination about how the art will look.

Tighten the pencil drawing until it contains all the information you'll need for inking.

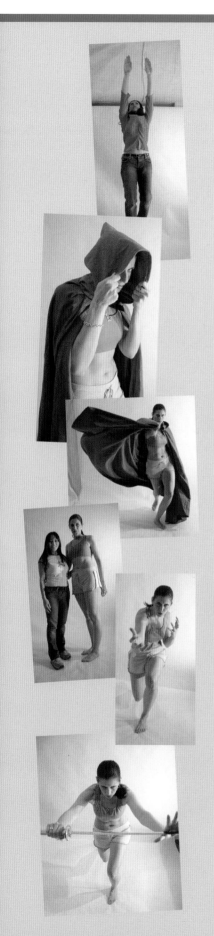

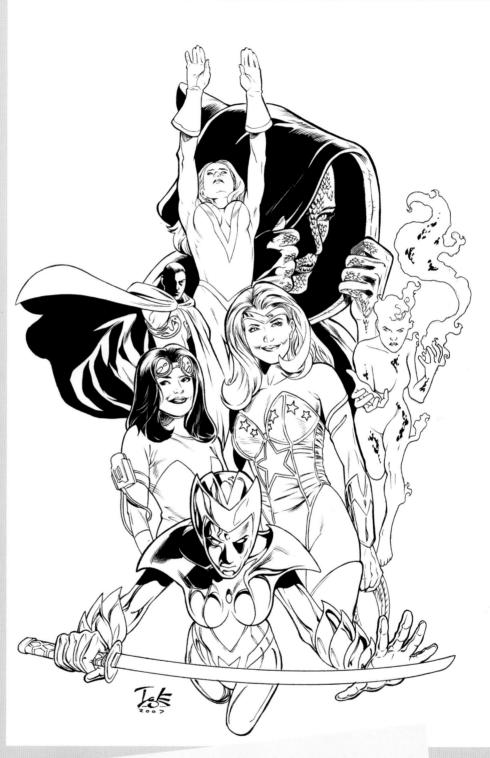

 Ink

Ink the drawing. For brush inking, I like a no. 3 Scharff Kolinsky Red Sable brush with Japanese Sumi ink (which I find to be the best ink for a matte black finish). For corrections, I use Faber-Castell PITT pens and Daler-Rowney Pro White ink.

Women
Haydee Urena

Age: 22

Height: 5' 7" (1.7m),

Weight: 130 lbs. (59kg)

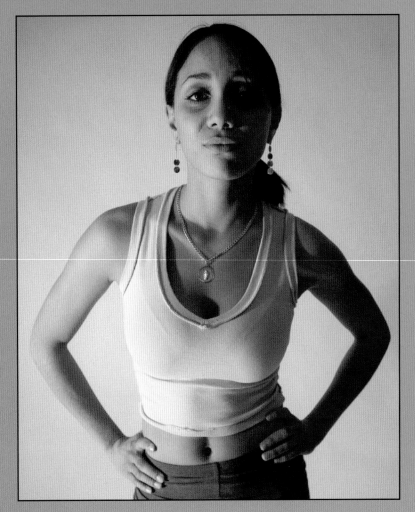

art demo BY GREG LAND

Vanessa Carroll

Age: 34

Height: 5' 10" (1.8m)

Weight: 146 lbs. (66kg)

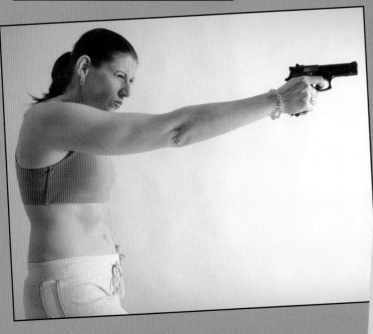

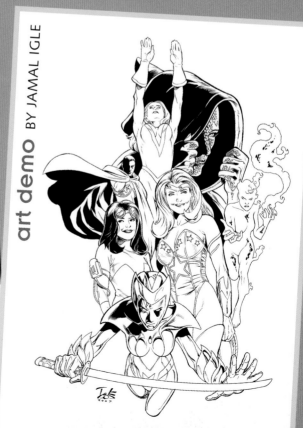

art demo BY JAMAL IGLE

Chanel Wiggins

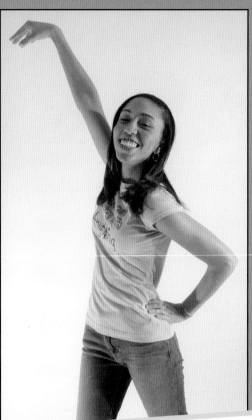

Age: 16

Height: 5' 3" (1.6m)

Weight: 103 lbs. (47kg)

art demo BY JOSH HOWARD

Pamela Paige

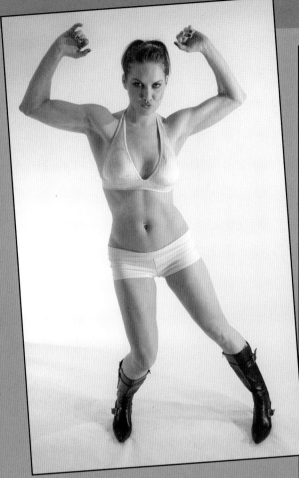

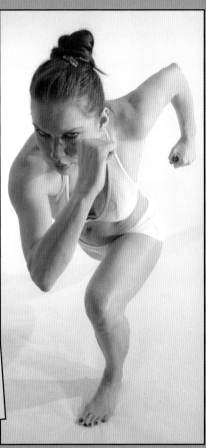

Age: 26

Height: 5' 10" (1.8m)

Weight: 145 lbs. (66kg)

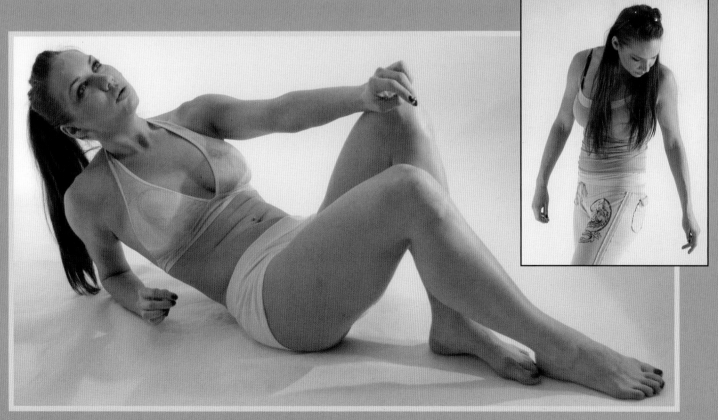

Zoe Labella

Age: 22 & 26

Height: 5' 9" (1.8m)

Weight: 125 lbs. (57kg)

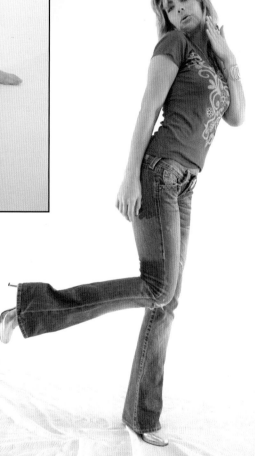

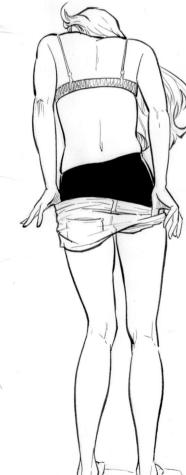

art demo BY TERRY MOORE

Ridada Elias

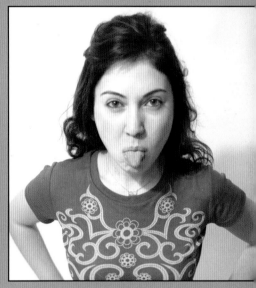

Age: 34

Height: 5'2" (1.6m)

Weight: 120 lbs (54kg)

art demo BY THOM ZAHLER

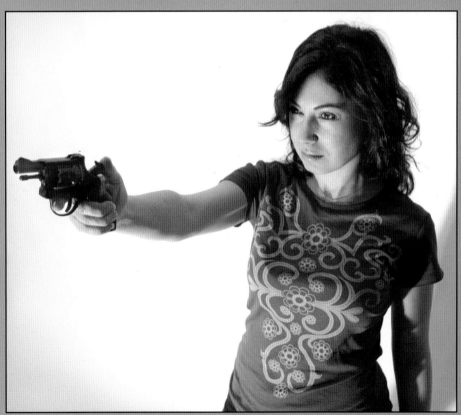

151

Veronica Bond

Age: 34

Height: 4' 10" (1.5m),

Weight: 100 lbs. (45kg)

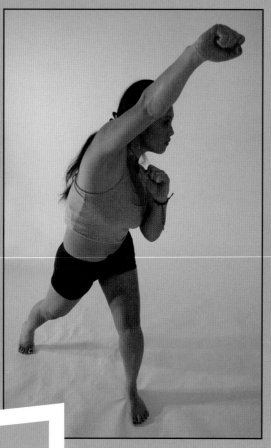

Clothes

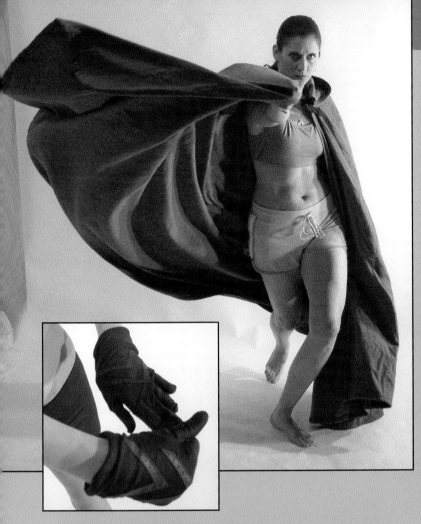

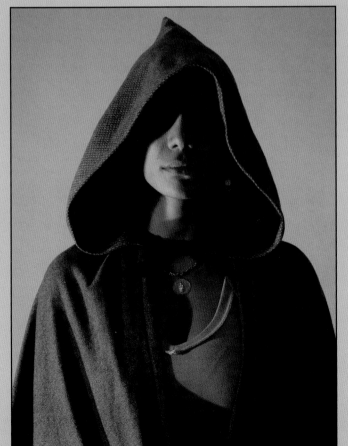

boots

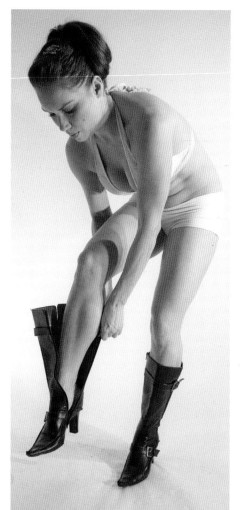

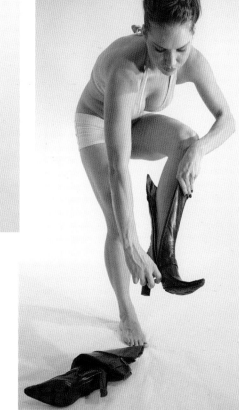

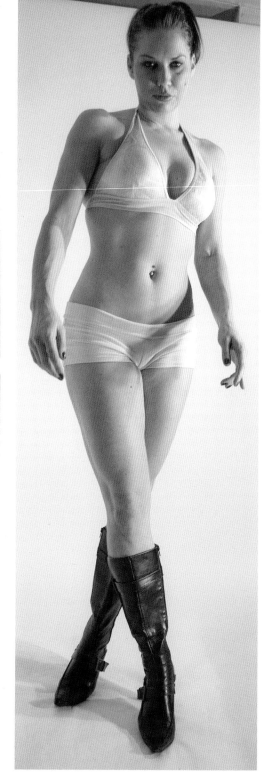

For more action poses, visit
impact-books.com/
colossal-collection

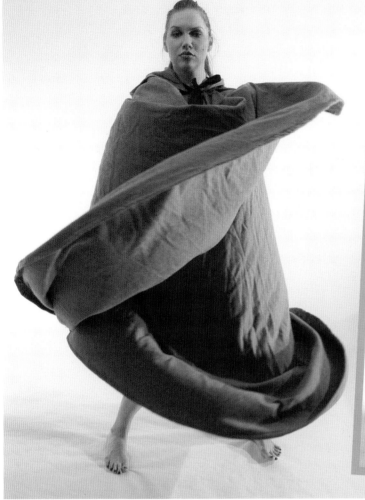

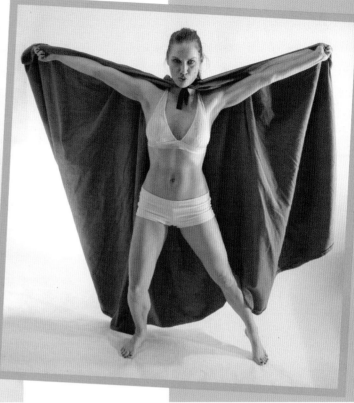

cape

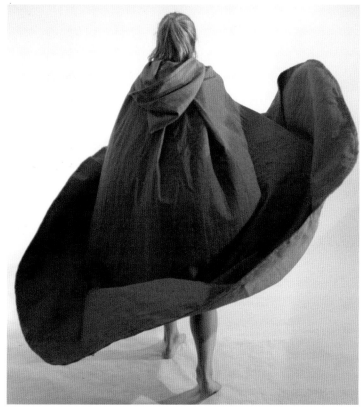

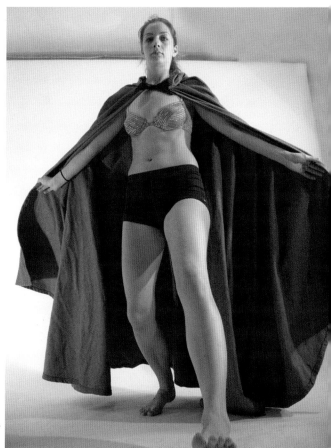

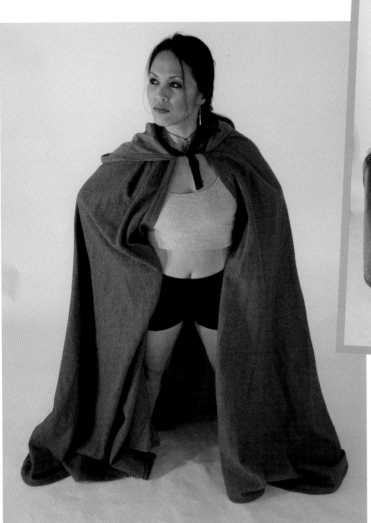

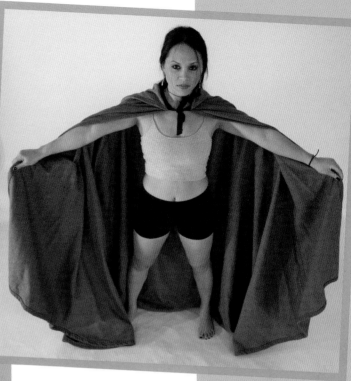

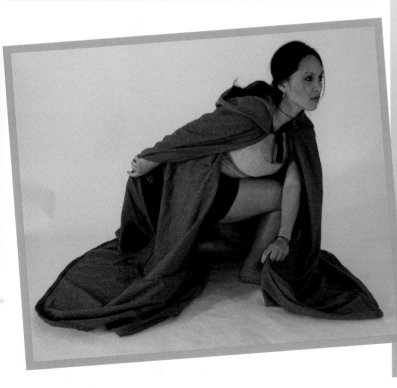

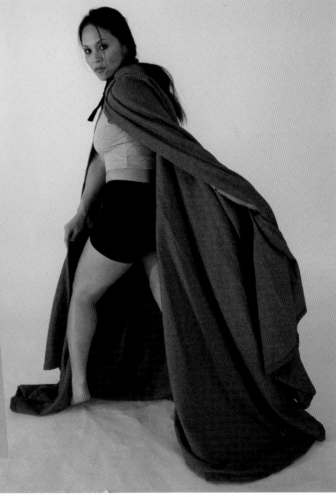

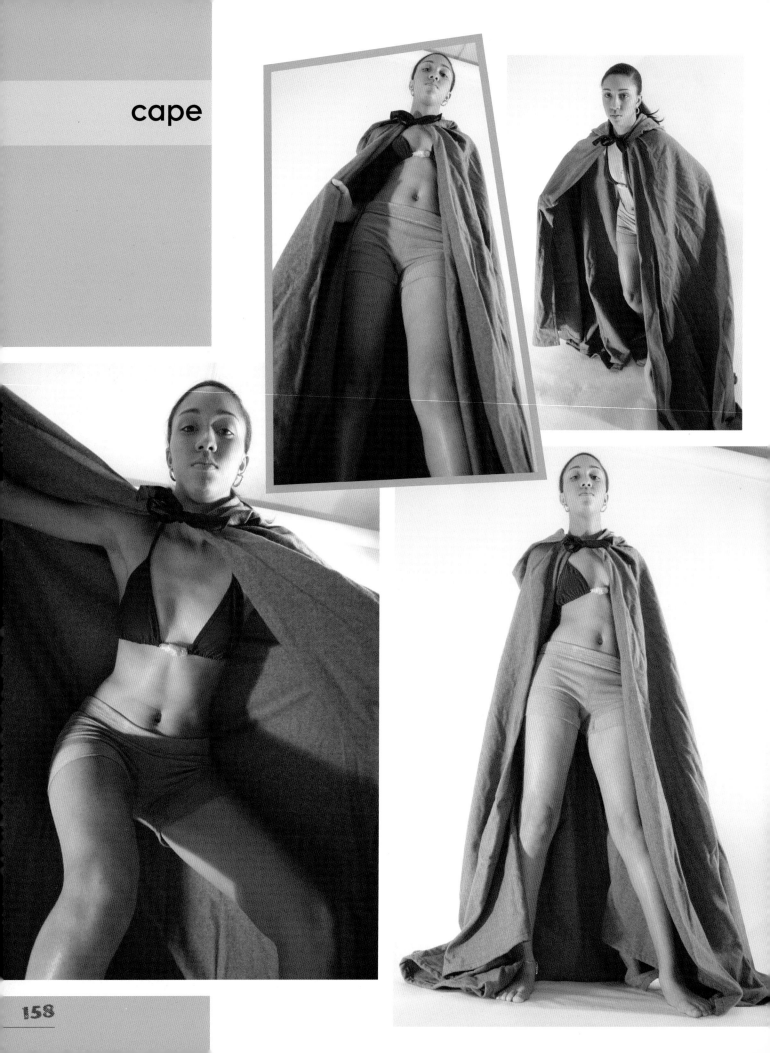

cape

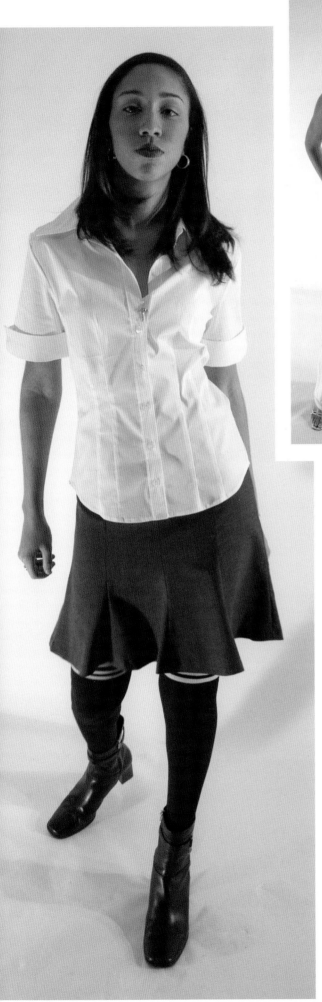
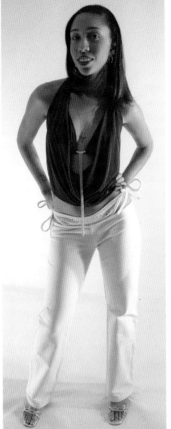

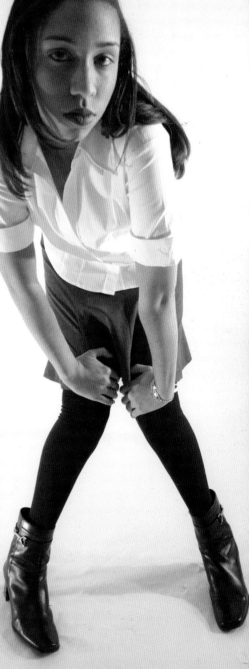

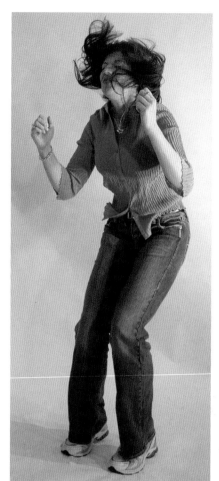

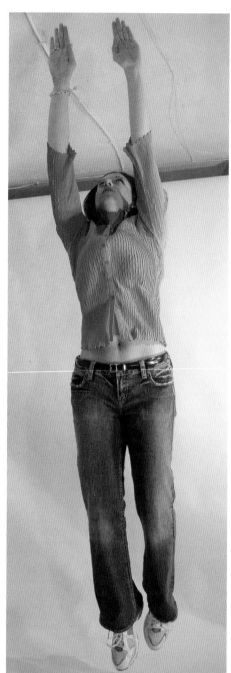

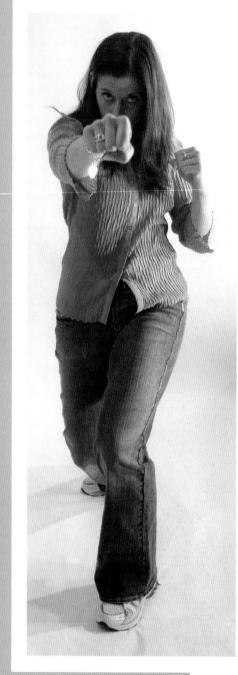

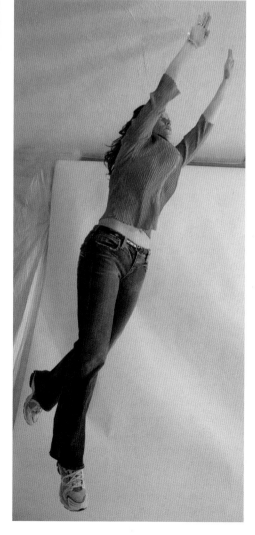

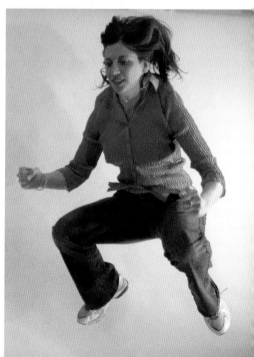

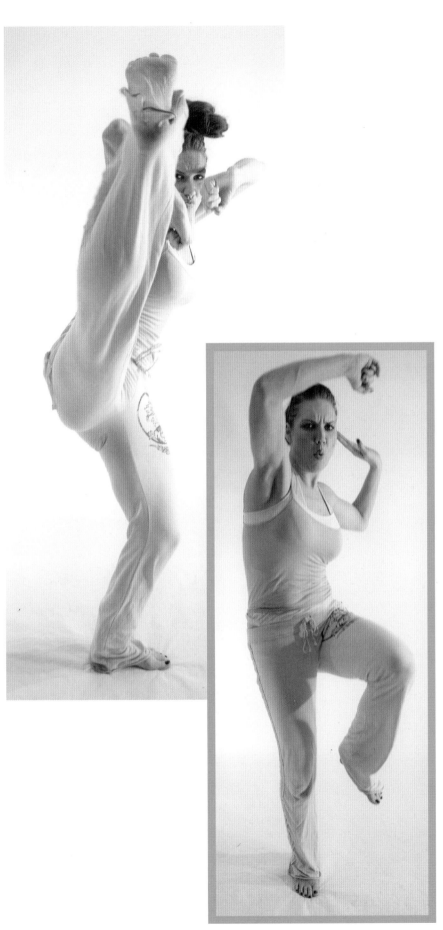

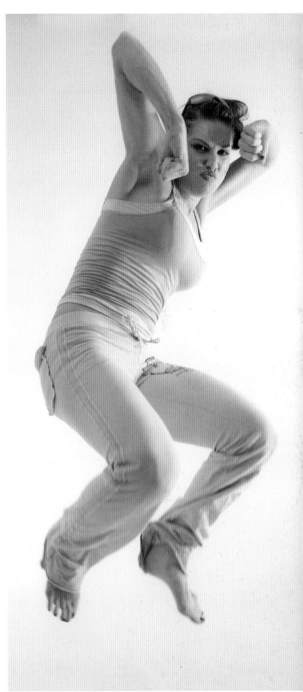

For more action poses, visit
impact-books.com/
colossal-collection

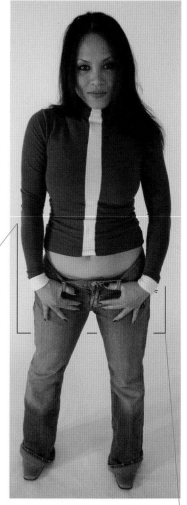

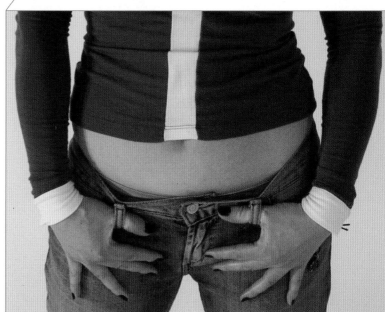

For more action poses, visit
impact-books.com/
colossal-collection

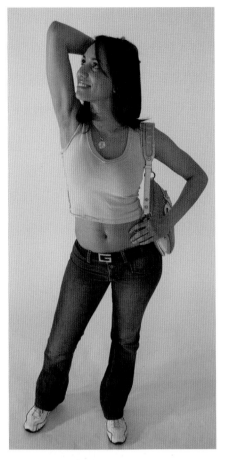
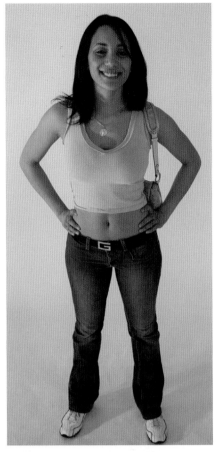

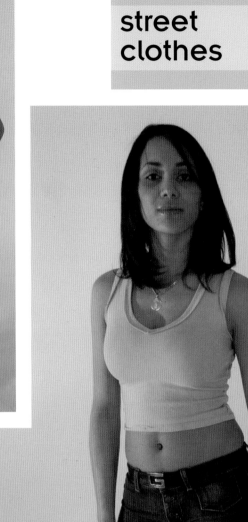

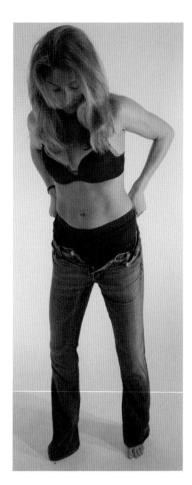

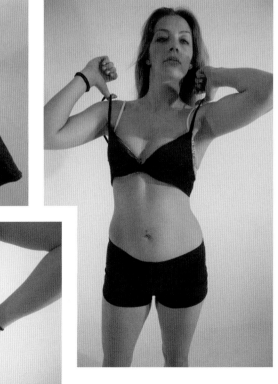

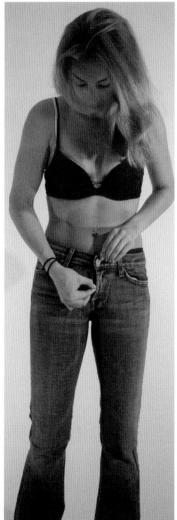

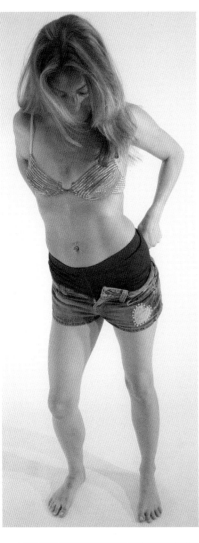
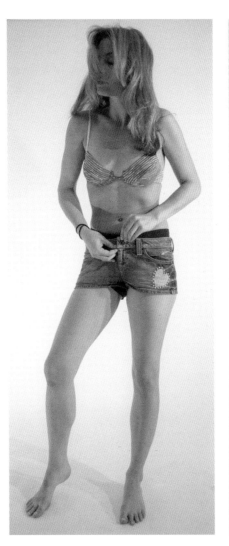
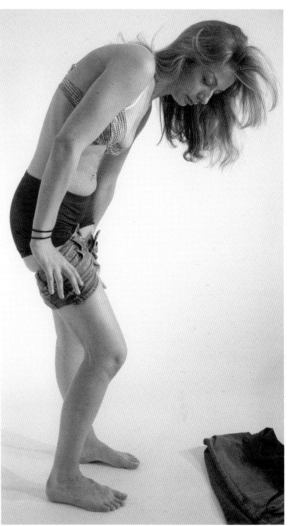
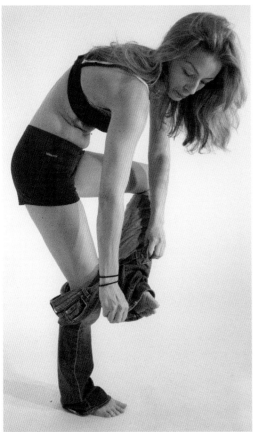
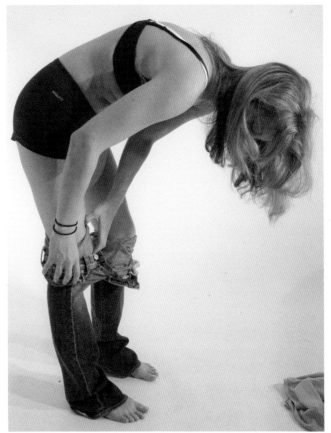

Think 3-D

BY TERRY MOORE

I like the flowing, uninterrupted body lines in this photo of Zoe (below). But when I draw, I like to remind myself that the body isn't just a collection of lines: it's three-dimensional; it's dynamic. If you draw only what the eye sees, your pictures will always look mechanical.

For example, always remember that when you're drawing a person, you're basically drawing muscles and bones with skin stretched over them. Skin and muscles bend and flex; they respond to gravity differently in people of different ages, weights and sizes. These are the things I'm thinking about when I study the body.

Another suggestion: Imagine (and sketch) what the subject would look like from many different angles, not just the angle shown in the photo. It's important to remember that the muscles and bones you can see are connected to ones you can't see.

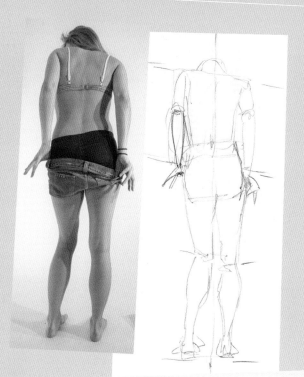

2 Find the Contours

Start darkening the major lines to capture the large shapes of the torso and limbs with more precision. Keep paying attention to balance, but add gravity and mass to your considerations. Where can you see the effects of gravity? You can tell her right leg is bearing more weight than the left because it's straight and the tendons above the knee joint are visible. Go ahead and create those tendons with two lines.

You can do this step quickly. Even though you're working from the model, what you've drawn is almost generic: This could be almost any woman of similar height and size.

1 Capture Body Mechanics and Proportions

Lightly sketch the pose with a few crude lines. Early in the process, mark a center line and use it to keep the body's weight balanced. For example, since Zoe's shoulders go left of center, you know that something else has to go right (in this case, the hips); otherwise she'd fall over.

To help yourself judge the body's proportions, make roughly horizontal marks at the heels, knees, wrists and shoulders.

3 Get Specific

Now, check your drawing against the photo on a more detailed level. Study every viewable inch of the model. Does she have long, slender fingers, or are they short and stubby? Sturdy ankles, or skinny ones? Finish her hands and feet. See how the outside ankle bones are lower than the inside ones? And how the Achilles tendon goes all the way down to the heel? Add detail to the hair (and make it longer, if you want to). Now you're taking the drawing beyond a generic representation and making it about this specific woman.

There is so much information about this woman in the photo, I could write an entire chapter on her body type, age and lifestyle. We know that she is not large-breasted, because her bra straps are skinny and the skin on her back and around the band of her bra is taut and unstressed. Her softly contoured waist tells us that she doesn't have pronounced "six-pack" abs, but the indentations at the waistband of her spandex shorts are shallow, so her stomach must be pretty flat. The prominent veins over the muscles of her lower arms indicate that she works out. Her rounded calves, though, are the result of genetics; nice calf muscles are something you have to be born with.

If this is all beginning to sound very personal, it is. To draw the model correctly, you have to know what you're looking at, what it looks like, and how it got that way—even if it's hidden.

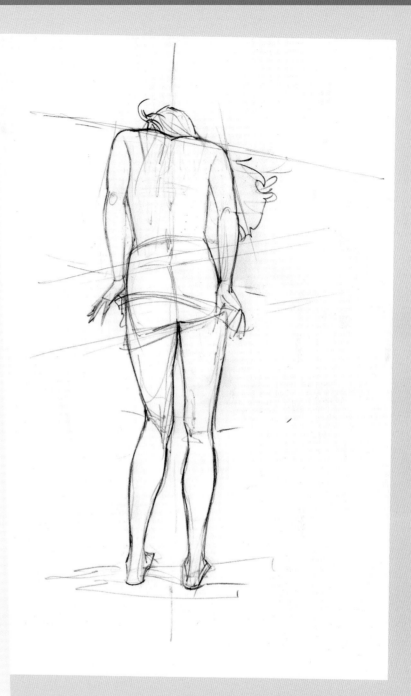

For more action poses, visit impact-books.com/ colossal-collection

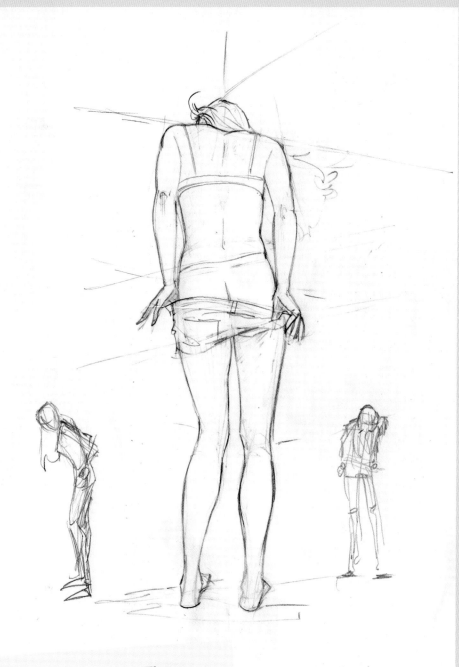

 ## Sketch a Few More Angles, Then Add Clothing and Anatomical Detail

Take a moment to scribble the pose from a couple of other angles, imagining what you'd see on other sides. Like I said at the beginning, being able to picture what's going on around the bends is crucial, because everything you see is connected to the parts you can't see.

Remove the generic lines with a kneaded eraser, and draw in more of the details that are specific to this model. I think about the transition points of the muscles on her shoulders, arms and

legs. My pencil runs over her back and tries a few lines to see if I want to go there with the art. Probably not. What are the denim shorts getting hung up on there—what's keeping them up on the left? Ask yourself questions like these; they remind you that these forms are round, they jut out, they bump into things and push and squeeze and deform and bounce back.

OK, in the next step you'll start inking. Whatever you haven't yet penciled, such as the details of the shorts and hair, you will draw as you ink.

Ink Like a Penciller

Using a brush or pen, ink the main lines of the body, leaving the details for your second pass. Start inking at the head, then work your way down: left arm, right arm, torso, legs, feet. As your brush moves around the body, think about the muscles and bones, making bumps and mounds for muscles stretched and contracted. You need both the skill of an inker and the mind of a penciller to make the lines smooth with varying weights that imply mass and light.

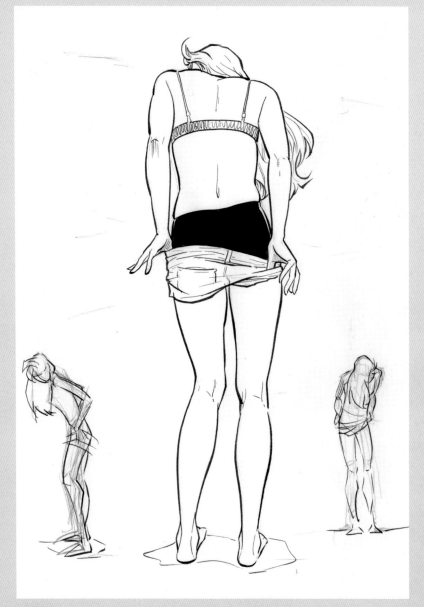

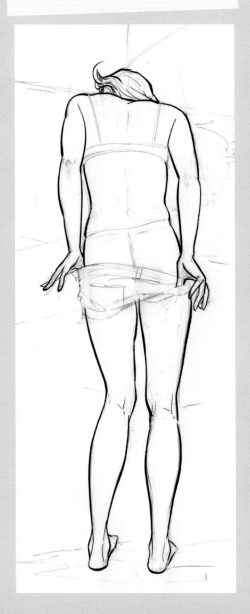

Add Final Details

Ink the details on the elbows, hands, back, knees and clothing. Fill in the solid black area. If the drawing is going to be computer colored, say for a comic book, these lines will be enough for the colorist to play off of. The colorist can create nice, subtle toning that harsh inking cannot achieve.

Erase the remaining pencil lines with the kneaded eraser, and your art is ready to scan. The few stray ink lines (like around the shorts) can be touched up digitally after scanning.

On the smaller, sketched figures, I tried to illustrate the body language with a few brush strokes. I think this pose would be interesting from any angle.

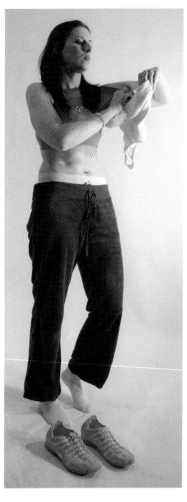
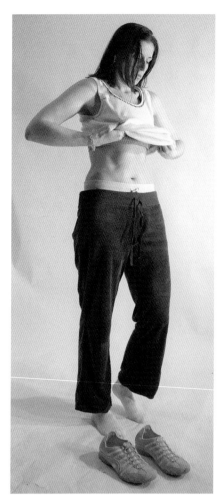
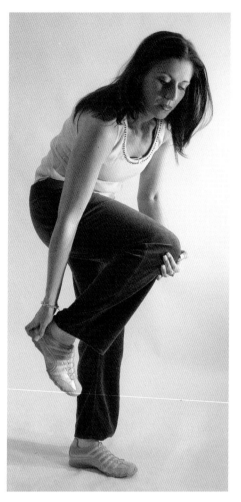
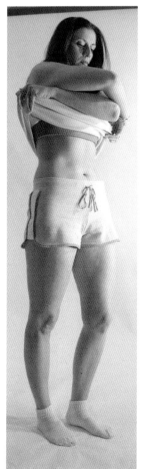
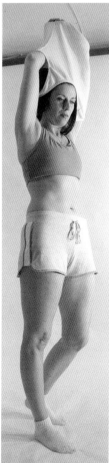
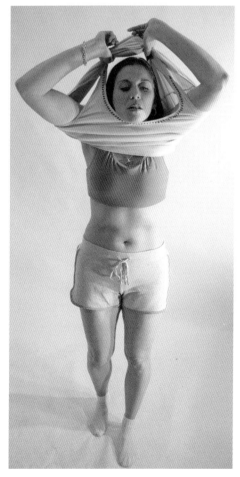
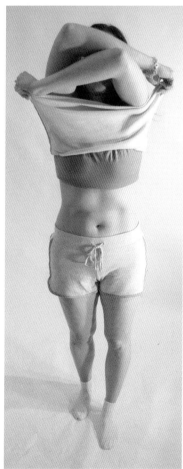

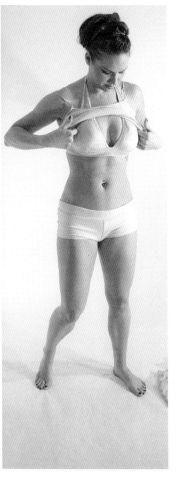

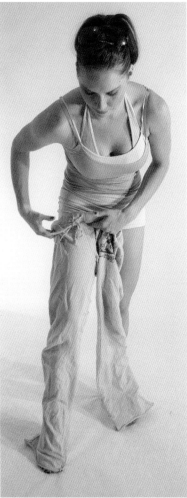
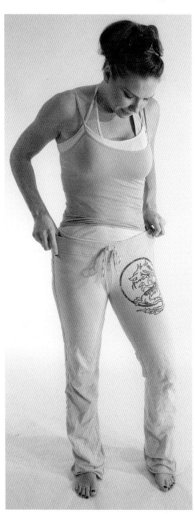

gloves

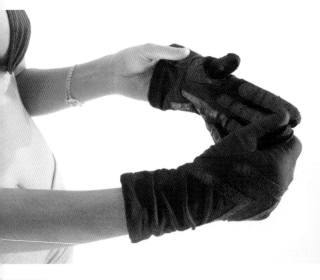
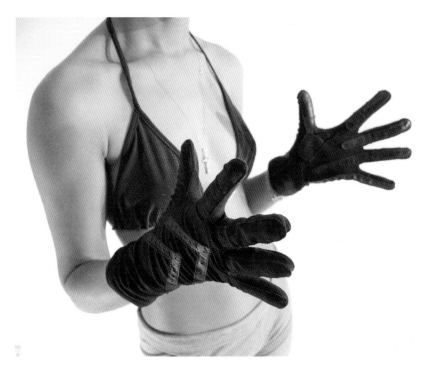
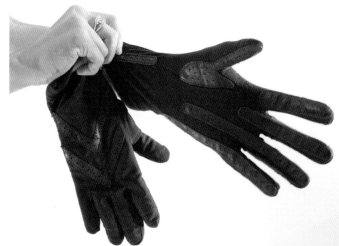
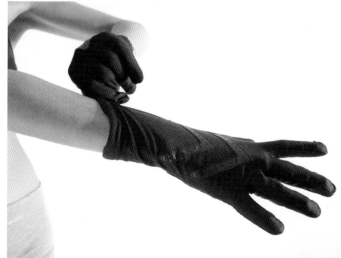

For more action poses, visit
impact-books.com/
colossal-collection

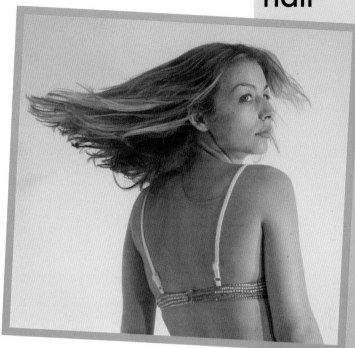

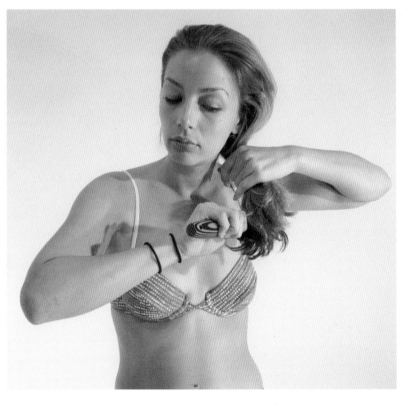

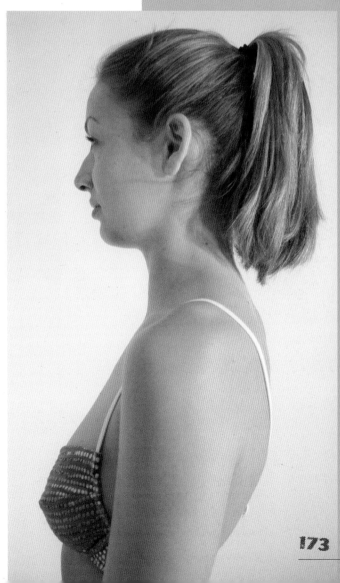

hair

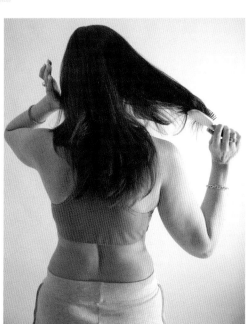

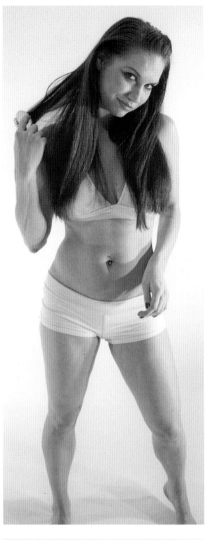
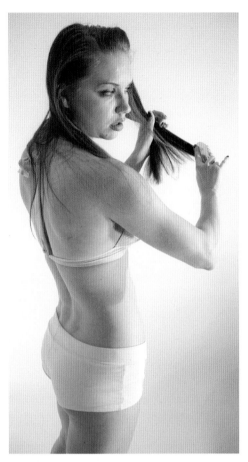
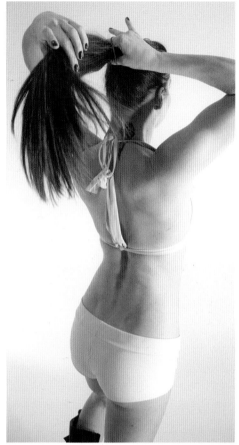
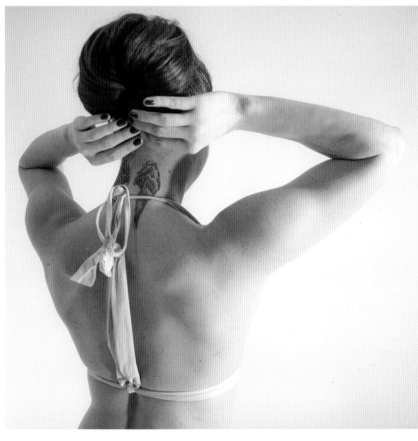
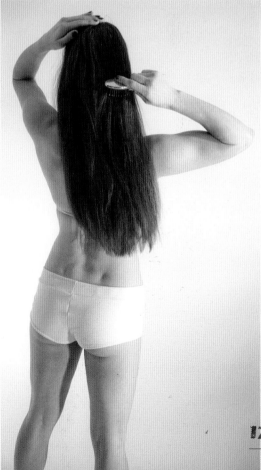

Expressions

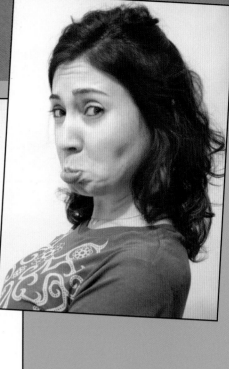

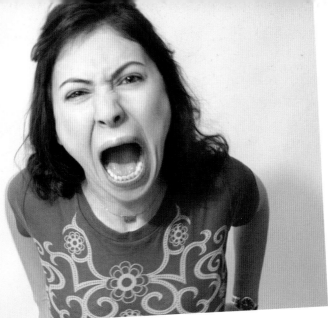

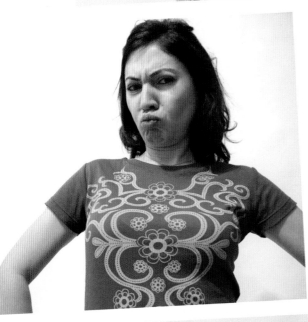

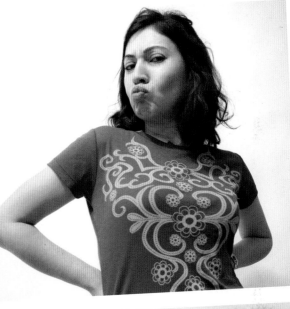

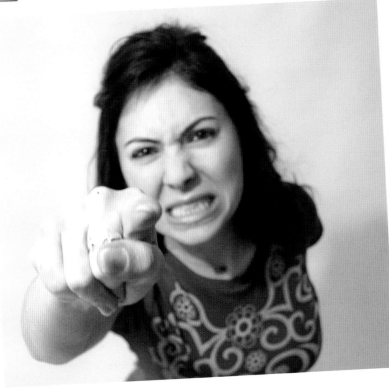

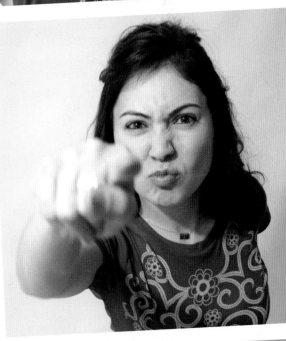

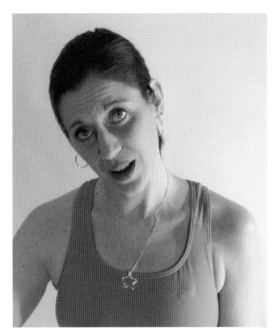

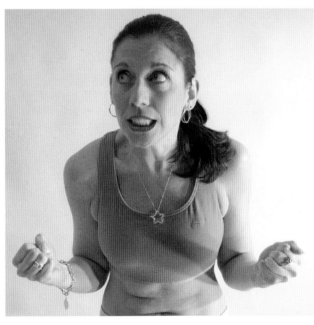

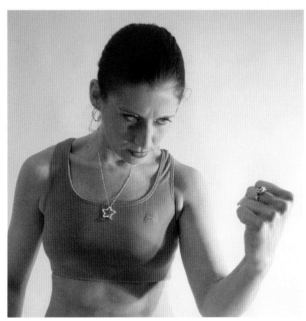

For more action poses, visit
impact-books.com/
colossal-collection

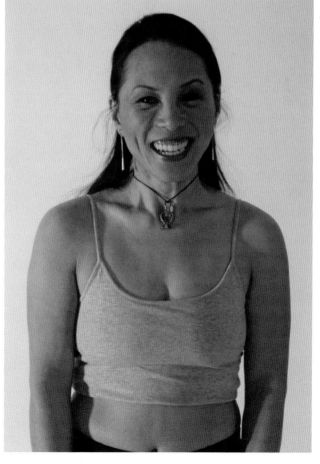

sad

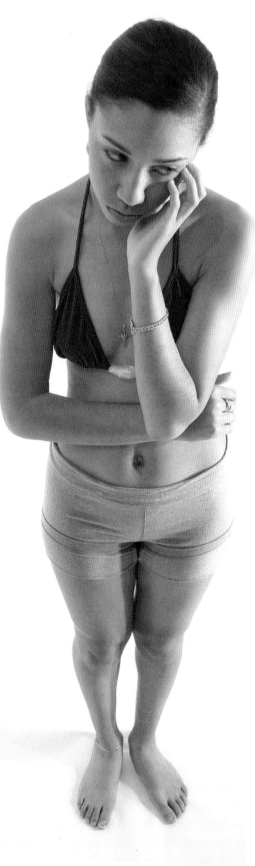

For more action poses, visit
impact-books.com/
colossal-collection

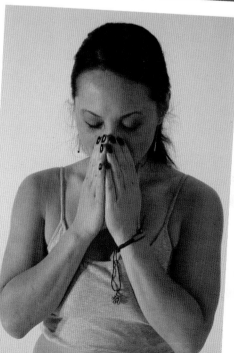

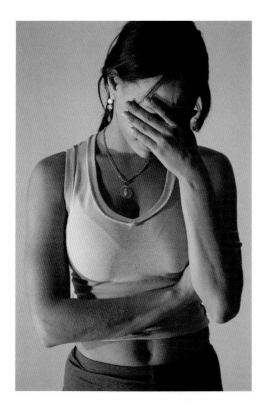
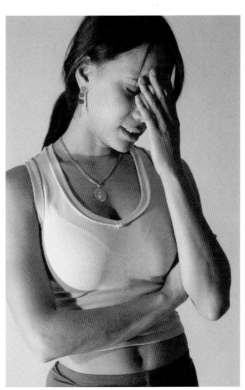

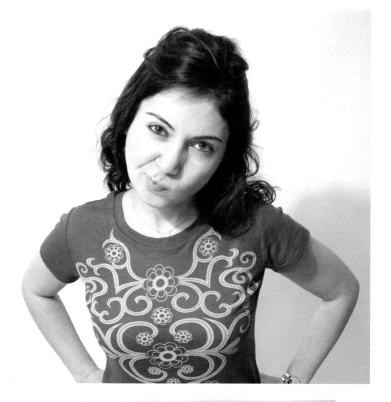

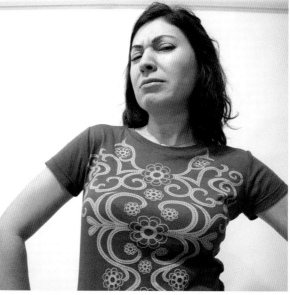

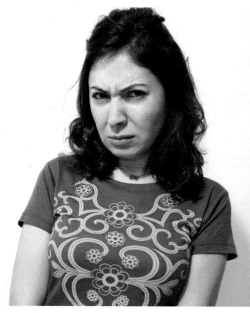

For more action poses, visit
impact-books.com/
colossal-collection

Draw a Beautiful Woman

BY GREG LAND

Comic book artists are often asked to draw beautiful women. Yet capturing the subtleties of the way women stand and move can be challenging. A good reference photo will help you to understand how to capture the nuances of the female form.

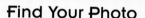 Find Your Photo

Every photograph captures a little piece of the model's personality. In this case, the photo reveals a playful yet sultry woman. Don't just look at the surface of the photograph; look beyond by imagining what your model is thinking. Read this woman's facial expression and her body language, and you will see someone who is relaxed and confident. Her slight smile and faraway gaze reveal a peaceful, private moment. Explore this book to find the photos that either capture a mood and expression that match your vision or simply inspire you to draw.

Photocopy and Find the Outline

Make a quick photocopy, enlarging the image to the size you want for your final art. Using a marker, "find" your character's outline. Remember, you do not have to follow every detail of the photograph. Your job is to interpret the photograph and make it into art. In this case, the final image will be a beautiful jungle girl, so you should find lines that make the model look as slender and athletic as possible. Sketch a few lines to indicate how you think jungle clothing will drape on this figure.

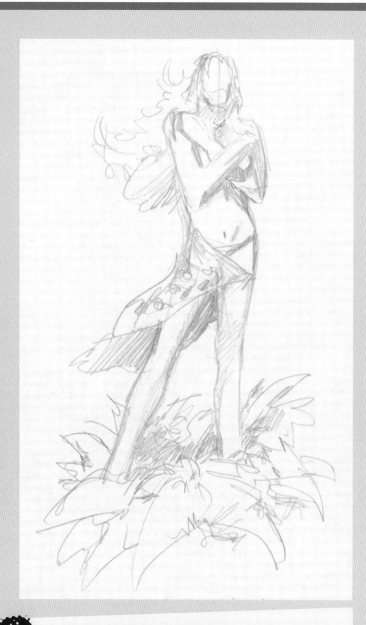

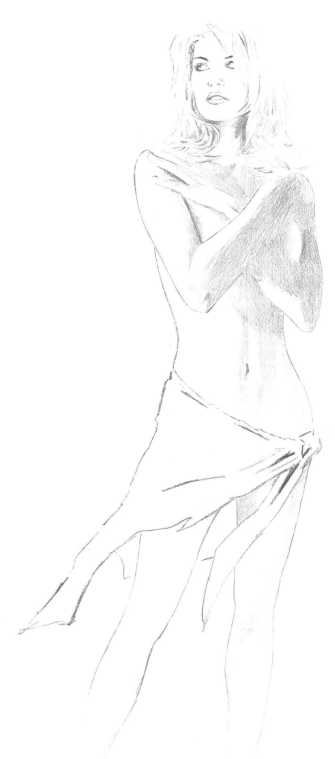

Rough a Thumbnail

Start with loose pencil lines that capture the gesture of the pose, using a soft lead pencil. Later, you can go back with a variety of harder lead pencils to tighten and finish the piece. If necessary, trace over the gesture lines that you created in step 2. This will help you maintain the proper scale and proportions. Erase lines that do not create the right form. Since this is a glamour sketch, go for the aesthetic of the "ideal" female form. Draw longer, thinner limbs. Rough out the hair, clothes and background just enough so that you know where your illustration is going.

Begin the Drawing With a Loose Sketch

Find the right lines by referring to the reference photo, which will show you the direction of the light, the placement of the hands, the angle of the face and other key details. Draw the kinds of features readers expect to see on this sort of character, including full lips, a petite nose, and eyes that have a nice darkness around them to draw the reader's gaze to the pupils.

S Tighten and Finalize Your Sketch

Add shading on the arms and loincloth based on the shading you see in the photo reference. Insert visual imagery in the background to convey that this woman is in the jungle. When you add the background art, keep things flowing in a standard Z pattern (see **TECHNIQUE** below) so you can control the way the reader absorbs your art. Keep the background simple so that the reader's focus is on the figure.

the Z pattern

Even on pinup art like this, you want to control the reader's eye, just as you would on a sequential page. Design the page so the images guide the reader's eye in a Z from top left to top right, then diagonally down to bottom left, then across to bottom right. The Z pattern is ingrained into us because of the way we read. If you did something that went against that, it would be like missing a gear when you drive a car: You can keep going, but you have to retrace yourself to get into the correct gear again.

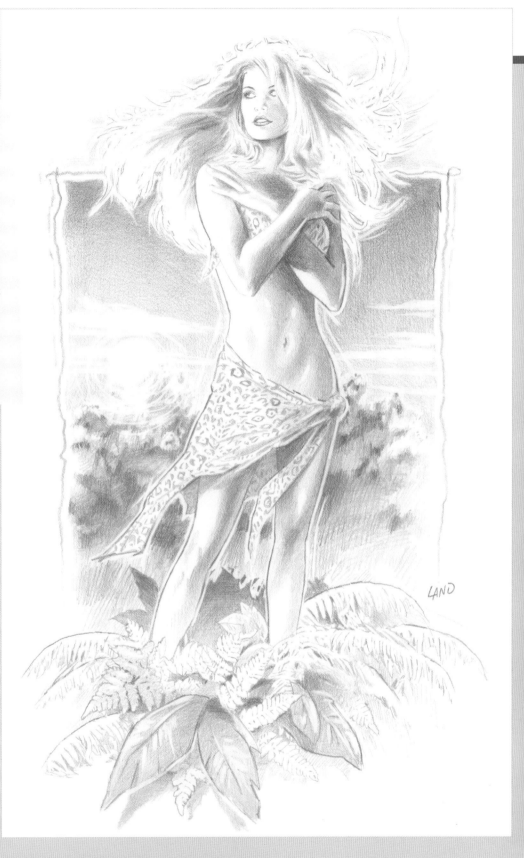

I know what a tree looks like, but when I draw one, I want there to be a realistic feel to it. I could wait for the right time to sit in the yard and draw that tree, but in reality, I have deadlines, so I use photo reference to get the realism I'm trying to achieve.

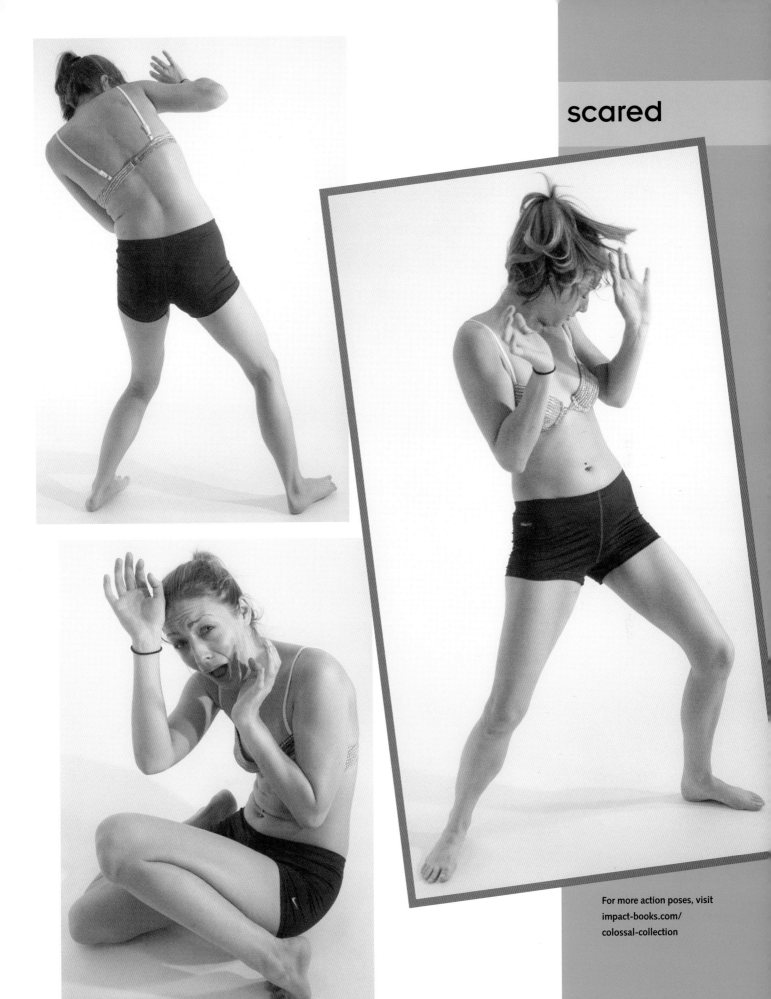

For more action poses, visit
impact-books.com/
colossal-collection

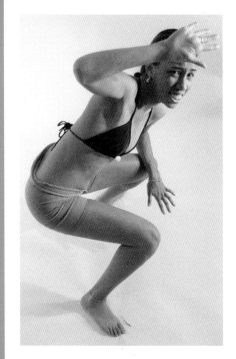

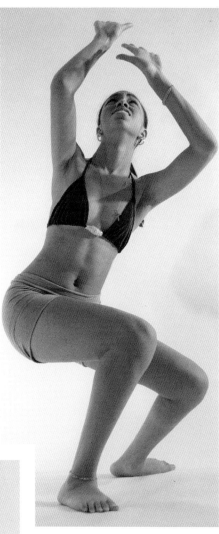

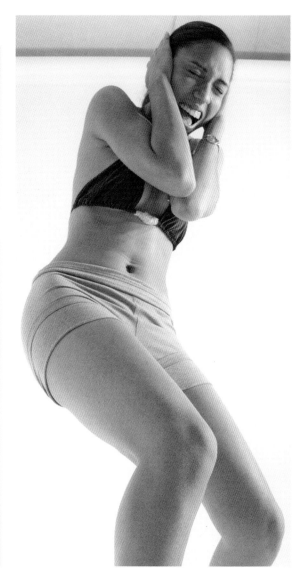

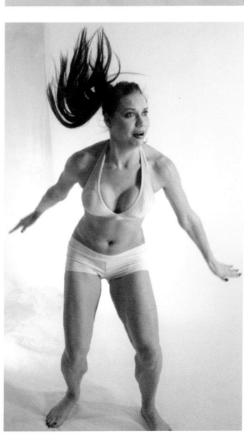
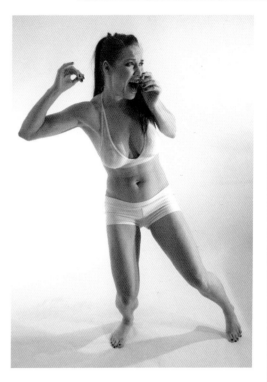

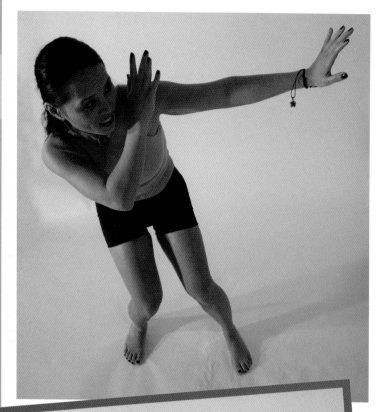
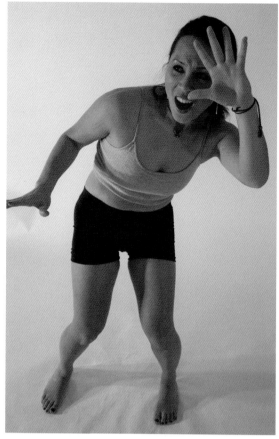
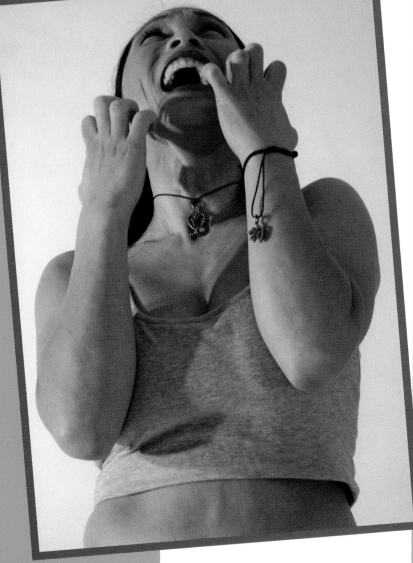
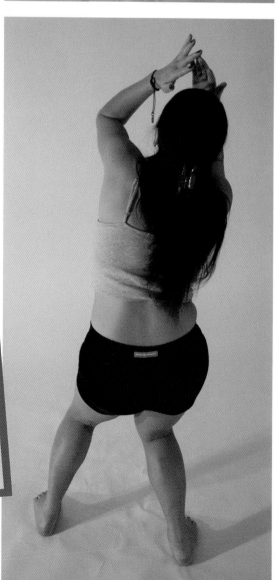

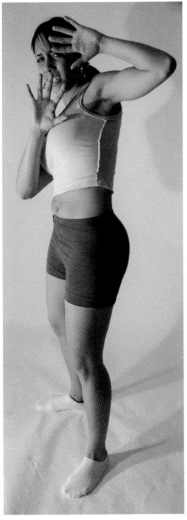

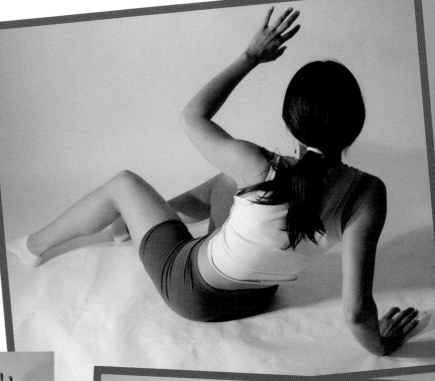

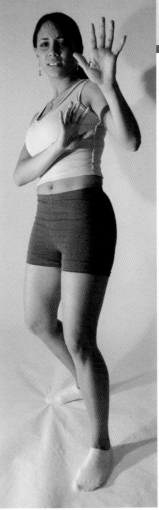

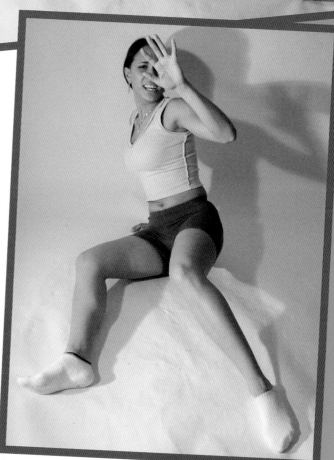

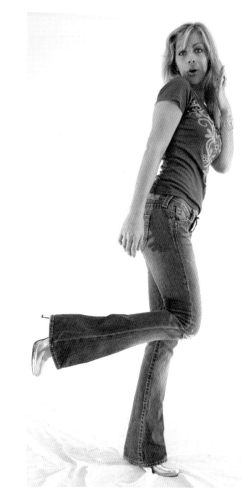
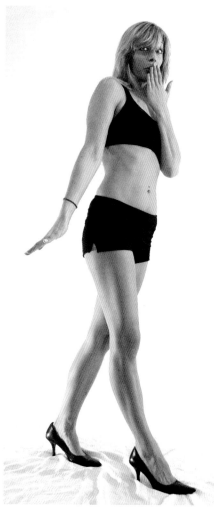
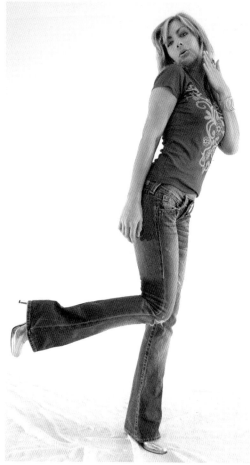
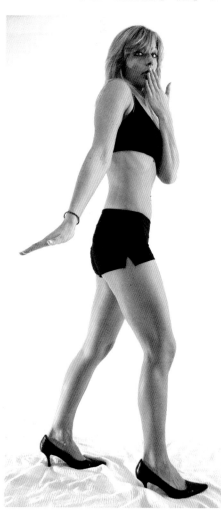

For more action poses, visit
impact-books.com/
colossal-collection

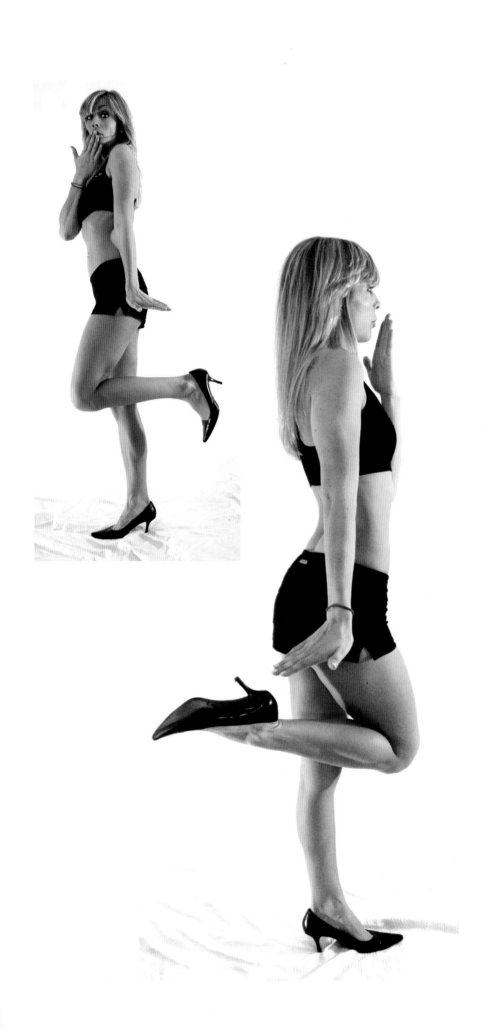
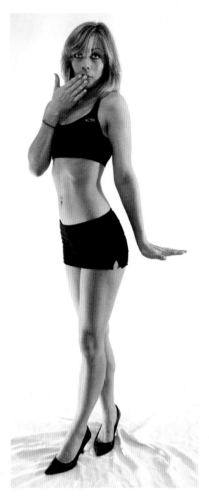
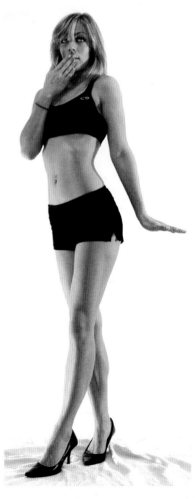

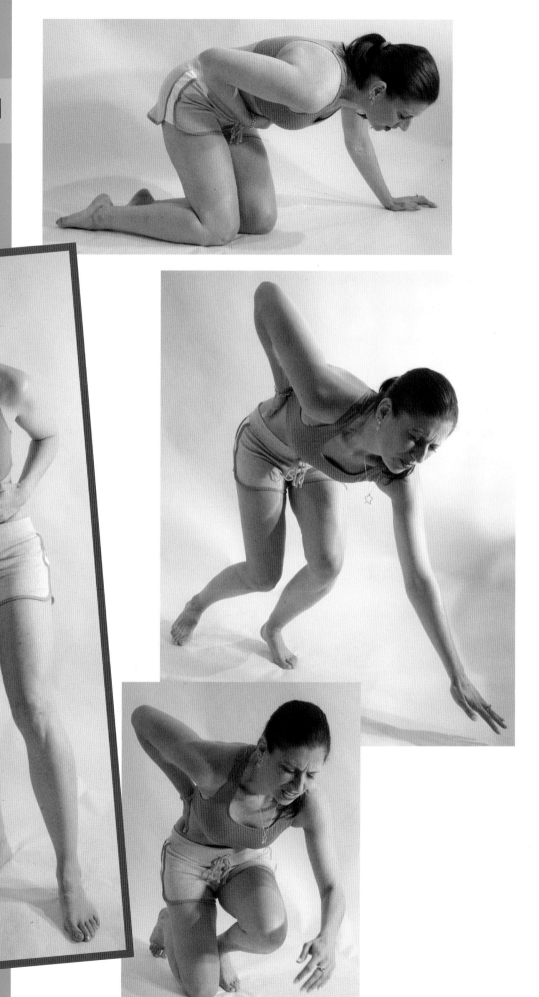

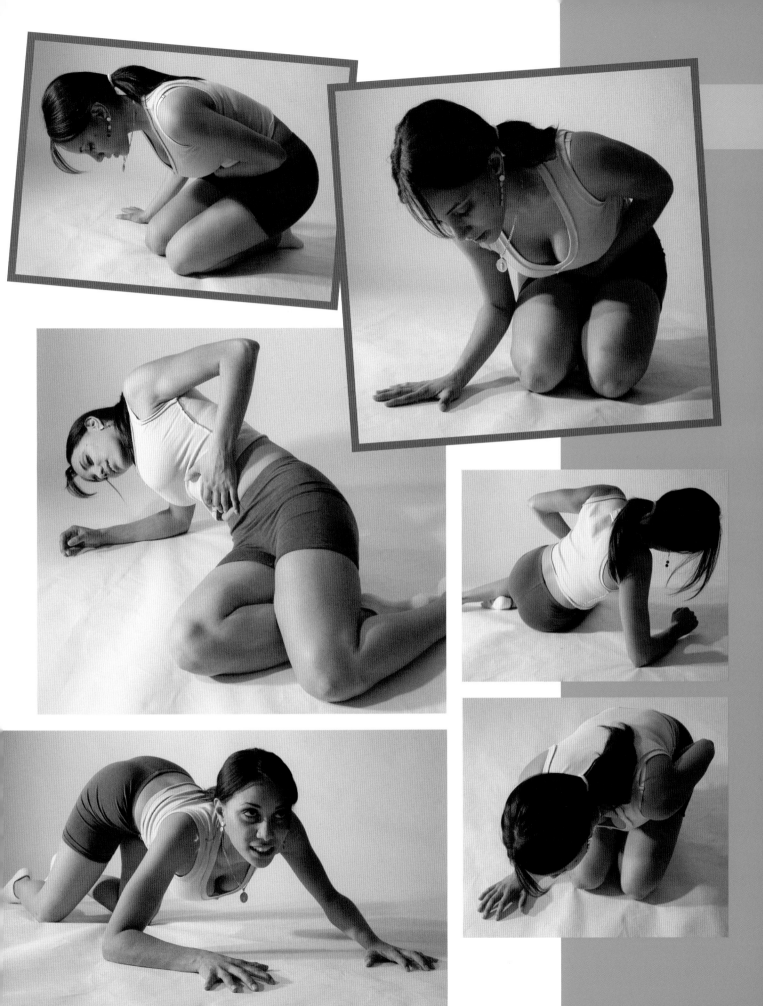

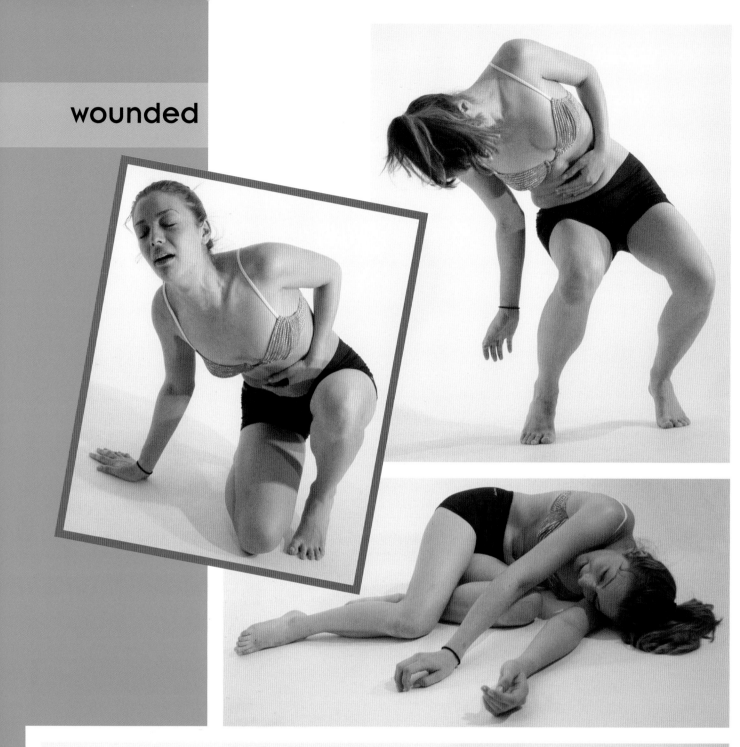

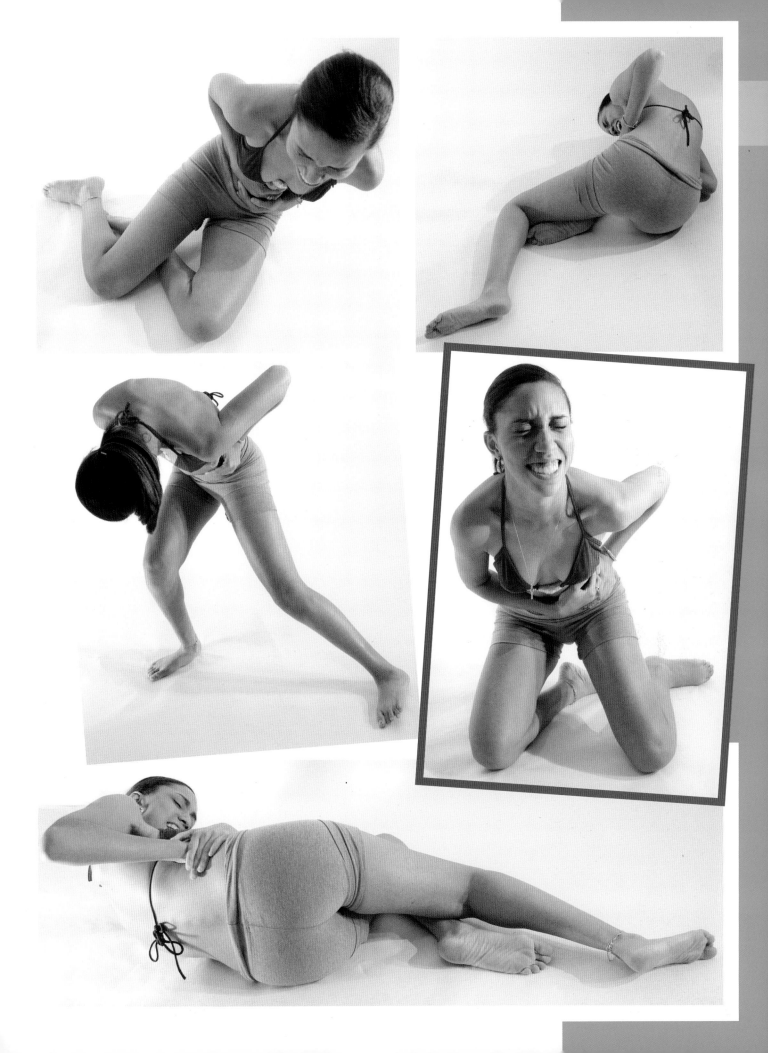

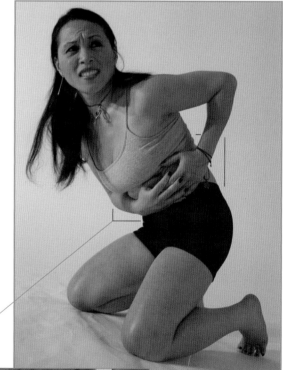

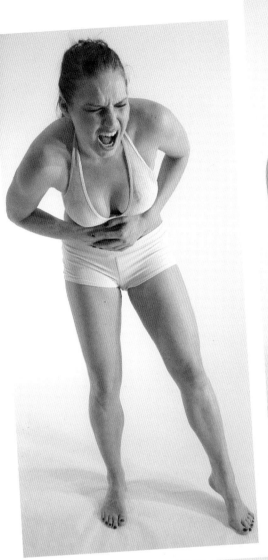

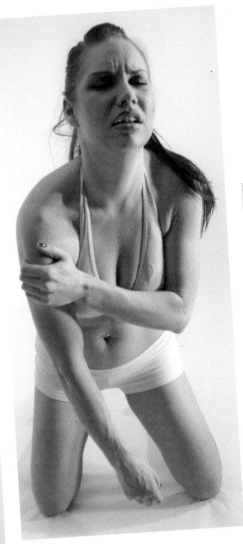

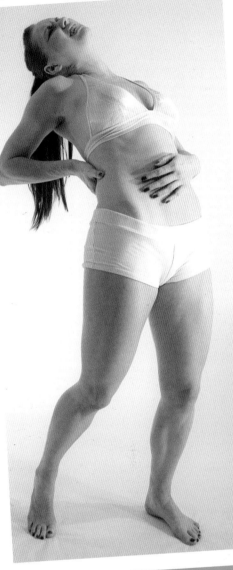

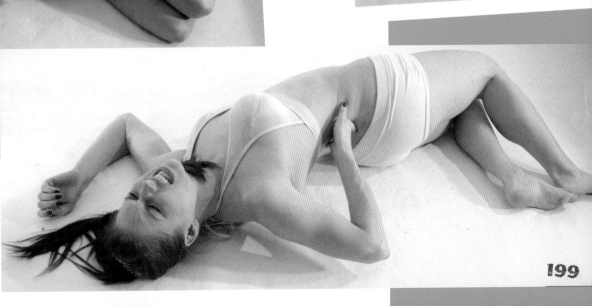

Work From Studies

BY WILLIAM TUCCI

I'm not the fastest artist; in fact, drawing is pretty laborious for me. So I like to do a few quick studies before I go to the finished art. You can work out mistakes and revisions in studies so that when it comes time to draw on the actual board, your artwork will be much cleaner.

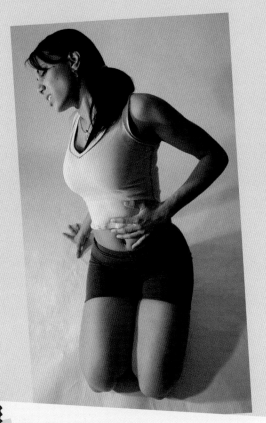

Do a Head Study

Hair is very important when you are drawing female characters. Shi, the subject of this demonstration, has beautiful, flowing hair. The model in the photo has her hair pulled back, so it will take some rough lines to get Shi's hair right.

Find the eyes, jaw and nose and indicate them with blue lines. Then, with graphite, work up a fairly detailed facial study, even though you may change some of the details later.

Find Your Photo

We're going to draw my character Ana Ishikawa (a.k.a. Shi) being shot with an arrow. (The title for this illustration could be: "Please, God, Don't Let It Be My Liver.") I like this photo because it could be from the point of view of the arrows, which will be raining death from above. This photo has the energy and drama I need.

Study the image to get a grasp of the body position before committing anything to paper. Notice the hand in the back; without it, it would be impossible to tell that this is a high-angle shot. That important detail will give the illustration depth.

Study, study, study. Draw, draw, draw. Study anatomy. Draw from life. Draw from photo reference. You'll draw many things better when you're referencing a photograph than when you try to do it from your head. Really know your stuff.

3 Do a Shoulder Study

In your shoulder study, figure out how the clothing material will fold given the figure's position. Fabric will pull against the contours of the body.

Because the arrow is in Shi's abdomen, the reader's eye will naturally travel to this focal point. It's critical to think about the costume details here, such as how the gauntlet and sleeve are being affected by the position of the arm.

4 Do a Skirt Study

Because of the way the model is leaning and the position of her legs, the natural flow of anatomy is distorted. Moreover, the photo is from a slight side angle, so the legs will not be perfectly symmetrical.

The model is wearing shorts rather than a skirt, so to dress her like Shi, try to imagine how the skirt would respond to this kneeling position. Notice that the skirt does not drape straight down, but rather responds to the curves of her legs.

Draw as realistically as possible without tracing the photo. Where's the excitement in tracing? I use photo reference to start off, but when I draw, I interpret and modify to give the final art more of a "living" look.

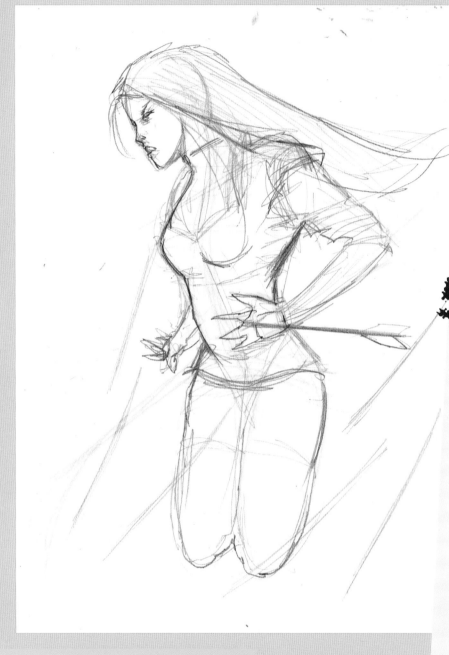

5 Do a Rough of the Entire Figure

Start the rough using a blue pencil on a fresh piece of regular copy paper. Draw some lines to indicate the direction of the eyes, jaw and nose, and a gesture line (see **TECHNIQUE** below left). This line follows from the base of the neck through the spine. In a standing figure, it's more evident because the gesture line travels down the spine, through the hip, down the legs, and to the feet where the weight is planted.

Here you can see how the neck and spine are positioned. The neck is turned a little, and you can see it in the line. This gesture line gives you a strong grasp of the image before you even commit graphite to paper.

Start sketching over the blueline with a soft graphite pencil. As you find the correct lines, tighten with a harder pencil.

Indicate the rain of arrows around Shi with rough lines. You can always decide to change their location later. Put in enough arrows to show that she's under attack from many enemies.

TECHNIQUE

gesture line

A gesture line is a guideline that shows the position and arc of the spine. This line allows you to push or pull the figure a little and still maintain the anatomy. The more you draw from reference photos and real life, the easier it becomes to find the gesture line.

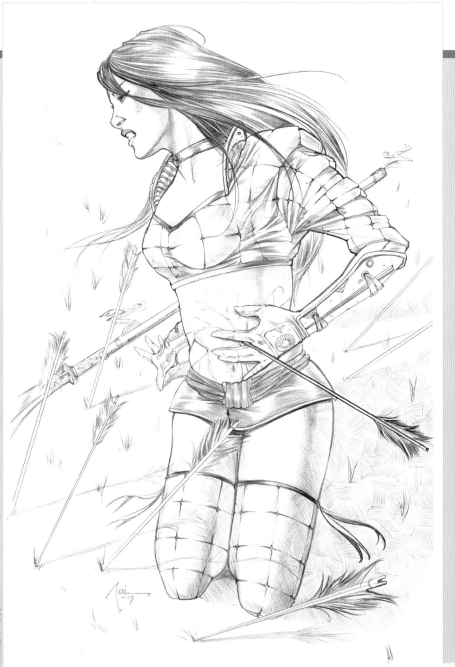

Shi © William Tucci

Since I don't use an inker,
I have to make sure that
my pencils are really tight.

make your art your own

Using photo reference will help you achieve proper anatomy and perspective, but if you are a slave to the photo, your art will come out stiff. So don't just copy; interpret and modify. Use photo reference as a tool, almost like the first link in a long chain that leads to the final art.

Compare our reference photo to the final art here, and notice how I've made modifications to suit my needs. Shi's back is arched a little more than the model's. I've added long, flowing hair. These small changes in the details give the final art energy and motion.

6 Draw the Finished Art

After you complete your studies, put them on a light box and transfer them to Bristol board. If you've been drawing in a notebook or on scraps of paper, you may need to modify the size of your sketches to fit the panel. If so, simply use a photocopier to scale your art up or down to fit your needs. Place the correctly sized art on a light table and transfer it to the 11" × 17" (28cm × 43cm) Bristol board.

Draw in the elements that are not part of the photograph. Shi's weapon is a Japanese nagi-nata. Putting it behind her hand shows that she's dropped it and that she's in real danger. It also creates depth and perspective by showing the viewer exactly where the ground is.

Next, draw the arrows. This is the fun part. The arrows on the ground cast shadows, giving the drawing extra depth and dimension. The light source for the photo is to the left, so to be consistent, make sure all your cast shadows fall to the right.

Finish the drawing by refining the details, such as the blood streaming out of Shi's wound.

Action

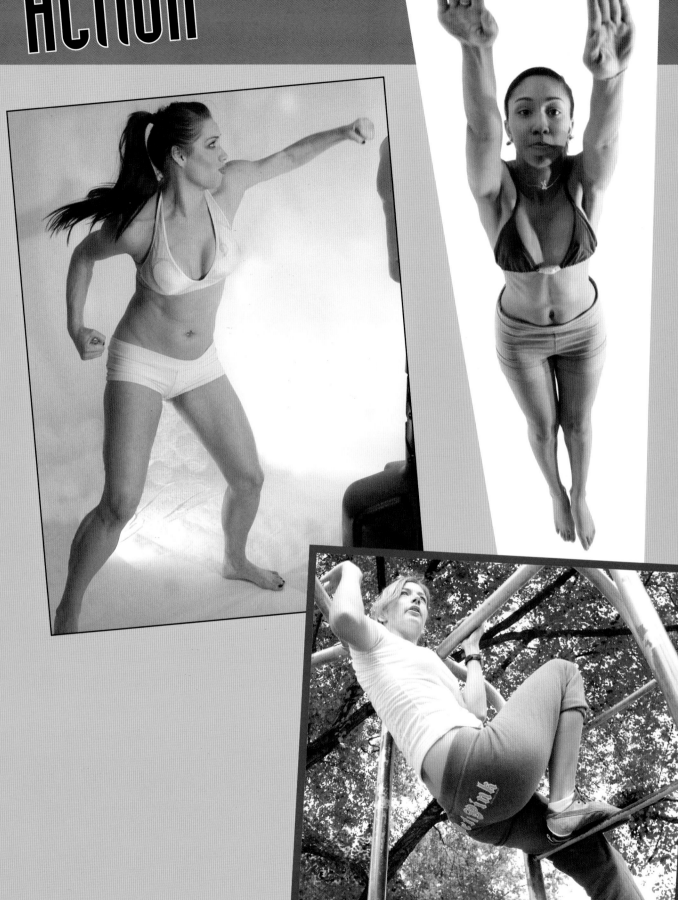

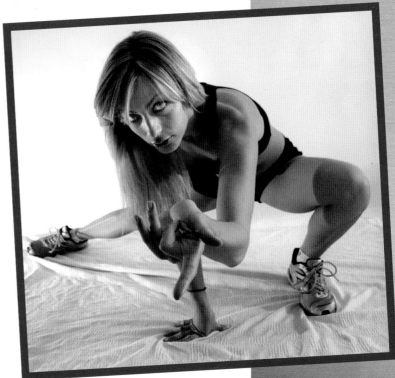

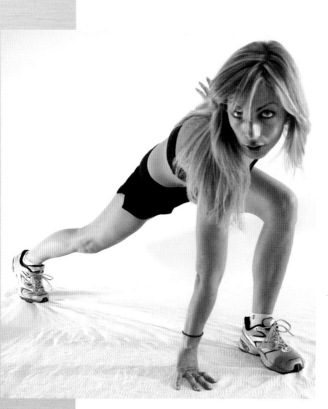

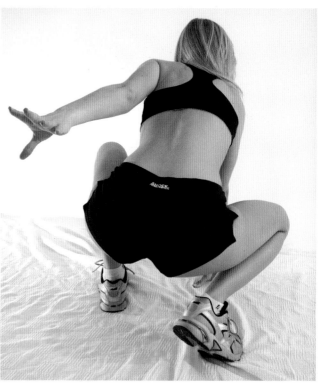

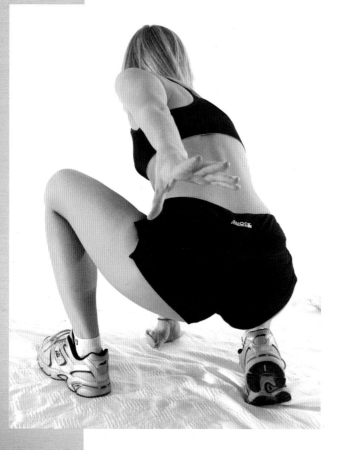

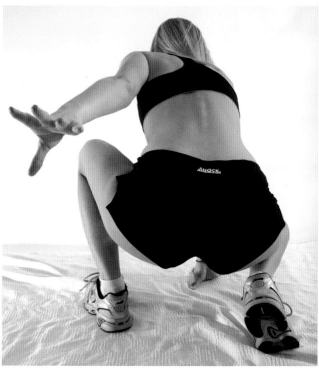

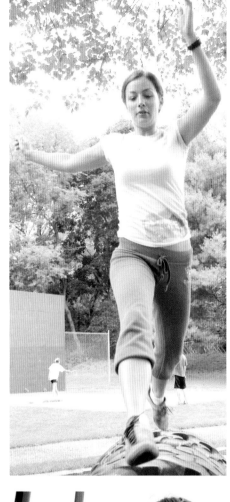

Climbing

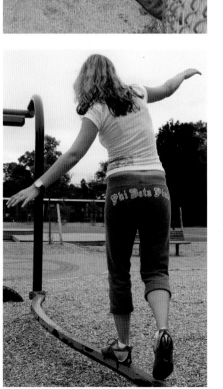

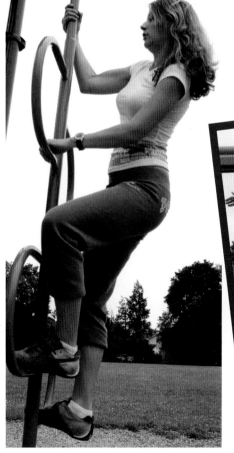

Flying

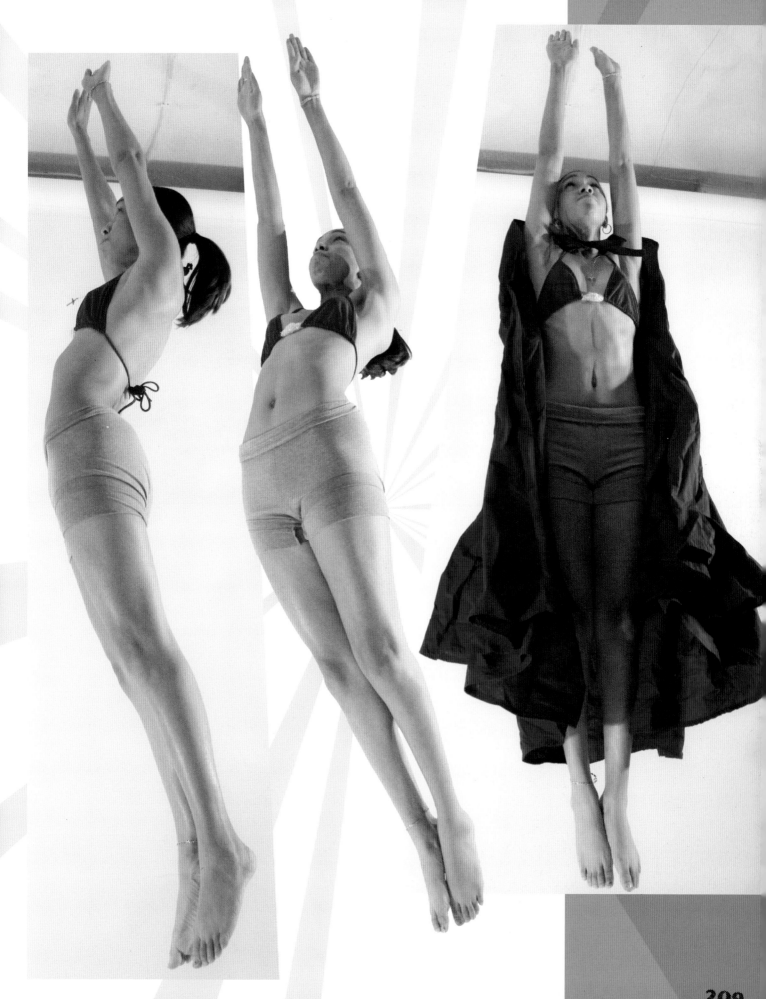

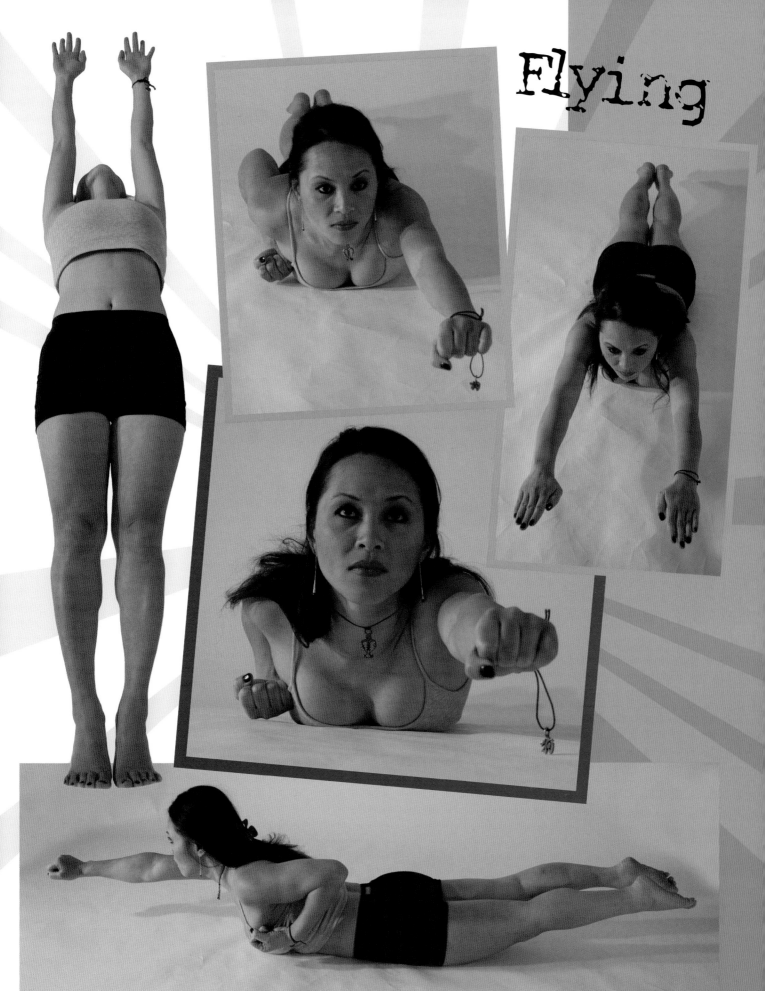

Flying

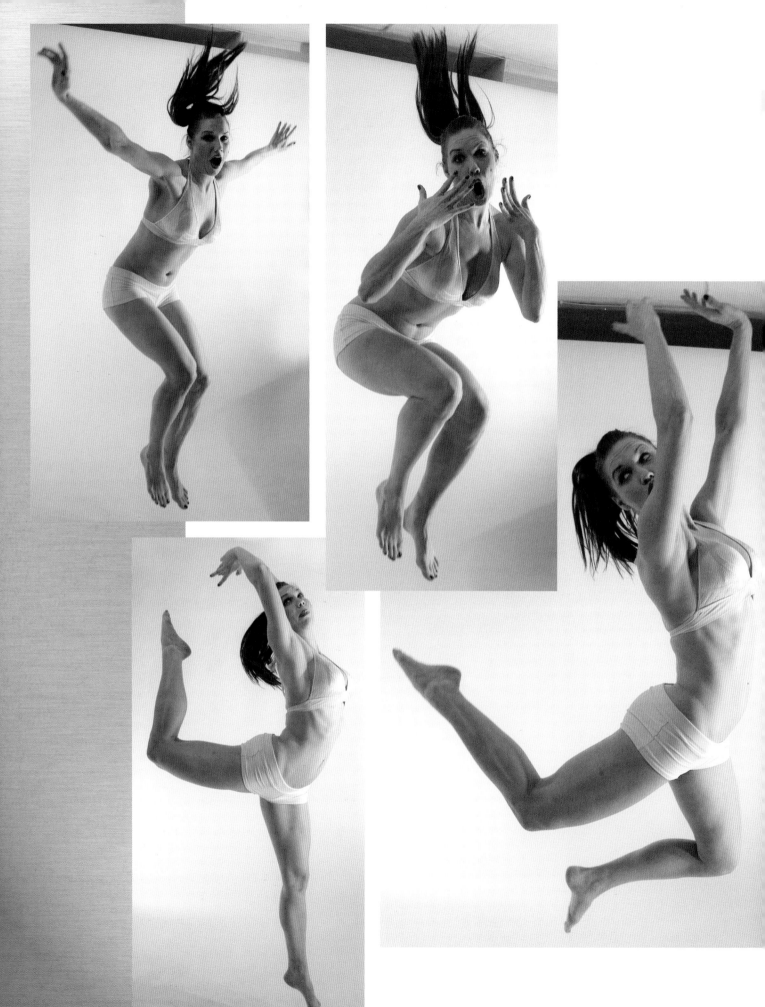

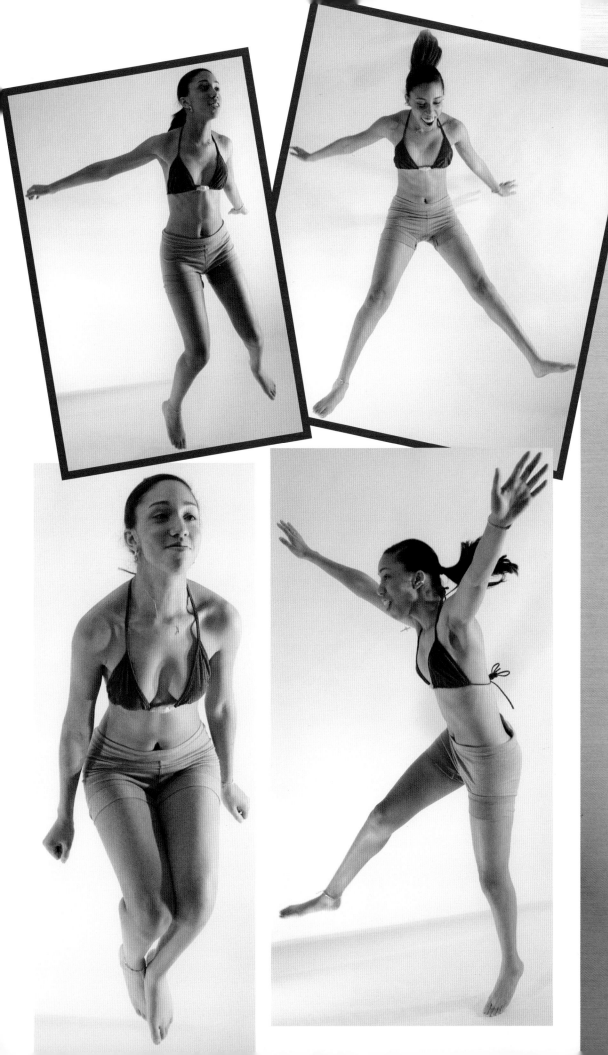

Jumping

For more action poses, visit
impact-books.com/
colossal-collection

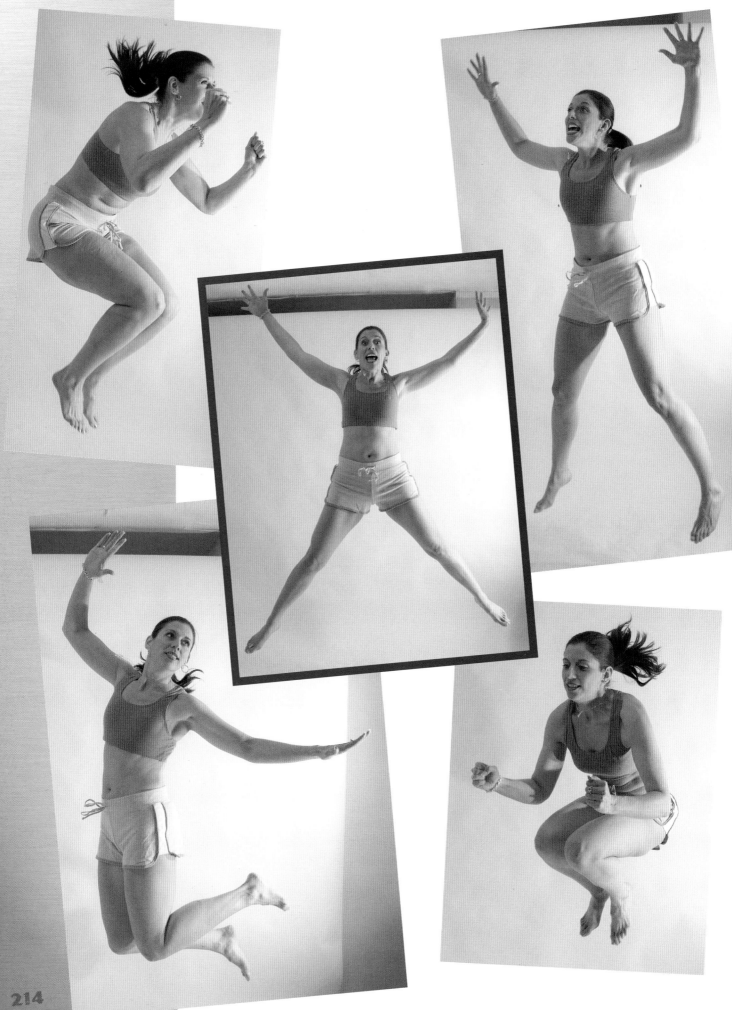

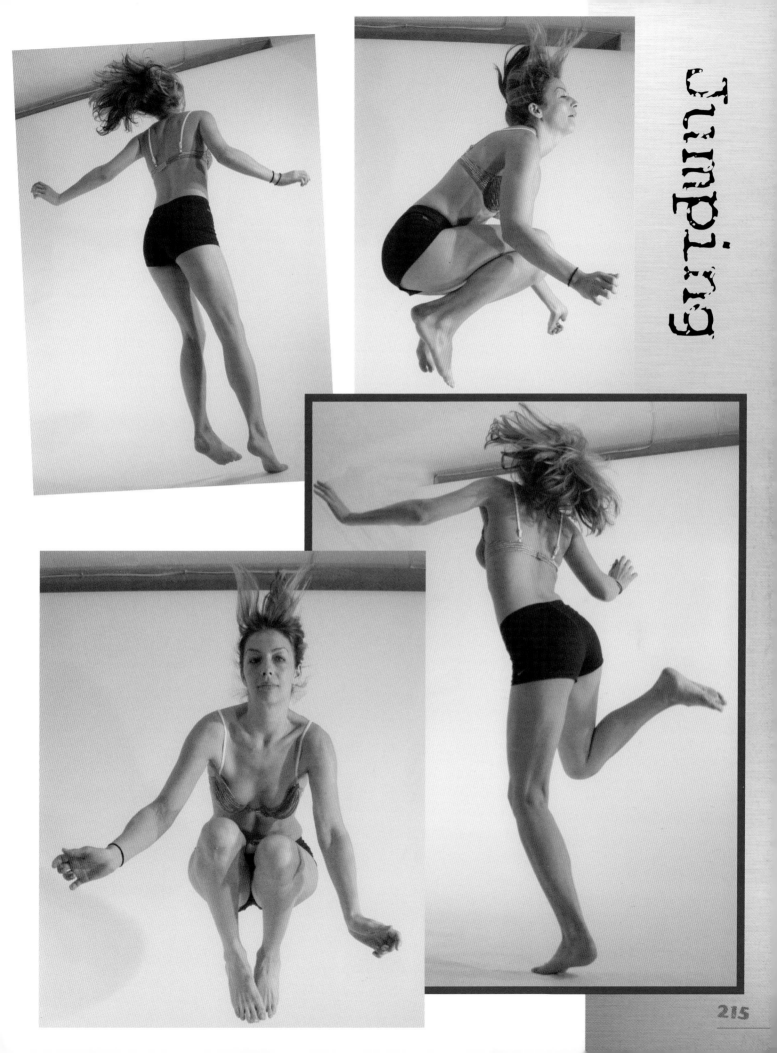

Demonstration

Tracing (Yes, Tracing!)

BY MICHAEL OEMING

Sex change for Zoe!

What can I say about photo reference? It's a dangerous game if you don't know what you are doing. By that I mean art that looks photo referenced makes me vomit in my eyes. Realism is fine, but there is a stiffness, a lifelessness that ruins comics when the artist becomes a slave to the reference. It has ruined many a great artist for me.

Now let me tell you, I use photo reference all the time, even with my cartoony style. Beyond reference, I often trace photos. It's not an ugly word, just say it out loud: *trace*. See, no one slapped you, right? So let me show you how I use photo reference. I will trace the photo I was given of this beautiful model named Zoe… and turn her into a man!

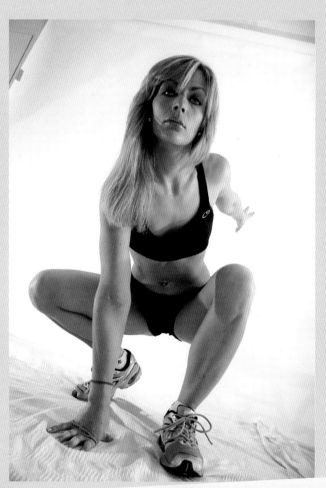

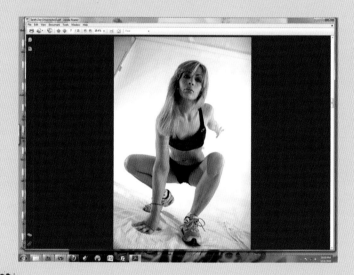

2 Get the Photo Into Photoshop

In this case I am working with my Cintiq, a tablet you can draw directly on, just like paper. But all of these steps could be done with a lightbox and regular paper. I could import the image, save the image as a JPEG, but the fastest step for me was to take a screen shot and then pasting it into Photoshop.

1 Find Your Photo

I've been working on a character called Faustus. I've picked out a pose I thought could work for him.

216

Create the Page and Sketch

I've pasted the photo and turned down the opacity about 45%. On another layer, I sketch out my Faustus character directly over the model using a small pen size. I am using the pose and energy of the model, that is all. But I am tracing it.

Sometimes I even grab parts of the photo and move things around. Her right arm is too far in, I want to flare it out a bit more. Instead of drawing like I did here, I could have moved the hand on the photo and drawn over it. Instead, I just drew, using the photo as a guide. I also squished her slightly to make her proportions thicker like a man. I just selected the area and then distorted the figure to give it more weight.

The head feels a little big, so I'm going to make it smaller. I've also sketched out a vague composition here, although right now, I'm not sure what I want to do with it.

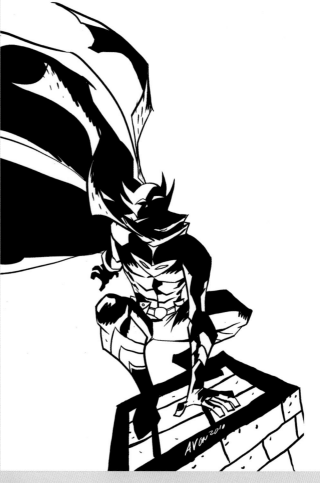

Refine

Now I get rid of the photo (unless I took it with a very specific purpose, like lighting, costume and such). Here I only needed the pose. You can always change things you don't like, including flipping your photo, like I did here.

Time to refine the sketch. I did some shading, and used a second photo, a city photo which I then distorted in Photoshop. This would be much harder with a lightbox, but it could be done.

Ink

Inking is done digitally and there is a lot I could get into about that, but since this is about photo reference, I'll leave that to another time. The city photo is on another layer, so when I inked this I kept the foreground and the background separate. This helps the colorists. Since this is just a black-and-white piece, I simply turned down the opacity on the background to give it more depth.

Again, the background is traced but I only traced the shapes. By manipulating the photo I even changed its composition. I inked it freehand so it looks and feels totally organic. Despite being done digitally using photos, I dare say it is as natural as anything I've done. The last part is simple: just sign it!

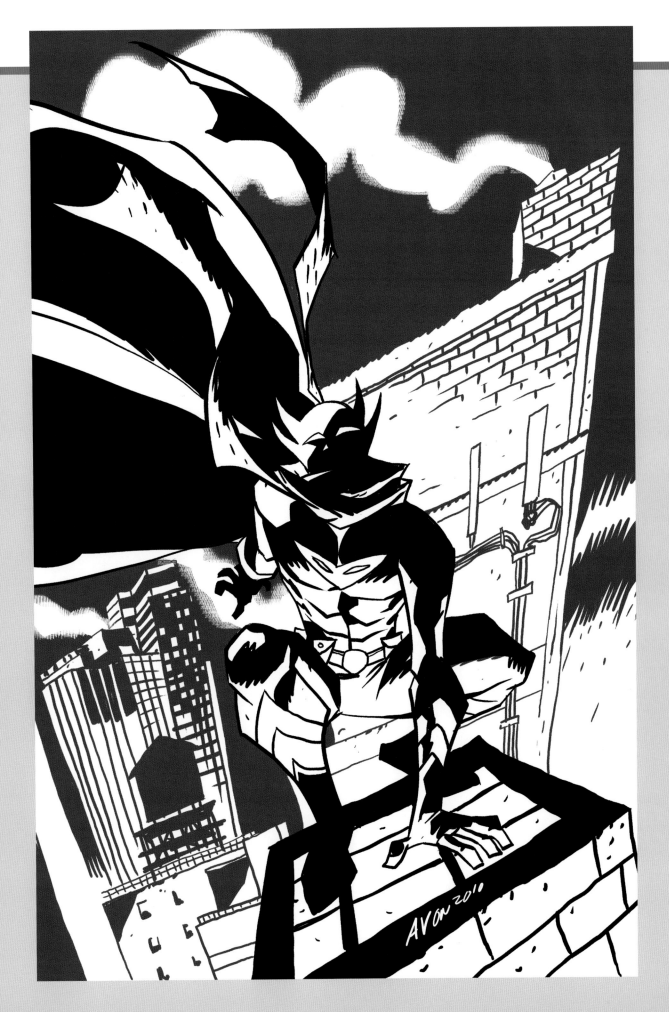

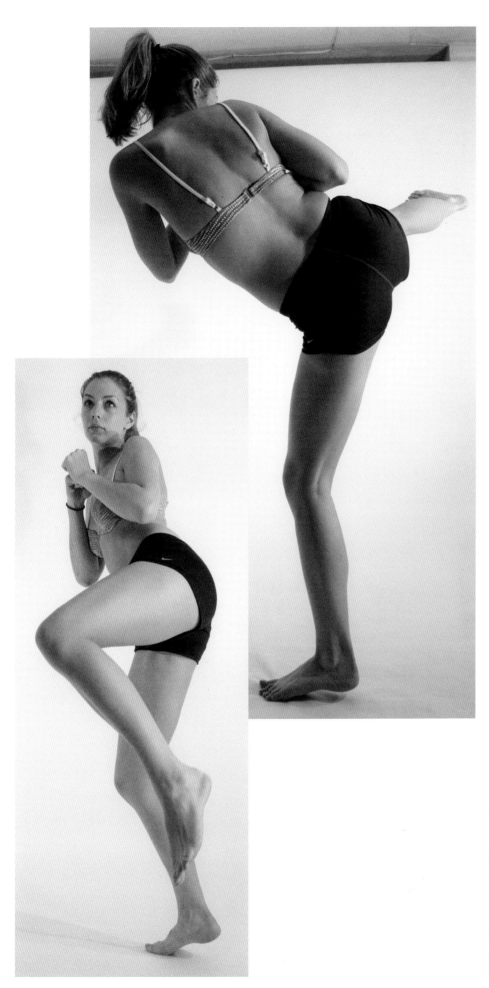
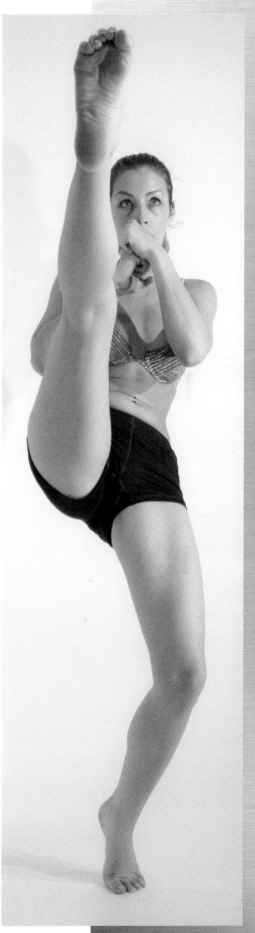

Lifting

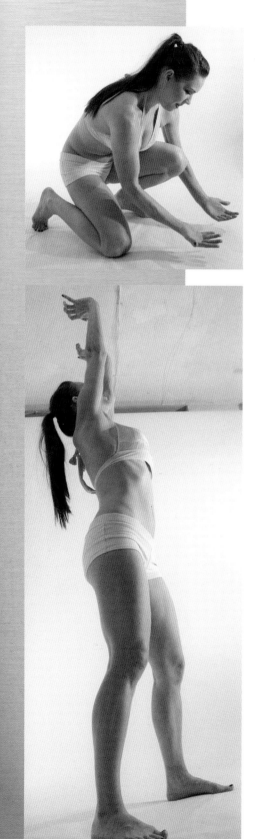

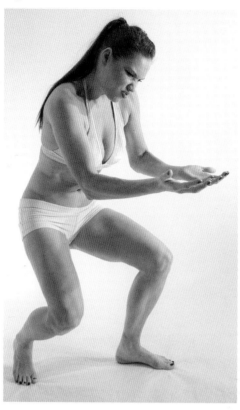

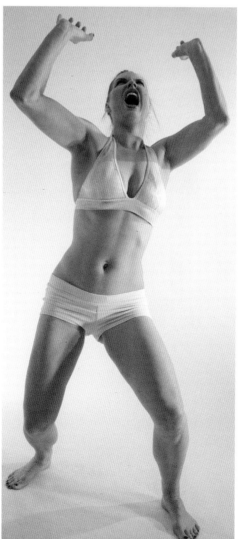

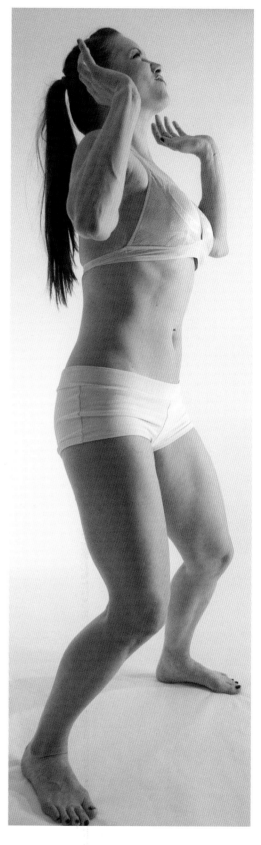

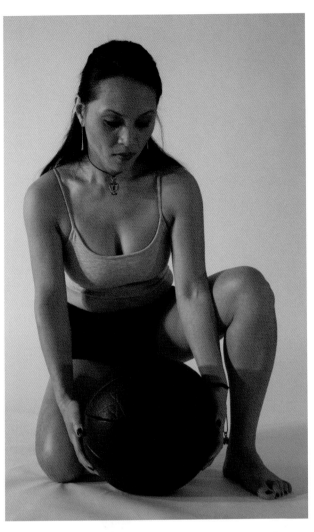
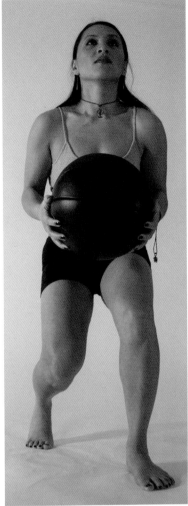
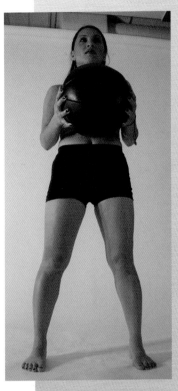
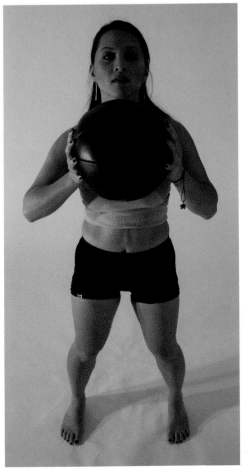
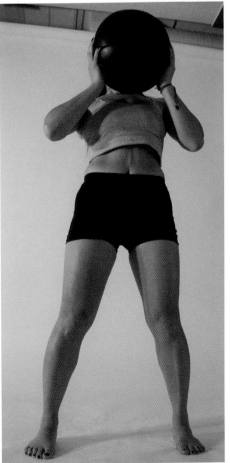
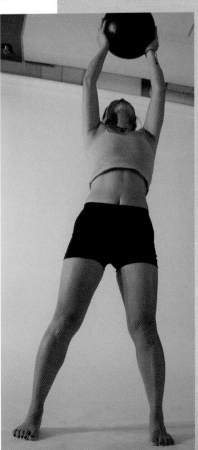

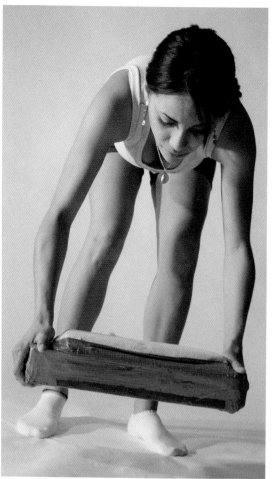
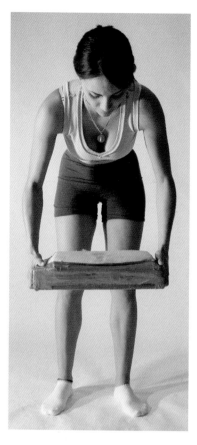
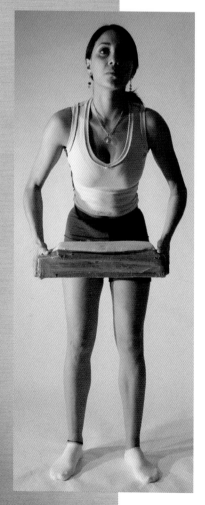
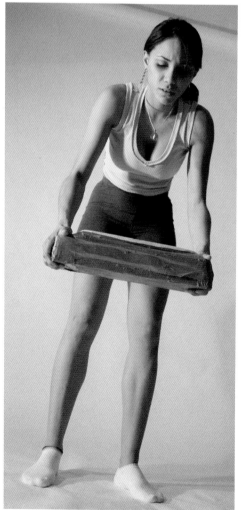
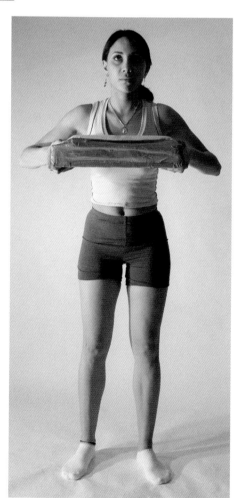

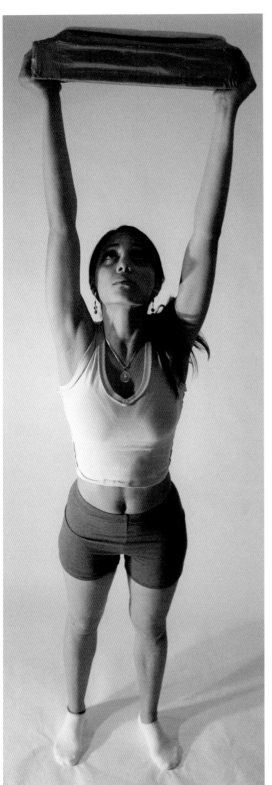
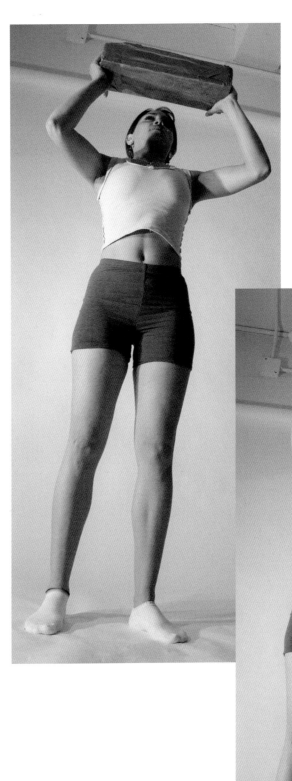

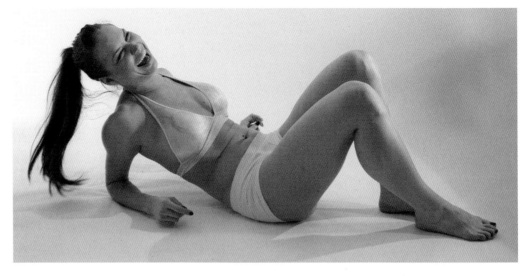

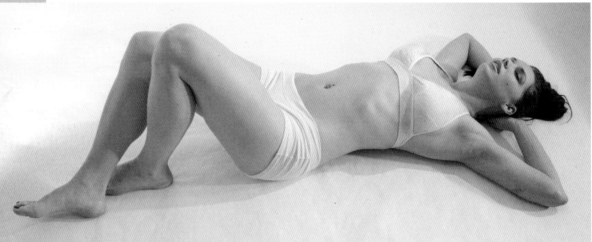

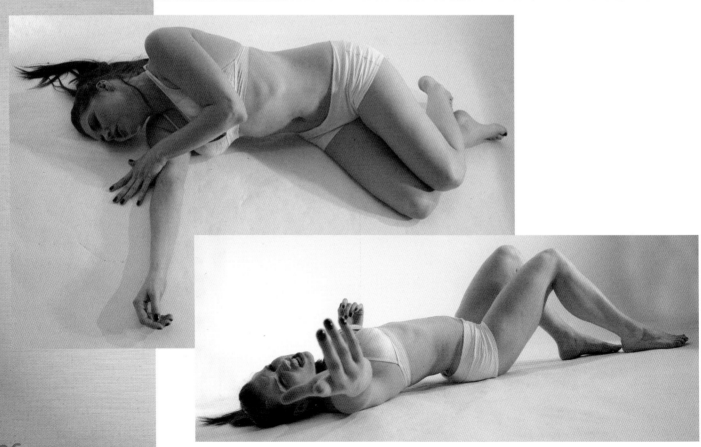

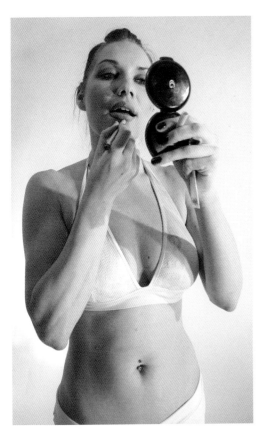
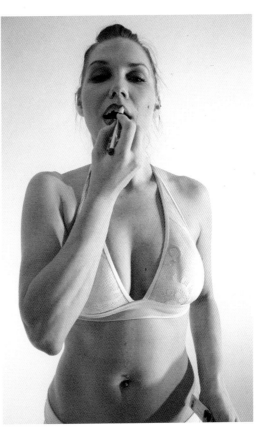
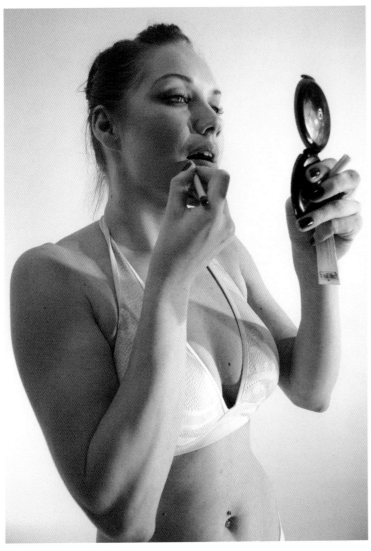

Make-up

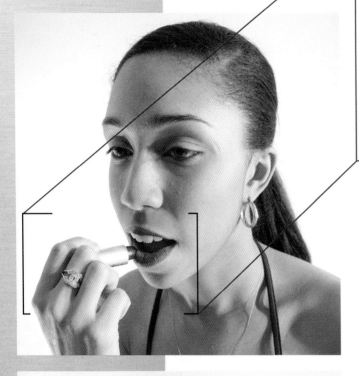

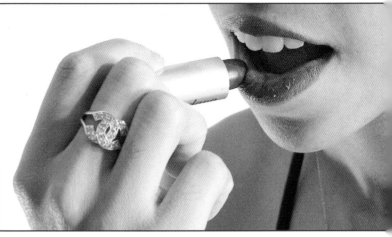

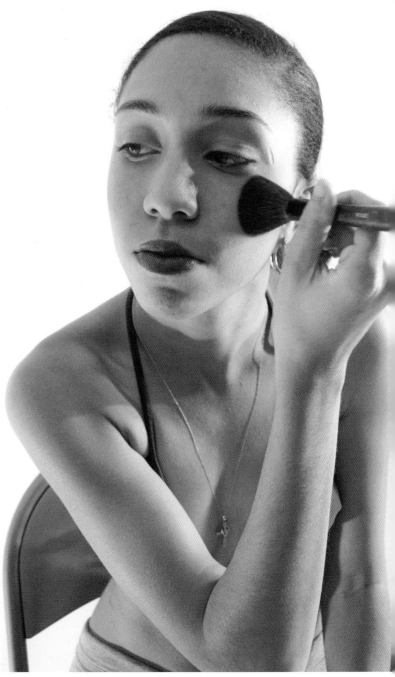

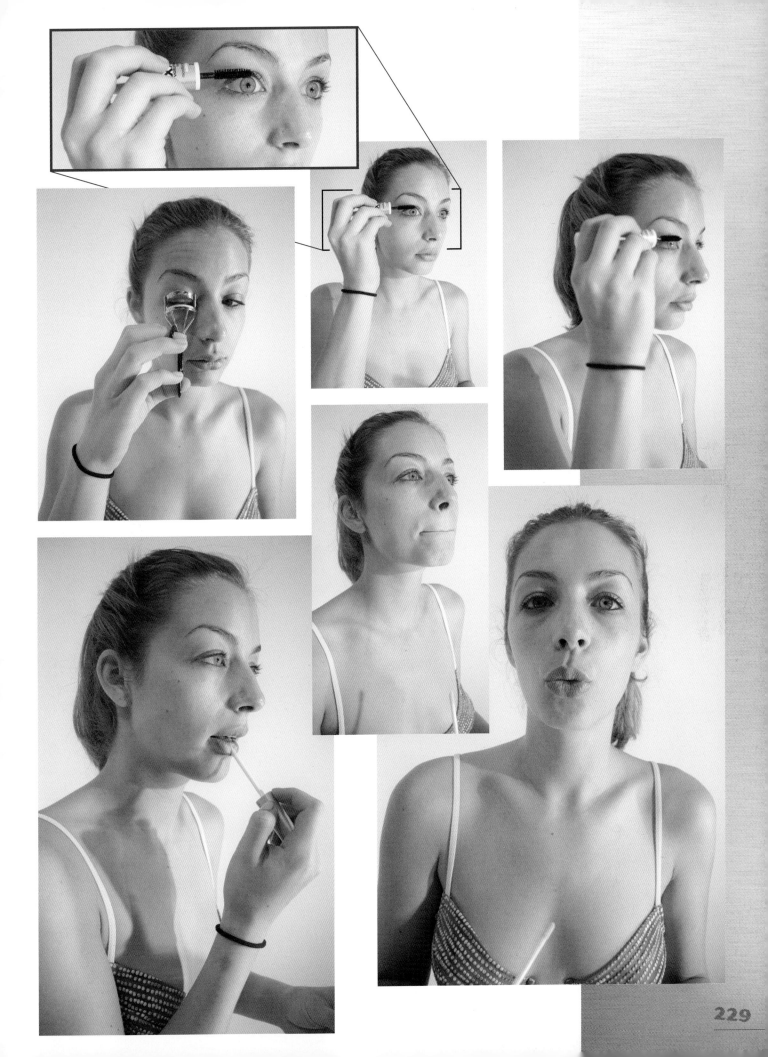

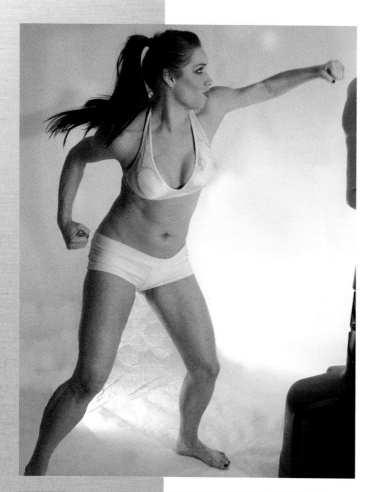
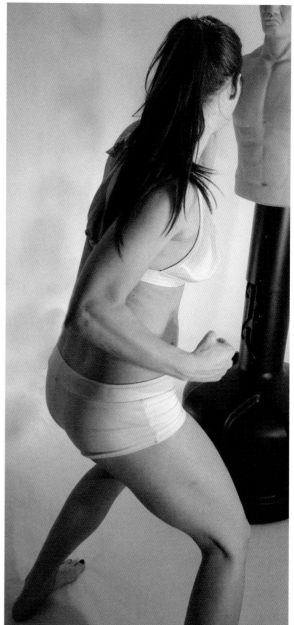
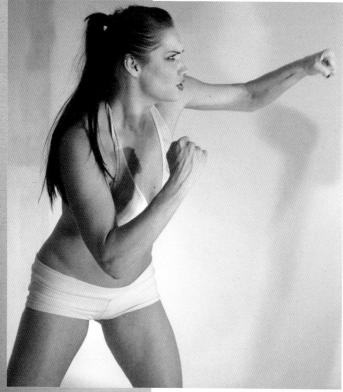
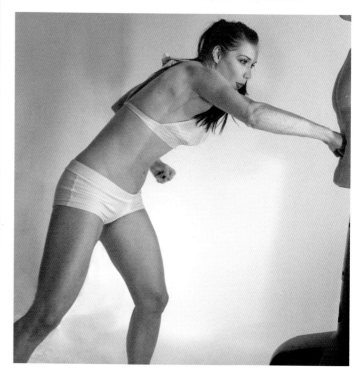

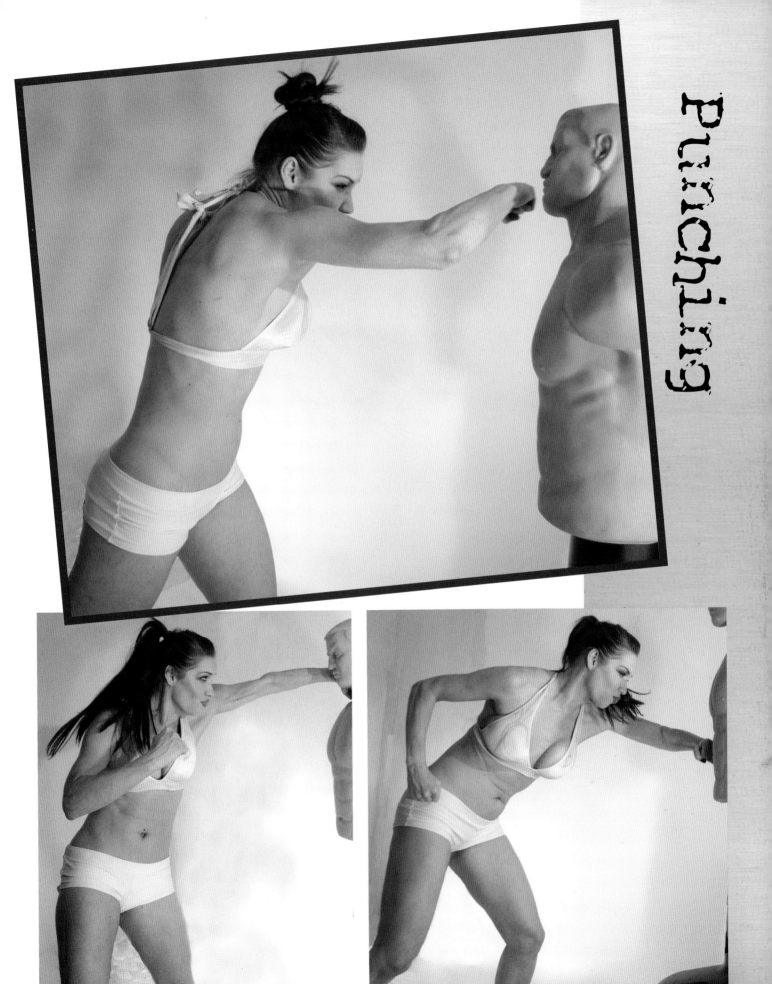

Punching

231

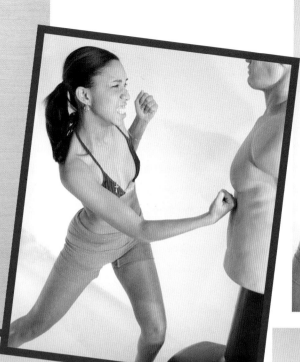

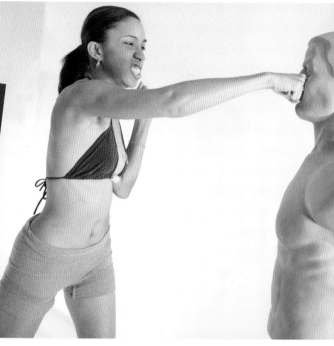

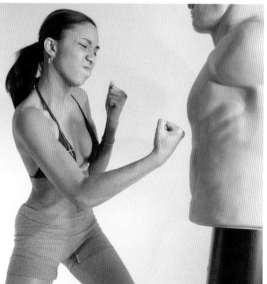

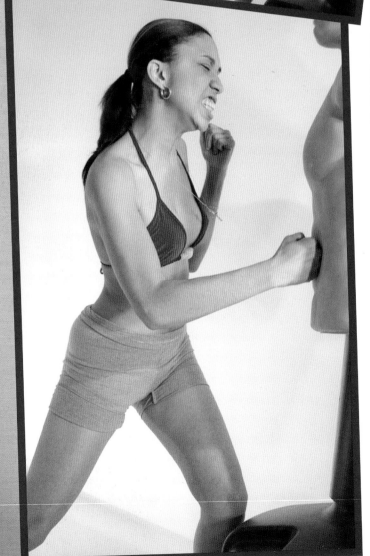

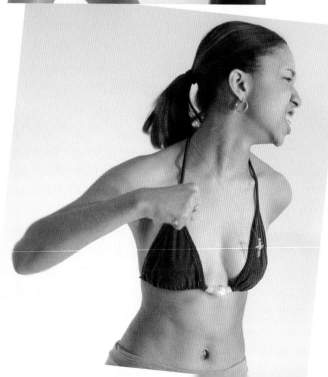

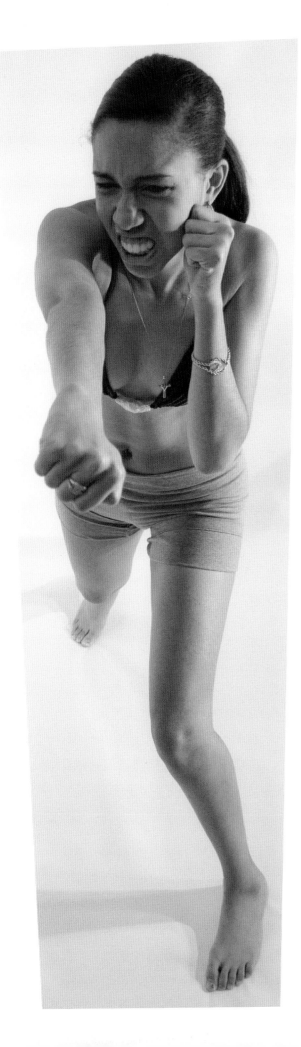

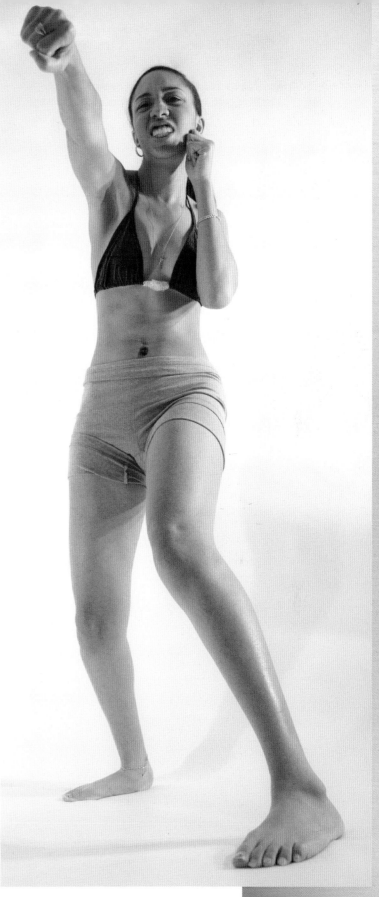

For more action poses, visit
impact-books.com/
colossal-collection

Demonstration

Teen Action Hero

BY JOSH HOWARD

I chose this picture of Chanel for my demo because I liked the tilt of the head and the position of the legs. I remained fairly faithful to the pose but went my own direction with the aesthetics. That's what it's all about—using the photo as inspiration without being a slave to it.

Sketch Thumbnails

First, I sketch the pose with a regular mechanical pencil to capture the shapes, angles and general feel. I like to do several sketches before deciding which one to run with. I always have three or four sketchbooks going.

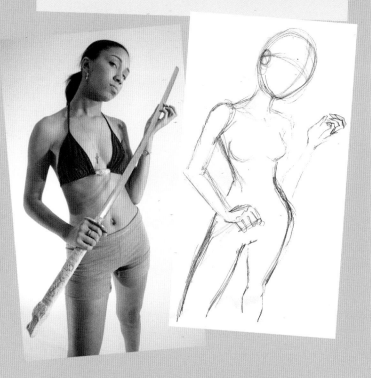

Because I ink my own work, I can keep my pencils loose, knowing I'll tighten the drawing during inking. This is one way I've learned to streamline my process.

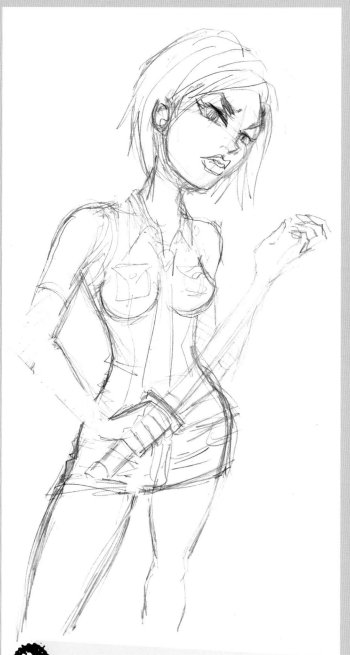

Pencil the Best Pose

I redraw my best sketch onto art board, then rough in the details of the clothing. This is where my illustration begins to deviate from the photo. I'm envisioning a teen hero dressed in a sort of hybrid punk/militaristic style.

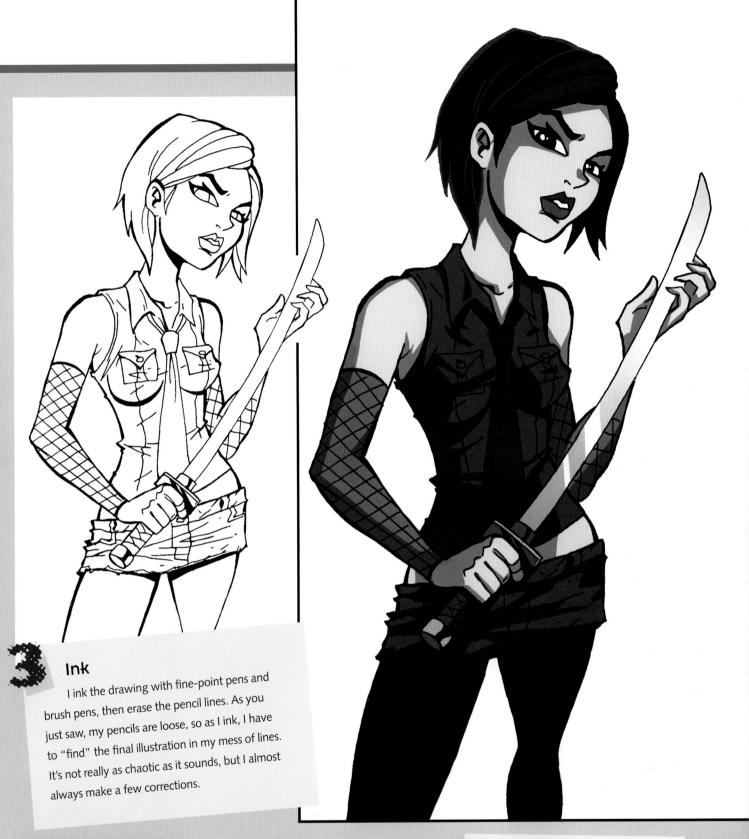

Ink

I ink the drawing with fine-point pens and brush pens, then erase the pencil lines. As you just saw, my pencils are loose, so as I ink, I have to "find" the final illustration in my mess of lines. It's not really as chaotic as it sounds, but I almost always make a few corrections.

After I scan my inks, I can manipulate the scan before I color. If I decide that the head is at the wrong angle or a hand is too large, I can fix it.

Color

I scan my inks, then add color on the computer. The final product is a piece I'd gladly add to my portfolio.

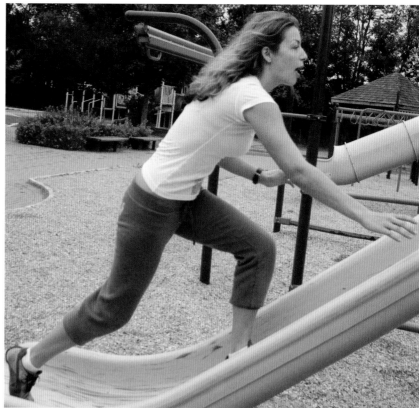

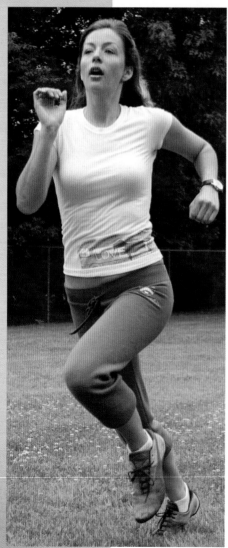

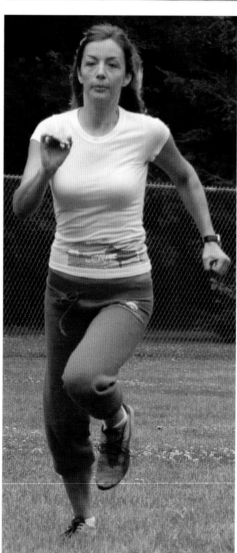

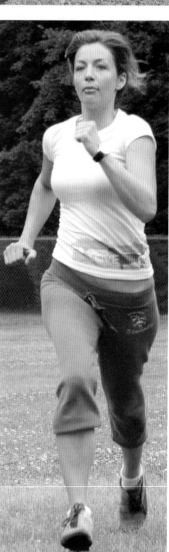

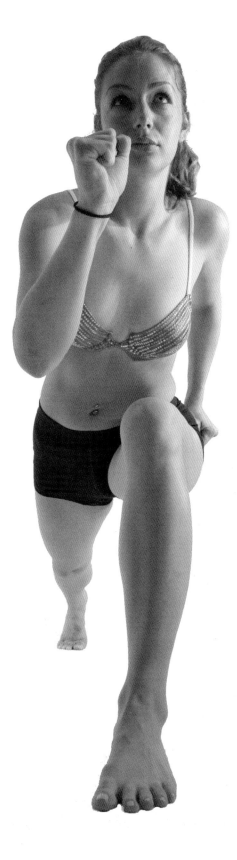
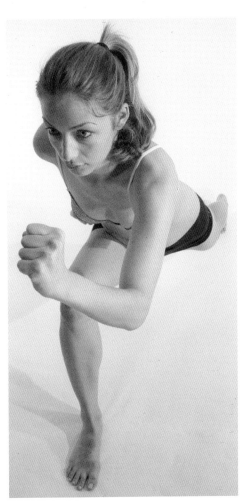
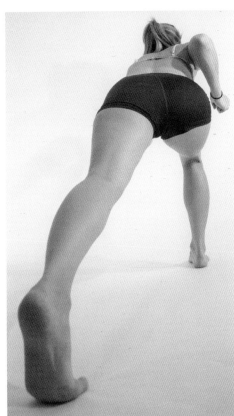
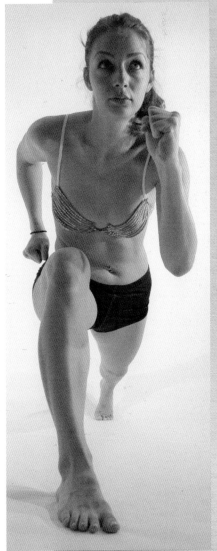

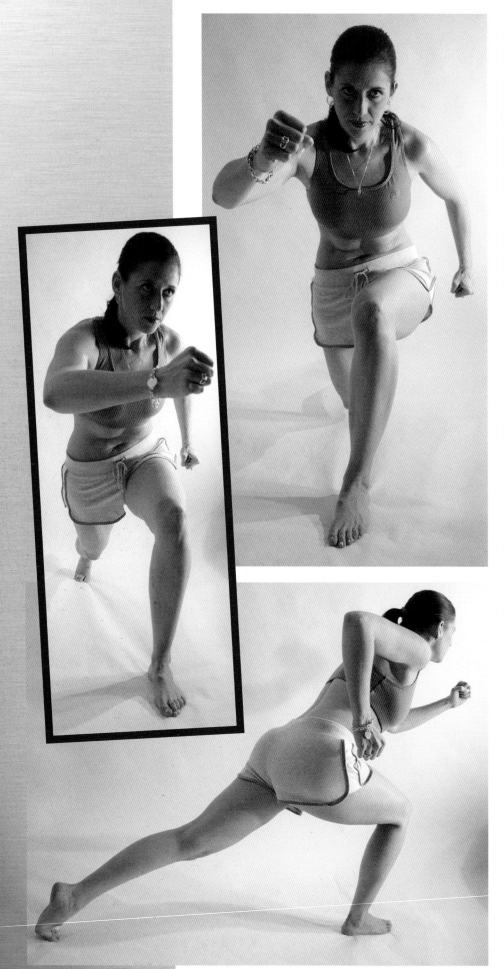
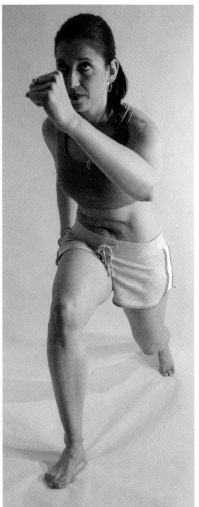

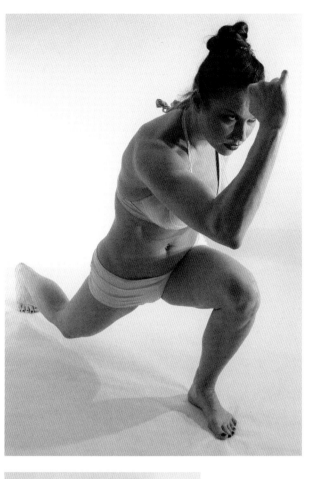
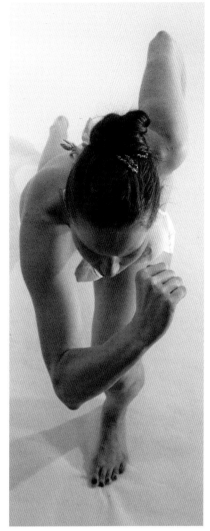

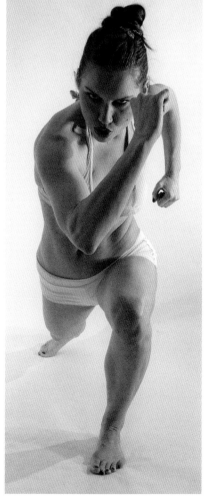
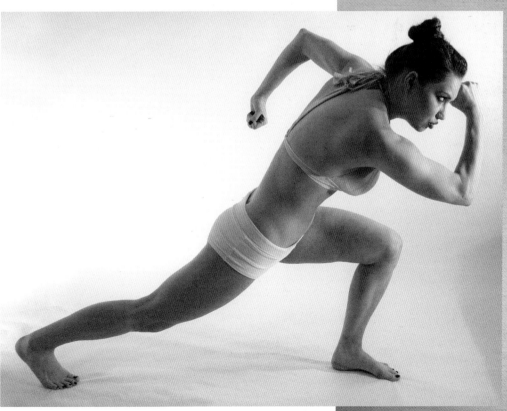

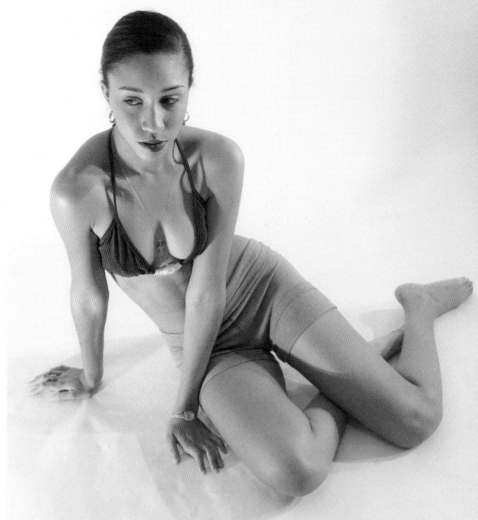

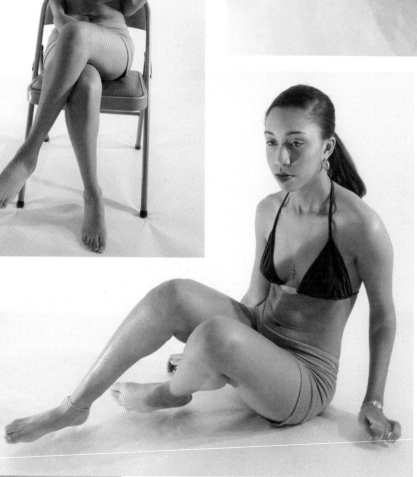

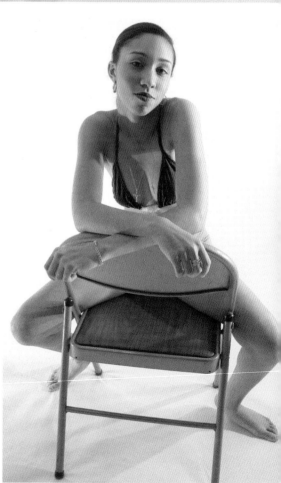

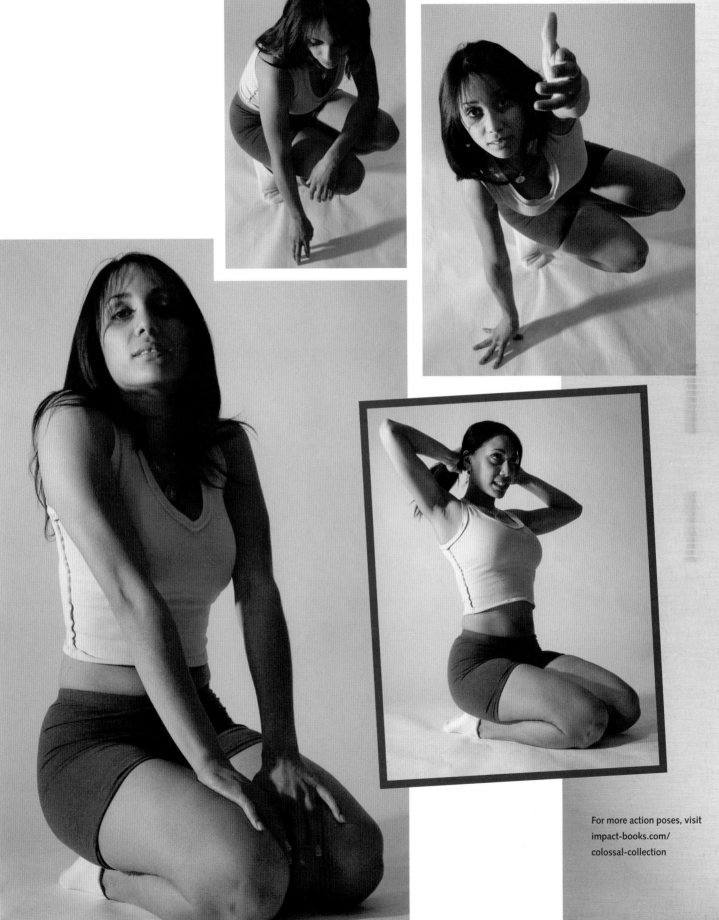

For more action poses, visit
impact-books.com/
colossal-collection

sitting

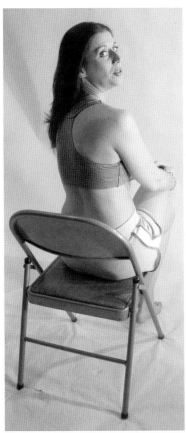

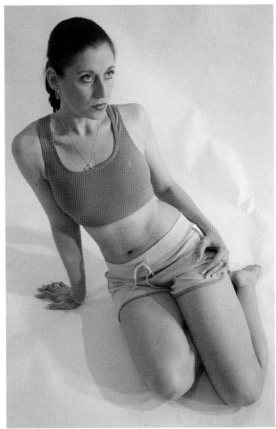

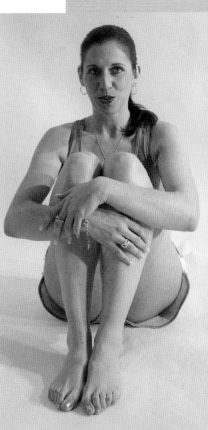

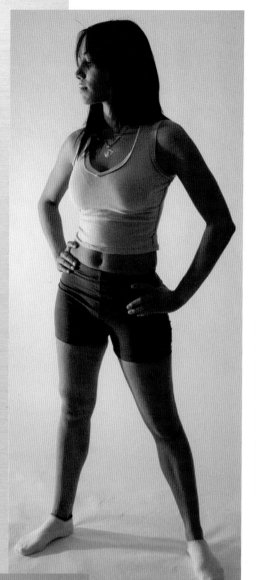
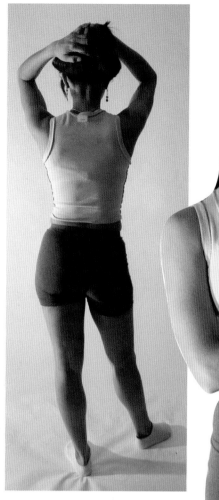
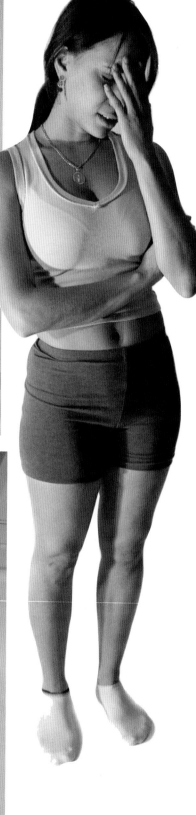
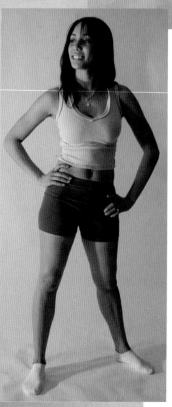
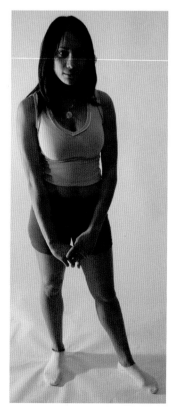
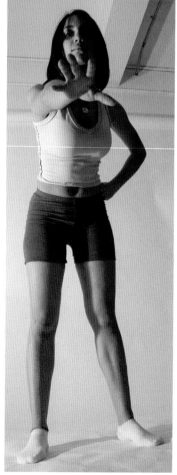

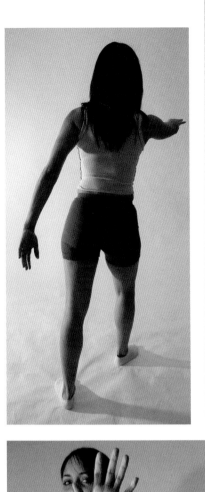

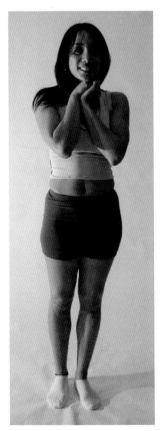

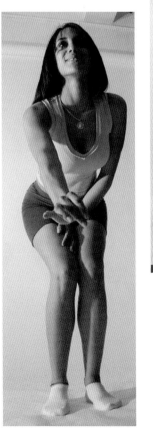

For more action poses, visit
impact-books.com/
colossal-collection

245

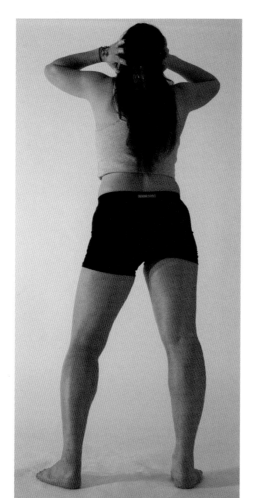

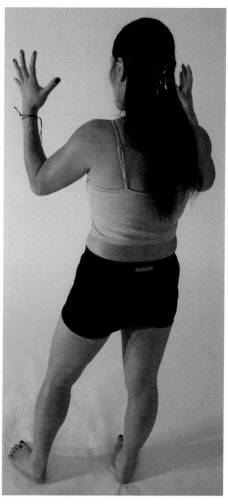

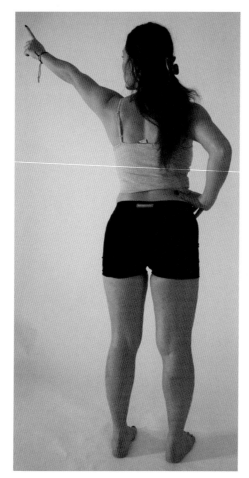

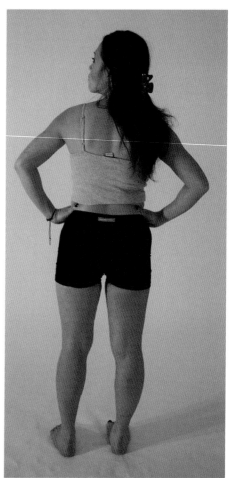

Drawing Energy from a Photo Reference

BY THOM ZAHLER

I usually start working in light blue Col-Erase pencil. I like the way these pencils are like regular pencils, rather than waxy as some colored pencils are. And I work on tracing paper so that I can overlay drawing after drawing to try to chip away at it.

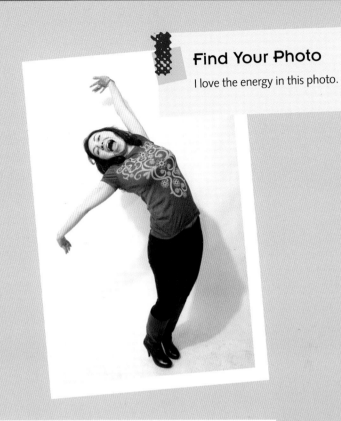

1 Find Your Photo

I love the energy in this photo.

2 Draw a Curved Line

To start, I drew a curved line to try to follow the pose and position of the spine. Drawing this line will hopefully keep me from stiffening the pose up too much.

3 Work the Stick Figure

I start working out the pose as a stick figure, being particularly conscious of the position of the shoulders and hips. It's the contrast between these that show the movement in the figure.

My characters are cartoony, but they still stick close to realistic proportions. They tend to have larger heads and smaller bodies, so I've tried to incorporate that into the stick figure.

Block Out the Figure

I've added the guidelines to get the position of the face. There are a few points that I pay particular attention to:

Arms. It's tempting to try to make her arms completely straight, but they're actually hyper-extended. In trying to straighten them out she's actually bent them a little further than straight. It gives a great flow to the figure, helping the curve of the arms. So I'm trying to make sure I have that break.

Hips. I'm also trying to keep the hips positioned right. Her torso is twisting just a little bit. If she were completely straight, you'd see a lot less of her left leg and the left part of the pelvis.

Feet. The feet are interesting, too. They're not lined up straight. They actually point towards each other slightly.

Block In the Anatomy

I'm trying to see how her muscles overlap, like how her shoulder pops in front of the trapezius (back part of the neck). I've also started drawing her breasts. You'll notice a line I've drawn from her neck down to the center of her pelvis. This is because the breasts will overlap and extend past the torso box, and it'll start making that center line drift unless I work it out.

There's a visual temptation, at least for me, to use the edge of the right breast as the center of the figure, but that will throw off the position of the navel and the hips. Working out that center line will help me keep true to the pose.

I've also started working on the fingers. Up until now, the "mittens" were fine, but I have to start considering them.

Tighten the Drawing

I've started adding the costume. The photo reference is invaluable for figuring out the direction of the limbs. Amazonia has two bands on each arm, and they have to curve the right way to get the direction. (The bands on her right arm are C-shaped, rather than going in the other direction.)

I've placed her belt/hip band, too. The difference between the band on the bustier and the belt shows how tilted the figure is. The bustier is closer to straight on and therefore flatter. The belt is much rounder because we're looking down at that part of the figure.

You can see an arrow pointing to her left hip where I've adjusted the pose. I was turning the figure too much and needed to add more to the left hip.

I've begun to work out the expression, too. A lot of my cartooniness is in the face, so I'm trying to keep that stylization and make it work with the great expression the model has.

Complete the Final Pencil Stage

I've switched from Col-Erase to a mechanical pencil now. This is the final stage on pencils, and the darker pencils will be easier to ink when I throw it on my lightbox.

Everything's here now. The costume is present in full. You will see that I adjusted the V-ornament on the bustier. In looking at it, I realized that it was drooping too far for what the pose was. The way I had it previously would have been lopsided if you saw it straight-on. So, I fixed that.

And I changed the curve of her back. I had it too curved and she was starting to look like she had a hump on her back. I adjusted it so there was less of her back to be seen, but without losing the curve present there. You can now see the back curving down to the hips, where the direction reverses and it curves outward to the hip.

I'm also playing with the expression a little bit. The model's eyes are almost closed, and in an attempt to redraw the eyes, I ended up with a double line that started reading truer for me. It's one of those situations where I'm drawing not what I see, but what I feel from the pose. The model's eyes aren't closed, but Amazonia's now will be.

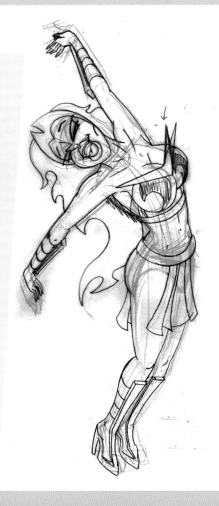

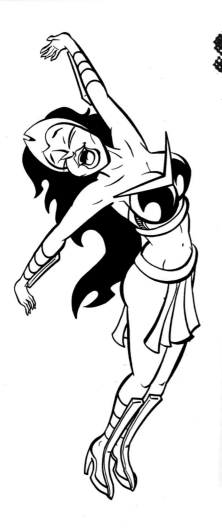

Ink

I ink on layout paper for the most part. I tape the pencils to the back of the paper and put it on my lightbox. This way I'm working on a clean sheet of paper with no pencils on it at all. It'll save me the step of erasing.

I ink mostly with a brush, but I also use Micron pens and a French curve. I abuse my Microns and bear down on them while I work. I think it shortens their lifespan, but it adds life to the line.

A cartoony style requires an economy of line. When you're keeping it simple, every line has to be right. If I were working in a more realistic style, I could use a lot more lines to define the shapes. Instead, every line has to be placed just right and the more lines on a woman, the older they look. So define your shapes in the simplest way possible.

Amazonia's entire right arm is defined through the contour/exterior lines, with the exception of a light line indicating part of the shoulder. There are muscles overlapping at the bend of the arm, but none of them are seen. It's indicated from the overlapping of the lines near the elbow where you can see the upper arm shape goes inside the forearm.

The curve of the abdominal muscles leading into the pelvis is indicated with a couple of lines leading into the belt. This helps show the left leg as a separate object, rather than having them blend together and reading as a solid shape.

Color

I work in a "cut color" animated style. It really helps define the shape of the figure. The shadow on the torso strengthens the curving there. And leaving the highlight on her right leg helps get a bend to her leg and clarify that shape as well.

My last step was adding the curls in her hair. When I first started, I would ink these lines in brush, then scan and reverse them. I've gotten confident enough with my graphics tablet to make those kind of lines directly on the computer, so I now add them right as I color.

Hey, that's it. I really like the way this drawing came out!

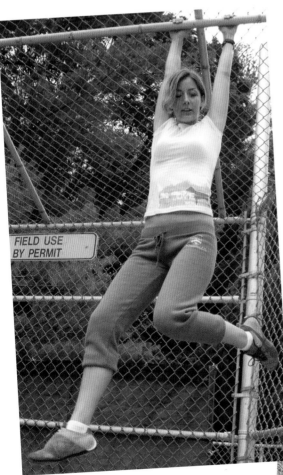

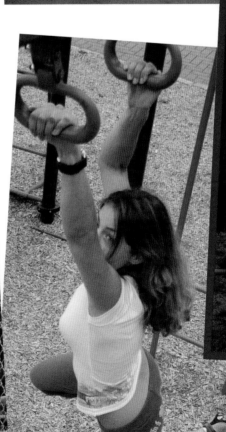

For more action poses, visit
impact-books.com/
colossal-collection

FIELD USE
BY PERMIT

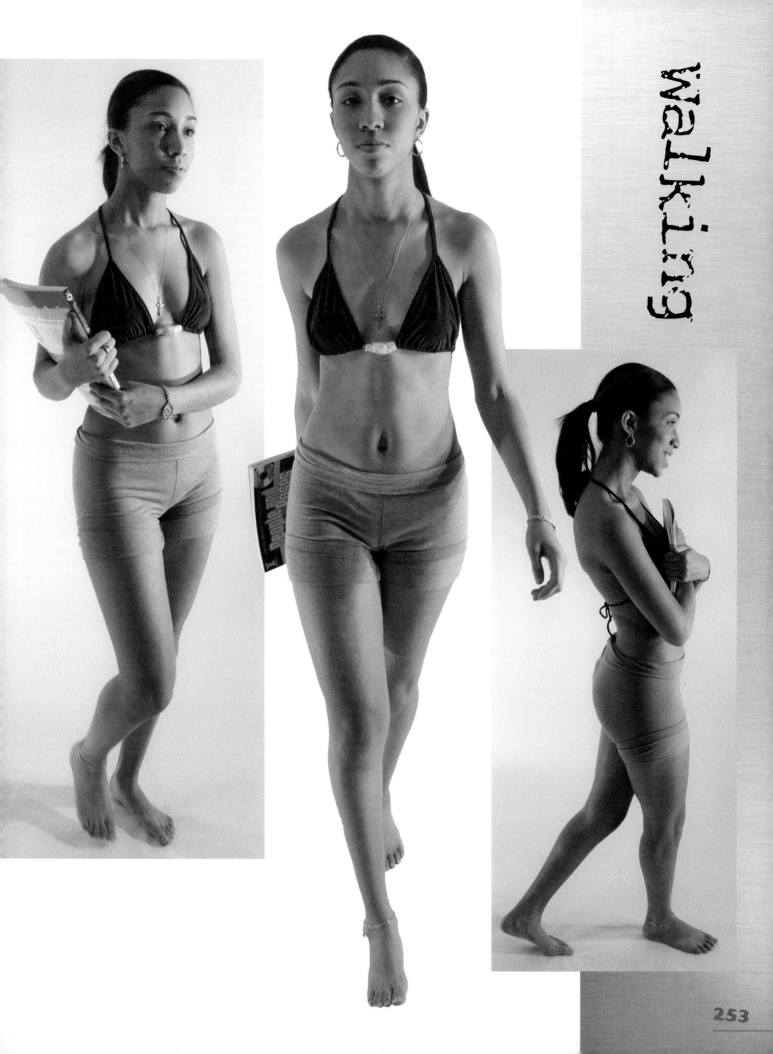

Weapons

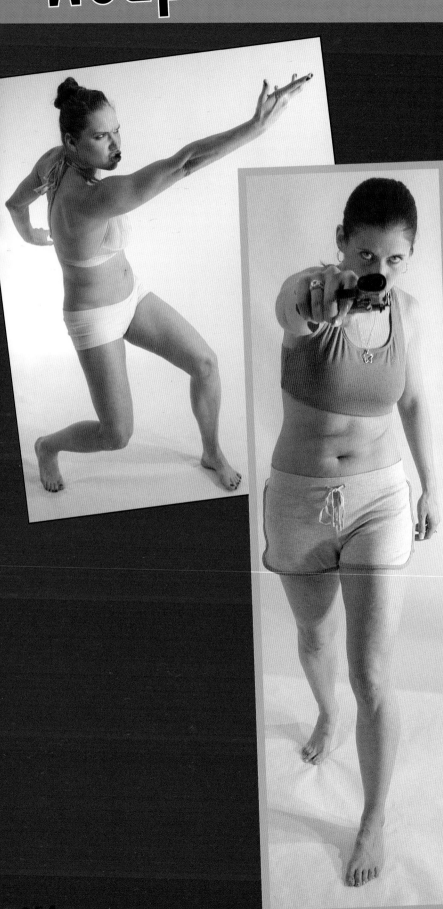

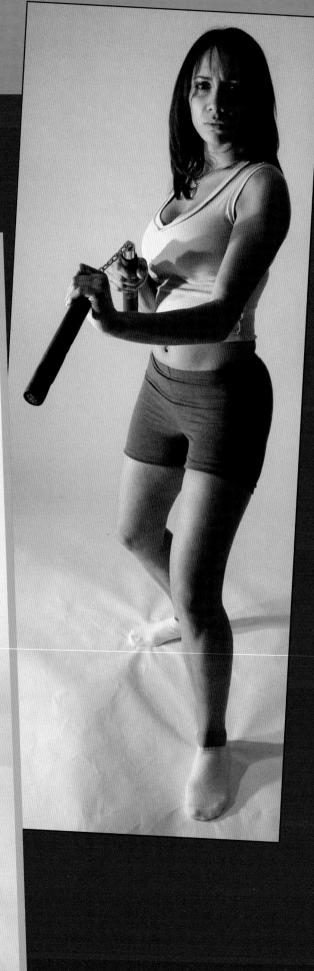

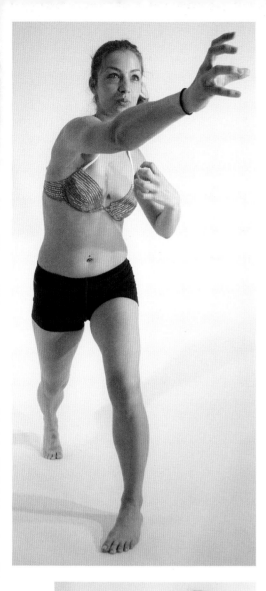

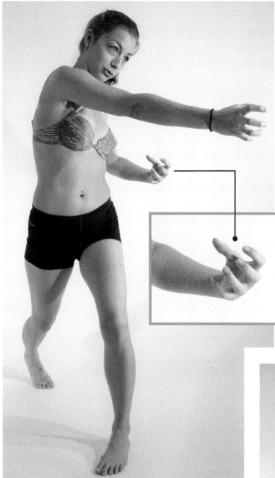

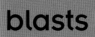
blasts

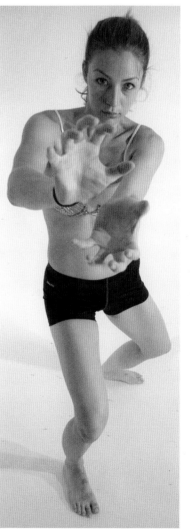

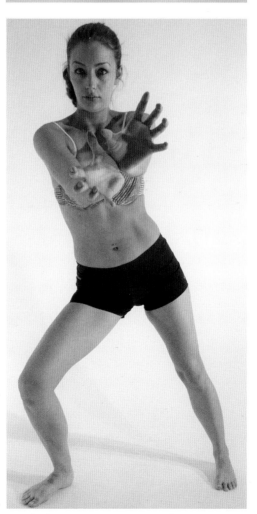

blasts

Demonstration

Draw a Character on a Background
BY PAUL CHADWICK

Comic book artists use photographs as a starting point to create a visual story in one or more panels. Most reference is photographed in a studio with simulated daylight conditions. Creating a night-time scene in an exterior setting requires imagination and maybe some additional photo reference.

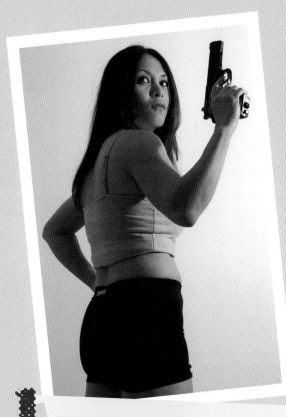

Rough a Sketch

Make some rough sketch lines to get a sense of perspective and proportion. Don't worry about getting the pose perfect at this point; you are just trying to see how these pictures can be merged. The figure and the background exist in two different three-dimensional worlds, and all you have to work from are two-dimensional representations of those worlds. Figure out how far this person is from the building. Based on the width of the sidewalk and the photographer's position in the street, this person would be at least 30 feet (9m) from the building. The head is placed slightly higher than the roof line to keep the focus on the character.

Don't overlook opportunities to change hair and clothing.

Find Your Photos

The model here is in a striking, dramatic pose from a slightly low point of view, which gives her a sense of imposing power. Note the strong light coming from the right side.

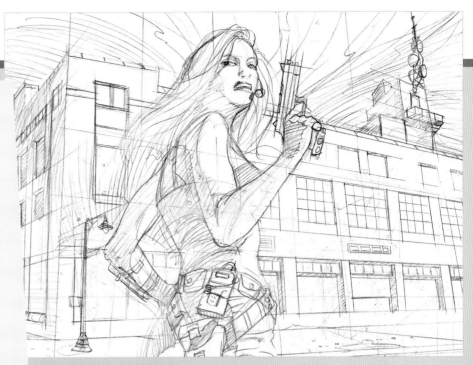

3 Tighten the Sketch

Begin tightening both the background and the figure. Use a ruler to create the rigid lines of the building. Add repeating elements such as windows and doors; their angles help create a sense of distance and perspective. The perspective lines radiating from the peak and corner of the building point to the center of the image, which directs the eye to the figure. Add small details to the background that will add realism without distracting from the visual story.

Add costume details. Snaps and buttons make nice repeating images on your character. When adding belts and holsters, be sure to follow the curve of the hips.

TIP

On a pretty female, delineate the nose as little as possible. Keep lines off the face; in fact, let the face get washed out a little, because every line can look like a wrinkle. If you are drawing a young woman, never draw the line that comes from the edge of the nose down to the mouth; that line adds years to a character's appearance.

TECHNIQUE

inking with a brush

Start from the thin end of the line and then thicken. Practice different motions until you gain the proper brush control. Try inking the stroke toward the base of your hand rather than away for greater control.

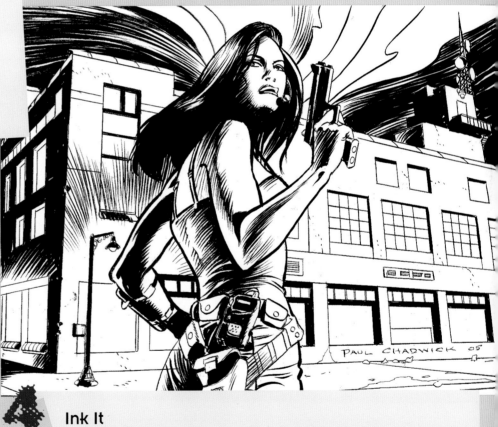

4 Ink It

Artists who ink their own work can be loose with their pencils. Here, I went from loose, fluid pencils right into the final art. Use a brush to get a nice line shape and curve.

A few bold brush strokes make the sky look imposing and dark. The character now has an eerie moonlit appearance, while the background seems foreboding.

A few well-placed ink strokes on the figure show the direction of the light, which comes from the upper right. Add small details to the background. Beat the building up a little with stains and missing chips. These details add to the overall realism and mood without distracting the reader.

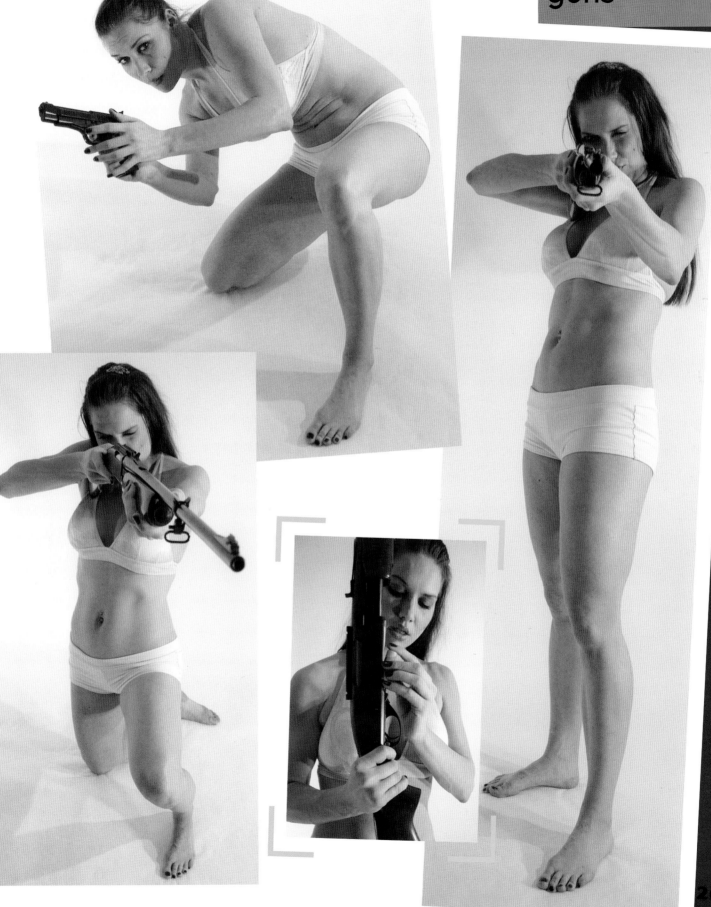

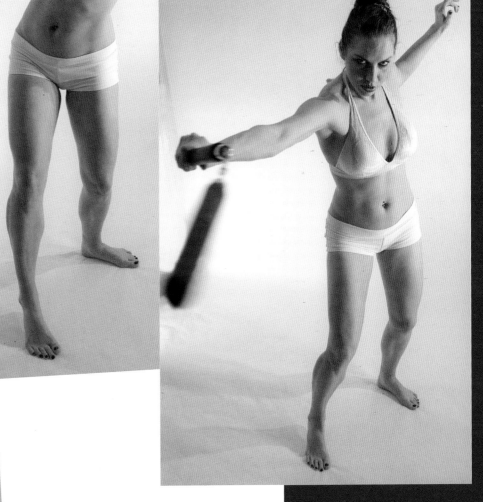

For more action poses, visit
impact-books.com/
colossal-collection

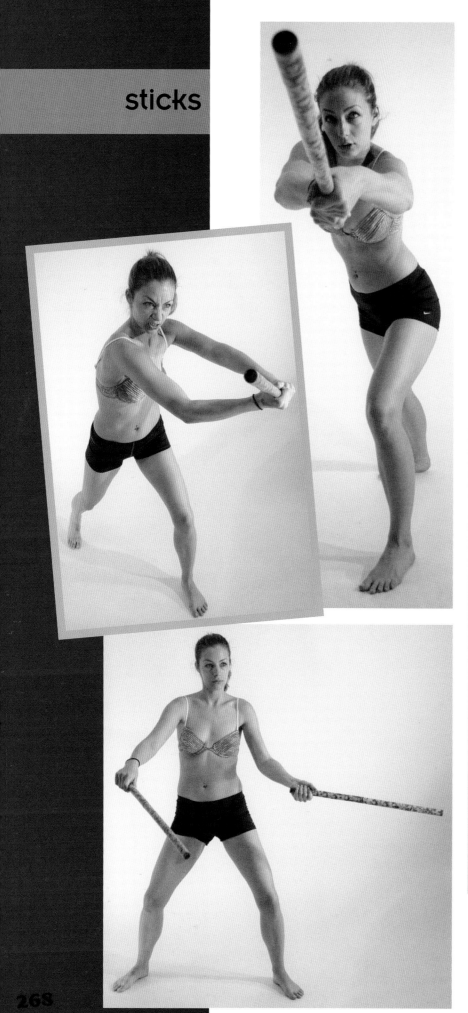

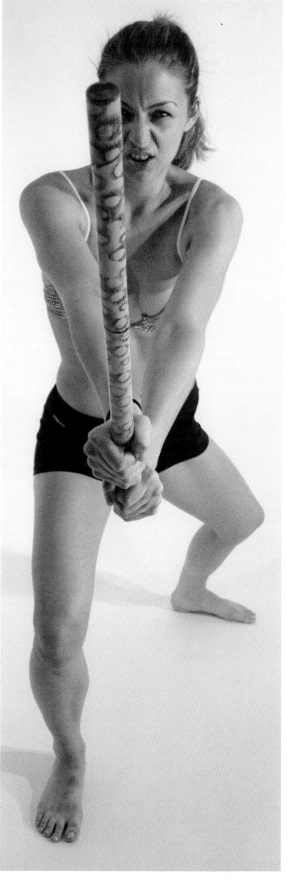

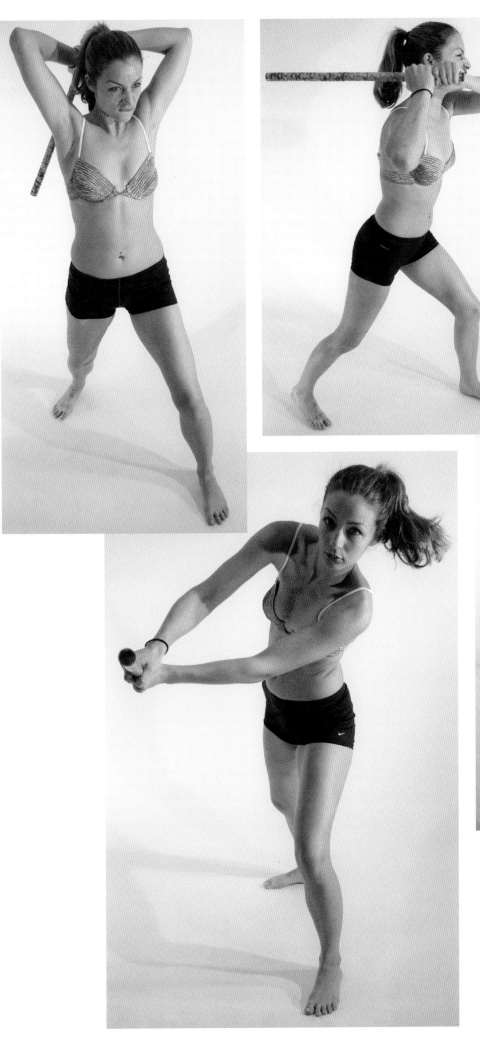

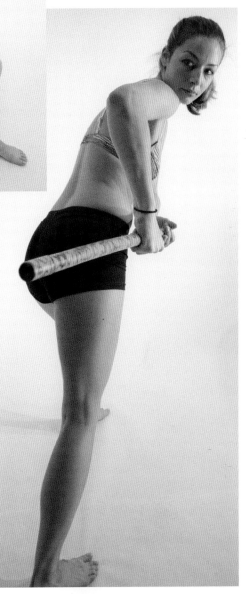

For more action poses, visit
impact-books.com/
colossal-collection

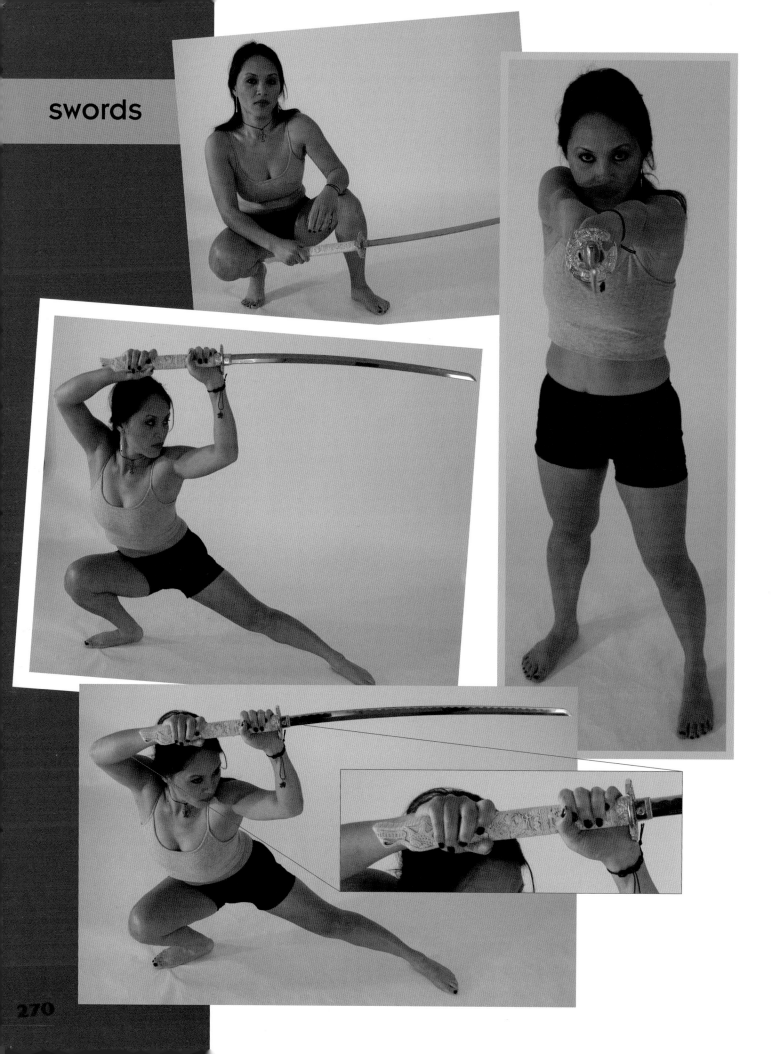

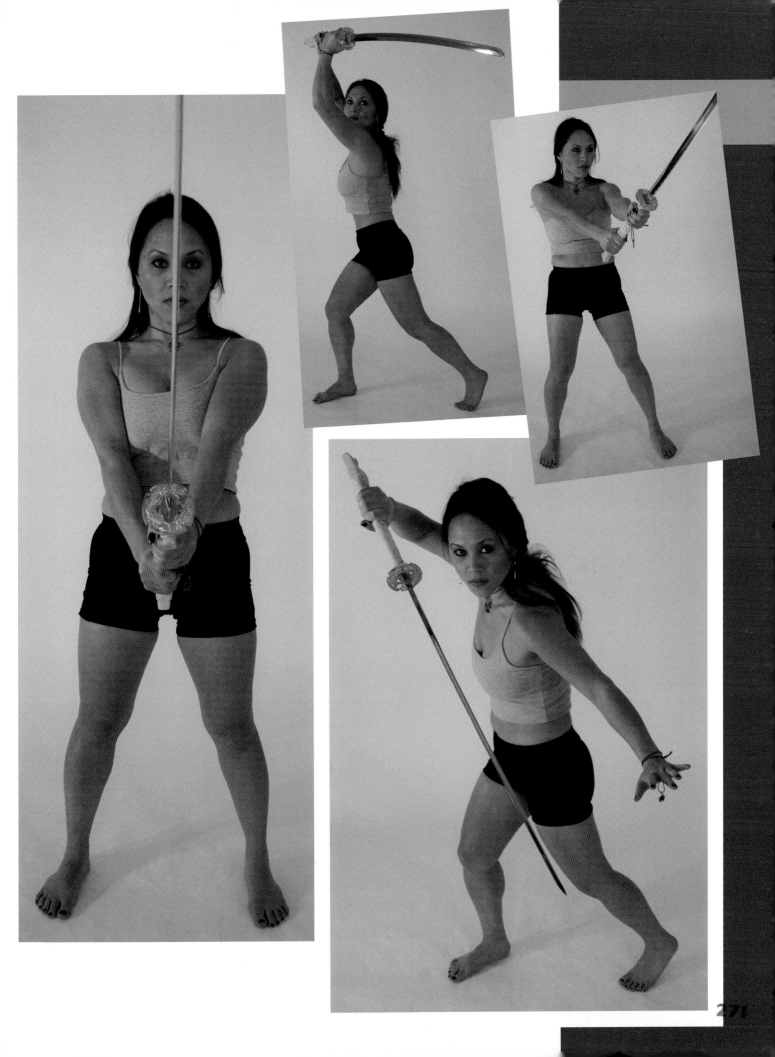

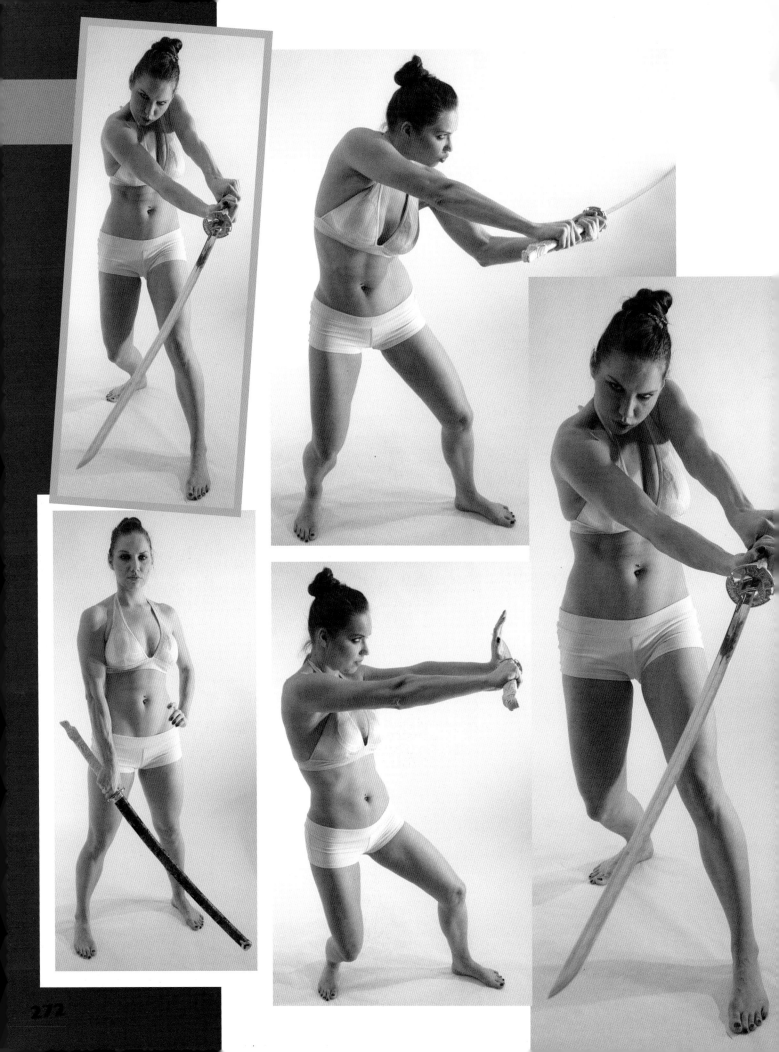

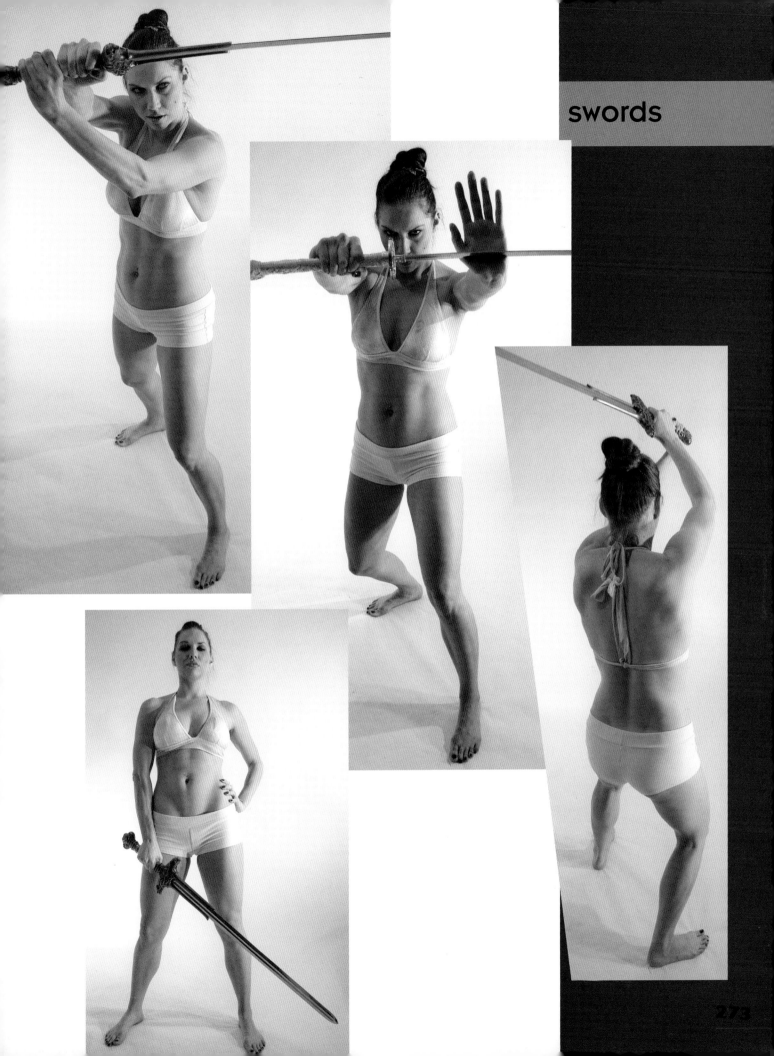

Demonstration

Evolution of a Cover
BY JG JONES WITH COVER DESIGNER TERRI WOESNER

We all know we're not supposed to judge a book by its cover, but that's what people do when they browse bookstore shelves. For this project, IMPACT Books needed cover art with attention-grabbing action, color and energy. We knew superstar cover artist JG Jones had the artistic stopping power to help this book leap off the shelves.

In this lesson, JG Jones gives you a behind-the-scenes look at his sketches, studies and notes, while Buddy Scalera and IMPACT designer Terri Woesner share their recollections and observations about the cover development process.

1 TERRI

I asked JG to choose two of Buddy's photos to use as the basis for a piece of dynamic cover art that would engage the reader at first glance. JG picked these photos of Pamela. In the sword photo, she grabs the viewer with her direct gaze and aggressive pose. JG thought the cape from the other photo could be incorporated to create contrast and visual interest in the background.

I agreed that the concept was cover-worthy. I asked JG for art with a science-fiction/fantasy theme.

3 BUDDY

JG flops the image back and forth using his computer. In this early sketch, he uses both photos backwards, testing whether the image "reads" more naturally that way.

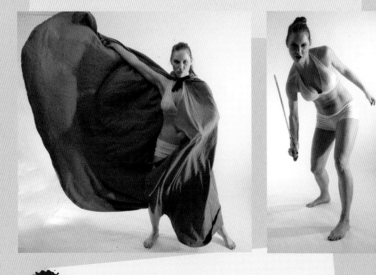

2 BUDDY

If you want the subject of a photo to look strong and dominant, you shoot from a low angle. That's what I was doing here.

4 TERRI

This rough thumbnail sketch let me see how JG was planning to pull the two photos together, so that I could give him my input before he started to invest a lot of time in creating final art.

274

TERRI

JG said this concept was inspired by the warrior women on various covers from the science-fiction classic John Carter of Mars series. Here, you can see him starting to add costume elements that are in that spirit.

For this sketch, JG flopped the photos back to their original orientations. In a minute, you'll see why.

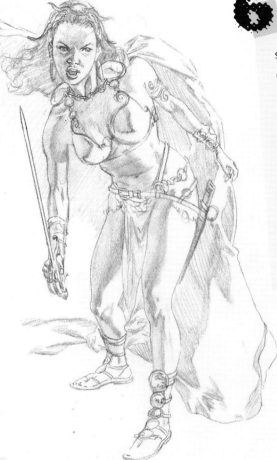

BUDDY

As JG takes Pamela's core pose and starts to add props and costume, he doesn't just paste them on like paper-doll clothes; he wraps them around the figure. The scabbard of the sword hangs behind the leg; the bracelets curve around the wrists; the straps and chains drape around the hips; the loincloth partly disappears behind the leading leg. All of these details contribute depth and realism, enhancing our sense of this character as a 3-D woman.

BUDDY

Pamela was in motion when both of the reference photos were shot. JG does a great job of adding visual cues that capture this sense of motion: the flowing cape, the flying hair.

BUDDY

A figure in motion is inherently off balance. If you draw the lines of Pamela's frame on the photo, you get subtle clues as to how she was moving when I snapped the picture. In this pose, Pamela was pretending to duel with an unseen opponent. Even though her body and shoulders are tilted, she keeps her eye level almost perfectly horizontal, which is typical of people with good physical control.

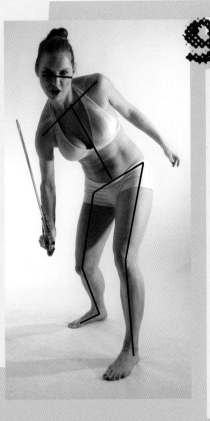

BUDDY

When I photographed Pamela, I was using more than one light. The most intense light was coming from her left. Additional studio lights made it easier to see details that would otherwise have been lost in the shadows.

The sketch above clearly shows the direction of the light source, even though JG had no specific knowledge of how I had set up the photo studio.

Flying Reptiles

Cape

Giant Lizard

Warriors in background

Lizard's Tail

10 TERRI

JG scanned the cover of the first book in Buddy's series, People and Poses, and used it as a template for a mock-up. I didn't ask him to do this; he just did it, and I was thrilled because it made it much easier for everyone at IMPACT to visualize the final product. Also at this stage, JG started painting with watercolors to show me the color notes he had in mind.

The first cover in the series featured reference photos in the lower left corner. For consistency, I wanted to keep the photos at the lower left for this cover as well. So JG flopped the pose again, back to the original orientation, to make room for the photos.

11 TERRI

You can see JG's handwritten notes in the margins here. The creatures and other background touches were all his idea. I was excited to see JG's vision for the entire piece starting to materialize.

12 TERRI

I really liked the red tones JG used for the loin-cloth, and I asked him to repeat those colors in the background of the image.

13 TERRI

The red-orange palette worked well with Pamela's warm skin tones. The hint of purple amid the orange in the loincloth was an exciting contrast.

14 BUDDY

As JG roughs in the background creatures and other elements, the cover is gaining depth and context. With just a few carefully chosen details, he is creating a complete and believable environment for the character.

15 TERRI

Buddy's studio floor was of course flat, yet just by curving those long shadows in the foreground, JG was able to make the character look as if she is standing on uneven ground or even stepping over something!

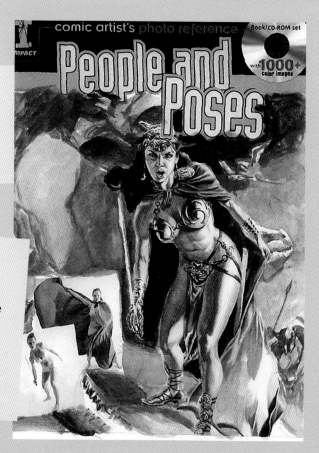

16 TERRI

The colors in the studies were pretty muted, so I asked JG if he could brighten them up a little for the final. I was impressed by how much punch he was able to add with watercolors.

To make the character work with the red-and-orange theme, JG changed the color of the character's hair from brunette to blonde so that it wouldn't get lost in the background.

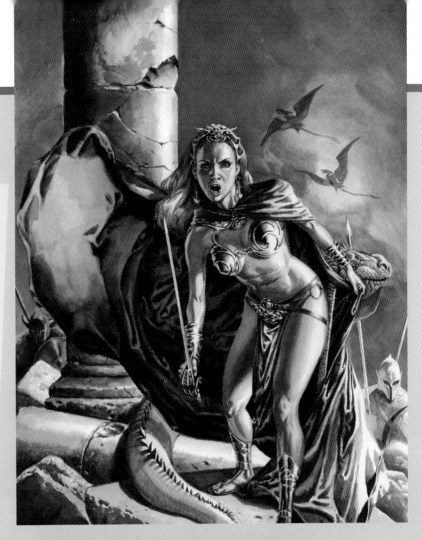

17 TERRI

Books in a series need to have a unified design, yet they also need to be easily distinguished from one another. The green title treatment in JG's mock-ups came from the first book in the series. For the second book (this one), I knew I would be changing the color behind the title. I allowed JG's artwork to guide my choice. The purple that started out as just a hint of color in the loincloth became a powerful yet feminine color for the title treatment.

comic artist's photo reference

Book/CD-ROM set

with 1000+ color images

Women and Girls

Buddy Scalera

swords

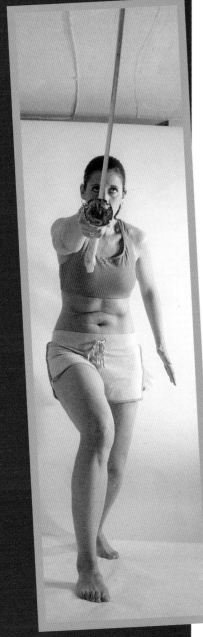

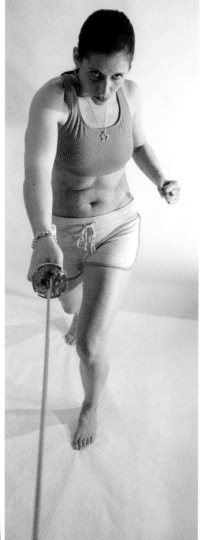

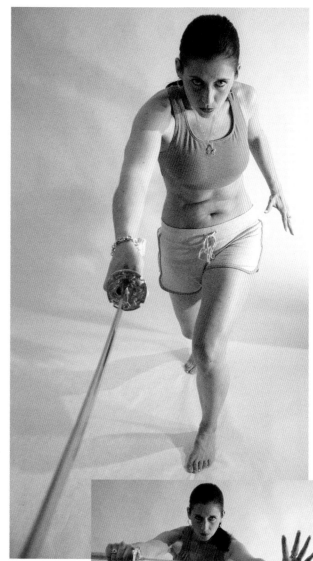

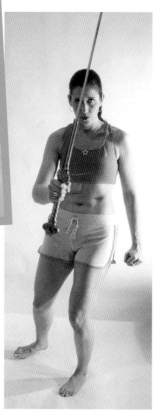

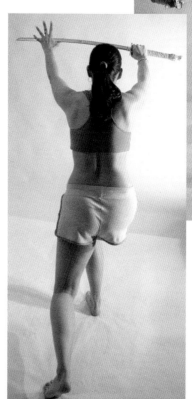

For more action poses, visit
impact-books.com/
colossal-collection

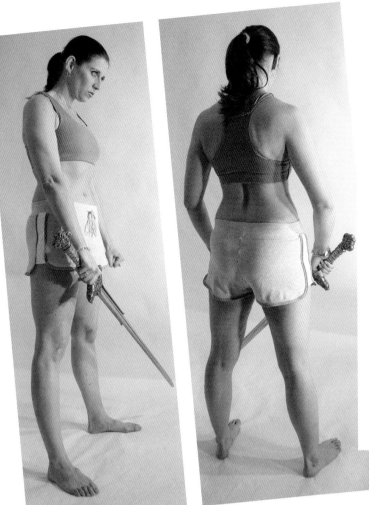
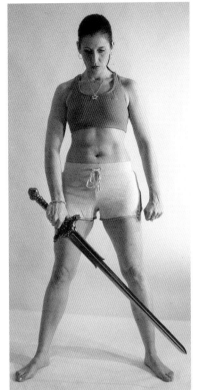
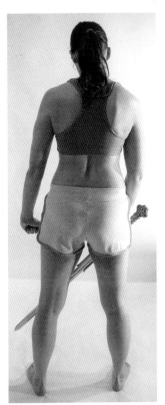

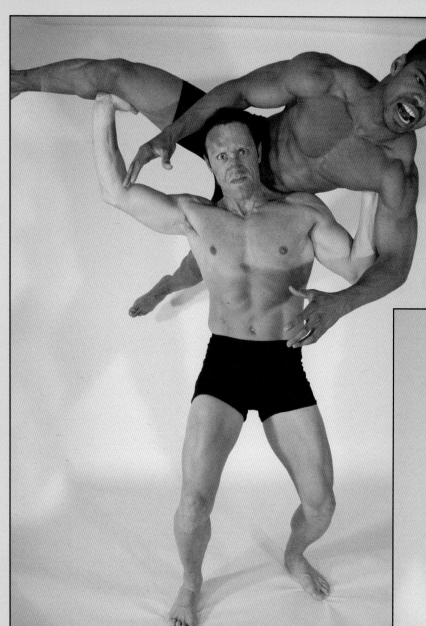

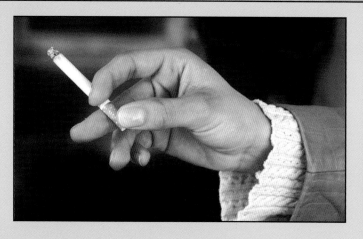

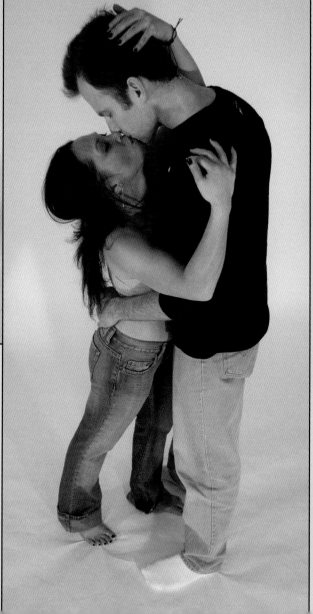

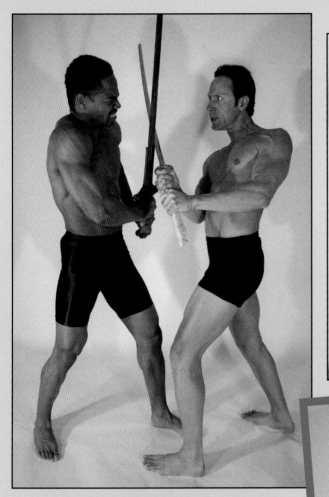

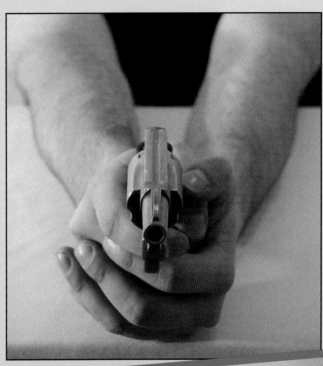

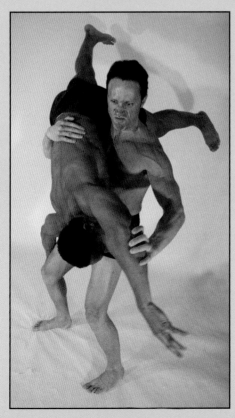

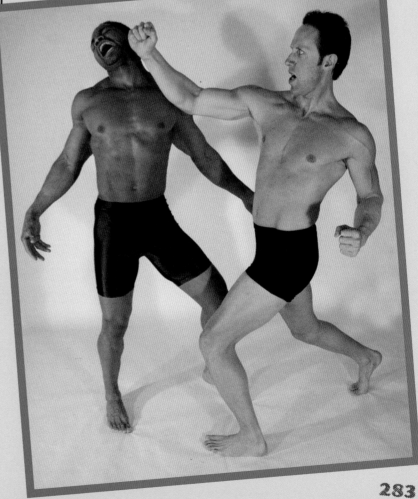

Creating Pitch Art
BY DAVID HAHN

I needed art for a comic story I was pitching about a couple of juvenile delinquents on the run. In one of the key scenes, the boy is about to rob a drugstore and the girl thinks he shouldn't. They have a big fight about it, and the boy decides to do it anyway. This is a pivotal moment in the story, so I decided to use it for the pitch art.

I chose the two photos below because the girl character is a smoker and the boy character is holding a gun and turning away from the girl.

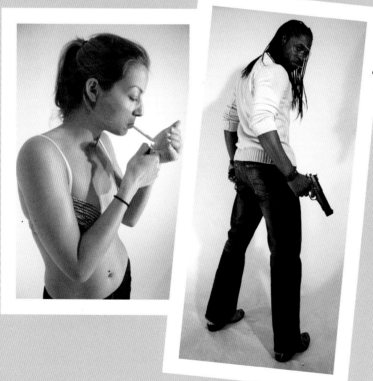

Construct the Figures

First I compose the drawing in my head. Then, using a regular .05 HB mechanical pencil, I do sketches. I usually construct figures with the block-and-cylinder method, but for the male here, I went with a hybrid of skeleton/cylinder. I find that method helpful when a figure is going to be dressed in baggy clothing.

The model in the photo looks like a tough, ass-kicking type of guy. My character is more trepidacious, so I needed to tone down the pose by dropping the arms a bit and deflating the chest.

The female model conveys just the right attitude for my character. Judging by the perspective distortion in her photo, it looks as if the camera was about two feet from her head. For my illustration, I needed the "camera" to be pulled back a bit more, so I didn't draw the perspective distortion.

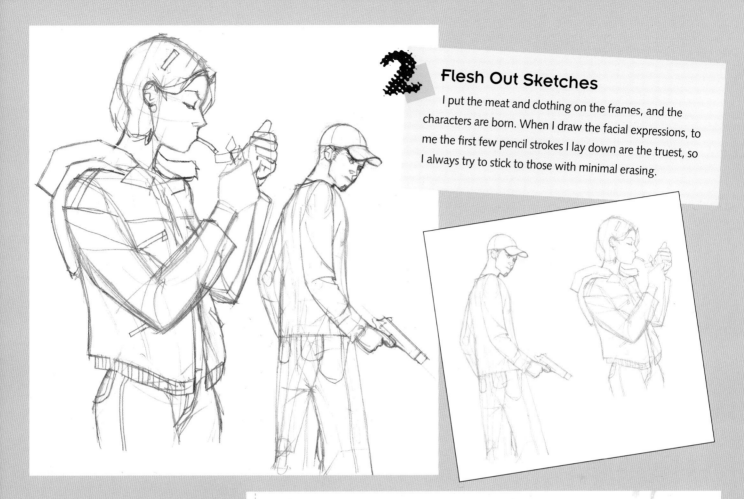

Flesh Out Sketches

I put the meat and clothing on the frames, and the characters are born. When I draw the facial expressions, to me the first few pencil strokes I lay down are the truest, so I always try to stick to those with minimal erasing.

Sketch Background

I draw the background, a simple alley behind a drugstore, separately on a piece of scratch paper.

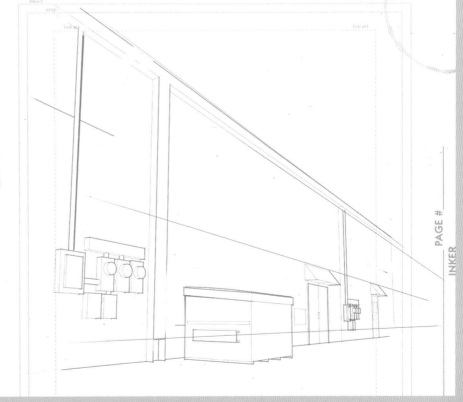

Create a Composite

I scan the figures and the background as grayscale 300 ppi TIFFs, then drop in the figures over the background. Then I move the figures around and scale them until I get exactly the composition I want. I also look for errors. I can see that her left hand is too big and his neck is too long, so I fix those digitally.

Once I am happy, I print the composite image as a blueline drawing.

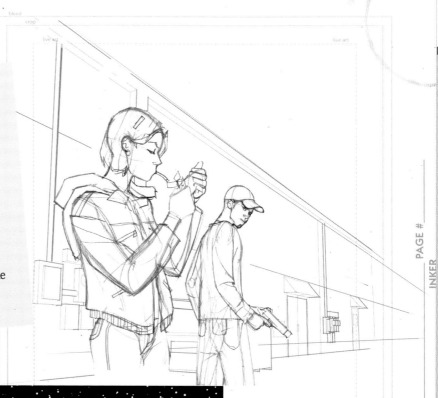

Mask and Ink

I mask out stars in the sky area using spatters of latex masking fluid. Then I ink. I like Zebra Hyper Jell gel pens; for finer details, I use Hi-Tec Pilot pens (Japanese) or a Pigma Micron 04 pen. Finally, I peel away the masking to reveal the stars, and the piece is done.

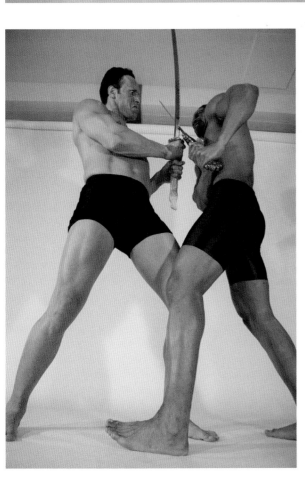
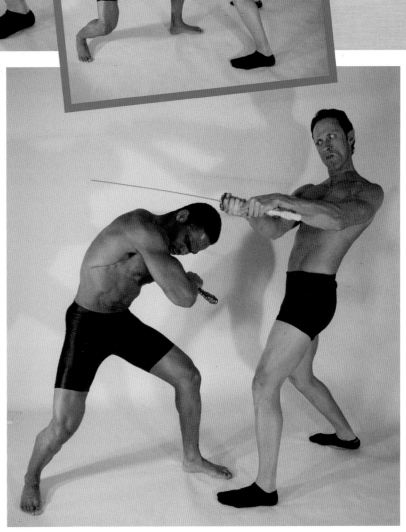

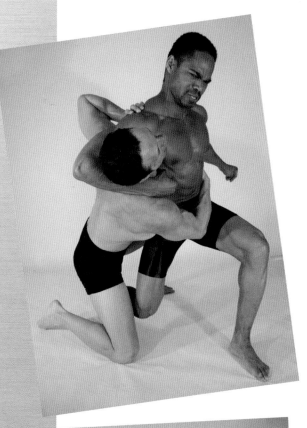

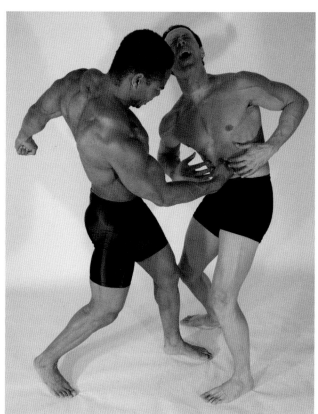

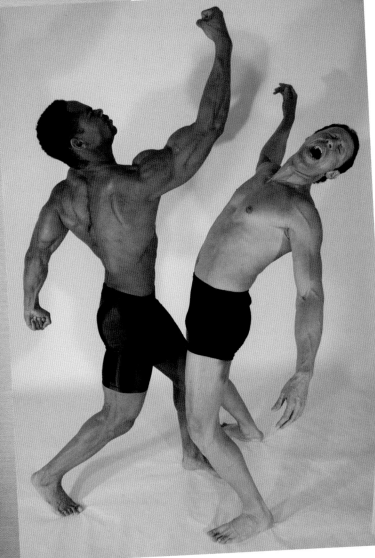

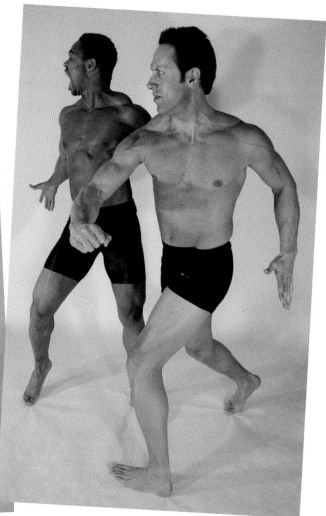

Battle

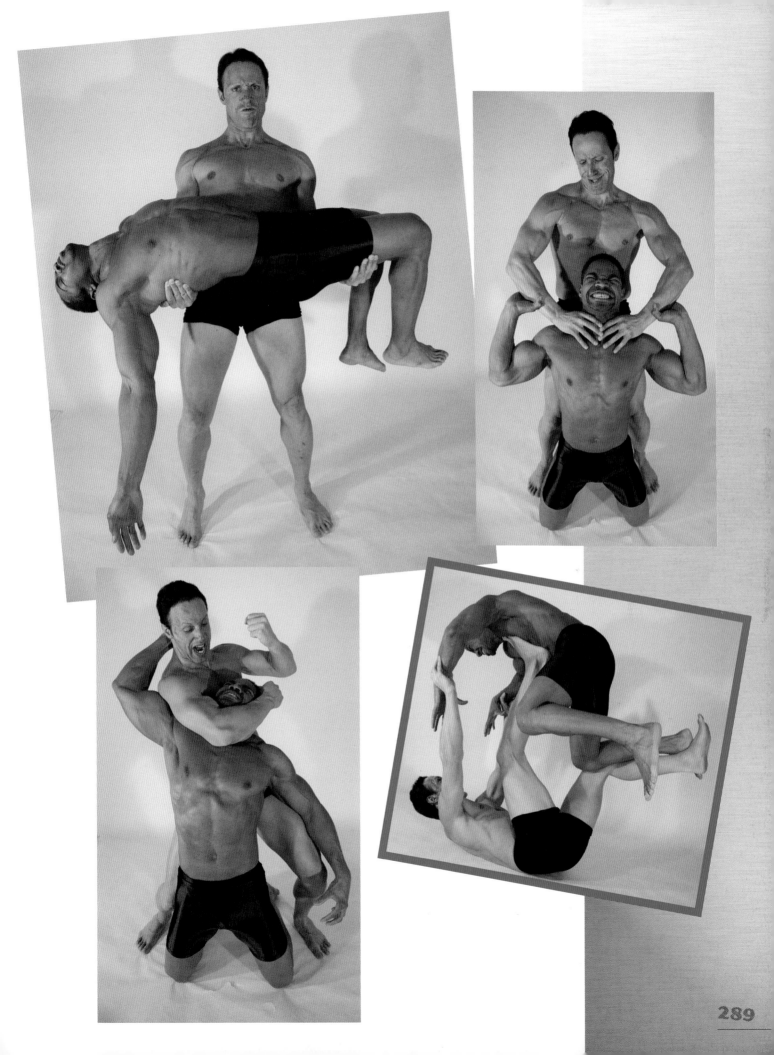

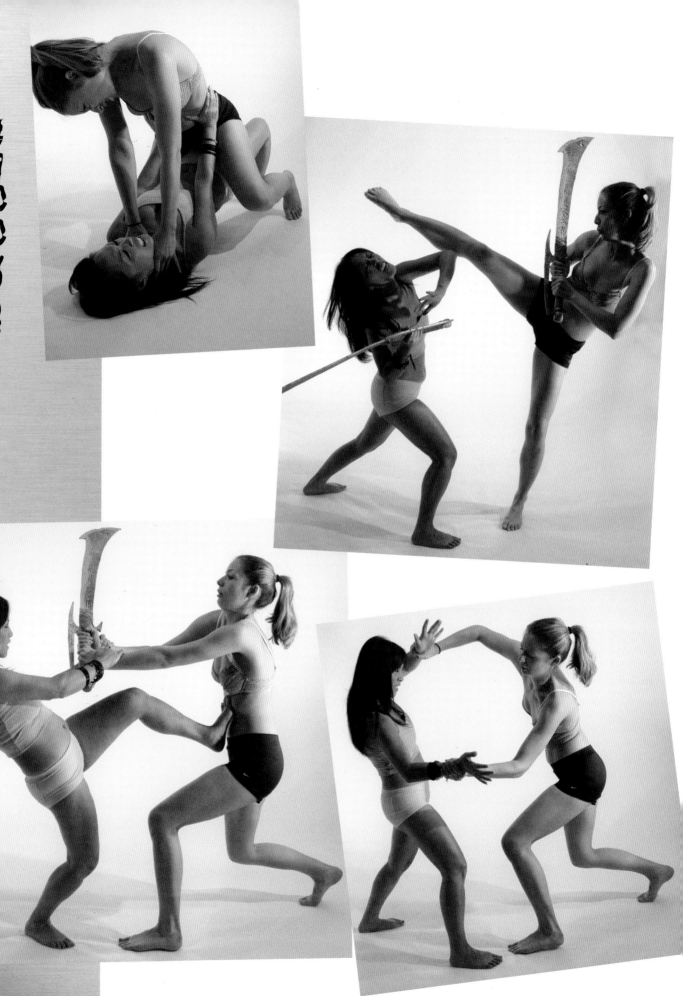

Battle

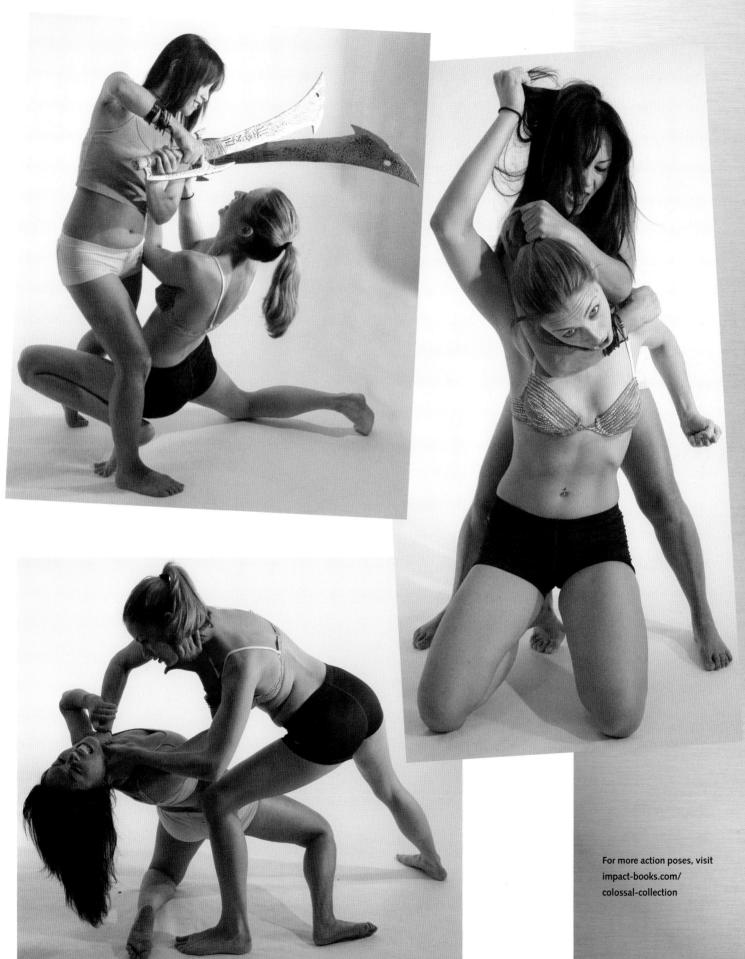

For more action poses, visit
impact-books.com/
colossal-collection

Drinking

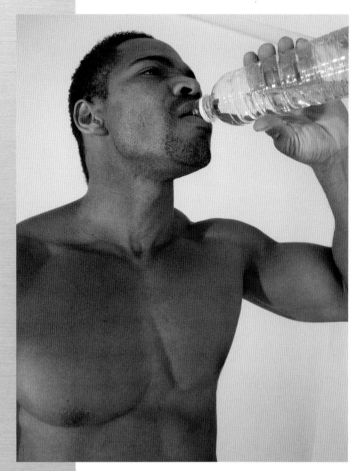

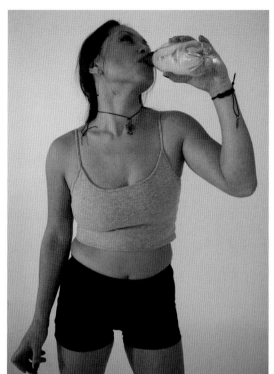

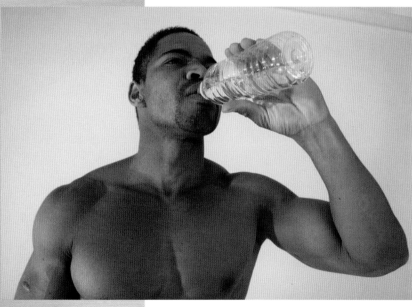

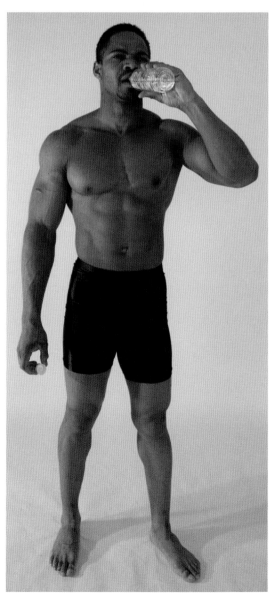

For more action poses, visit
impact-books.com/
colossal-collection

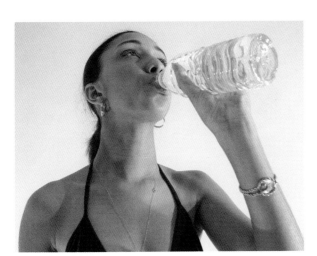
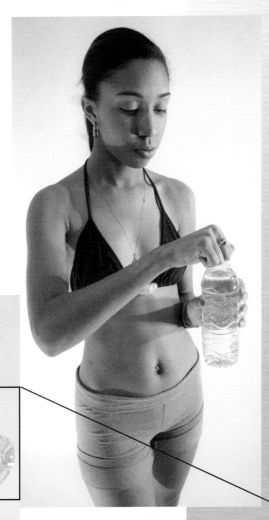
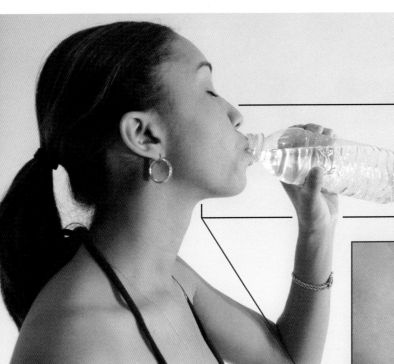
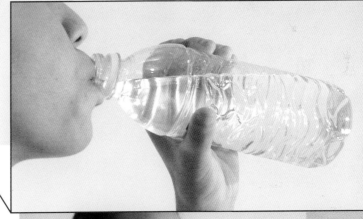
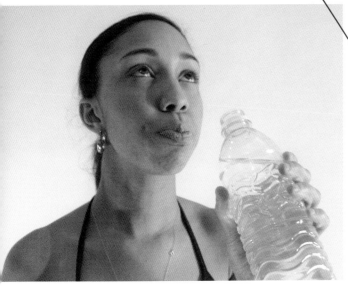
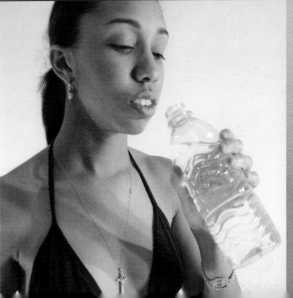

Loading a Gun

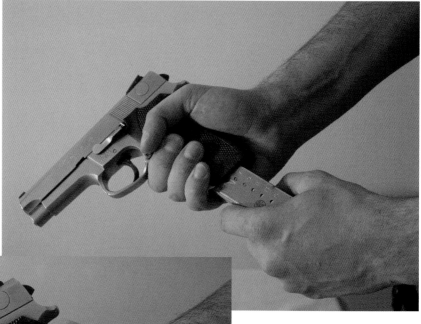

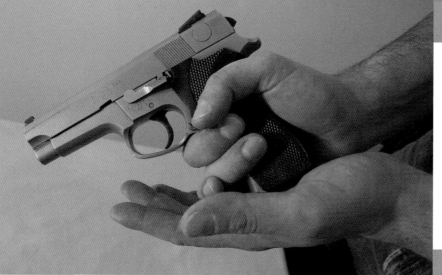

Gun: Smith & Wesson 9mm—Model 5946

Note to artists: This model is made specifically for the New York Police Department. Other models will differ slightly.

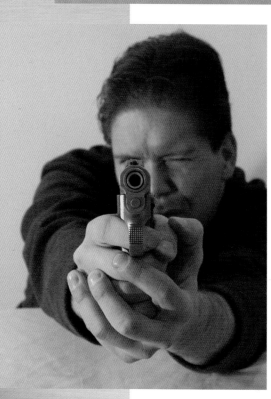

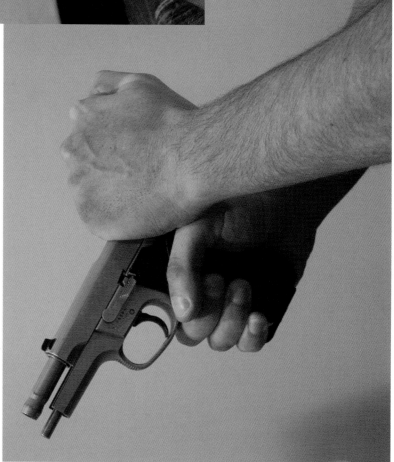

294

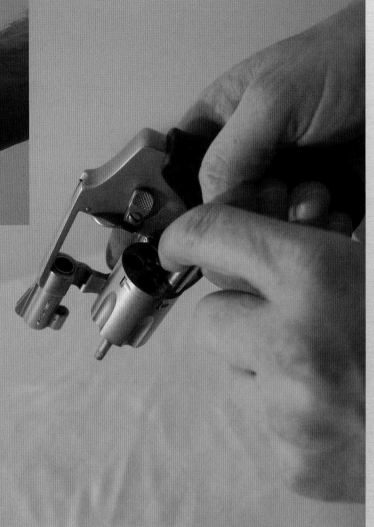

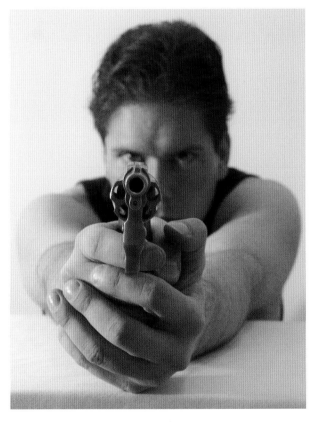

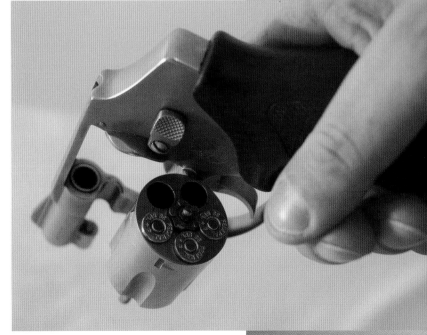

Use Photo Reference to Create a Cartoonish Figure

BY FERNANDO RUIZ

Reference photos are a great resource. Use them anytime you have a shot that you can't readily envision in your mind's eye. Don't be afraid to put a visual in front of yourself.

It's perfectly acceptable to combine references. A single shot may not have all the answers you're looking for. Plus, it's always a good idea to be as visually familiar with your subject as possible. Multiple photos of the same model help you understand how that person moves and exists in the real world.

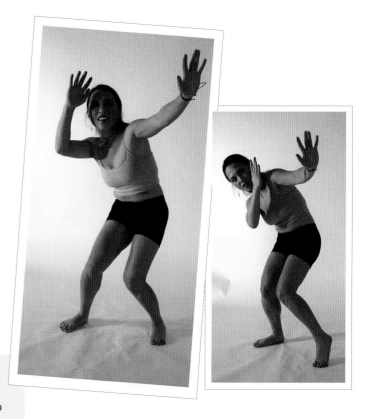

Find Your Photos

In the photo at the left above, the position of the model's torso and the up-shot on her face are very interesting. (Let's face it, up-shots can be difficult. We're not used to looking at people from underneath their jaws.) The lower body on this picture is a bit too animated, though—we're drawing an ordinary girl here, so she's not supposed to look as agile as Spider-Man. The slight foreshortening on the legs and arms in the other photo is really cool. Like up-shots, foreshortening is one of those aspects of art that will look glaringly wrong if not done exactly right. Use reference to gauge yourself and make sure you're doing it properly.

2 Rough It

Now let's get to the actual drawing. Start with a piece of white two-ply Bristol board and a 0.3mm mechanical pencil with an HB lead. This thin, medium-density lead will give you a fine, light line for the initial stage of the drawing—the underdrawing.

Very lightly sketch the critical gesture lines that dictate the pose: the shoulder line, the spine line and the hip line. Add lines that follow the movements of the limbs. Create a face grid showing the center line of the face and the levels of the eyes, nose and mouth. All of this is the raw armature upon which you'll build the figure.

TIP

Lots of artists use the "gesture line" concept to get their drawings started. In addition to the rough on this page, check out these other examples:

- How To Use A Photo Reference
- Work From Studies
- Drawing Energy

The sketching styles are different, but a gesture line is at the heart of all of them.

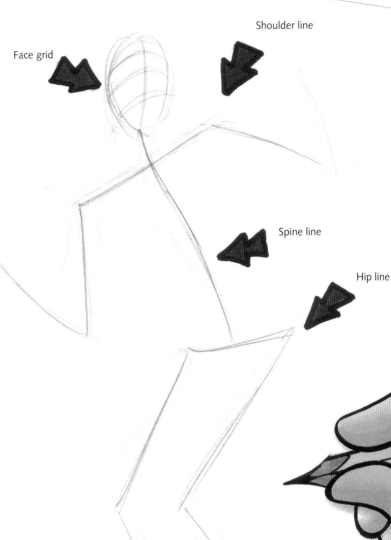

Face grid

Shoulder line

Spine line

Hip line

3 Add Form

Now you're ready to start fleshing out the figure. At this stage, the artist is akin to a sculptor who is ready to pack clay on his wire armature. Still drawing lightly, sketch some simplified forms over the "stick woman" you drew in step 2. Don't be concerned with details, anatomy or even proportions. They will come later. Right now, just give your lines a more three-dimensional form.

Remember, at this stage, you're still keeping your lines light.

roughing in with basic shapes

In this sketch are certain lines that indicate the dimensionality of the form, such as the oval at hip level. Some artists take this a step further and use cubes, spheres and cylinders to rough in the form. For an example of this, look at step 3 of Sean Chen's demo.

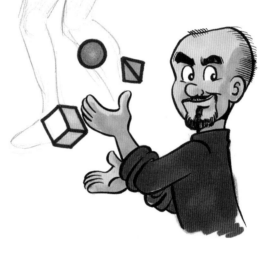

4 Add Details

At this point, you're heading toward the finish line. Make adjustments to the pose and proportions of your figure. Now switch to a harder 0.5mm pencil that will give you a heavier line. This will overpower your sketchy underdrawing and let you tighten up the entire drawing. Clean up your figure and add facial details, clothing and anatomical detail. This is a simplified, cartoonish style, so don't overdo the detail or over-render the figure. Also, don't be slavishly precise. Take liberties with the model's face, hair, proportions and other details. This way you can make her older or younger as needed, and you can adjust her facial expression accordingly.

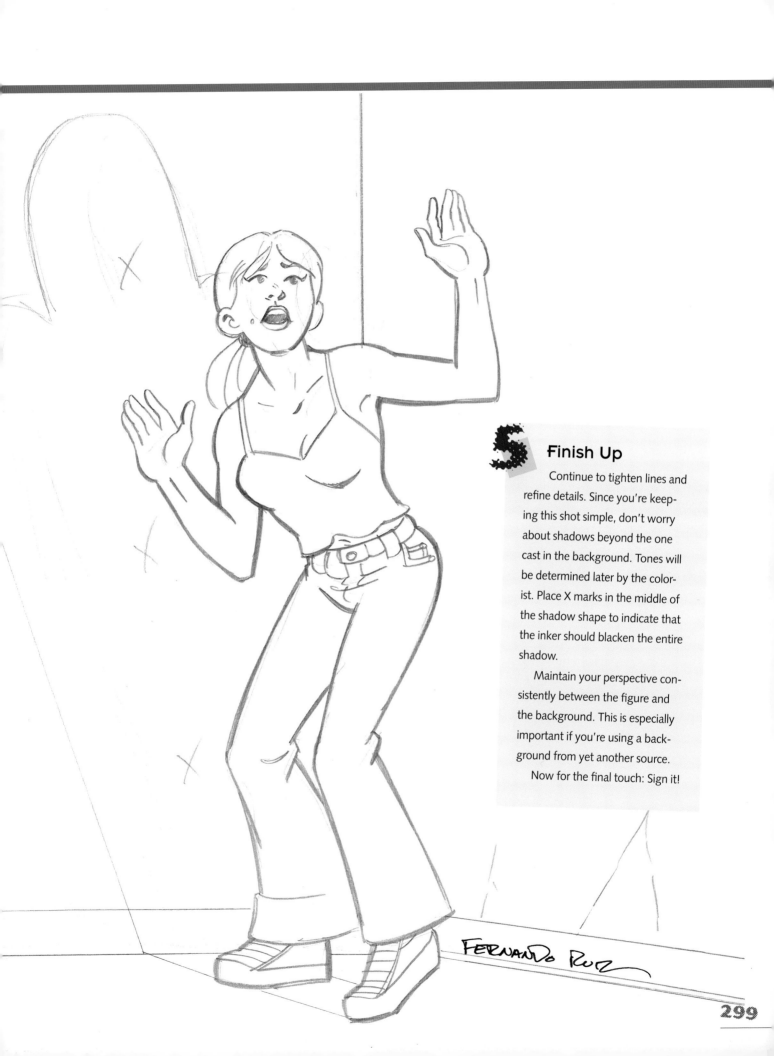

Finish Up

Continue to tighten lines and refine details. Since you're keeping this shot simple, don't worry about shadows beyond the one cast in the background. Tones will be determined later by the colorist. Place X marks in the middle of the shadow shape to indicate that the inker should blacken the entire shadow.

Maintain your perspective consistently between the figure and the background. This is especially important if you're using a background from yet another source.

Now for the final touch: Sign it!

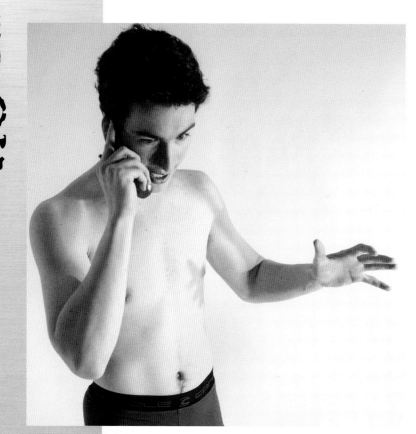

Phone

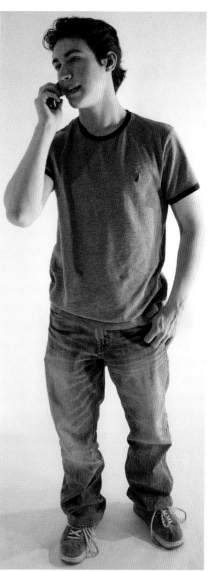

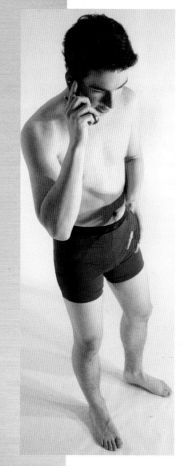

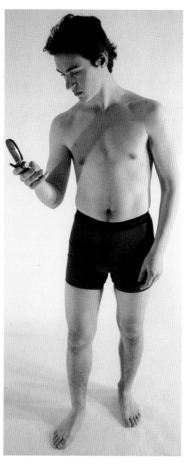

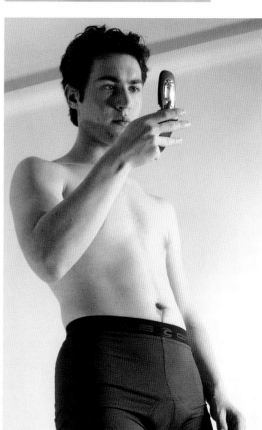

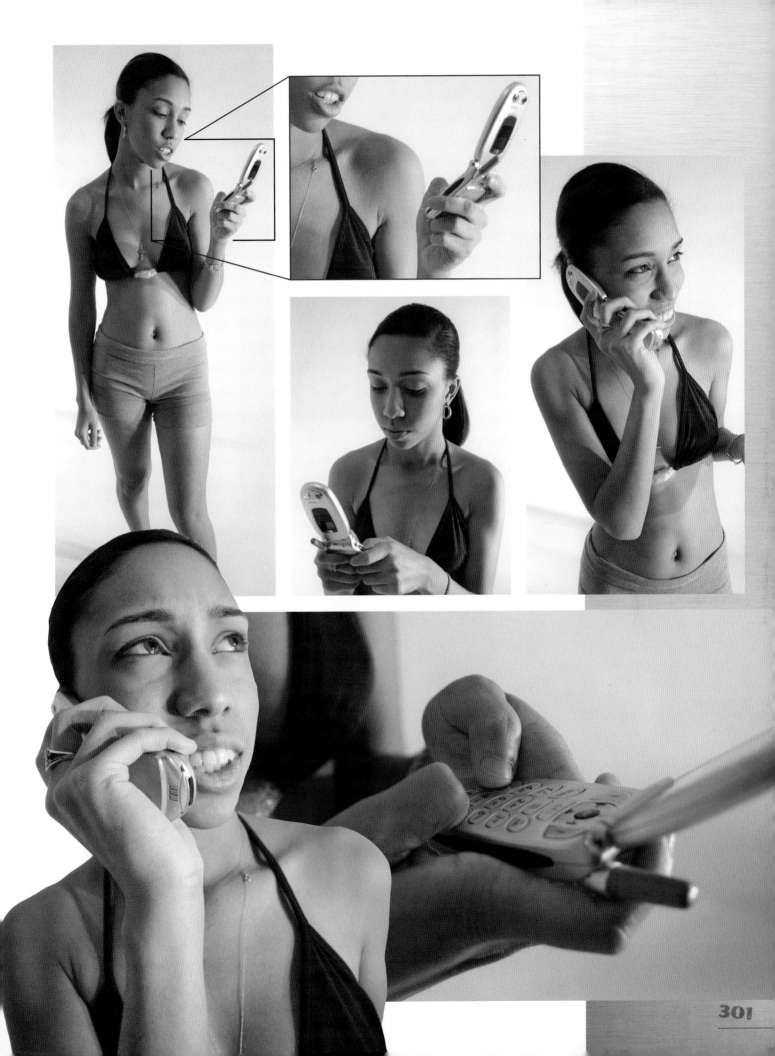

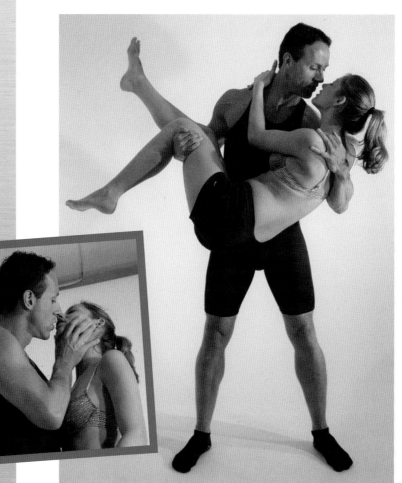

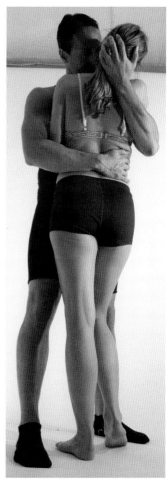

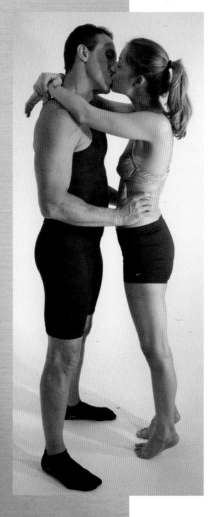

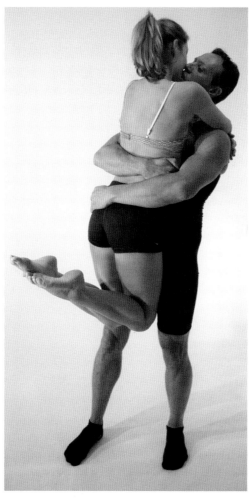

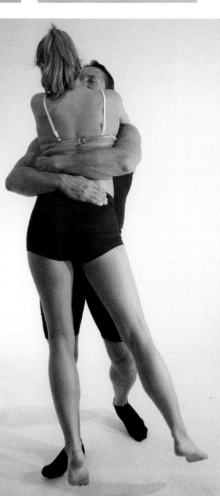

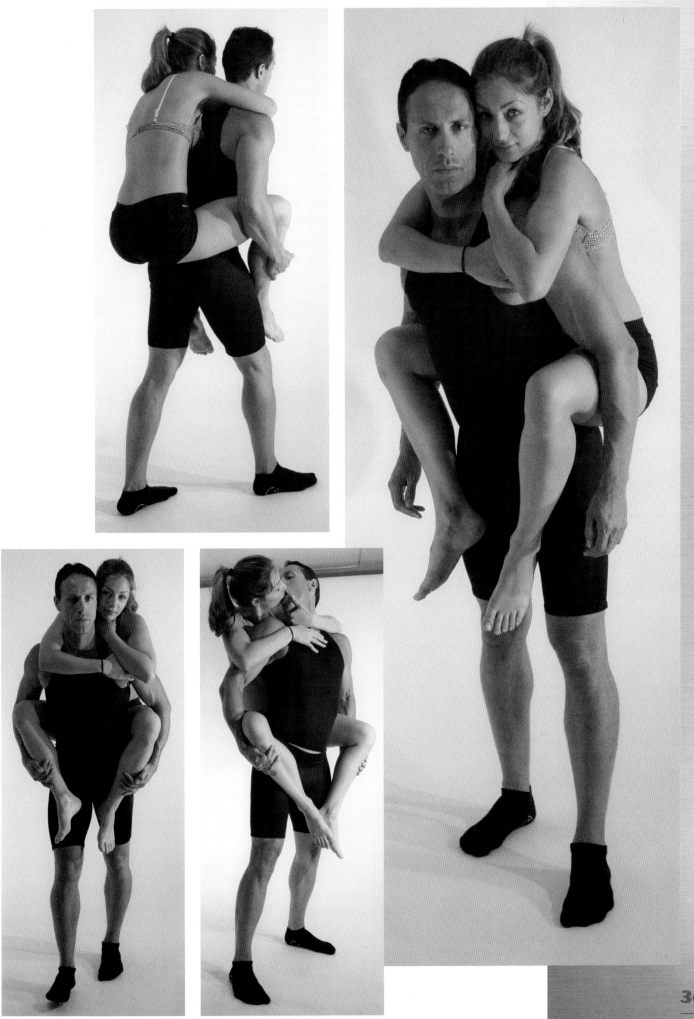

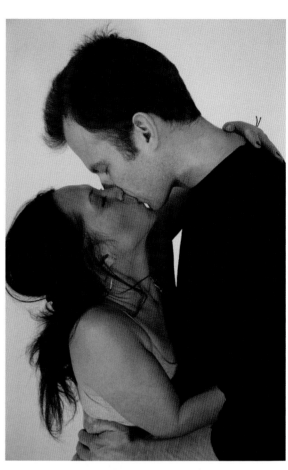

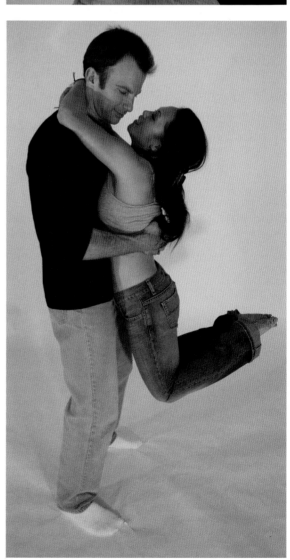

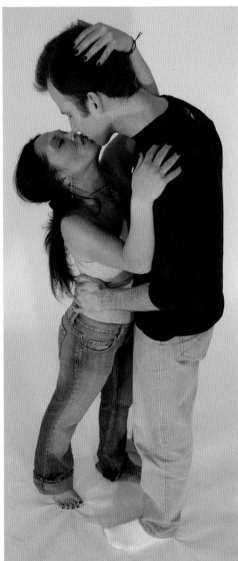

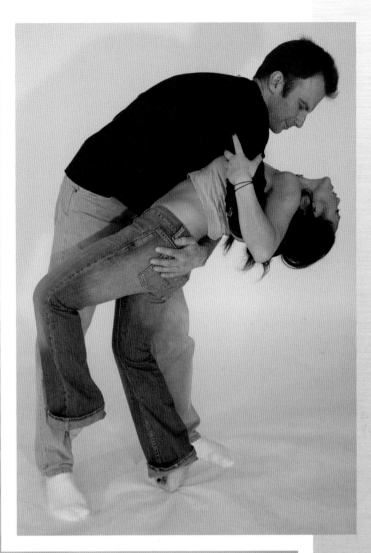

For more action poses, visit
impact-books.com/
colossal-collection

Slapping

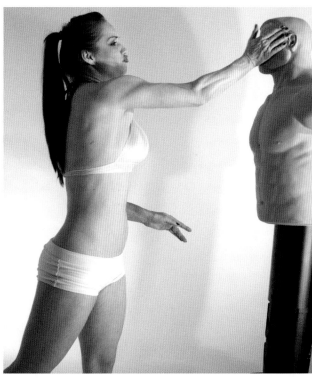

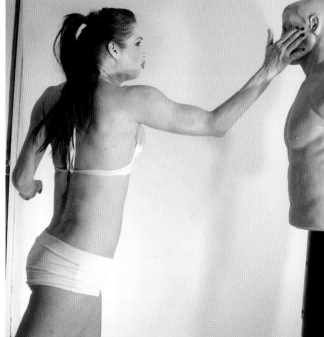

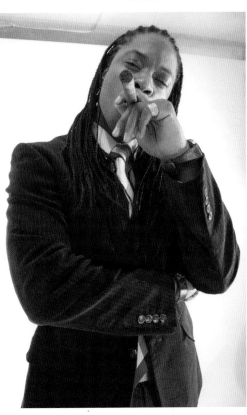

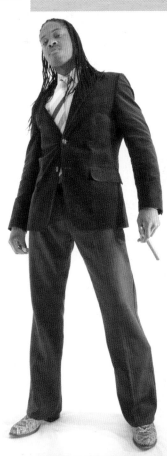

Smoking

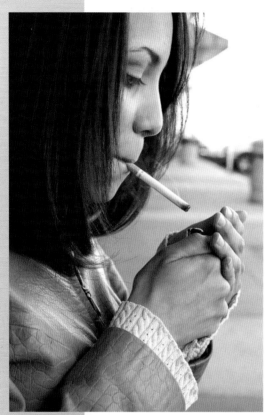

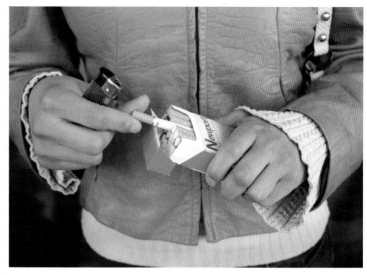

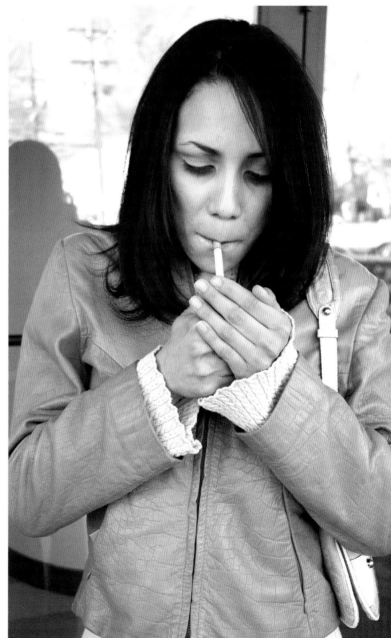

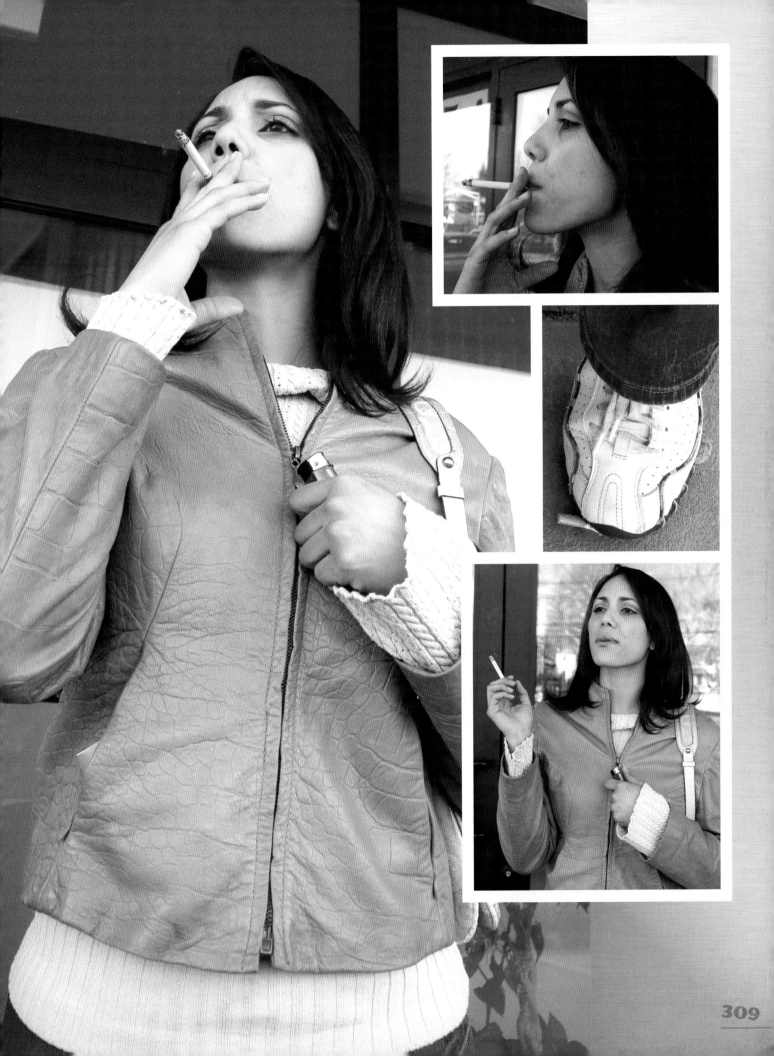

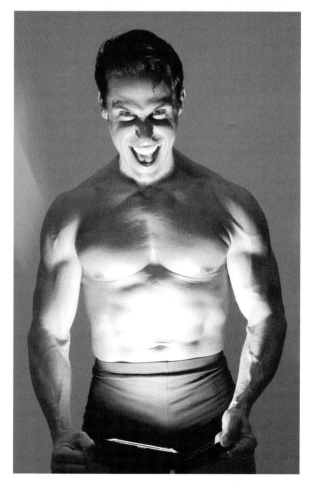

Special Lighting

For more action poses, visit
impact-books.com/
colossal-collection

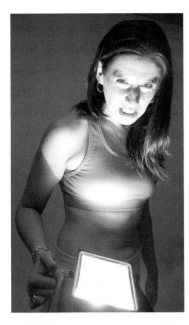

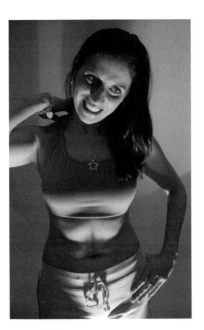

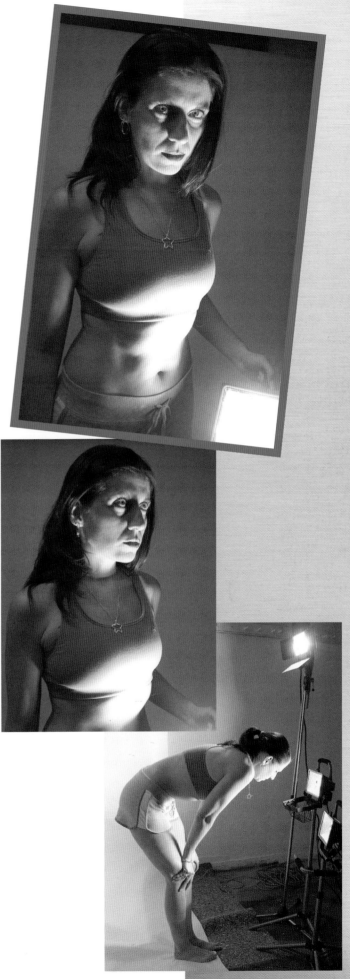

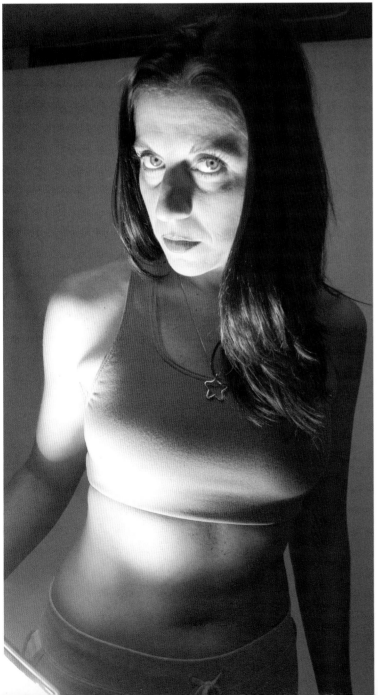

special Lighting

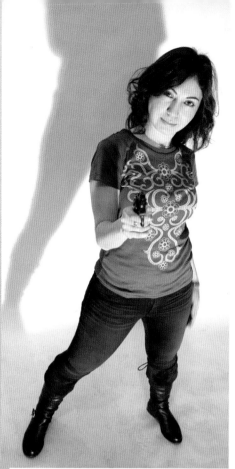

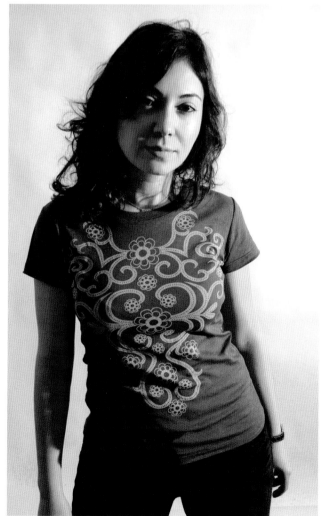

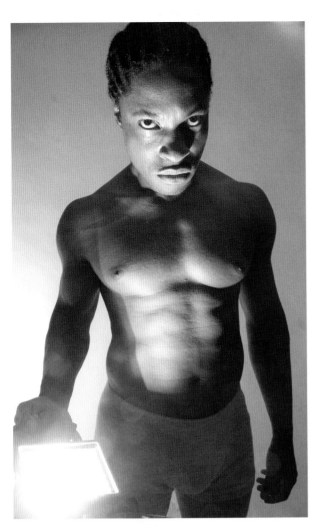
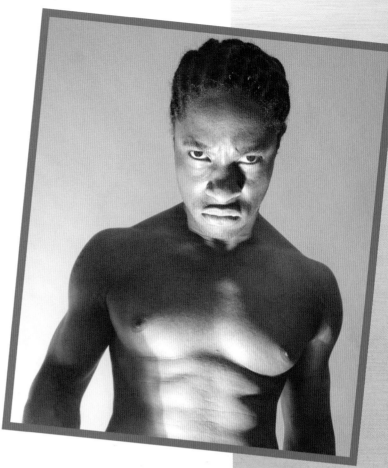
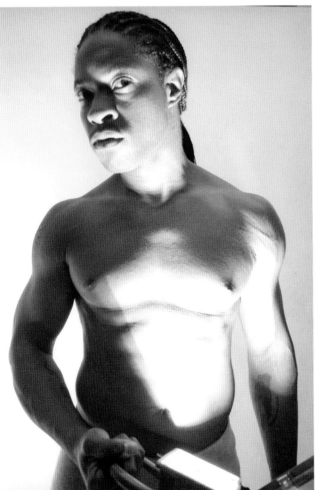
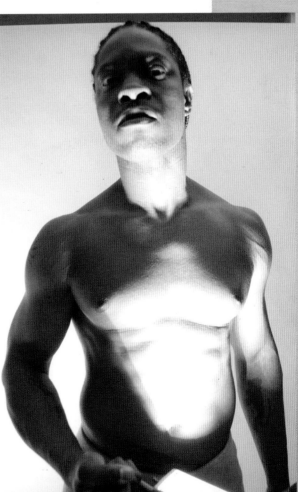

about the artists

MITCHELL BREITWEISER

Mitchell Breitweiser's art has appeared in *Agent X*, *Drax*, *Phantom Jack* and other independent titles. His highly textured art shows a unique and original vision for the future direction of comics.

Just after finishing my run on *Deadpool*, I was asked to write an inventory story in case someone missed a deadline. The story sat in a drawer for over a year until one day my editor told me they were going to dust it off. The artist was Mitchell, who turned out some gorgeous art. The book looked great but made almost no sense in terms of the new continuity for the comic, which had become something called *Agent X*. I met Mitchell at a convention and somehow he forgave my awful script, and we've been friends ever since.

www.mitchbreitweiser.com

PAUL CHADWICK

Eisner Award winner Paul Chadwick is one of the most successful and influential independent comic book creators. As the writer and artist on *Concrete*, Paul has set the gold standard for what can be accomplished in comic books. His work has appeared in dozens of titles, including *Dazzler*, *Deadpool*, *Gifts of the Night*, *The World Below*, *The Matrix* and others. Paul continues to work in comic books, but has also branched out into video games and films.

Before I really knew Paul Chadwick, I was a fan of *Concrete*. I was writing, producing and hosting a small television show called *ComixVision*, and at the end of almost every episode I would tell everyone to go read *Concrete*. It wasn't until several years later that I got to interview Paul, who is one of the nicest, smartest guys you'll ever meet.

www.paulchadwick.net

SEAN CHEN

Sean Chen is a leading artist for Marvel Comics with credits on *Wolverine*, *X-Men*, *Iron Man*, *Elektra* and other titles. He built a dedicated fanbase on his work at Valiant Comics with *X-O Manowar* and *Bloodshot*. His tight linework and detailed backgrounds are loved by fans and envied by other artists.

I first met Sean in 1993 when I was writing an article about Valiant Comics. He was quiet and reserved, but whenever he talked he always had something interesting to say. Despite his obvious talent even then, Sean was and still is refreshingly humble and unaffected. Sean drew the cover for my CD-ROM *Visual Reference for Comic Artists: Vol. 1*, which is one of the reasons it was so successful.

www.seanchen.com

Amanda Conner

Amanda Conner is one of the most sought after artists working in the comic book industry. Her unique style brings expression and life to her characters. I first met Amanda when she was drawing *Gargoyles*, but you could tell back then that she was going to be a superstar. As expected, her career skyrocketed and she continues to deliver intelligent, beautiful art on every one of her projects. My favorites include *The Pro*, *Power Girl* and *Terra*. I'm deeply grateful for this fantastic cover with stunning colors by Paul Mounts! It fulfills a longtime goal of working with Amanda, a professional who also happens to be a personal friend.

See more Amanda at: paperfilms.com

See more Paul Mounts at: www.bongotone.com

DAVID HAHN

I first discovered David Hahn through *Private Beach*, a small independent comic he was writing and drawing. I was so impressed with his confident, clean storytelling style that I reached out to him immediately. Together we pitched DC on a Catwoman story. Unfortunately it didn't get picked up, but David went on to co-create *Bite Club* for Vertigo, which showcased his artwork. I finally got the chance to produce something with David with his art lesson.

davidhahnart.com

JAMAL IGLE

When I first discovered his work, Jamal Igle was a young kid breaking in on a respected indie comic called **Blackjack**. Even then, he had an incredible sense of energy and motion. Jamal is known for his influential art on *Green Lantern*, *New Warriors*, *Firestorm*, *Nightwing* and his own co-created book, *Venture*. He's drawn hundreds of pages for Marvel, DC and Image, yet he remains accessible to his fans. Early in his career, I tried to snag Jamal for a small, indie comic I wanted to publish, but our schedules didn't cooperate. Fortunately we got to work together on the Superhero team where you'll see Jamal go above and beyond the call of duty. I asked for a drawing of one woman, and Jamal gave me an entire superteam.

jamaligle.com

MATT HALEY

Matt Haley is the successful co-creator of *G.I. Spy* and the cover artist for DC Comics' *Firestorm*. His work has appeared in *Gen 13*, *Batgirl*, *Tomb Raider*, *Wonder Woman* and other comics. In addition to his ongoing work as a comic book penciler, Matt has extended his art portfolio into video games and commercial art.

In the mid-1990s, Matt was working in a popular art studio with several top comic creators. He called me when I was at *Wizard* to see if we wanted to do some promotional stuff on Wizard Online. Matt was and still is a bundle of artistic energy. He's the kind of guy you can talk to for hours about life, comics, women—just about anything.

www.matthaley.com

JOSH HOWARD

Josh stormed the indie comic scene with his creator-owned *Dead@17*, in which he skillfully blended modern horror, action and gorgeous women all in one fun story. Everything Josh draws is so fluid and natural—cartoony, yet rooted in realism. It's amazing what he accomplishes with a few well-placed lines. He seamlessly meshes several art styles to produce a look that is unique and exciting. I'd never met Josh prior to this project, but I jumped at the chance to see how he would interpret my photographs. Check out his lesson to see how he combines fun and danger in one subtle illustration.

joshhoward.typepad.com

JG JONES

JG Jones is one of the most exciting and influential cover artists working in comics today. His art has appeared on countless covers, including DC's *52*, *Wonder Woman* and *Y: the Last Man*; Marvel's *Marvel Boy*; and *Wizard* magazine. The depth, texture and energy that he brings to his artwork are simply stunning. His use of color brings power and impact to every image. I've been fortunate enough to know JG many years, so I've seen his work develop and mature. He is a true gentleman and one of the nicest people I've ever met in this business. Check out the progression of his cover to see how he works his magic.

www.jgjones.com

Artist photos supplied by the artists.

about the artists

RAFAEL KAYANAN

Ever since I saw his work on *Conan the Adventurer*, I'd been trying to track down Rafael Kayanan. His incredibly detailed work captured the true essence of Conan's savage ferocity. I was fortunate that his schedule allowed him to contribute. The art he generated for this project shows the depth and complexity of his work.

www.rafaelkayanan.blogspot.com

MIKE LILLY

I first saw Mike Lilly's work when I was hired to write a licensed comic book property for a famous actor. Mike was the artist, and I was blown away by his dynamic pencils and fluid storytelling style. Unfortunately the book never came out, but I saved those precious photocopies. Our careers took different directions, but I always admired the art Mike created for Marvel, DC, Harris and others. These days, his career is really taking off, and his work keeps popping up everywhere as people discover his talent. Check out his art demo to see for yourself.

www.mikelilly.com

GREG LAND

Greg Land is the red-hot artist whose work has appeared on covers and interiors for *X-Men*, *Spider-Man*, *Wizard* and more. His textured and detailed cover-art style is even more amazing when you consider that he can do sequential pages and maintain the same quality. Greg's art has appeared in dozens of comics including *Birds of Prey* for DC. Not until his work on *Sojourn* for CrossGen did people appreciate the full potential of Greg's artwork.

I'd seen Greg's art and I really wanted to show him my visual reference CD-ROMs. I tried several times to meet him at a convention, but it was always too busy. Finally I managed to get in touch with Greg after a convention, and we had a great talk about comics, art and photo reference. He's a guy who really paid his dues to break in, so I have a lot of respect for him.

TERRY MOORE

Terry Moore is an accomplished and revered comic writer-artist. His award-winning series *Strangers in Paradise* stands as one of the finest stories ever to be published in the medium. I'd first discovered Terry's work when SiP was bubbling up as an underground sensation. Even then, his art and writing could steal your breath away. As you read his lesson, you will understand why Terry is a modern master of the art form. He reveals how he not only draws the model but actually thinks about her as a person. I've known Terry for many years, and I'm thrilled and honored to have him be part of this project.

MICHAEL OEMING

When I first met Michael Avon Oeming, he was starting to gain attention with his indy series *Ship of Fools*. I covered his work online, but I knew that he was a rising star. A few years later, he burst into the mainstream with ever-maturing work on *Powers*, which led to work on *Thor* and *Red Sonja*. He's a genuinely nice and charming guy who helped me out with a terrific art lesson. Check out how he can turn an ordinary woman into a male supervillain.

michaeloeming.com

FERNANDO RUIZ

Fernando Ruiz has been drawing Archie comics for over ten years and shows no sign of stopping. His clean, fluid story-telling style is perfect for the fun-lovin' gang from Riverdale. For over fifteen years, he has been shaping the next generation of artists as a staff teacher for the Joe Kubert School of Cartoon and Graphic Art in New Jersey.

I met Fernando at a comic book convention where he was busy creating gorgeous color sketches. He has an amazing sense of color and design. We see each other at conventions and talk on the phone. He's a really mellow, cool, generous guy.

MARK SMYLIE

I was working at *Wizard* when an unusually well-designed independent comic called *Artesia* crossed my desk. I called the artist, Mark Smylie, and we did a short feature on this amazing painted comic that he was self-publishing. Mark was then, as he is now, a smart publisher, and his Archaia Studios Press publishing venture continues to grow. Mark doesn't do quite as much art these days as he used to, but you can see from his art lesson that he certainly hasn't lost his touch.

www.artesiaonline.com

WILLIAM TUCCI

Billy Tucci burst onto the comic book scene with the red-hot comic book, *Shi,* which he self-published through his company Crusade. The success of *Shi* led Billy to launch a dozen other comic book titles, an interactive comic book/game with characters from Marvel and DC Comics, and more merchandise than you can possibly imagine. Billy wrote and directed the very funny short film *Some Trouble of a SeRRious Nature,* which won a prestigious New York film award.

I met Billy at a convention in Philadelphia where he was debuting *Shi.* The minute I saw his art, I knew he was something special. We've stayed friends through all the crazy ups and downs of this business.

www.crusadefinearts.com

THOM ZAHLER

Thomas Zahler writes and draws a very clever and compelling comic series called *Love & Capes.* It's really quite amazing that nobody before ever came up with a genuine romantic sitcom with superheroes…and that Thom does it so well. What I like about Thom's work is that he knows exactly how much to leave into the art and story, and what to leave out. Check out his lesson to see how he uses photo reference to create energetic cartoons and comic characters.

www.thomz.com

About the Author

Buddy Scalera is a writer, editor and photographer. He is the author of the popular Comic Artist's Photo Reference book series for IMPACT Books, and he is also known for his best-selling series of photography CD-ROMs, Visual Reference for Comic Artists. His most recent work, *Creating Comics From Start to Finish*, is available from IMPACT Books.

He has written for many mainstream comics, including Marvel Comics' *Deadpool*, *Agent X* and *X-Men Unlimited*, and he also contributed to Marvel's all-ages series *Lockjaw* and *The Pet Avengers*. On the indie side, he has written many comics including *Richie Rich*, *Elvira*, and *Comiculture*. Over the years, Buddy has self-published comic books through After Hours Press, including *Necrotic: Dead Flesh on a Living Body*, *7 Days to Fame*, *Bonita & Clyde*, and *Parts: The SitComic*.

Buddy's written over 100 articles on the topic of comics for *Wizard*, *Comics Buyer's Guide* and *Spin Online*, among others, and he was the creator and editor of Wizard Entertainment's WizardWorld and WizardSchool websites.

As an educator, Buddy has hosted and organized workshops and panels at major conventions in locations including New York City, New Jersey, Chicago, Long Beach, and Philadelphia.

Visit his website at www.buddyscalera.com.

Acknowledgments

To Pam Wissman
You've developed and nurtured a wonderful collection of unique and inspirational books. Thank you for taking a chance and letting me contribute to your world. I am honored and grateful.

To Amy "The Professor" Jeynes
Thank you guiding me through the original books. Without you, I almost certainly would have gotten lost.

To Vanessa Wieland & Clare Finney
Thank you for the ongoing encouragement and patience. You both worked hard to keep this project on track.

To Amanda Conner
Thank you for this amazing cover. I'm so glad that we finally got to do something together.

And, of course, to the actors and models who generously gave their time until we got the shots:

Loukas Papas
Norman A. Kellyman
Haydee Urena
Liam Devine
Chanel Wiggins
Zoe Labella
Pamela Paige
Vanessa Carroll
Veronica Bond
Rory Quinn
Jarrett Alexander
Anthony Catanzaro
Mark A.S. Dolson
Ridada Elias
William Paris

Another Production.

Other fine IMPACT Books are available from your favorite bookstore, art supply store or online supplier. Visit our website at www.fwmedia.com.

15 14 13 12 11 5 4 3 2 1

DISTRIBUTED IN CANADA BY FRASER DIRECT
100 Armstrong Avenue
Georgetown, ON, Canada L7G 5S4
Tel: (905) 877-4411

DISTRIBUTED IN THE U.K. AND EUROPE BY F&W MEDIA
INTERNATIONAL LTD
Brunel House, Forde Close, Newton Abbot, TQ12 4PU, UK
Tel: (+44) 1626 323200, Fax: (+44) 1626 323319
Email: enquiries@fwmedia.com

DISTRIBUTED IN AUSTRALIA BY CAPRICORN LINK
P.O. Box 704, S. Windsor NSW, 2756 Australia
Tel: (02) 4577-3555

Edited by Vanessa Wieland and Maija Zummo
Production coordinated by Mark Griffin

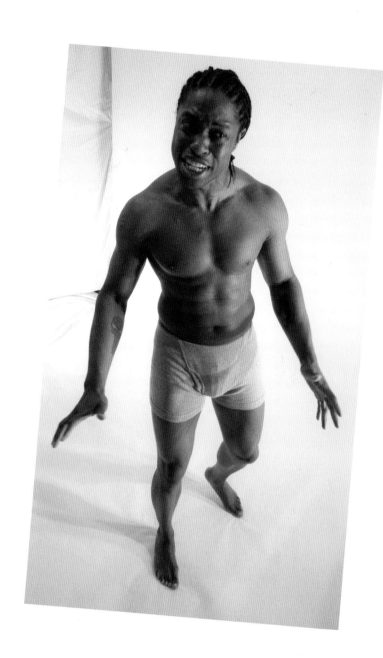

Metric Conversion Chart

To convert	to	multiply by
Inches	Centimeters	2.54
Centimeters	Inches	0.4
Feet	Centimeters	30.5
Centimeters	Feet	0.03
Yards	Meters	0.9
Meters	Yards	1.1

Ideas. Instruction. Inspiration.

These and other fine IMPACT products are available at your local art & craft retailer, bookstore or online supplier or visit our website at impact-books.com.

Download bonus poses and photos at impact-books.com/colossal-collection

IMPACT-Books.com

- Connect with other artists
- Get the latest in comic, fantasy and sci-fi art
- Special deals on your favorite artists